MANET
AND THE FAMILY ROMANCE

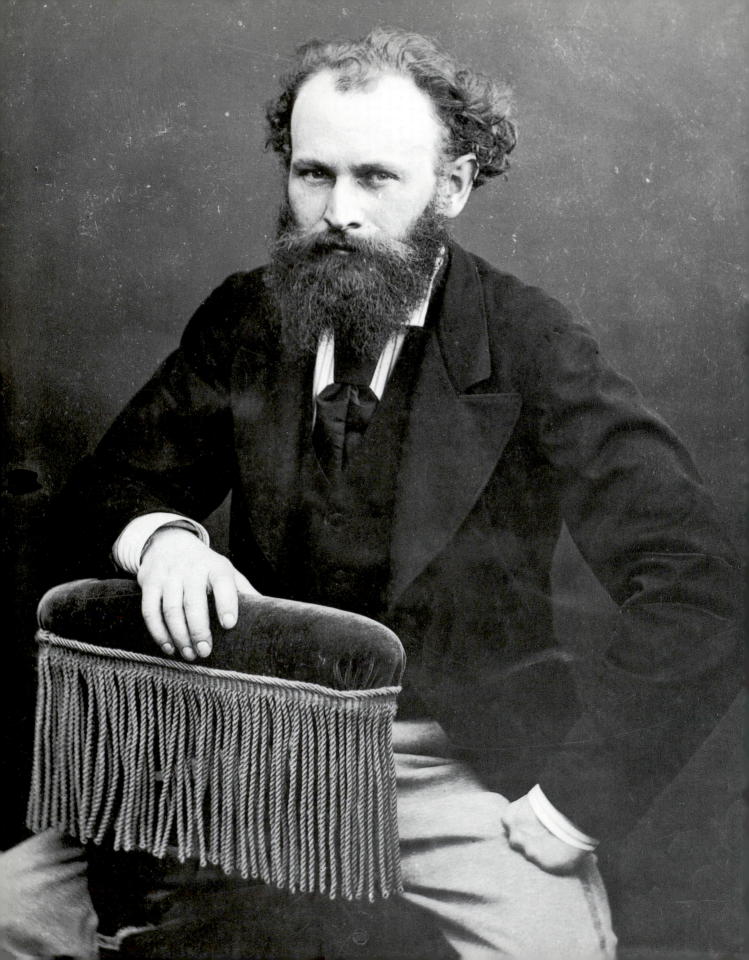

MANET
AND THE FAMILY ROMANCE

Nancy Locke

PRINCETON UNIVERSITY PRESS

PRINCETON AND OXFORD

Cover illustration: Édouard Manet, *La Pêche*, c.1861 (fig. 30)
Frontispiece: Felix Nadar (French, 1820–1910), *Édouard Manet*,
1863–64. Photograph. Bibliothèque Nationale, Paris

Published by Princeton University Press
41 William Street
Princeton, New Jersey 08540

In the United Kingdom:
Princeton University Press
3 Market Place, Woodstock, Oxfordshire OX20 1SY

www.pup.princeton.edu

Designed by Jo Yandle
Composed in A Garamond and Meta
Printed by South China Printing

Printed in Hong Kong
1 3 5 7 9 10 8 6 4 2

Library of Congress Cataloging-in-Publication Data
Locke, Nancy, 1963–
Manet and the family romance / Nancy Locke.
p. cm.
Includes bibliographical references and index.
ISBN 0-691-05060-0 (CL: alk. paper)
1. Manet, Édouard, 1832–1883—Criticism and interpretation.
2. Manet, Édouard, 1832–1883—Psychology. 3. Family in art. I. Title

ND553.M3 . L63 2001
759.4—dc21 00-064265

CONTENTS

ACKNOWLEDGMENTS

I KNOW I AM NOT the only writer on Manet who felt she almost inhabited the paintings, or who started investigating Manet's art out of a sense of personal necessity. These essays have their origins in a seminar paper I undertook with the guidance and encouragement of Timothy J. Clark. I would like to attribute most of their strengths and none of their weaknesses to things I learned from him and from my colleagues in a seminar called "Context and Form: Problems in the Social History of Art" at Harvard in 1985. The paper led to a dissertation and to a subsequent development of some of its tenets, along with a repudiation of others.

Much of the dissertation was written during a year of support from the Mellon Fellowships in the Humanities. Research in Paris was undertaken with the support of a Lurcy Traveling Fellowship awarded by a Harvard University fellowships committee. I also spent a valuable semester undertaking initial research with the help of a Harvard Merit Fellowship (Arthur Lehman Fund, underwritten by the family of the late John L. Loeb). My second reader, Henri Zerner, offered many important suggestions at various stages, including a healthy skepticism. Since I have had a position at Wayne State University in Detroit, its Office of Research and Sponsored Programs has been unfailingly supportive of my continued research and revisions; I would like to thank Dan Walz and Richard Lintvedt. A faculty research grant and a special dispensation came at crucial stages of the process. Insights gleaned while working on other Manet projects supported by a National Endowment for the Humanities summer stipend and a Humanities Center fellowship from Wayne State University also found their way into final passages. It is a pleasure to work in a university setting that has been so supportive of my work, and I would name Jeffrey Abt, Richard Bilaitis, Walter Edwards, Mame Jackson, David Magidson, and Linda Moore among the responsible parties. My chair, dean, and university research department have also generously assisted in funding the costs of permissions and photographs for the book, and I am extremely grateful to them. I would also like to acknowledge a gift from Annetta Miller toward the illustration costs.

I owe a great deal to what I learned from Beatrice Farwell during a summer of working with her on Manet with a National Endowment for the Humanities Younger Scholars grant. Several people were helpful with resources, notably Inge Dupont at the Pierpont Morgan Library, New York; Claude Bouret at the Cabinet des Estampes of the Bibliothèque Nationale, Paris; Peter Sutton and the late Robert Boardingham at the Museum of Fine Arts, Boston; R. Stanley Johnson, Chicago. Along the way, I benefited from scores of helpful suggestions, large and small, particularly from Svetlana Alpers, Marie-Claire Belleau, Richard Bienvenu, Norman Bryson, Walter Cahn, Anna C. Chave, Hollis Clayson, Patricia Crown, Raquel Da Rosa, Paul Franklin, Elisabeth

Fraser, Annie Gutmann, Danielle Haase-Dubosc, Ewa Lajer-Bucharth, Howard Lay, Jann Matlock, Alexander Nagel, Claudia Rousseau, Fredrick Seguin, John Shearman, Craig Tomlinson, César Trasobares, Anca Vlasopolos, Anne M. Wagner, and Christopher S. Wood.

Several individuals and groups have offered opportunities to present aspects of this work that have invariably expanded my thinking. I would like to acknowledge Patricia Crown at the University of Missouri-Columbia, Mary Miller at Yale University, and the members of the History of Psychiatry Section at the New York Hospital-Cornell Medical Center.

There are a few people whose help deserves special mention. Juliet Wilson Bareau provided information and answered questions, reinforcing some previously tentative figural identifications which were of particular importance. She also helped locate pictures in private collections, as did Joachim Pissarro and Sophie Pietri. My close friend and critic throughout this process has been Yule Heibel; my work has been greatly enriched by our exchanges over the years. Christopher Billick has given invaluable technical assistance. Christopher Campbell, who has helped me to look again and again at the paintings themselves, has been a tremendous source of moral and editorial support. David and Beverly Campbell helped in innumerable ways. The arrival of Catherine Locke Campbell made the final stage of work the most interesting of all.

Throughout this process it has been a pleasure to work with Patricia Fidler, Nancy Grubb, Sarah Henry, Devra Kupor, Curtis Scott, Ken Wong, and Kate Zanzucchi at Princeton University Press. The book has been improved immeasurably by the keen eye of Sharon Herson.

My greatest debt in every sense is to my parents. This work is dedicated to Lucy S. Locke and to the memory of John Raymond Locke (1925–1991).

INTRODUCTION

"'ILLUSIONS,' SAID MY FRIEND, 'are as innumerable, perhaps, as the relations of men to each other and of men and things.'"[1] So begins Charles Baudelaire's "La Corde," a prose poem published in early 1864 and dedicated to his friend, the poem's would-be narrator, Édouard Manet. "And when the illusion disappears, when, that is, we see persons or things as they really are, detached from ourselves, we have a strange, complex feeling, half regret for the vanished phantom, half agreeable surprise at the appearance of this novel, of this real thing.'" Baudelaire's lines could be taken as an account of Manet's art, or at least, as the kind of account the art historian dreams of writing. Manet, the painter of modern life, it is often suggested, paints the elusiveness of the relations of figures to each other, of figures to objects, of figures to the spectator. The illusion is exposed as the painter reveals the constructedness of painting itself, or so the modernist account goes. The spectator is struck both by the power of the illusion and by the raw edges of its unraveling.

Yet Baudelaire was speaking not of painting's illusions but of the illusions of social relations and the way these relations present themselves as natural. The idea that Manet's art is concerned with social roles, and with a certain dissonance between contingent circumstance and its appearance as natural, has had a long ascendancy in Manet studies. But the narrator of Baudelaire's poem, the painter, has a particular relation in mind: "'If there is one obvious, ordinary, never-changing phenomenon of a nature to make misapprehension impossible, it is surely maternal love. It is as difficult to imagine a mother without maternal love as light without heat; is it not then perfectly legitimate to attribute all a mother's acts and words, in regard to her child, to maternal love? And yet, let me tell you this little story in which you will see how I was singularly deceived by this most natural illusion.'" Thus Baudelaire sets up "l'amour maternel" as the very natural phenomenon his poem will expose, and as an illusion which at some level had deceived Manet. In the course of these essays, I hope to suggest some ways of thinking about Baudelaire's dedication to Manet of a poem on the illusory nature of maternal love.

Manet frequently painted friends, family members, and intimates; in several cases, he painted the same models again and again. In my view, a set of family relationships structures Manet's art, and we can better understand the work as a whole by looking at emerging patterns in a mythology of the family. I would like to take the broadest possible view of Freud's concept of the "family romance," and that is, in the sense of a mythology of the family. This book explores the private, familial side of the painting of modern life: it argues that the painting of modern life—which often entails the painting of the family—gives form to desires, conflicts, and repression of and in the family. Taken a certain way, it is a small step from the notion of looking at social class as an ideological matrix to that of looking at the family as an

analogous ideological construction: Manet's repeated choices to paint family members should not be regarded as neutral. Yet I will say now that once we begin to examine this "ideology of the family," in Louis Althusser's sense, we will find a complex dynamic which cannot be reduced to a predictable formula about the law, parental authority, or the wish to sleep with one's mother.[2]

Although my central argument here comes from Freud, for many reasons it will not do for me to assume the authorial pose of a dogmatic Freudian. In attempting to follow in Freud's footsteps, it is all too tempting to search for the hidden meaning, the screen memory, the clue that will confirm some correspondence with a pre-given scenario. Works of art are more complex, as are lives and cultural matrices, as are, for that matter, Freud's own astonishing writings (as opposed to pallid imitations of some of his interpretative maneuvers). In a sense, I would prefer to look upon Freud as a kind of ethnographer—or mythographer—of the nineteenth century, rather than as a theorist whose methods ought to be followed or applied by an art historian. My real project here remains primarily historical, and one can certainly make a case for the historical contingency of the Freudian myths and structures with which I am concerned. That case involves the usual suspects: Baudelaire, Flaubert, Maupassant; it involves—let it be said now—the Manet family in a biographical sense; it involves the impact of social changes in Paris in the latter half of the nineteenth century on the upper bourgeoisie in general. This history also should not be considered apart from the particular aims and ambitions of a young painter who, in the process of contending with tradition and marking off his own territory, became one of the most innovative artists of the modern era.

There are those who have doubts about the reconcilability of historical materialism with any sort of psychoanalytic interpretation; they conceive of history and psychoanalysis as incompatible insofar as they see, from one perspective or the other, "society" and "the individual" as mutually threatening realms of explanation. I would like to show that these modes are not incompatible. It makes little sense to schematize "society" and "the individual" as if they do not overlap. However, one can readily see the problems inherent in the importation of psychoanalytic ideas in such a way that social circumstance and history are completely marginalized in favor of the individual: for instance, in the supposed revelation of one traumatic childhood event as the sole factor in accounting for a complex body of work, or in the privileging of a universalizing myth or other "timeless" frame of reference over all historical and social matters. If that kind of error could be seen as occupying one undesirable end of a spectrum of historical/psychoanalytic interpretation, at the other end there would be a kind of social history that attempted to incorporate a notion of a family romance, let us say, which was completely emasculated, completely stripped of what psychoanalysis would hold to be its power: its horror and depth.[3] If psycho-analysis is to be part of an art-historical enterprise, clearly it is possible to make it continuous with an historical project; it is, in fact, necessary. Althusser addressed this issue when he wrote: "no theory of psycho-analysis can be produced without basing it on historical materialism (on which the theory of the formations of familial ideology depends, in the last instance)."[4] A notion of "familial ideology" will be central to my approach here, and in my view such a construction should remain embedded in the history of the nineteenth-century family.

As early as 1867 and countless times since, writers have offered various constructions of Manet. Émile Zola sketched a Manet who lived, in contrast to his reputation as a painter of shocking obscenities, "l'existence réglée d'un bourgeois."[5] (It would be a valid project for a psychoanalytic history of art just to question the coexistence in the 1860s of those two Manets.) For Zola, the outward appearance of propriety in Manet's life could be combined with an account of his art as exclusively concerned with color and form in order to dispel the synonymity of Manet's art and "scandal" in the popular imagination. In 1965, Michael Fried wrote of a Manet who was "the first post-Kantian painter" for whom "self-consciousness" was "the great subject of his art."[6] In Fried's 1965 account, the way the paintings forced "an inhibiting, estranging quality of self-awareness" on the viewer was an essential component of the pictures' modernism—of their ability to call attention to themselves as paintings. And in 1984, T. J. Clark proposed that "[the] world that Manet offers as 'modern' [. . .] is not simply made up of edges and uncertainties. It is plain as well as paradoxical, fixed as well as shifting; it lacks an order, as opposed to proclaiming the end of order as the great new thing."[7] If Manet lays bare his own technique of painting in a way that has been called modernist, Clark would say, then that fact must also be reconciled as a creation of Manet's world, not a mechanism by which the art historian escapes from it in order to attend to the formal qualities of the paintings. The combined effect of Manet's choices to paint uncertainties in the social world and to expose the paintings' constructedness does not make for an art that restricts itself to "seeing" as a subject for art; by contrast, it dismantles the very "self-evidence of seeing" in its view of the world.[8] These views, with their at-times-divergent agendas, nevertheless point to a Manet whose subject matter is in some way loaded; both Clark and Fried suggest a Manet for whom "form" implies a consciousness of itself that is in some way inseparable from the painting's subject.

Along the way, there have been many less reflective accounts of Manet, which have relied on his connection with the Realist school in painting or with positivism in philosophy (and its correlatives in politics) in such a way that Manet is seen as a painter of *matter* to the exclusion of the metaphysical. The shock of the bizarre materiality of Manet's *Le Christ aux anges* or *Jésus insulté par les soldats* would support this general way of thinking, as would many accounts of *Olympia* offered in undergraduate lectures ("The painting was shocking because the woman is depicted as a prostitute, not as a goddess"), or even the sensuous elegance of many of Manet's still-life paintings of a few flowers, a bunch of asparagus, or a Parisian ham. It is perhaps the pervasiveness of this view that would seem to present the greatest obstacle to a psychoanalytic investigation: if Manet painted out of raw physical sensations—preceding the Impressionist concentration on optical sensations—how can his paintings be seen in terms of ineffable matters such as "desire"?

Although Manet's connection with the positivist belief in the material as the basis for one's knowledge of the world is a notion often invoked in attempts to explain, for instance, the controversy over *Olympia* or the religious paintings, the positivist stance—if not Manet's particular adherence to it—is highly paradoxical and was seen to be so at the time. It would be a mistake to think that someone in Manet's time who had a vague inclination away from religion and toward science or positivism would have felt completely grounded in the physical and the material. It is not for nothing, after all, that

Flaubert's Monsieur Homais is the object of some parody. I would like to argue that by contrast with the view that a belief in materiality precludes belief in the metaphysical, nineteenth-century materialism promotes an acute awareness of its own limits. Moreover, this philosophical skepticism did not depend on a background in philosophy; it could be found in the daily newspaper.

On a given day in April 1869, an acquaintance of Manet's might have been sitting in the Café Guerbois, perhaps leafing through *Le Temps*, a liberal newspaper which tried to stick to the business of news reporting seriously. *Le Temps* also gave over a certain amount of space to science reporting in the form of a column, "Causerie Scientifique" (science chat). There, our café-goer would have found a discussion of the latest contentions in Émile Littré's *Revue de philosophie positive* on the notion of "la physiologie psychique," or the extent to which the discipline of the physiological study of bodily organs and tissues would ever be able to explain ideas, feelings, or the human will.[9] These kinds of questions fascinated nineteenth-century readers, for whom the growing body of scientific theory of a physical basis for all phenomena was alternatingly threatening and compelling.

Positivism had already posed a challenge to the Cartesian motto "je pense, donc je suis," which located our knowledge of the exterior world in the interior world—in thought. Positivism began to regard the human subject as the product of a physical and economic environment; in its most restrictive form, it held that our knowledge of the world was limited not to thought but to physical sensations. By the late 1860s, Littré had moved away from the strict materialism of Auguste Comte's formulations. Turning to thinkers such as George Berkeley and Destutt de Tracy, Littré postulated that if our knowledge of the world is indeed rooted in physical sensations, these sensations in turn depend on a dynamic interaction between the inner and outer worlds. The sensations do not precede external stimuli such as light; in fact, they would not exist without the external stimuli. To say that our knowledge of the world begins and ends with physical sensations is to locate being itself in a gap between the self and the world: "La sensation nous borne, pose entre le monde et nous une limite infranchissable." In this unbridgeable gap between us and the world, the self seeks to know itself, and it finds only physical sensations. "With the question 'who?',", writes Paul Ricoeur—*who* is seeking to know itself and finding only physical sensations—"the self returns just when the same slips away."[10] Ricoeur's elegant turn of phrase would have been perfectly comprehensible to our reader in the Café Guerbois.

Manet, like his contemporaries, was interested in the idea that our knowledge of the world is rooted in physical sensations. It seems unlikely that he would have painted the *Olympia* and the religious paintings the way he did without having something of an investment in these ideas. But if even a newspaper-column account of *la philosophie positive* would suggest that a real concentration on physical sensations opened up an unbridgeable gap between us and the world, a gap in which the self discovers itself just as it slips away, then this attitude toward subjectivity and knowledge is far from straightforward. It could be said to involve the depiction of subjects who, as Richard Wollheim suggests, have momentarily withdrawn from the world.[11] Manet's interest in what we might call this slippage of subjectivity—and this recalls the Manet of Fried's "post-Kantian" consciousness as well as the Manet of Clark's dismantling the very "self-evidence of seeing"—belies the validity of a historical project that would restrict itself to gatherable data. For all its faith in the physical and material world, positivism as it evolved did not cor-

don off the internal world or deny its existence. The paradoxes of positivism's view of our knowledge of the world are central to its practice. I will argue that they are central to Manet's practice as well.

There are important distinctions to be made among so-called psychoanalytic approaches to art. The ur-texts of this mixed field would surely be the writings of Freud, primarily the case study of Leonardo, a famously flawed study of the artist's personality and character rather than his works of art.[12] Freud's study of the *Moses* of Michelangelo, first published anonymously, also presents a somewhat problematic model for psychoanalytic considerations of art, as it has often been seen as overly autobiographical.[13] Psychoanalytic models that are best known among students of art history include attempts to analyze symbolism in much the way that dreams are deciphered in Freud's seminal *Interpretation of Dreams*; a good example would be Meyer Schapiro's essay, "The Apples of Cézanne: An Essay on the Meaning of Still-life."[14] Schapiro's work remains a subtle and erudite model, yet the act of interpreting symbols in a Freudian mode can easily constrict itself by looking for, or finding, too definite a meaning or too much certainty of one; an overdetermined image that might open onto many readings is proposed to symbolize one construct.[15] Psychoanalysis would seem to offer explanations of the creative force; along those lines we could locate the work of Jack J. Spector, John E. Gedo, and Mary Mathews Gedo.[16] Yet in these examples, there is an emphasis on exceptionality and even genius that remains conceptually at odds with many art historians' interest in the cultural meanings of works of art.

Social history, with its interest in material production, political activity, and social relations, shunned emphasis on artistic intentions that pointed toward more individualistic accounts of how art was made. As history began to look at *mentalités*, however, psychoanalytic ideas began to inform readings of an epoch, a complex unfolding of events, or even the attitude of an entire generation. There are many examples, but two that stand out are Lynn Hunt's account of what happens to a nation after it kills its father and mother figures, *The Family Romance of the French Revolution*, and Carl Schorske's analysis of Oedipal strivings in a generation, *Fin-de-Siècle Vienna: Politics and Culture*.[17] These are strong theses amply supported by strong historical work. One is left with the question, though, of how and whether psychoanalytic ideas that arose from case studies of individual persons could ever be used in conjunction with historically based approaches to a single artist's work.

Some artists and works of art are obvious candidates for a psychoanalytic approach to their study, yet there is no agreement in the field about the best way to proceed. In *Compulsive Beauty*, Hal Foster reads Surrealist texts and images whose *modus operandi* was thoroughly imbued with Freudian ideas or Lacanian variants, yet a critic can nevertheless question the connection between particular Surrealists and Freud, or the necessity or desirability of even invoking psychoanalysis when looking at Surrealist art.[18] Foster's readings are compelling where texts are key to artists' self-propounded myths of origination and trauma. Psychoanalysis has always been strongly text-based; witness Freud's "Jokes and Their Relation to the Unconscious," which one psychoanalyst used as the basis for a reading of Manet's famous mistakes and compositional idiosyncrasies.[19]

Psychoanalysis also remains friendly to writers who wish to bring themselves into their narratives, either to produce a personal reading of a group of pictures (Martine Bacherich, *Je regarde Manet* comes

to mind) or to reflect on the subjective nature of the historian's enterprise.[20] For Steven Z. Levine, for example, the myth of Narcissus emblematizes Monet's interest in picturing reflections in the water; at the same time, it remains a cultural myth that resonates throughout the nineteenth century, a complex representational strategy that might be described as a *mise en abîme*, and an occasion for Levine to reveal a set of personal interests.[21] Psychoanalysis is also now generally regarded as an interpretative strategy appropriate for analyses of spectatorship, the gaze, and the construction of the visual field, especially for the consideration of the participatory dimension of the viewer's role.[22]

Recent art-historical attempts to come to grips with questions of gender, sexuality, and identity have provided some of the most promising models for the use of psychoanalytic ideas in the history of art. Because the construction of gender, for instance, is both socially determined and uniquely expressed, the historian can move from an analysis of personal narrative to that of societal forces, or from social context to biographical detail and back. In the best of these accounts, psychoanalysis also has a chance to illuminate the work of art without reducing it to an instance of symbolism or a symptom of a malady. Sometimes the psychoanalytic weaponry is amply used, as it is in Whitney Davis's work on Thomas Eakins; sometimes it merely makes an unforgettably powerful suggestion, as in Anne Wagner's work on Eva Hesse.[23] In his analysis of Eakins's *Swimming Hole* and related works, Davis looks for and explicates the way a given fantasy, in this case a homoerotic one, intersects with the very process of painting. As the subject of male swimmers is chosen, photographs made, sketches drawn and painted, an existing desire is given form, rejected, revised, relayed, metaphorized, transformed. Davis shows that psychoanalytic theory can inform an analysis of painterly *procedure* and still coexist with a social-historical study of homosocial athletic culture.

In her study of Minimalism and the work of Eva Hesse, Briony Fer raises some important issues regarding the use of psychoanalysis in art history. She clearly proclaims her interest in the work of art, and in its "effects, not intentionality"; she searches for structures and formal shifts that might be comprehensible if "seen from the point of view of an unconscious symbolic structure."[24] This Lacanian idea is more accessible than it perhaps sounds. Fer suggests that in place of mapping the historical connections between a given artist and a particular psychoanalytic idea—something that can be daunting even when the artists (like Foster's subjects) were under the spell of psychoanalysis itself—what matters is the way psychoanalytic theory might enable the historian to make sense of a given set of forms. I think it crucial that art historians acknowledge the potency of psychoanalysis as an interpretative tool where the form of the work and the process of its making are concerned. Here, too, the work of Wagner and Davis can be taken as (distinctly different but exemplary) models.

My approach in these essays, although far removed from Fer's Kleinian readings of spaces and objects, shares Fer's interest in looking to psychoanalysis to illuminate formal structures in art. In my view, such readings of individual works or groups of works in an oeuvre should still be knitted into a larger history; that is at least my aim here. Psychoanalytically informed approaches to art will always also be divided between practitioners like Ellen Handler Spitz, whose clinical experience can be brought to bear on works of art, and humanists, who look to psychoanalysis for constructions of historical epochs

or stylistic maneuvers.[25] Yet psychoanalysis itself should not only be scrutinized as a hermeneutic practice or source of interpretation, as James Elkins urges; it should also be considered as a theory of history, a way of making sense of the subject's past.[26]

One of the most powerful reasons to look to psychoanalytic concepts in the first place has to do with the importance of an understanding of the formation of self, whether in representation or in a given social milieu. The methodological imperatives of moving from "self-formation" to representation and social formation, however, make the application of concepts from the discipline of psychology all wrong for the job. It is along these lines that the work of Michel Foucault is of critical importance. Foucault opened avenues of inquiry that spanned history and philosophy; he examined the construction of self in relation to others, in relation to knowledge, and in relation to notions of moral agency.[27] He also radically rethought the Enlightenment construction of individual human rights existing in relation to a notion of power as inherently repressive. For Foucault, power could be exercised in any direction; it moved in complex, nuanced exchanges along many points in a social relation. The family provided a special example of these localized maneuvers. In his *History of Sexuality*, he wrote: "The family, in its contemporary form, must not be understood as a social, economic, and political structure of alliance that excludes or at least restrains sexuality, that diminishes it as much as possible, preserving only its useful functions. On the contrary, its role is to anchor sexuality and provide it with a permanent support."[28] Such a way of looking at the social unit of the family is unthinkable without psychoanalysis. At the same time, it opens onto a larger historical project that continues to suggest new directions for thinking about the family as a structuring influence or ideological field.

My thesis here is in many ways more Foucauldian than Freudian. In these essays I wish not so much to propose a Freudian source for a certain image or pictorial interest as to consider how a particular sort of repression might operate in contradictory ways: as the internalized enforcement of a bourgeois code of conduct, and at the same time, an incitement to rebel against it. This simultaneous self-imposed compliance and resistance can be seen in the life of the artist, to be sure, but it is perhaps more compelling in the ways it can be observed in various painterly decisions and strategies.[29] What I am calling Manet's "family romance" might draw on Manet's life, but it is not the equivalent of an iconographic proposal about the meaning of his art. It is rather an attempt to integrate the life of the artist into a reading of formal and contextual issues; it is, for instance, an attempt to account for Manet's highly charged relationship with tradition and his place as a singular figure in the history of the avant-garde. The circumstances for art production from the late nineteenth century onward necessitate such a theoretical integration. As Foucault has shown, the modern artist is one who tries not only to make art but also to invent a self, to produce a self.[30] An account of modern art should, in my view, unravel the ways in which the artist's "work" encompasses more than what gets made in the studio.

Because the terms "the subject," "the object," and "desire" will be of some importance in the following essays, I would like to give a brief sketch of what I mean by these designations. "The subject" refers to the human being who in a given case occupies an active position. In that sense an easy transfer can be

made from the grammatical term: the subject in question is the subject of the sentence. The term "subject" avoids the belief-systems which surround the term "individual"; moreover, in Lacanian theory as in many other ideas of the subject (Jean-Paul Sartre's, for instance), the subject is not an individual because he or she is not indivisible, but marked by division.

Let us return for a moment to the very scene of subject formation in Jacques Lacan. That scene is, of course, the mirror stage, the drama in which the child recognizes its own image in a mirror, and is simultaneously absorbed in and alienated from the image he perceives—an image of a child moving with greater integration and coordination than the child experiences within. A split is instituted between the child's experience of himself and his experience of himself as he is perceived by others. Thus is established the condition of division and alienation, which will mark his experience of the world. From then on his notion of himself, and his articulation of himself in language and culture, will reflect an appropriation of the way he is seen by others, and hence by the presence of others—in short, by his internalization of a social experience.

Lacan's view of the subject, with all its debts to Alexandre Kojève, Sartre, and Surrealism, with all its implications for the twentieth century, would not have been so alien to a nineteenth-century person. The same 1869 newspaper column quoted above suggests that we conceive of the relationship between the subject, or the *moi*, and the object, or *non-moi*, "as two twin sisters of the primordial phenomenon which begins with the sensation and ends with thought. The soul is like a mirror placed before an object, one which would have consciousness of reproducing its image. If the mirror did not have this consciousness, the object would stay unknown; if the object did not exist, the image would not come into being." Littré's positivism constructs a dynamic dependence between the interior and exterior worlds. Far from suggesting that the only reality is material reality, it argues that our knowledge of the world is produced by a contact with it. Lacan's divided subject who came into being by realizing its split from others' perceptions of it would make sense to someone who thought that "if the object did not exist," then neither would the consciousness which comes from the *moi*.

Lacan's notion of the subject is in many ways profoundly social. Its essence is the subject's internalization of the Other. That Other is many others: it could stand for the mother as Other, the father as Other, the family as Other, the family's social world, one's siblings, peers; it could stand for the beloved; it is, in short, society itself. I say this again to those who might unwittingly fear that a psychoanalytic construction of the subject remains at odds with social history, or who find themselves recoiling from the overused·and now-jargonistic sound of "the Other." It is unfortunate that the term "the Other" has lost a great deal of the philosophical precision and political bite it had in the hands of Sartre and Simone de Beauvoir. For these thinkers, as for Hegel, it is not a static label or buzzword; it is a term of relation that positions another subject on whom the very consciousness and position of the subject depends. Sartre, in *Being and Nothingness*, spoke of the Other as "a look," distinguishing the definitive nature of the specular relation: "the Other's look fashions my body in its nakedness, causes it to be born, sculptures it, produces it as it is, sees it as I shall never see it."[31] Sartre's choice of words—the Other as a look—is fortuitous because so often what is important about the Other is the Other's implied, not

literal, presence, and the effect of that presence on the subject. The Other can often be thought of as the look of one in whose eyes the subject wishes to appear a certain way.

If "the Other" is a term of relation that refers to one whose look shapes the subject and brings it into being, then "the object" is also an opposing term. Usually "the object" is the recipient of the subject's desire or the object of the subject's look. Yet in psychoanalytic theory, the object is not the passive or dehumanized "thing" of the locution "he treats her like an object." For instance, the object of desire in Lacanian theory remains inaccessible; hence it can hardly be treated with abandon. The very act of desiring surrounds the object with a kind of aura; René Girard has called it "metaphysical virtue"; he suggests that desire "transfigures its object" by creating an illusion of its desirability.[32] The slightly religious ring to Girard's words "virtue" and "transfigure" is telling: the object is as far removed from the subject as is the chaste virgin of courtly love poetry from her knight who loves her from afar. The "object," like a mirage, slips away before its possession can be attained.

In attempting to suggest a few things about the subject, the Other, and the object, I have already said quite a lot about the psychoanalytic notion of desire. For one thing, it is never satisfied; it is not to be thought of as "satisfiable" the way hunger or thirst—or a sexual urge pure and simple—might be satisfied. The word "desire" has unfortunately become a bit of a buzzword, and it can have an uncomfortably modish way of cropping up in sentences as if it were some sharp-edged and cerebral way of speaking about sex. In the sense I will be using the word here, "desire" implies much more than sexual desire: indeed, it can encompass ambition, identification, love, envy, rivalry. I will be relying on, and explaining, Lacan's theory of desire, as well as some aspects of René Girard's idea of mimetic desire. Basically, desire will be taken in a broad sense of the emulation and imitation of one who already possesses the object of desire. As Lacan and Girard (and incidentally, Kojève's theory of Hegel) would have it, one does not desire things or persons for themselves, out of the blue. One wants to be like another, and hence to have what the Other has. In desiring the Other's desire, then, one unwittingly makes the object of desire inaccessible, for it was originally the Other's. Thus desire becomes a movement which invents its own obstacles. It can be understood in contexts ranging from the classical Oedipal scenario to the desire to surpass one's teacher or rival in a professional sense, from the romantic triangle to the scene of class warfare or social masquerade. The "object" desired, after all, may not be a "thing," or even a person, but rather a matter of the prestige possessed or enjoyed by another. And as Girard reminds us, "prestige" is nothing but phantasmagoria, spells cast and woven around that which we think we want.[33]

T. J. Clark's *The Painting of Modern Life* suggests several levels on which the Paris of Manet's time worked its phantasmagoria around its refurbished boulevards, its courtesans, its growing suburbs, and its newfangled entertainments. Clark locates some of Manet's paintings—especially but not exclusively *Olympia* and *A Bar at the Folies-Bergère*—as occupying a precarious and unstable place in the instantiation of this new world of public desire and consumption: at times the paintings lift a corner of the phantasmic veil, at times they play into the illusion. His critical social history asks us to think further about the production of desire in and around Manet's paintings. I would argue that this requires that we look beyond the purview of social history proper: that we allow for an interplay between external

and internal forces of desire for society at large and for the artist whose work is our object of study. I think that psychoanalytic theory has a role to play in unfolding this history.

In order to bring psychoanalysis into our historical project, we do not have to worry overmuch about relying too heavily on a twentieth-century body of thought in order to understand an earlier epoch. The scientific, philosophical, and artistic interest in dreams in the nineteenth century, for instance, is well documented. I will argue that there was a real recognition in the mid-nineteenth century that dream images could be the visual embodiment of what we would now call repressed desire, and that this idea was accessible to Manet. One of the points that made mental images of pivotal interest to the nineteenth-century thinker was the fact that such images came into the mind without our conscious solicitation. As the dream physiologists began to postulate the primacy of the imagination for perception and the ways in which it operated without our conscious control, they edged their way toward Freud's radical displacement of the ego—the conscious—as the seat of power in our being in the world. I believe that Manet's portrayals of figures at odds with one another and with their surroundings, his way of freezing the action on figures with notoriously blank expressions, can be seen to stress the determinant role of the unconscious with all of its radical epistemological implications. What confronts the viewer of the paintings is the apparent absence of free will possessed by the figures; this absence shows the ego, as Freud would later say, "*is not master in its own house.*"[34] The famous foursome in *Le Déjeuner sur l'herbe* (fig. 1), whose Raphaelesque poses do not make sense, was seen as dangerous not only because of the naked woman and the implication of prostitution, but also because of the painting's *mise en scène* of the kinds of involuntary desires that come to us notoriously in dreams.

Le Déjeuner sur l'herbe is the pivotal point of the book for several reasons. I analyze it as a family drama, as a key portrayal of Victorine Meurent, and as its peculiar spatial disjunctions and conjunction of nakedness and sociability seem clearly related to the common anxiety dream of nakedness. As it happens, a variant on the dream of nakedness was one of Freud's most significant dreams when he was on the verge of articulating the Oedipal complex, in the aftermath of his father's death. The dream of nakedness, claims Max Milner, signals both the dreamer's risk of reprobation and his affirmation of his own creative power, his act of dispossessing the father of his (physical or intellectual) paternity.[35] Manet's engagement with the theme occupies just such a place in his life and art. That recognition calls for an analysis which refuses to see them as separate. To isolate social context, or iconographic sources, from the terrain of the personal in the case of *Le Déjeuner* is to wall off crucial facts of the painting's context (the father's death, the sale of some of the family property where the figures are pictured), as well as the potential import of those sources (the meanings in circulation in the 1860s about Venetian painting, seen as an art of fantasy and enigma). I will not argue that the meaning of *Le Déjeuner* lies in the biography, but rather that we cannot understand the painter's particular compositional choices without enlarging our notion of the "social" to include the familial.

A further example of a family-romance thesis perhaps illustrates my point. In *The Infection of Thomas de Quincey: A Psychopathology of Imperialism*, John Barrell argues for the inextricability of the text of a family romance—in this case, a scene of incest, disease, and death in the sister's bedroom—and De Quincey's texts of British imperialist conquest in the Orient.[36] Barrell wants neither for the family

romance to become the secret meaning behind all De Quincey's writings, nor for the political writings to amount to an espousal of a social guilt over imperialist politics. Internal and external worlds each become "the double of the other": there is terror in each.

In "La Corde," Baudelaire's painter-narrator tells a story in which a boy from the streets is taken in and employed as a model and studio assistant. In the poem, the Manet figure rebukes the boy for petty theft, and the boy hangs himself. According to Berthe Morisot, the episode actually occurred, and the victim was the model for Manet's *Boy with the Cherries* (fig. 2), a youngster named Alexandre.[37] Baudelaire's poem chides the painter for his attitude toward the poor. It is this attitude that had prodded the painter into caring for the boy, and that same attitude had been at the root of his suspicions that the boy was stealing sweets and liquor. Yet after the boy's suicide, it is the boy's mother who is revealed to be the real manipulator of the painter and of her son; her crass interests had masqueraded as maternal love.

It is impossible to separate the family drama in Baudelaire's poem from the class attitudes that move its narrative; one cannot say that the figures' relationships with one another are more important

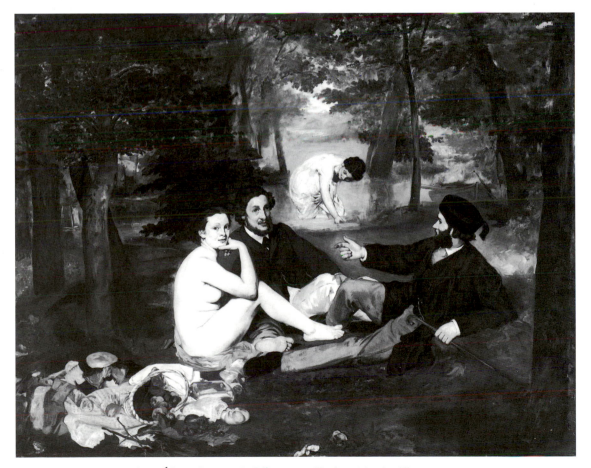

Fig. 1. Édouard Manet, *Le Déjeuner sur l'herbe*, 1862–63. Oil on canvas,
82 x 104 in. (208 x 264 cm). Musée d'Orsay, Paris

than the class interests which grip them. Yet neither can one say that Baudelaire's poem is *about* class interests or that it is an indictment of Manet's attitude toward the poor, without also saying that it is a very pointed statement about the illusory nature of maternal love as it is played out in this hideous drama. Internal worlds and external worlds mirror one another, Barrell might say, and Baudelaire's poem asks us to see the way both realms constitute the world of Manet's art. "La Corde" opens onto two dramas—in one, the painter searches for a physiognomy of modern life and transforms a street urchin into a mythological cupid, an angel, and a Christ crowned with thorns; in the other, the painter, faced with the boy's suicide, tries to do right by the boy's mother and finds himself (or is found to be) completely unaware of her actual interests. Art history has long regarded Manet as the artist who painted such street urchins, who transformed Victorine Meurent into a bullfighter, a street singer, a courtesan. "La Corde" offers another fiction at the core of Manet's art and what we call, after Baude-

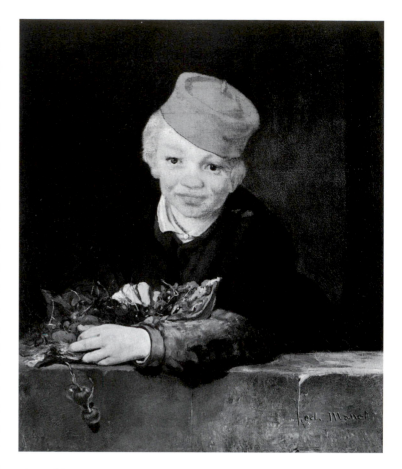

Fig. 2. Édouard Manet, *The Boy with the Cherries*, 1859. Oil on canvas, 25 5/8 x 21 11/16 in. (65 x 55 cm). Museu Calouste Gulbenkian, Lisbon

laire, the painting of modern life. I will argue that this other fiction is a family romance that is inseparable from the more familiar story of Manet's art.

"Father," he said to me, "I had such a strange
dream that I am truly upset you will learn of
it; it is perhaps the work of a demon, and . . ."
"I absolve you," I replied, "a dream is always
involuntary; it is only an illusion. Speak
from the heart." "Father," he said then, "I had
barely fallen asleep and I dreamed that you
had killed my mother; that her bloody shadow
appeared to me to demand vengeance, and
at this sight I was beside myself with such
fury that I ran like a maniac to your apartment,
finding you in your bed, I stabbed you."

*Duhaget, formerly the priest of the charterhouse
of Pierre-Châtel, as retold by Anthelme Brillat-Savarin*

WHEN THOMAS DE QUINCEY wrote of "the couch of Orestes" in the *Confessions of an English Opium-Eater* of 1821, he was calling up two images at once: on the one hand, the barrage of thoughts and dreams that tormented Orestes after his murder of his mother, and at the same time, the tender attention of his sister Electra. One might say that Orestes' delirium is entirely created and aggravated not by the wishes of the god Apollo, but from within the house of Agamemnon. In a footnote, De Quincey refers the reader "to the early scenes of the *Orestes*,—one of the most beautiful exhibitions of the domestic affections which even the dramas of Euripides can furnish."[1] The image serves De Quincey's purpose of describing his feverish opium dreams, and the extent to which the devotion of his "own Electra," his faithful wife, Margaret Simpson, was both a comfort and a substitute for the love of his own sister.

Baudelaire's "Les paradis artificiels," an essay on opium and hashish accompanied by his translation of excerpts from De Quincey's *Confessions* and its sequel, *Suspiria de Profundis*, appeared in Paris in 1860. Baudelaire explains De Quincey's theory of the mind as a palimpsest of indestructible memories by quoting the English author:

Yes, reader, countless are the mysterious handwritings of grief or joy which have inscribed themselves
successively upon the palimpsest of your brain; and, like the annual leaves of aboriginal forests, or the
undissolving snows on the Himalaya, or light falling upon light, the endless strata have covered up

each other in forgetfulness. But by the hour of death, but by fever, but by the searchings of opium, all these can revive in strength. They are not dead, but sleeping. In the illustration imagined by myself from the case of some individual palimpsest, the Grecian tragedy had seemed to be displaced, but was not displaced, by the monkish legend; and the monkish legend had seemed to be displaced, but was not displaced, by the knightly romance. In some potent convulsion of the system, all wheels back into its earliest elementary stage. The bewildering romance, light tarnished with darkness, the semi-fabulous legend, truth celestial mixed with human falsehoods—these fade even of themselves as life advances [. . .] but the deep, deep tragedies of infancy, as when the child's hands were unlinked for ever from his mother's neck, or his lips for ever from his sister's kisses, these remain lurking below all, and these lurk to the last. Alchemy there is none of passion or disease that can scorch away these immortal impresses.[2]

This passage becomes transparent onto the family romance of De Quincey as analyzed by John Barrell: one of the memories that lurks to the last is certainly that of the last time De Quincey kissed the body of his beloved sister Elizabeth, a memory that remained laced with guilt. It is also a model of the mind and of memory, one which is not all that different from the stratographic model used by Freud at the turn of the twentieth century.[3] And it suggests a recognition of the power of the hallucination and the opium-induced dream to access the experiences and feelings of earliest infancy.

Memories and experiences accumulate in the palimpsest of the mind like snows on the Himalayas, says De Quincey. And dream states blow away those "oriental" snows to reveal the earliest impressions of mothers and sisters, kisses and embraces, just before they were torn away from us. Freud would later theorize that a dream represented the fulfillment of a repressed wish, but De Quincey and Baudelaire, among other nineteenth-century thinkers, already recognized the elements of childhood longings that could resurface in dreams.

This chapter aims to map the fascinating terrain of dream theory in mid-nineteenth-century France. Although it is the paradigm of the dream image that interests me, and that I think could be related to aspects of Manet's composition and style that have remained unexplained, in delving into the world of the dream one necessarily encounters mostly textual accounts of these night visions. The chapter, then, will be more textual than the ones that follow. I will be paying particular attention to the thinking of writers in Manet's circle, such as Baudelaire and Edmond Duranty, as well as to the models of dream theory that interested them, such as De Quincey and Alfred Maury. Some of the central questions that occupied these thinkers had to do with moral responsibility and individual autonomy with respect to the appearance of desires in dreams. Near the end of the chapter, I will test the applicability of these notions on a few images in the work of Courbet, Manet, and Cézanne.

Manet's art is often explored as a representation of modern life, but "modern life" remains a problematic construction, and the extent to which modern-life subjects actually provided links to the past—society's or the child's—needs to be explored. Manet's images of street people, gypsies, Spanish dancers, society personages, and artist friends are sometimes discussed tautologically, as if the artist were

interested in those subjects because they were intrinsically "modern," and as if they were modern because he chose to paint them. It was, of course, equally a concern of Manet's to rework the art of the past.[4] The art of Velázquez, Hals, Titian, Murillo, Marcantonio, Watteau, Rubens, Brouwer—*ad infinitum* artists and sources—not only presented subjects, techniques, and pictorial solutions for Manet, but also seemed to represent art itself, or an aspect of "Art" or "Painting" that Manet felt it necessary to take on, re-create, or negate. The art of the past was a more explicit concern for Manet than it had been for his predecessor Courbet, or for many of his contemporaries in landscape; hence, it must be understood as particular to Manet and not as a stage through which modernism or modern-life painting necessarily had to pass. We could perhaps say that in addition to the art of the past as a subject, that *the past itself* was a subject—or even, as Malcolm Bowie says of Freud—"the past is a character" for Manet.[5]

Let us recall the Manet of T. J. Clark, the Manet for whom modernity is not a set of exciting new subjects just waiting to be painted, but a set of problems, or a series of dislocations: on the one hand, the sweeping changes of Haussmann's Paris, on the other hand, an ever-present sensation of that

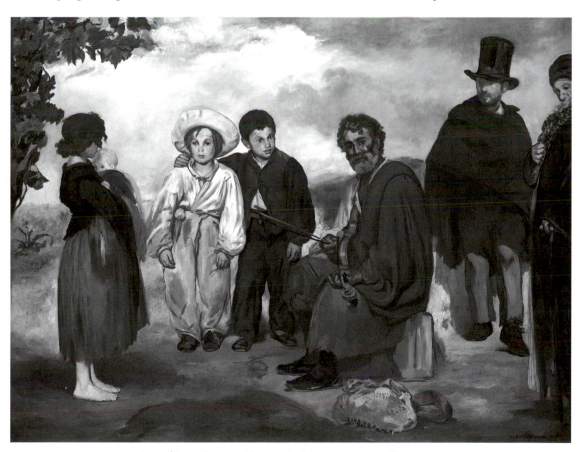

Fig. 3. Édouard Manet, *The Old Musician*, c. 1861–62. Oil on canvas,
73 3/4 x 97 3/4 in. (187 x 248 cm). National Gallery of Art, Washington, D.C. Chester Dale Collection

which was passing away; on the one hand, a set of strange new motifs and subjects, on the other hand, a context for seeing them that was itself shifting, which was alternately celebratory and unsettling. One gets a sense in paintings such as *The Old Musician* (fig. 3) that despite the painting's evident concern for the people marginalized further by Haussmannization, these figures are neither quite seen as victims nor quite established or monumentalized by the painting—at least, not in the manner of Velázquez's *Water-Seller of Seville. The Old Musician* has a haunting, uneasy way of juxtaposing the members of this motley assembly. They may look strikingly familiar, the way street people repeatedly encountered become recognizable to many urban dwellers. Yet neither that sense of recognition nor any amount of ink spilled on Haussmannization, Baudelaire's influence, or figures taken out of Watteau, Velázquez, and Le Nain, will make the painting seem *plausible*. And this implausibility is a central problem to be contended with by any discussion of the picture's modernity, for it becomes less comprehensible on account of its glaring unlikelihood.

Seven figures sit or stand in a friezelike arrangement in the painting. The two end figures, usually identified as a young gypsy girl at left and the figure possibly described in Manet's notebook as "the old Jew with a white beard," face inward; the others, including the baby held by the girl, all face frontally.[6] The nondescript space in which the figures stand serves to focus attention on the figures, but it also highlights the disjunctions in scale between them: the boys look too large with respect to the musician; the cloaked figure (Manet's own *Absinthe Drinker*) is too small with respect to the boys but too large to be behind the musician, and so forth. As Theodore Reff points out, the grassy setting could remind Parisians of open spaces still prevalent beyond the *barrières*, as the types in the picture—gypsy, beggar, itinerant, clown—were mostly associated with the city and its margins. Although they stand in close proximity, they display disparate gestures and poses and appear to come together only in the most ad-hoc manner. Their very unrelatedness is key to the strange unreality of the image as a whole.

The painting's haunting quality is what prompts me to invoke the dream image as an explanatory mode. By doing so, I do not wish to diminish any account of the painting as a highly politicized image of figures who were subject to harassment by the police, regulation by the authorities, and displacement by Haussmann's destruction of La Petite Pologne in the Batignolles. *The Old Musician* is very much a politicized painting that responds to those social realities. But it does not become transparent in its concern over the plight of these figures, or even in its uneasy homage to earlier masters. I introduce the term "dream image" hoping to allude to what Baudelaire, or Walter Benjamin writing about Baudelaire and Paris, would mean if they were to consider the painting to be a dream image. For them, the word "dream" would likely conjure the diorama, the photograph, or the shock of a new boulevard in the space of a familiar building. The suggestion of a dream might be connoted in the eerie ways in which the image appears as a reappearance (the figures appear familiar, as if they have been seen before, but also gathered together inexplicably), the way it represents an *internalization* of an earlier series of encounters with some of these characters, or perhaps most tellingly, the way the image displaces the figures from their discrete contexts and projects them onto what is almost a blank space.[7] Such an internalizing recombination is not quite the same thing as a modern-life painting of a scene

simply out there waiting to be painted. The insistent frontality of Manet's figures, noted by Richard Wollheim, can be understood as another characteristic of the dream image, and it creates a situation in which the spectator, or the painter, appears to be at the center of the action.[8] What the spectator sees is less a scene of Parisian life, and more an actionless restaging of assorted perceptions and encounters. Even Manet's friend Théodore Duret, recalling decades later the novelty of *The Absinthe Drinker* (fig. 4), would write: "It is true that it was conceived in the realistic manner which was then so much detested; but, as the unusual costume of the Spanish model gave it almost an air of fantasy, it seemed more or less removed from the reality of everyday life."[9] Integral to the difficulty of Manet's realism was the very way in which the all-too-real figure of the homeless drunkard was somehow set apart from the ambient reality. Duret's words "qualité d'Espagnol" and "fantaisiste" connote the quality of otherness that gives the paintings a slightly shocking, estranging quality despite their rootedness in social reality.[10]

Of course, there is no such thing as an unmediated image of modern life, but it is striking to note the difference between the way Courbet's *Stone Breakers*, for example, presents a convincing scene and the way *The Old Musician* does not. Manet's image is not held together by the kind of sensory immediacy that binds Courbet's. One could say that Courbet in this example sought to create an illusion of unmediated perception and considered that illusion to be the animus behind the

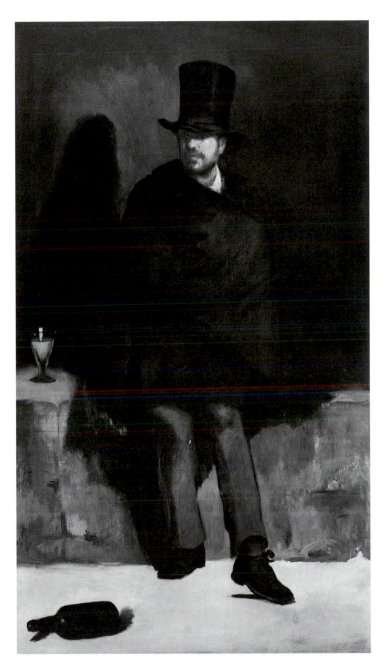

Fig. 4. Édouard Manet, *The Absinthe Drinker*, 1859. Oil on canvas, 71 1/4 x 41 3/4 in. (181 x 106 cm). Ny Carlsberg Glyptothek, Copenhagen

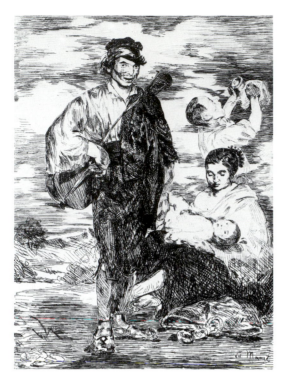

Fig. 5. Édouard Manet, *The Gypsies*, 1862. Etching, 12 5/8 x 9 3/8 in. (32 x 23.8 cm)

painting's rawness. Manet, by contrast, relied on the kind of fictional license that makes possible Ingres's *Apotheosis of Homer* or Raphael's *Parnassus*: La Petite Pologne as *Le Parnasse contemporain*. By thinking about the idea of the dream image in the nineteenth century, I suggest that we can get at the animating fiction behind *The Old Musician* and Manet's work in general, that we can attend to the actual oddness of the images, that we can begin to think about the way "modern life" in Manet is keyed in to various pasts, public and private.

Put another way, to try to incorporate a specifically nineteenth-century idea of a "dream image" apropos of Manet's art is to transform, but not abandon, an idea of "context." Common sense tells us that dream images include elements out of everyday life mixed with highly idiosyncratic reactions, memories, and emotions, which rearrange those "real" elements and introduce fantastic and unreal elements. A work of art is certainly not a mere transcription of something out there in the world, and what art history often must tease out of the work is the extent to which it both transcribes some aspect of the world that needs to be reconstructed and struggles against that reality in its form or in its view of the world (what was, what could be, what would be ideal).

Another way of looking at *The Old Musician*, then, would begin with the social realities already known about the painting: Jean Lagrène, the gypsy violinist; figures taken from Manet's large-scale painting *The Gypsies*, later destroyed (fig. 5); the repression of the outcast gypsies in nineteenth-century Paris; the beggar-boys reminiscent of Manet's *Boy with the Cherries*, which pictured the young studio assistant who hanged himself in Manet's studio; the reappearance of *The Absinthe Drinker*, Manet's first Salon submission, a portrayal of a shiftless drunkard not unlike a character out of *Les Fleurs du mal*; La Petite Pologne, a neighborhood razed by Haussmann as the XVIIème arrondissement came to be constructed.[11] Into the mix, add Manet's interest in Courbet, Caravaggio, Velázquez, Watteau, and the Le Nain brothers. Manet dated the picture 1862 and exhibited it at the Galerie Martinet in early 1863. This was precisely the period during which Manet was in close contact with Baudelaire, and in which he was beginning to experiment with ways of combining poses, costumes, and compositions of Old Master paintings with figures and elements of modern life.

We learn from Antonin Proust that he and Manet strolled around Paris, witnessed various scenes of destruction and renovation, spotted various characters, and discussed subjects for paintings such as

The Street Singer (fig. 6).[12] In all likelihood, Manet and Baudelaire did the same thing. Manet had been doing paintings that involved some of the characters from *The Old Musician* for years. If we picture Manet and Baudelaire walking through La Petite Pologne, or standing in Manet's studio looking at *The Gypsies* or *The Absinthe Drinker*, Baudelaire might well have been reminded of a section of Thomas De Quincey's *Suspiria de Profundis* of 1845 called "Levana and Our Ladies of Sorrow," which Baudelaire had just translated almost in full in *Les Paradis artificiels*.[13] Its subject also appears to have influenced Baudelaire's poem "Les Dons des fées," published in September 1862.[14] In De Quincey's oeuvre, the piece not only stands as a compelling prose poem in its own right, but it also figured as the author's sketch for the philosophical and structural key for the entire *Suspiria*.

The prose poem concerns the Roman goddess Levana, who presides over the child's education, and the three sisters, Our Ladies of Sorrow. De Quincey's narrator, whom the reader is encouraged to consider as De Quincey himself, claims to have seen Levana in dreams. Levana delegates an earthly representative—often a child's father—to raise the child to the heavens right after its birth, defying the gods in the process. This prideful gesture marks the beginning of the kinds of ambitions for children and for children's education that lead to the likes of sending them to Eton at age six. "Children torn away from mothers and sisters at that age not unfrequently die," writes De Quincey.[15] In the dreams in which Levana is revealed to De Quincey, the three sisters are also seen communing with the goddess. Each sister has a realm, and her works are invisible on earth except through signs and symbols, which De Quincey is able to translate into words. The eldest sister, *Mater Lachrymarum*, Our Lady of Tears, stands by the vanished: children who are taken from their parents, the children massacred by Herod, the child who had served as guide to a blind beggar, left in darkness as his child is taken to God. The second sister, *Mater Suspiriorum*, Our Lady of Sighs, "is the visitor of the Pariah, of the Jew," of the criminal, the penitent, the slave, "every captive in every dungeon; all that are betrayed, and all that are rejected; outcasts by traditionary law, and children of *hereditary* disgrace: all these walk with Our Lady of Sighs," writes De Quincey; "her kingdom is chiefly among the tents of Shem, and the houseless vagrant of every clime."[16] The third sister, *Mater Tenebrarum*, Our Lady of Darkness, "is the mother of lunacies, and the suggestress of suicides."[17] The work thus links the repressive stringencies of the proper education with being snatched away from one's parents and becoming an outcast in society, a lunatic or a suicide.

There is not a figure in *The Old Musician* who had not already been touched upon by De Quincey's description of the subjects in the realm of one of the three sisters: they are the forgotten, the vanished, the rejected; Alexandre the young suicide is among them either in body or in spirit. The text has proximity to Manet via the translation Baudelaire labored over during the period when he and Manet were in close contact. In his later letters to Baudelaire, Manet gives every indication of having read Baudelaire's works with interest. Of course, there are differences in tone: De Quincey's text is personal and melancholy, and he uses the story of the sisters to illuminate his own access to various "abominable" and "unutterable" truths. Manet's painting has clear connections to modern Paris and to various sources in the history of art. But what links the characters in Manet's painting if the old

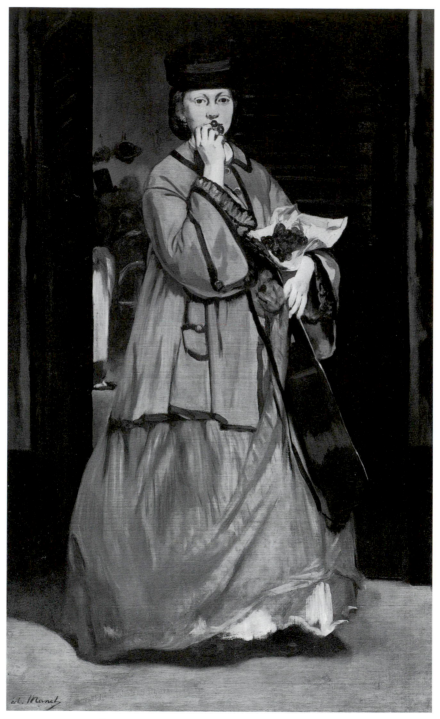

Fig. 6. Édouard Manet, *The Street Singer*, 1862–63. Oil on canvas,
67 3/8 x 41 11/16 in. (171.3 x 105.8 cm). Museum of Fine Arts, Boston.
Bequest of Sarah Choate Sears in memory of her husband, Joshua Montgomery Sears

musician himself is not in the middle of a concert, if the gypsies are away from the gypsy camp, if the absinthe drinker has wandered away from his bottle and his perch?

The Roman goddess Levana, according to Lemprière's dictionary, "presided over the action of the person who took up from the ground a newly born child, after it had been placed there by the midwife. This ceremony was generally performed by the father, and so religiously observed, that the legitimacy of the child could be disputed without it." In De Quincey's text, the *Mater Suspiriorum* walks with "children of *hereditary* disgrace" (De Quincey's emphasis). And in Manet's painting, a tow-headed baby is carried by a dark-haired, barefoot young girl in tattered clothes; if she appears to be a gypsy, the boy does not appear to be related to her. The boy may simply represent an *enfant trouvé* among all the other misfits in the painting. It is hard to ignore, however, the presence in Manet's life of a tow-headed boy, the illegitimate son of Suzanne Leenhoff, the woman Manet married in 1863. De Quincey's prose poem suggests a link among the gypsies, beggars, street musicians, and lost boys of Manet's painting, but that link is an imaginary one. "Levana and Our Ladies of Sorrow" is not a key for the deciphering of Manet's painting; it is not the text of the piece, which depends for its effect on its scale and on the relationship of its figures to the viewer. De Quincey's dream-legend mode, however, offers a way of thinking about the painting as a tableau that implausibly juxtaposes figures taken out of discrete settings.

If *The Old Musician* possesses a degree of romanticized unlikelihood, which creates a kinship with a literary text such as that of De Quincey, it is nevertheless the case that a quality of implausibility is integral to Manet's art in general, even as his figure paintings of the early 1860s move toward more direct engagement with modern subjects. It is furthermore indisputable that the implausibility of a painting such as *Le Déjeuner sur l'herbe* had already given rise in the 1860s to some readings of the subject as a dream image. As Meyer Schapiro has shown, an illustration for Hervey de Saint-Denys's *Les Rêves et les moyens de les diriger* of 1867 may well be related to Manet's scene of a nude woman among clothed men.[18] Schapiro also proposes that Cézanne's early *déjeuner* and pastoral fantasies regard Manet's 1863 canvas as "a dream image that [Cézanne] could elaborate in terms of his own desires." I would add that Cézanne's paintings (*Le Déjeuner sur l'herbe*, *Pastorale*, and related images) can be seen as fantasies in the psychoanalytic sense insofar as they stage variations on a core scenario provided by Manet's *Déjeuner*. In Cézanne's *Déjeuner* of 1869 (fig. 7), for example, the crouching red-haired woman at right appears as a reversed image of Manet's Victorine Meurent; the entire scene begins to take on the quality of a complex restaging of Manet's tableau, with Cézanne himself participating.[19] The relationship between the Cézanne and the Manet thus is not unlike that between the Manet and its precedents, such as *Le Concert champêtre* (fig. 43).

There are several aspects of improbability in Manet's *Déjeuner sur l'herbe*. It is a large canvas, nearly square. A nude woman gazes at the viewer, while two clothed men recline and gesticulate as if deep in conversation. The contrast between nude and clothed is accentuated by the strong contrast between the light, bright flesh of the woman and the black clothing of the men, in addition to the very dark green of the landscape. This formal starkness highlights the strange situation suggested by Manet's original title *Le Bain*: this is a riverbank bathing area, but only one of the four—the woman by

the water's edge—is wearing a shift and bathing.

A viewer in Paris in the 1860s would have known, for a start, that clothed men and a nude woman should not be found together in a bathing scene. Police ordinances renewed yearly during the 1860s designated separate bathing zones along the Seine for men and for women.[20] The mingling of the sexes was forbidden, as was complete nudity for women, who were required to wear shifts like the one on Manet's background figure. As Flaubert wrote to Louise Colet in 1853: "The two sexes used to bathe together here [in Trouville]. But now they are kept separate by means of signposts, wire netting, and a uniformed inspector."[21] Law or custom

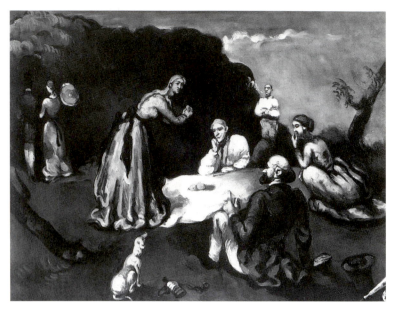

Fig. 7. Paul Cézanne, *Le Déjeuner sur l'herbe*, c. 1869. Oil on canvas, 23 3/4 x 31 3/4 in. (60 x 81 cm). Private collection, Paris

notwithstanding, Manet's way of depicting the foursome emphasizes incongruity. The bathing activity has little relation to the remainder of a picnic lunch at lower left, with fruit, brioche, and empty water carafe. Relationships among the seated figures are also unclear. The man at right gesticulates as if in conversation, the other man looks away, and the nude woman looks out of the picture, at the viewer. The figures' legs and feet almost touch, but the intimacy of their physical grouping is contradicted by their unrelated gestures and expressions. Their poses are strangely static. As has often been remarked, they appear as if they are posing in a *tableau vivant.*

The twentieth-century viewer might think that the nude woman's gaze, the immobility of the figures, and the implausibility of the scene are all reminiscent of the dream, especially the anxiety dream of being naked in a social situation. A link between Manet's painting and the topic of dreams is easily demonstrable. Although we commonly associate the birth of modern psychoanalysis with Freud—usually with his 1897 discovery of the Oedipus complex[22]—interest in psychology was quite common in the nineteenth century.[23] Even before the efflorescence of *la psychologie nouvelle* in the 1880s and 1890s,[24] mid-century Paris witnessed a great increase in the number of psychological studies with scientific pretensions: evening lectures at the Faculté de Médicine on such topics as the nature of hallucinations, dreams, and what we would now call the unconscious,[25] as well as newspaper *feuilleton* popularizations of these advances in psychological theory. Courbet's awareness of contemporary theory on sleep and somnambulistic fantasy has been established.[26] Given the proximity of such dream enthusiasts as Baudelaire and Duranty to Manet in the 1860s, a historical link becomes quite plausible, and as I will show, contemporary thinking on the subject of dreams informs both Manet's painting and some of the

ways it was seen. It does not seem particularly interesting or important to suggest that dream imagery or dream theory were necessarily explicit interests for Manet; rather, I am interested in corollary ideas about free will and moral volition, and how Manet and his contemporaries would have viewed the dream state as a situation in which the human will was temporarily in suspension.

In nineteenth-century studies on dreams and other kinds of mental images, the notion of free will figured prominently in positions taken on both sides of a philosophical and political debate. This interest in free will led both physiologists and spiritualists, both positivists and psychologists to look to the dream or the hallucination as a supportive example. The human imagination, the capacity to visualize, the mental image—all provided a kind of border territory between, as Pierre-Jean-Georges Cabanis called them, *le moral* and *le physique*.[27] On one side of the debate stood science, physiology, and the exclusion of intangibles like the soul. Advocates of positivism, or materialism, as it is sometimes called, argued that there was no such thing as free will, that all aspects of human behavior and mental life could eventually be explained by physical laws. They saw themselves as heirs to the Enlightenment, and their politics tended toward the radical.[28] On the other side were religion, a belief in the soul and in free will, and the treatment of "mind as a reality distinct from body, as a radically free entity not subject to the laws prevailing in the physical world," as historian Jan Goldstein puts it.[29] Viewing positivism as an attack on the existence of the soul, the spiritualists countered that the positivists attempted to quantify immaterial phenomena—dreams, for instance—which would always escape the laws of science. A dream or a hallucination had the potential to reveal a physiological nature in actual retinal images or brain impulses; it could also manifest a potential relation to external sensory stimuli. These qualities attracted interest in dreams on the part of the so-called physiologists. At the same time, because dreams and hallucinations were involuntary, they could be analyzed as evidence that the mind escaped the order which the physiologists sought to impose. The dream, on the borderline between conscious and unconscious, between that which could be measured and that which eluded our force of will, became a centerpiece of interest for philosophers and doctors of all persuasions.

One of the books that received much critical notice and was more than likely familiar to Zola and to others in the Manet circle was Alfred Maury's *Le Sommeil et les rêves: études psychologiques sur ces phénomènes*, which appeared in Paris in 1861.[30] The book was exceedingly well received by members of the Société Médico-Psychologique,[31] a psychiatric association that was in part dedicated to furthering "the services that medical science can render to religion, morality, jurisprudence, education, metaphysics, etc."[32] Since many of the members sought a compromise between the positivist or physiological position, and the spiritualist one, a study such as Maury's and the views of the society are extremely pertinent here. Maury viewed dreams as having an indisputable physiological reality of their own. This physical aspect, however, was not a manifestation of the will; it was not a conscious activity. In an attempt to avoid alienating those readers fearful that the physiologists were reducing human beings to the level of animals, Maury theorized about the involuntary but physical reality of dreams: "It is neither attention nor will which conjures these images for our intellectual notice, these images which in dreams we take to be realities; they produce themselves, following a certain law due to the unconscious movement

of the brain, and are a matter of discovery; thus they dominate our attention and will, and in this way appear to us as objective creations, as products which do not emanate from us and which we would contemplate in the same way we would exterior objects. These are not only ideas, but images, and this character of exteriority gives us reason to believe in their reality."[33] One of the most striking aspects of this passage is the claim Maury makes that dreams have a reality of their own, that they "produce themselves, following a certain law due to the unconscious movement of the brain." Since such unconscious activity remains unknown to us (we would now say, unknowable), the image of the dream could take on a "character of exteriority"; it became something seemingly separate and isolated from the dreamer. Since we could look at the dream—which involved images, not just thoughts—as something outside ourselves, as something coming from without, not within, we could believe in the reality of the dream.

Maury postulates that because of an unconscious activity, dreams seem to produce themselves; their reality seems exterior to the dreamer. An insistence on the material reality of such a thing as a mental image, however, would in this period become a loaded proposition. Accordingly, an advocacy of the faithful study of nature in art, for instance, entailed a belief in the involuntary character of mental images such as dreams. The claim as to the involuntary nature of the dream image became the linchpin of the reaction to the potential danger of an image that could embody repressed desires.

A notion of involuntary brain activity became a crucial component in most theories of dreams and hallucinations by mid-century. The reason a concept of the involuntary was so important was that it did not heretically contradict a belief in free will. When, in 1845, Jules Baillarger, the founder of the Société Médico-Psychologique, articulated a dualistic program under the name "automatisme,"[34] he established the terms for a seductive philosophical compromise. According to Goldstein, he "postulated a split between the voluntary and directed use of the faculties of memory and imagination and their involuntary and unregulated use."[35] Thus the deliria of the insane could be scientifically investigated by those interested in the physiology of the hallucination, while the existence of the will remained intact. Theories such as Baillarger's opened up the possibility of involuntary departures of the imagination in the form of hallucinations. Just as the insane experienced delusions "as belonging not to themselves but to an alien being,"[36] so too were all dreamed images exteriorized by this philosophical split.

What began as a philosophical compromise between the physiological study of hallucinations and a maintained belief in free will, then, generated a notion of dreams or any mental images as fundamentally cut off from the dreamer. Analogies with the world of art were soon to follow. Consider this excerpt from an article on dreams by one of Manet's colleagues, Edmond Duranty: "On a black background, which is none other than that of the eyelids when the eyes are closed, dream images come to depict themselves. They *paint* themselves there in every sense of the word, for in the dream, neither the sun, nor the sudden appearance of a source of light whose brightness is reflected by other objects, manifests itself. [. . .] Objects appear to be colored like pure paintings, sometimes completely covering the black background [. . .], sometimes merely detaching themselves from it."[37] Duranty uses the term "pure paintings" to describe the way dream images and their colors superimpose themselves on the

blank, black background of the mind's eye—literally the eyelids. Earlier in the article, he refers to a recurring dream of an open window that looks out onto a "black background, as if painted on a black canvas."[38] The image's self-detachment that Duranty describes is reminiscent of Maury's notion of the dream's character of exteriority, and the debt to Maury is one Duranty acknowledges elsewhere in the article. If the analogy beween the work of art and the dream was a very ancient one, then by the mid-nineteenth century that analogy had almost become one between the dream image in the physiological sense and the work of art as "pure" or autonomous.

The involuntary or unconscious nature of dreams was the key to the dream's power to call up forgotten memories. This ability to tap into buried layers of experience was described aptly by the spiritualist Théodore Jouffroy: "We feel . . . our understanding let loose in the country while we ourselves are not on holiday; it runs hither and thither like a schoolchild at recess and brings back to us ideas, images, memories that were found without our aid and without our ever having requested them."[39] This foreshadowing of the Freudian Id was in 1828 an extreme anti-physiological articulation of the uncontrollable nature of the imagination. Nevertheless, by mid-century, this notion was thought to be compatible with the new emphasis on the involuntary character of dreams. Consider, for instance, Alexandre-Jacques-François Brierre de Boismont, a phrenologist in the 1830s who became a convert to spiritualism by 1851, and in the following year, published a treatise on hallucinations.[40] (Baudelaire knew his treatise on suicide, published in 1856.)[41] Following Jouffroy, Brierre de Boismont conceives of the imagination as capable, in a hallucination, of tapping into memories we did not know we had: "Hallucinations can have reference to objects perceived in remote times, to long-forgotten subjects which are put back into memory by inappreciable causes, often by virtue of the associations of ideas; it is also a fact that in a majority of cases, hallucinations are only reminiscences, creations of known objects."[42] Brierre de Boismont here not only attests to the power of the imagination to retrieve long-forgotten impressions, but also posits a rudimentary notion of free-association and its role in linking "long-forgotten subjects" (we would now say long-repressed)[43] with vivid present images, via seemingly insignificant matters.

For Maury, too, the revival of old memories was one of the significant aspects of dreams. As one would expect, he discusses the key roles of family members and intimates in dreams, and how they can appear somewhat different in the dream; likewise, a totally unknown person or place can take on a peculiarly vivid quality: "Sometimes our mind [*esprit*] evokes well-known images, such as the face of a friend or parent, without recalling his name; sometimes sensations which we feel when three-quarters awake are only imperfectly perceived; we attribute to them an intensity or a character which they do not have. In the first case, we can speak of a debility of memory; in the second, a weakening of perceptivity."[44] The physiological forces affecting the intensity or inaccuracy of these conjured images is high on his agenda. On a more personal note, he writes about a dream of a trip to the country with a brother who had been dead for over ten years and was much missed. Attesting to the remarkable power of the dream of his lost brother, he writes: "The theory of memory I have just given seems to me a sufficient explanation [of the power of dreams to recall forgotten memories] without which one must

admit, as have several writers, that we lead two distinct lives, real life and dream life, each following their separate course and each responding to a distinct chain of actions."[45] Maury thus moves from a simple reiteration of the idea that unconscious brain activities could bring to the surface memories which were long buried, to a notion of the dream image as an alternative to reality. Memories were the links between the dream world and the real world. The "distinct life of the dream" and its chain of acts and associations—whatever endowed the dream with its dynamic potential to suggest an alternative to reality—were, however, obscured by the period concern to guarantee free will in the conscious by asserting the otherness and separateness of the unconscious.

Those on the spiritualist side of the dividing line, again, insisted on the radical unstructuredness of the mind, but they were capable of looking into that chaotic domain and seeing tremendous suggestiveness. Louis-François Lélut, for instance, who published in 1852 a memoir on dreams and drew heavily on his spiritualist predecessor Jouffroy,[46] wrote that the half-fantastic, half-real nature of dreams proved the fundamental separation between the dream and the conscious *moi*.[47] His text reads: "[D]reams constitute the state of thought during sleep. [. . .] there, the mind would return to its free character, to the free character it has when at rest, [. . .] it would be the return of this same mind to its original state of being, to the state it enjoyed in the maternal womb, in the dark ages of life." For Lélut, the dream becomes an evocation of a primitive self.[48]

Baillarger claimed universal agreement, speaking at least for members of the Société Médico-Psychologique, that dreams were a transmutation of primitive aspects of the self into complex, observable forms. In his review of Maury's book, he takes special note of what Maury dubs "hallucinations hypnagogiques," or sleep-induced visions, and writes: "The sleep-induced vision evidently becomes a complex phenomenon comprised of two elements, the *original* nervous impression and the mind's reaction to it, which, as Maury rightly states, is a metamorphosis of that impression. The transformation, instead of being based on ideas, is based on the original nervous impression."[49] Maury, and Baillarger, suggest that there are two elements involved in sleep-induced visions: a primordial or original nervous impression and a transformation of that impression. The transformation—what Freud would call the dream-work[50]—actually revolves around unconscious material, not conscious thoughts. Again, conscious will need not be threatened by the scientific study of these departures from the conscious, provided that a dualist system such as Baillarger's preserved the division between voluntary and involuntary brain functions.

Dream investigators on both sides of the philosophical divide often sought to isolate the sensory characteristics of dreams. No doubt the attraction of this particular sphere of inquiry was the hope of discovering definitive evidence that empirical methods could, or could not, gain access to the true nature of dreams. The question of whether dream images and perceived objects had the same optical properties on the retina was one that plagued a generation of physiologists. Brierre de Boismont, before disputing the conclusions of one A. Dechambre, quotes a long passage from the latter's analysis of hallucinations: "We have never been able to discover clearly, notwithstanding the great authority of Müller and Burdach, the alleged intervention of the senses in hallucinations. According to the former,

visions are *actually conditions of the sense of sight*, and according to the latter, we then perceive *in the eye*, when the thought occurs, the same sensation as if an external object was placed before the open eye."[51] Dechambre looks closely at the work of the German physiologists Müller and Burdach and questions the accuracy of their analyses that hallucinations form retinal images of the same nature as those of perceived objects. He continues: "One can only mean one of the following two things: either a false sensation formed in the eye, is conveyed to the brain, or the brain, by the action of a false thought, creates a sensation on the eye. [. . .] How can a cerebral or a psychical conception engender the sensation of an image in the eye? [. . .] In hallucination, the brain imagines, creates, and perfects them, and that is precisely the fundamental character of the phenomenon. All this does not prevent a distinction between intellectual hallucinations and those which are characterized by a sensible sign, a phenomenon of the sensorial order."[52] Dechambre rejects the notion that it is possible for a psychological phenomenon, or a mental image, to engender a physiological sensation, an actual image in the eye. For him, hallucinations are of a fundamentally mental character. This difference, however, could support a distinction between hallucinations that are purely psychological and those that include or draw on something seen or heard in the real world. Brierre de Boismont, we recall, supports this distinction, as it preserves intact a notion of free will and helps differentiate the sane person temporarily seeing things from the insane person, who imagines things and cannot tell the difference. Brierre de Boismont also uses this notion of basing hallucinations on something perceived in the world to set up a tautology about visionary works of art: "Hallucinations appear sometimes to produce strange forms; but on careful examination, their elements are found to have been imbibed from books, pictures, traditions, etc. Thus, in the Middle Ages, the figure of the devil was borrowed from the prevailing architecture of the time, whose fantastic compositions formed extraordinary ornaments in their Catholic churches; witness the Abbey of St. Martin de Boscherville, near Rouen."[53] Just as medieval sculpture appears to borrow elements from the most bizarre and extreme visions of the devil, according to Brierre de Boismont, so too, hallucinations, on close examination, can be found to draw on artistic and literary images.

By now it should be evident that the distinction between conscious and unconscious phenomena, at least in the compromise of the Société Médico-Psychologique, opened the way for parallels to be drawn between dreams and works of art. A number of so-called "psychological studies" of artists began to appear in the 1860s on such historical figures as Shakespeare, Socrates, and Blaise Pascal.[54] Because of perceived similarities between the hallucinations of the insane and the dreams of the sane, Shakespeare's vivid evocations of madness attracted much attention.

One of the major concerns of those investigating dreams in this period was the moral system of the dream. Although morality was associated with conscious choice, it had no discernible physiological basis. Writers on dreams often vehemently defended their concept of the human soul by describing the existence of a moral system in dreams. Yet they also expressed surprise that an unconscious or involuntary activity could take on conscious aspects. Using the phrase "theater of contradictions" to describe dreams, Maury writes: "It sounds like an oxymoron to say 'a conscious unaware of itself.' The dream, in

effect, is a theater of contradictions, and the most opposite actions come together in a way which belies all our psychological theories. In dreams, I can pursue a course of action or thought, I can carry out a project which requires almost as much intelligence as I can muster when awake."[55] Maury here comes down on the side of those who would stress the incomprehensibility of mental processes. Nevertheless, this unfathomable realm could be a scene in which the subject pursued an activity requiring skills or intelligence hardly possessed in real life. The opposite of the anxiety dream of unpreparedness or awkwardness—the dream of great accomplishment—is here cited as evidence that confounds the psychological explanation of the time.

Maury also drew analogies between dreams and ecstatic or hypnotic states, proposing that the underlying mental condition for each was one in which "attention and a weakened will gives free rein to spontaneous ideas and the production of images."[56] Baillarger aptly called this a "relâchement de la volonté," a relaxation of the will, which left us as defenseless against the spontaneous production of external and illusory visions as was the hashish user or the anaesthetized subject.[57] Baudelaire remarked on a similar phenomenon in *Les Paradis artificiels.*[58] For Baudelaire, "because the will has no more force and no longer governs the faculties," under opium or hashish, "man no longer evokes images, but images offer themselves to him, spontaneously, despotically."[59] Again we note that for many, there was a link between the involuntary nature of dream images and a way of exteriorizing them. Although Maury and others noted that dreams could incorporate the desires and residues of everyday life, the dreamer was seen as a passive observer of images that came from elsewhere.

Maury's reference to dreams as a "theater of contradictions," as well as Baudelaire's interest in the spontaneous, exterior nature of hallucinations, are both indebted to Jacques Joseph Moreau de Tours's 1845 manual on hashish and its accompanying mental states.[60] Moreau de Tours also emphasizes the passivity of the drug-ingesting dreamer, and he points out the basis of dreams in elements from the dreamer's own life, in a long quotation from his mentor, Esquirol:

> In hallucinations there is neither sensation nor perception any more than in dreams and sleepwalking, since external objects do not impinge on the senses. . . . The individual who is delirious, *who dreams,* cannot control his attention, cannot direct it, nor distract it from these fantastic objects. He surrenders to his hallucinations, to his dreams. . . . *He dreams while wide awake.* In the dreamer, thoughts of waking life continue during sleep, while he who is delirious completes his dream, as it were, although wide awake. Dreams, like hallucinations, always re-create old sensations and ideas. As in a dream, the sequence of images is sometimes regular. More often the images and the ideas occur in the greatest confusion and provide the strangest associations. As in a dream, those who hallucinate sometimes are aware that they are delirious, without being able to release their mind.[61]

In Moreau de Tours's analysis of the special case of hashish-induced hallucinations, dreams not only rehearse events from waking life, but also recombine them. The theory is significant when we consider how many thinkers such as Maury drew parallels between ordinary and drug-induced dreams. Moreau

de Tours also wrote of the hallucination as a separate world: "As the action of hashish is more keenly felt, one passes imperceptibly from the real world into a fictitious world without losing consciousness of oneself. In a way, a fusion takes place between the dream state and the waking state; *one dreams wide awake.*"[62] For Moreau de Tours, the dream world was an alternative reality; the effect of the drug, however, was to blur the boundaries between reality and dream. Empirical tests of this hypothesis were no doubt conducted by the doctor, by Baudelaire, and by other members of the Club des Hachischins at the Hôtel Pimodan in 1845.[63]

De Quincey's meditations on the mind as a palimpsest were of great interest to Baudelaire. Echoing De Quincey, Baudelaire writes that in a near-death experience, for instance, a person could see a succession of images that condensed years of his life.[64] De Quincey's palimpsest brings to mind Freud's now famous analogy of the mind as a "Mystic Writing-Pad"—that wax slab which retains all traces of writing underneath a superficial transparency.[65] Of course, the palimpsest as a model of the mind suggests a largely unorganized accumulation of images. Freud's model, on the other hand, tries to unite the mind's receptiveness to new impressions (the writing on the transparency) with its simultaneous capacity to repress and retain other impressions (the writing on the slab). He attempts to give these strata a precise physiological organization. The dynamic structure of Freud's model stands in contrast to those of the nineteenth century.

In the realm of dream theory, too, the great philosophical divide continued to cause conceptual divergences. Baudelaire, for instance, writes about two distinct types of dreams and fails to see their connection: "Man's dreams are of two kinds. The first, filled with details of his ordinary life—his preoccupations, his desires, his vices—combine, in a more or less bizarre manner, with things glimpsed during the day, which have been imprinted at random on the vast backdrop of his memory. That is natural dream; it is the man himself. Ah, but the other kind of dream! The absurd, unexpected dream, that lacks bearing or connection with the character, the life and the passions of the dreamer! *this* dream, which I will call 'hieroglyphic,' evidently represents the supernatural side of life, and it is precisely because it was absurd that the ancients believed in its divinity."[66] Baudelaire differentiates between the type of dream that is clearly transparent onto the frustrations and the banalities of ordinary life, and the "hieroglyphic" dream, incomprehensible and apparently unconnected to the dreamer's daily life. It would be Freud's great breakthrough to suggest that these two types of dreams are actually one and the same: that the hieroglyphic dream consisting of mysterious ciphers fundamentally is the dream filled with the preoccupations and desires of ordinary life.

We have already seen how several writers on dreams postulated the ability of dreams to retrieve experiences that the mind had buried or repressed. Duranty not only comments on the sensation, in dreams, of the strangely familiar, but also speculates on the connections between his father's death and a series of dreams that exemplify the Freudian uncanny: "Nothing could be more bizarre, or more vexing, than the dreams I have had about my father since his death. First of all, each time he is someone other than himself, and yet it must be he. At the same time, while the dream follows its course, I say to myself: But am I really the son of this strange man with whom I find myself moved to singular acts

which plunge me into astonishment, although I submit to their necessity? [. . .] What really strikes me is that it is a stranger who is my father, and if I witness his fate with interest, for he is my father, I do not intervene, for he is a stranger to me."[67] Leaving aside, for the moment, considerations of Duranty's awareness that he was illegitimate, we note several fascinating ideas. Duranty is able to connect Maury's notion of the "theater of contradictions" with a solid basis in the life of the dreamer. He attests that in dreams, his father can appear different, can be a stranger, yet still be his father. Duranty struggles over the incomprehensible necessity with which he must come to his father's aid: he freezes, unable to act, because his father appears as a stranger.

Duranty is attentive to the striking ambivalence he experiences in the rescue-fantasy-*manqué* he dreams after his father's death. Yet before Freud proposed a dynamic model for understanding the workings of the mind, a writer in Duranty's position was fettered by a kind of either/or model of the mind's functioning. *Either* the sane, conscious mind acted in accordance with a moral system, *or* something like insanity or animalistic behavior took over in dreams and hallucinations, and the mind was powerless against it. Either the freedom of the human will existed, or it did not. Duranty could hardly have seen the operations of dreams as exerting a shaping force on waking life.

Nevertheless, the dream world remained an attractive subject precisely because of the wild and inexplicable things that could happen in it: the dream world could be seen as an alternative reality. Duranty touches on this with some difficulty:

> From that, [aspect of the dream] this sort of exaltation of all sorts of feelings; from there on an immediate obedience to things, which appeared to us as a greater liberty, or as a weakness comparable to madness. Our secret longings will reveal themselves there, while something from the past will spring up, free of the constraints of the present, and show us a scene from another time which, in waking life, would be repressed, effaced, or hidden.[68]

In the world of the dream, our longings spring up, unconstrained by those around us. What is repressed in waking life can surface in the dream, Duranty had learned from Maury.

In Maury's book on dreams, he capitalizes on the spiritualist idea of "l'automatisme" to speculate on how and why we do things in dreams which we would find embarrassing or abhorrent in waking life:

> The best proof we have that in dreams, automatism is complete, and that the acts we accomplish in dreams are imprinted with the habits of our waking life, is that we can commit reprehensible acts, even crimes which we would never submit to in waking life. These are our inclinations which speak and which make us act, without which our conscience restrains us, as well as holding us back at times. I have my faults and my vicious propensities in waking life, I struggle against them, and it often happens that I don't succumb to them. But in my dreams I always succumb to them, or to put it another way, I act on their impulses, without fear or remorse. I let myself have the most violent fits of anger, the most unbridled desires, and when I wake up, I am almost ashamed of these imaginary crimes.

Evidently the visions taking place in my imagination which constitute the dream are suggested to me by incitements which I experience, and which my absent will does not attempt to repress.[69]

Whereas in waking life Maury claims he successfully fights off his darker impulses, in the world of the dream, with his conscious will absent, he succumbs to these incitements and even commits crimes. Without the conscious will there to repress the wishes and restrain the subject, he becomes the agent of his own unbridled desires. It is easy to relate Maury's concern about the way the dream gives form to desires we would now call repressed, to Freud's articulation, less than forty years later, of the dream as the fulfillment of a repressed wish.

Maury goes on to explain that with the conscious will absent, gone too are conscience, reason, honor, and fear—the forces that are there to repress the passions.[70] Following the work of Jean-Étienne-Dominique Esquirol and Théodore Auzouy on the analogies between madness and the dream, Maury marvels at dreams of murder and of modest young women showing themselves shamelessly.[71] Yet, just as the dreamer imagines crimes and immodest passions, he often does so with a sense, in the dream, of moral reprehensibility. Despite the fact that the relaxed will permits the dreamer to carry out various dark deeds, he can be aware of his conscience in the process: "Therefore in my dreams I find myself possessed by religious scruples, by infantile terrors which I would completely ignore in waking life, and which go back to my earliest childhood. [. . .] when the will is banished [. . .] we become genuine automatons."[72] Here is one of the most extraordinary contradictions about dreams noted in the period: the fact that a dream can animate desires we did not know we had, that via the relaxation of conscious repression, these desires could be fulfilled without resistance; yet, resistance can also make itself felt in the dream. Resistance is not absent or screened out in the dream, although it can be paralyzed or hampered. While the subject pursues his wildest imaginings, resistance can be present in the dream, looking on helplessly. And even while the subject carries out acts he would shun in waking life, resistance can also conjure up scruples or infantile terrors, which are, according to Maury, "imprinted on a person in one's early education."[73]

As products of involuntary mental functions, dreams could be marshalled as evidence that voluntary and conscious control did not physically exist in certain states; dreams could also illustrate the radical unstructuredness of the mind. In either case, dreams represented the intersection of repression and desire: dreams took up the materials of instincts, primitive or uncivilized impulses, desires, bodily or animal responses, and gave form to those sensations. Well before Freud's conception of a dream as a representation of a desire, nineteenth-century writers considered the interplay between the dream image and the representation of actions over which we had no control.

Yet despite the lack of the dreamer's willed control over the dream, the dream itself was likely to veer toward the known and familiar. Were the dream entirely fanciful, it would perhaps be of no consequence. Not surprisingly, we can find several of our writers—De Quincey, Baudelaire, Duranty, Maury—lying figuratively on the couch of Orestes: subject to fits of wild imaginings seemingly external or beyond control, but also under the sway of infantile fears and familial affections. De Quincey intones:

> Imagine yourself seated in some cloud-scaling swing, oscillating under the impulse of lunatic hands; for the strength of lunacy may belong to human dreams, the fearful caprice of lunacy, and the malice of lunacy, whilst the *victim* of those dreams may be all the more certainly removed from lunacy [. . .] Seated in such a swing [. . .] the reader has reached the lowest depths in my nursery afflictions.[74]

De Quincey weaves together the "fearful caprice," or lack of control in dreams, and his own "nursery afflictions," which John Barrell calls "the mythic melodrama he created from his childhood memories and his adult fantasies."[75] Baudelaire explains De Quincey's visions to the readers of *Les Paradis artificiels*:

> Finally, and this is of immense importance, certain accidents—perhaps common enough in themselves but particularly important and serious because of the sensitivity of the person who experienced them—become the key, so to speak, to the extraordinary visions and sensations that will later return to torment his mind. Many an old man, leaning his elbows on a tavern table, sees himself surrounded by his former companions; his drunkenness springs out of his vanished youth.[76]

Baudelaire's formulation, "his drunkenness springs out of his vanished youth," embodies De Quincey's image of the couch of Orestes: feverish dreams are rooted in what Baudelaire calls "les chagrins d'enfance" (the sorrows of childhood). His text is laced with a high degree of identification. Baudelaire imagines the banal experiences of his own, subsequently wrought into exquisite poetic sensations. He cannot help but see himself as De Quincey, "the future *opium-eater*, who was seven years old when his father died, leaving him to tutors who gave him his early education in several schools"; Baudelaire himself was six when his father died, and seven when his mother's remarriage instigated his own consignment to boarding schools. Even the love of the English language, which facilitated Baudelaire's translations of De Quincey and Poe, can be traced to his mother, whose early years were spent in England.

At the very opening of his study of Baudelaire, Sartre argues for the importance of the family drama in Baudelaire's life and art. Sartre is not overstating the case when he suggests that Baudelaire "felt that he was united body and soul to his mother in a primitive mystical relationship. [. . .] There was nothing but a home, a family and an incestuous couple."[77] But however powerful the pull of this "incestuous couple" on Baudelaire's imagination, he also articulated the world of dreams in terms like those of Euripides' Orestes, who figures prominently in the mysterious dedication of *Les Paradis artificiels*.[78] Dreams during deep sleep are of two kinds, he wrote: the natural and the hieroglyphic. Those who have never experienced the effects of hashish imagine "a sort of fantastic landscape [. . .], a vast theater of conjuring and illusion where all is miraculous and unforeseen."[79] They are mistaken. Hashish does not usher in a strange and bizarre world; the user remains in the world of the natural dream: "Throughout its duration, the intoxication will be nothing but a fantastic dream, thanks to the intensity of colors and the rapidity of the conceptions, but it will always retain the particular quality of the individual."[80] Hashish would seem to be a way to leave behind the cares of ordinary life, and under

the right circumstances, one can be delivered from daily tasks and worries. But because hashish will ulti-
mately only exaggerate the sensations of everyday life, the "chagrins de famille" (familial sorrows), the
"douleurs d'amour" (love's grief) can come ringing back at even greater intensity: "L'inquiétude
deviendrait angoisse; le chagrin, torture."[81] As in the world recounted in "Le Voyage," a poem dedicated
to Maxime du Camp, ideas of pleasure, novelty, travel swirl around even in sleep; curiosity and desire
drive us toward imaginary El Dorados, toward opium, sin, and death.

> We guess the ghost from the familiar tone;
> Our Pylades stretch out their arms to us.
> "Refresh your heart! To your Electra come!"
> Says she whose knees we once kissed, tremulous.

> [À l'accent familier nous devinons le spectre;
> Nos Pylades là-bas tendent leurs bras vers nous.
> «Pour rafraîchir ton coeur nage vers ton Electre!»
> Dit celle dont jadis nous baisions les genoux.][82]

The wild dream imagery of the traveler's tale impels Orestes toward his Electra. The endless voyages to
El Dorados take the voyager back to the arms of his sister.[83]

Baudelaire's poem "Le Voyage" concludes the section of *Les Fleurs du mal* called "La Mort," and
Death, "vieux capitaine," makes an appearance at the end of the poem: Death promises relief from the
boredom of one's own country. It matters not whether the yawning gulf beyond is that of Heaven or
Hell: "Au fond de l'Inconnu pour trouver du *nouveau*!" (To the depths of the Unknown to discover
something new). This is the oft-quoted battle cry of the dandy: he will flirt with death itself for the sake
of novelty. And yet, what is the point of Baudelaire's repeated wishes for travel, his incessant *invitations
au voyage*—which stand in stark contradistinction to the poet's actual reluctance to embark upon even
short trips—if not to maintain by opposition that which was close to home all along?[84] Baudelaire's ref-
erences to Orestes' friend and cousin Pylades, to Orestes' sister Electra, and to knees once kissed, come
straight out of Baudelaire's involvement with the translation of De Quincey: he was writing "Le Voyage"
just as he finished *Les Paradis artificiels*.[85] If we read the closing ode to Death, "vieux capitaine," not as an
expression of the dandy's earnest desire in the face of world-weariness, but rather as if this passage is as
overwrought and loaded with artifice as the rest of "Le Voyage," then the meaning of the entire poem
becomes quite different. What brings back "the familiar accent" of Electra calling her Orestes is the eat-
ing of "the fragrant Lotus," the invitation "Come and revel in the sweet delight of days where it is always
afternoon!"[86] The reader senses the return of De Quincey's account of the effects of opium not as facili-
tating exotic escapades, but as exciting and intensifying familiar and even infantile loves and terrors.

There is already in nineteenth-century writing a nascent awareness of the interconnectedness
of familial affection with dreams that may seem wildly foreign. The idea that dreams were involun-
tary made possible both the dimension of foreign or unthinkable behavior in them and a disavowal of

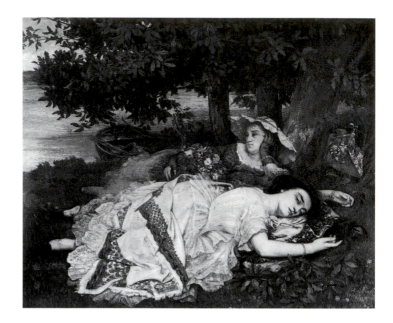

Fig. 8. Gustave Courbet, *Young Ladies on the Banks of the Seine (Summer)*, 1856–57. Oil on canvas, 68 1/2 x 79 in. (174 x 200 cm). Musée du Petit Palais, Paris

individual responsibility for them. For Maury, the dream itself figures both "imaginary crimes" and "infantile terrors," and these twin passions are brought on by a relaxation of the will. Just as De Quincey uses a notion of opium's physiological addictiveness to explain his prolonged use of it—while also sensuously indulging in it in order to explore the aesthetic experiences it makes possible—so too these writers on dreams rely on the absence of human will in dreams in order to excuse their behavior, while also relishing the chance to experience the forbidden.[87]

A possible nineteenth-century characterization of the dream image, in fact, is one of license: for writers and artists, the dream can be equated with the freedom to represent situations that might be objectionable, and the allowance for libertine behavior in those situations. The dream image is also one that is paradoxically both internal and external: it is undeniably individual and private; at the same time it remains somehow exterior to the dreamer. This dual character of interiority and exteriority provocatively emblematizes an approach to the painting of modern life when that painting represents or verges on the representation of fantasy. It may be the case, as I have tried to suggest, that nineteenth-century writers on dreams were themselves already on the "couch of Orestes," already involved in family romances of their own. The four remaining essays in the book will be concerned with Manet's own family romance. But before I move definitively onto that terrain, I would like to consider a few images that might invoke the dream and the fantasy. The mental image could be seen in the nineteenth century as one that embodied repression and desire, as I think these images show.

The fundamental reasons for the stir created by Courbet's *Young Ladies on the Banks of the Seine (Summer)* (fig. 8) at the Salon of 1857 hardly need repeating here: the painting exhibits an absence of decorum of the most unmistakable kind—its young women, with their petticoat finery, jewelry and flowers, languidly recline on the riverbanks.[88] Aaron Sheon mentions this painting as just one example

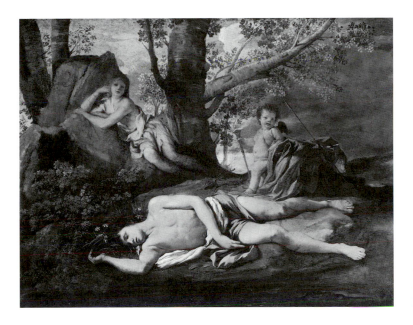

Fig. 9. Nicholas Poussin, *Narcissus and Echo*, c. 1629–30. Oil on canvas, 29 1/8 x 39 3/8 in. (74 x 100 cm). Musée du Louvre, Paris

in a long list of sleepers, sleepwalkers, and figures dozing and otherwise hovering on the edge of consciousness, all of which indicate Courbet's interest in the unconscious and in somnambulism.[89] If contemporary theories of the unconscious are one of Courbet's interests, as Sheon persuasively demonstrates, then the issue needs to be explored at greater length.

One of the paintings which Courbet probably emulated is Poussin's *Narcissus and Echo* of c. 1629–30 (fig. 9). The position of the dead Narcissus appears to have been the precedent for Courbet's half-asleep brunette, with her forearm next to her reclining head, her crown of leaves, and her legs just slightly splayed. She is also surrounded by flowers, like the Narcissus in the Poussin, that flower whose Greek name *nar-kisos* can connote *narke* or narcotic-induced sleep. According to Annie Gutmann's excellent study, the Poussin painting represents the triumph of Eros over the subjects in the painting who have dared to flout heterosexual conventions—Echo, by having no self, and Narcissus, by not being able to love an Other.[90] In Ovid, Narcissus mistakes for a body that which is only *unda*, waves or water; he is not able to possess the love object in a relation because he already contains it.[91] Gutmann takes Ovid a step further, arguing that there is a distorted image, a body, an exterior entity in the water: Narcissus idealizes a doubling of the self.[92] Similarly, in Pausanius's version of the story, Narcissus originally loved his twin sister and fell in love with the reflection, which resembled the sister he could not possess. This doubling of the self embodied in the reflected image brings out a bisexual dimension to the story. Gutmann's emphasis on Eros's rejection of the two subjects' failure to possess the love object becomes a failure of bisexuality, which in her view is one of the morals of the tale.[93] Courbet's *Young Ladies* doze; they dream; like the Poussin figures, they do not appear to be aware of what the viewer may make of their sexuality or their violation of decorum. The painting differs markedly from Courbet's earlier *Bather Sleeping by a Brook* (1845, Detroit Institute of Arts) in that the spectator of the Paris picture is

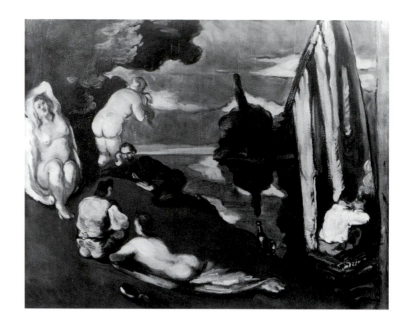

Fig. 10. Paul Cézanne,
Pastorale (Idylle), c. 1870.
Oil on canvas, 25 3/4 x 31 3/4 in.
(65 x 81 cm). Musée d'Orsay, Paris

not allowed the unobstructed view that enables him to possess, or visually appropriate, the female sub-
jects. The brunette does look out of the picture, though her eyes are almost closed. The other woman's
gaze, like that of Echo in the Poussin, is indeterminate. The young women are side by side, yet certainly
not in the intertwined, ecstatic poses of the lesbian *Sleepers* (or *Sleep*; 1866, Petit Palais, Paris). The
viewer of the *Young Ladies* is in the privileged position of looking at the languorous ladies, but part
of the picture's complexity lies in the indeterminacy of their relationship to each other and to the viewer.
It is this indeterminacy that evokes the involuntary nature of the desires accessed by the drowsy
dreamers.

Cézanne's *Pastorale* (fig. 10) at first glance appears hardly illusionistic, not giving us much by way
of reference to the colors and spatial requisites of the world: indeed, the painting appears to be more
hallucinatory than naturalistic.[94] The blue of the sky and water, the green of the ground and trees both
are too murky, too oppressively uniform to appear the least bit naturalistic. The artist takes such liberties
with the spatial organization of the work that it is difficult to imagine the lay of the land and how the
figures take their places in it. The island in the background, with its phallic shape silhouetted against the
sky and reflected in the water, hardly resembles anything in the natural world. Much of the picture's
right margin is occupied by a man in a boat. His back is turned toward the viewer, and he appears to be
smoking intently. The boat has been painted so as to come into contact, ambiguously, with the shore in
the lower right corner of the picture: it thereby creates its own separate space. I think it is tempting,
given the bizarre character of the work's colors and spatial organization, to toy with the idea that he is
smoking hashish. The sail in effect curtains him off from the rest of the picture; he is in his own world.

In a recent interpretation of another Cézanne idyll by Mary Louise Krumrine, she asserts that the
artist combines two distinct moments in a narrative to be read from right to left.[95] If we follow her line
of thought in this picture, it too could be read as a "before and after" composite: the man in the boat

smokes hashish, then has the vision pictured at left. He sees himself in the pose of Sardanapalus—a figure generally considered a self-portrait as well as an homage to Delacroix—surrounded by nude women and a clothed man. Perhaps what is most striking here is the lack of physical contact among the figures in the picture. As in Manet's *Le Déjeuner sur l'herbe*, the female nudity appears unnoticed, and a kind of immobility reigns. There is, however, an important difference. Whereas Manet paints his nude woman in such a way that the eyes of the viewer are riveted to her gaze and figure, Cézanne paints his nude women as apparitions, which incline the viewer to look away from them, or at least to wonder why they would appear in such distorted form. If the painting represents a dream or hallucination, it is of a totally different order than Manet's picture of a breach of decorum.

The solitary glass next to the wine bottle is emblematic of the picture. Although there are six figures, none engages with the reclining male figure: in fact, the grotesque female figures lean away from him. Although the woman who is stretched out along the central foreground may be addressing the seated man, it remains to be seen whether she will get anywhere with him, and there are no other instances of physical or social contact between men and women in the picture. Like Sardanapalus, the reclining artist-figure is isolated, and Cézanne's spatial organization, like Delacroix's, employs vertiginous diagonals: the reclining figure is physically poised on the edge of the hillside. Whether we read him as having smoked hashish or drunk the wine, he has done so alone, and alone he remains. Preparatory drawings demonstrate Cézanne's interest in a picnic still-life like Manet's, yet even in these there is only one wine glass.[96] Delacroix's picture is of a moment of ravishment and destruction before the enemy onslaught. What looms in the background in Cézanne's painting is the spectral phallus. The viewer must take the towering phallic form to stand for a tree in order to read the picture's subject matter. Once the reality of the tree is accepted, the viewer enters into the world of the picture, with its figures poised around the solitary bottle and glass, which echo the reflection of the tree form. The picture's reality is made and unmade around this tree form, this spectral phallus and its bizarre isolation. It is the artist-figure's solitude that is both threatened and threatening in the painting.

Whereas Cézanne's picture offers no escape from a fantasy of solitude, Manet's *Le Déjeuner sur l'herbe*, even as it resembles certain anxiety dreams, foregrounds social obstacles. Whereas Cézanne paints an identifiable male protagonist, Manet suggests, as Richard Wollheim has written, that the spectator is the major player.[97] It is the bright, stark nakedness of the woman and her gaze at the spectator that take center stage in the picture. In contrast with the self-contained nature of Cézanne's painting, much of what is important about Manet's painting occurs outside the painting itself, in an exchange between the nude model in the painting and the viewer who is the object of her gaze. Whereas Cézanne's viewer is not necessarily drawn into his picture, which appears to be someone else's strange vision, the viewer of *Le Déjeuner* finds himself or herself included in the picture. In the nude woman's implicating look at the viewer, several problems of beholding arise. I would argue that although some doubt remains as to *how* Manet construes the viewer's gaze, the viewer he imagines is male.

The woman's nudity in such a situation was recognized at the time as inappropriate: Théophile Thoré referred to the contrast between "this undressed female bather" and her clothed companion, "which is shocking."[98] If the viewer were to try to read the picture as an absolute mirror of reality in the

1860s, what would it represent? A flouting of bathing regulations? Some form of exhibitionism on the woman's part? Both are equally outlandish. The critical reaction to the scandalous indecency of the female nude notwithstanding, such a reading would still be problematic: even legal and medical analysts of the period noted that very few exhibitionists were female.[99] If the viewer, taking the cue from her gaze, were to conceive of an active role in the picture and a literal reading of the subject matter, he would become an accomplice either to what was seen as a rare perversion or to an act of trespassing in the segregated bathing zones. Just as the dreamer can be shocked, according to Maury, by things he sees and does in a dream that would be unthinkable in everyday life, so too the viewer of *Le Déjeuner* unwittingly becomes party to a scene—in Zola's words "not a *déjeuner*," and not a proper bathing regimen—which appeared at least illegal, if not perverse.[100] The viewer wishing to dispute the verisimilitude of the scene as a representation of reality might then look upon the painting as a dream image, as an absurd composite of the real and the imagined. Several critics remarked on the absurdity of the composition. If the viewer tries to remain a passive observer—if he renounces responsibility for the content as writers on dreams advised—he nevertheless finds himself in a public art exhibition, looking at a large-scale painting of a dream he would be embarrassed to recount at the breakfast table.

The reading I have just given depends on a reconstruction of a nineteenth-century male viewer. What if—as feminist historians have queried—we were to reconstruct a nineteenth-century female viewer? Griselda Pollock has argued that the entire presumption of the dangerousness of a painting like Manet's *Olympia*, of any flouting of morality in the period, in fact rested on the possibility of the female viewer who needed to be protected from witnessing such a *tableau*.[101] The positions women assume in *Le Déjeuner*—looking and being looked at, posing nude and bathing seminude, appearing in mixed company—signal a departure from the complicity with the male gaze that provided the normal code of relations between the sexes in paintings of the time.

The possibility that a mixture of the real and the unthinkable made Manet's *Le Déjeuner sur l'herbe* analogous to a dream needs to be examined. Freud attempted to explain dreams of nudity as invariably involving exhibitionism, usually the kind of self-exposure in which children take pleasure in showing themselves to strangers as well as to family members. Freud then postulates that this period of unashamedness in childhood exhibitionism surfaces in dreams and fantasies:

> When we look back at this unashamed period of childhood it seems to us a Paradise; and Paradise itself is no more than a group phantasy of the childhood of the individual. That is why mankind were naked in Paradise and were without shame in one another's presence; till a moment arrived when shame and anxiety awoke, expulsion followed, and sexual life and the tasks of cultural activity began. But we can regain this Paradise every night in our dreams. I have already expressed a suspicion that impressions of earliest childhood (that is, from the prehistoric epoch until about the end of the third year of life) strive to achieve reproduction, from their very nature and irrespectively perhaps of their actual content, and that their repetition constitutes the fulfillment of a wish. Thus dreams of being naked are dreams of exhibiting.[102]

According to Freud, dreams of nudity invoke the childhood pleasure we took in exhibiting ourselves in front of nursemaids, visitors and playmates. This paradisal unashamedness stands in marked contrast to the repressive adult world of Western civilization. The dream, which had long been considered able to resurrect childhood impressions and repressed desires, can thus re-create a childhood paradise.

Although in the above passage Freud generalizes about group fantasies of childhood, the origins of his analysis of nudity in dreams lie in one of his own dreams. As he recounts, in the dream he was climbing the stairs "incompletely dressed" when he was seen by a maid.[103] The turning point in the dream is the transition from his pleasure at being able to climb the stairs nimbly—a wished-for triumph over his heart condition—to his surprise at seeing the maid and his subsequent immobility. The elements of shock and immobility, the transformation of unself-conscious pleasure into self-conscious shame, are crucial to his discovery of the sexual character of the dream. The discovery also hinged on the dream's familiar setting (one of Freud's offices), and the connection, via the maid, between childhood and adult feelings about nudity.

Beatrice Farwell has argued that *Le Déjeuner sur l'herbe*, in its relation to Giorgione's *Concert champêtre*, can be read as a picture of "Paradise Regained."[104] Werner Hofmann has also read the picture in terms of the nineteenth-century topos of the earthly paradise, albeit one that places in stark relief the contrast between naked and clothed, between the artificial world of men and the natural world of women.[105] I would like to elaborate on this idea, for in my view the wish to regain what Freud called the Paradise of childhood exerts a powerful influence on Manet's picture, but it remains out of reach and was recognized as such at the time.

We have already seen how Freud describes dreams of nudity as dreams of a childhood paradise in which exhibitionism does not yet provoke inhibition. He claims that "we can regain this Paradise every night in our dreams." Yet he admits that this pleasure in nudity is a wish, not a state which can actually be attained. Freud himself felt ashamed in his dream when his maid saw him without a tie. Thus, an uninhibited Paradise is something wished for, but also countered by repression. Maury and other nineteenth-century dream analysts noted that the forces of repression—conscience, religious scruples, guilt—often made themselves felt in dreams.

Conscience was, of course, exactly the aspect of the conscious that was threatened in the age of Darwin. If the physiologists triumphed, human beings would be reduced, in the eyes of the spiritualists, to animals functioning automatically, on instinct. Art, which presumably demonstrates some differences between human beings and animals, was a domain in which one could expect to see operative evidence of free will. All three of the paintings just discussed in some sense foreclose on the will of the spectator. All three paintings depict some scene we are typically not meant to behold, with no pretext offered for our being there. Not only does the act of viewing evoke an awkward social situation, but also the subjects viewed evoke submission to involuntary desires.[106]

One of the negative responses Manet's *Le Déjeuner sur l'herbe* provoked was that the artist depicted persons as objects or as automatons. "He treats human beings and objects in the same fashion," wrote Adrien Paul; and Ernest Chesneau: "Manet's figures make us automatically think of the

marionettes on the Champs-Elysées: a solid head and flaccid garments."[107] The picture suggested that persons were puppets. This absence of conscious control was embodied by the nude woman, whose breach of decorum was exacerbated by the indifference of the men.

Manet's art was immediately associated with materialist or positivist currents. This applies both to those critics who reproached him for painting puppets or automatons, and to those, like Zola, who resorted to a discussion of formal values while circumventing subject matter. *Le Déjeuner sur l'herbe* made so little sense in 1863 as a literal transcription of reality that we should look beyond the level of subject matter when we examine the criticism that Manet was depicting obscene behavior. In light of the debate over whether unconscious or involuntary mental functions ruled out the existence of free will, I would argue that the charges leveled against Manet involve a fear of the representation of the involuntary life of the mind. The incongruous nude woman suggests not only actual libertine behavior, but also the notion that desires we did not know we had could take unsolicited form in our minds.

One of the critics who took a surprisingly progressive view of the Salon des Refusés was Charles Monselet, who wrote in *Le Figaro* under the pseudonym of Monsieur de Cupidon.[108] He took what was clearly a cynical stance on the Refusés, claiming that "all the artists want to be there, these days. It's the rage."[109] For him, the word "contre-exposition" connoted fashionable publicity. His remarks on Manet are unusually astute:

> —*The Bath*. In the middle of a shadowy woods, a young lady, deprived of any type of clothing, chats with some students in berets. Manet is a student of Goya and Baudelaire. He has already conquered the repulsions of the bourgeois. It is a major step.[110]

In my view, the words "repulsions of the bourgeois," as well as the associations with Goya and Baudelaire, indicate the apparent involvement of Manet's art not only with libertine behavior, but also with the involuntary life of the mind.

Le Figaro published a string of letters to M. de Cupidon two issues later. Gustave Mathieu admonished Monselet: "You must know there are four things about which it is in good taste to keep quiet: Family, dress, love affairs, and looks."[111] These are the subjects to which Manet's art would obstinately, and persistently, return.

Then what is the Other?
In the first place, he is the being toward whom
I do not turn my attention. He is the one who looks
at me and at whom I am not yet looking, the one
who delivers me to myself as *unrevealed* but without
revealing himself, the one who is present to me as
directing at me but never as the object of my direction;
he is the concrete pole (though out of reach) of my
flight, of the alienation of my possibles, and of the flow
of the world toward another world which is *the same*
world and yet lacks all communication with it. But he
can not be distinct from this same alienation and flow;
he is the meaning and the direction of them; he haunts
this flow not as a *real or categorical* element but as a
presence which is fixed and made part of the world if I
attempt to "make-it-present" and which is never more
present, more urgent than when I am not aware of it.

Jean-Paul Sartre, Being and Nothingness

ÉDOUARD MANET GREW up on the rue des Petits-Augustins (now the rue Bonaparte), more or less across the street from the École des Beaux-Arts he never attended. The address was a short walk down the quay and across the bridge from the Palais de Justice where Manet's father worked; indeed, many judges and magistrates lived nearby. As a family of a certain social standing, the Manets could be characterized by three things: considerable wealth, concern over appearances, and the survival of various links to the aristocratic past in the successful *haut-bourgeois* present. Whereas the first two characteristics should not be seen as unusual in the mid-century milieu of Paris magistrates, the last matter is a more interesting mix in Manet's case, as are its ties to the directions his art would eventually take.

In this chapter, I will argue that the theme of the family was not only a central one in Manet's art—especially in his formative figure paintings from the early 1860s, which I shall examine here—but also that a kind of family romance can be seen to develop in and through his figure paintings. Just as the dream theories and writings analyzed in the first chapter can be found to be circumscribed by structures of familial and familiar longings and desires, so too Manet's early figure paintings turn on and return to such configurations. After a brief exposition of some relevant Manet family history, I propose to look at

the theme of the ragpicker and street musician in Manet's art, with a special focus on the *Street Singer*; I will then examine such images as *La Pêche*, *La Musique aux Tuileries*, and *La Nymphe surprise* before returning to the central image in which a family romance is embedded: *Le Déjeuner sur l'herbe*. By "family romance," I mean a Freudian drama, complete with Oedipal desires, dilemmas of illegitimacy, and real and imagined deaths and absences. I will argue, as Sartre has done for Manet's close friends Baudelaire and Mallarmé, that it was particularly in this period that the "new (nuclear) type of bourgeois family [was] strengthening its ties" and that this ascendancy had profound implications for painting.[1] Sartre provocatively begins his study of Mallarmé: "In 1848 the fall of the monarchy blows the bourgeoisie's cover; then and there Poetry loses its two traditional themes: Man and God."[2] What takes the place of the questioning of theological and monarchical authority, which had occupied Enlightenment thinkers and Romantic poets, is, according to Sartre, a rebellion against the bourgeois family—one amplified by the freedoms and strictures of the Napoleonic civil code as against the familial alliances of the past. "During this entire period," Sartre says of the mid-nineteenth century, with particular reference to Poe, Baudelaire, and Mallarmé, "poets are sons [. . .]."[3] I will argue that Manet's art is similarly defined by the desires, strictures, and reactions within his own *haut-bourgeois* family. The origins and repercussions of this phenomenon, however, far outstrip its explanatory value vis-à-vis Manet's oeuvre: they suggest a different account of the painting of modern life, and by extension, of the origins of modernism.

As T. J. Clark has argued, "the terms of modernism are not to be conceived as separate from the particular projects—the specific attempts at meaning—in which they are restated."[4] The first wave of modernist painters—one could say Manet and his followers in the early 1860s, and Monet and his followers by the late 1860s—began to effect their revolution in painting by concentrating on modern-life subjects, and by doing so in particular and striking ways. One of the features of this new painting of modern life that set it apart from the existing art of its day was not only its subject matter, but also the extent to which it seemed "to break, mix or adulterate the existing genre-expectations of the time," as Tony Tanner has argued of the novel. "It is not for nothing that many of the protagonists of the early English novels are socially displaced or unplaced figures—orphans, prostitutes, adventurers, etc. They thus represent or incarnate a potentially disruptive or socially unstabilized energy that may threaten, directly or implicitly, the organization of society [. . .]."[5] It appears that the very forces by which the novel's tide swept in the surrounding social life, simultaneously created a narrative undertow which pulled it apart. I would like to make a similar case for painting. Although it is often acknowledged that Manet frequently painted gypsies, ragpickers, and other social outcasts, art historians have not yet explored what Tanner suggests is happening in the novel: that contained within the descriptive potency of Manet's vision of Paris is a similar subversion of social and familial order. Manet's painting of modern life unravels not only "genre-expectations," but also the world he depicts. Tanner's subject, of course, is not the narrative of the foundling and his family romance, but rather the subject of adultery, whose representation in the bourgeois novel, so he provocatively demonstrates, will come to dissolve the very form of the novel.

Art historians have long seen the Realist interest in the socially marginalized as politically subversive. Yet there are two things that I think are in need of a new emphasis. One is that the more controversial or potentially subversive aspects of Manet's art—there are many, but let us name its invocation of "sexuality" and "marginality" as two of its hot buttons—are actually played out in an arena best understood as circumscribed by the family. I will argue, for instance, that the paintings of the nude in *Le Déjeuner sur l'herbe* and *Olympia* (fig. 11) can be seen to participate in a larger Oedipal drama; I will also argue that paintings of gypsies and itinerants also participate in this family drama as expressions of *negation* (in the Freudian sense) vis-à-vis Manet's family as a whole and his father in particular. The other strand of the argument concerns painting itself. The extent to which the academic painting of Manet's day sustained a discourse on sexuality—the fact that it was monotonous and clichéd was part of its appeal and tenacity—was accomplished by keeping "society" (in the sense of modern society) out of the picture. Artists such as Delacroix did it by turning to literary subjects or faraway places. Likewise, many naturalist or Realist paintings made statements about society by keeping sexuality at bay. (Even Courbet produced some of his most Baudelairean nudes for private commissions; his sleeping nymphs do not address contemporary society in the manner of his other paintings. *Young Ladies on the Banks of the Seine (Summer)* of 1857, then, is the key painting in this regard and the key predecessor for Manet's

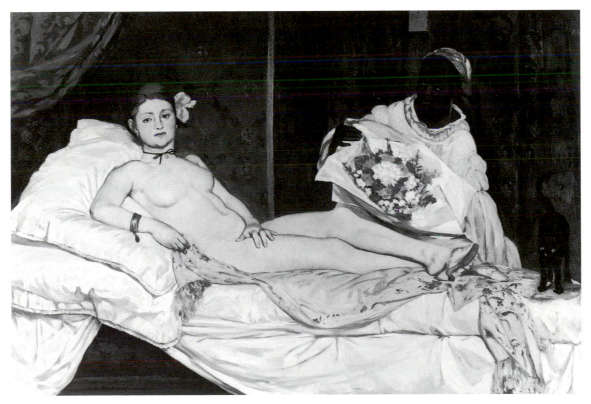

Fig. 11. Édouard Manet, *Olympia*, c. 1863. Oil on canvas,
51 3/8 x 74 3/4 in. (130.5 x 190 cm). Musée d'Orsay, Paris

paintings.) I am not trying to make a hard-and-fast rule, which surely can be contested with nuanced readings of particular examples; I am, by contrast, pointing to the volatile juxtapositions at work in Manet's nudes, the better to show up the representational work they manage, and to say that it was not a project likely to be sustained by anyone. I hope to show that the original effort of the painting of modern life was in many ways the painting of the family and that it involved the painting of desire, propriety, repression, and transgression within the family. It is in Manet's work that sexuality, figure painting, and society are brought together, and it is in his work that they will ultimately fall apart.[6]

Anne M. Wagner has argued that for Claude Monet, figure painting was "overdetermined from the start, since it involved a difficult positioning of himself as subject in relation to the fiction of reality represented with such studied urgency in the pictures."[7] Wagner suggests that complexities in the fabric of familial life play an integral role in steering Monet—and Impressionist painting—away from the figure by the close of the 1860s. Her prime example is Monet's *Le Déjeuner* of 1868 (fig. 94), a painting which is more indebted to the examples of Courbet and (even more strongly) Manet than any in Monet's art, and is the last large-scale figure painting of its sort that Monet would attempt. The dilemma Wagner poses as Monet's problem—the dilemma of how to depict modern life if doing so involves competing fictions, conflicting structures of subjectivity, contradictory appearances and realities—can also be seen to complicate Manet's art, which has always been noted for its familiar and familial cast of characters. One of Manet's most frequent models—and the first subject to pose in the costume and manner of an Old Master painting—was his wife's son (in fact his half-brother), Léon Koëlla. Manet's brothers posed in Spanish costume and as ragpicker-philosophers. A suite of paintings featuring the Impressionist painter Berthe Morisot (who married Manet's brother Eugène) became a kind of flirtatious dialogue between the two artists. Victorine Meurent, the nude model in *Le Déjeuner sur l'herbe* and *Olympia*, was a regular in Manet's art and played roles ranging from bullfighter (in male costume) to street singer. Manet's Paris is not just a site for "the modern" and the fashionable; it is a place where even the street people look familiar, and were meant to. Manet's art continues to engage members of this real and imaginary family because it is through the family that Manet positions himself and explores the illusory nature of social relations.

Auguste Manet, the painter's father, came from a distinguished family of *gens de robe* who held important positions in the world of the bar and in government administration. Born 30 August 1796, he came of age during the establishment of the Napoleonic code and a new government bureaucracy.[8] His grandfather and great-grandfather held noble titles and offices.[9] His father Clément, like his grandfather Clément Jean-Baptiste, had been mayor of Gennevilliers,[10] where the Manet family had owned 150 acres of prime residential property since the beginning of the eighteenth century.[11] Auguste Manet was quite typical of the judges and magistrates of nineteenth-century France, most of whom came from—and married into—families of lawyers and judges who protected the reputation both of the family and of the profession.[12] For example, Auguste's sister Emilie married Denis François Claude de Jouy, a member of the Gennevilliers municipal council and mayor of Gennevilliers, thus creating an important alliance of

two Parisian magistrate families who were major landholders in the nearby canton.[13] Auguste moved in a social élite which assured him of certain rewards, such as early attainment of the Legion of Honor and a judgeship.

The education and early professional years of Auguste Manet went like clockwork. After he received his diploma in 1821, he moved on to a clerkship and then to a master clerkship.[14] On 25 February 1828, he was temporarily placed in charge of the personnel division of the Ministère de la Justice. A few months later he was named a supervisor, and a year later, he became head of personnel for the entire ministry (then called "Justice et Cultes"). His duty as head of personnel was to assemble the *dossiers* of all prospective judges for the Département de la Seine.[15] He was named a Chevalier of the Legion of Honor on 25 January 1832.[16] After five years in the justice ministry, his salary increased from an already comfortable five thousand to twelve thousand francs annually. This initial period of rapid promotion in the Ministère de la Justice no doubt played a key role in facilitating the start of a family. He married Eugénie-Désirée Fournier on 18 January 1831, and their firstborn son Édouard was born a year later, just two days before his Legion of Honor award. Men of his profession were known to marry advantageously, and many married daughters of judges and district attorneys.[17] The marriage to a daughter of the vice-consul of France in Sweden would have been held in good esteem in the eyes of the magistrature and the Legion of Honor.

In January 1841, his own *dossier* went through the system he had formerly overseen, and with the signature of Louis-Philippe he was named a judge at the Tribunal de la Première Instance.[18] After spending part of his first year in criminal law, he transferred to the civil law chambers, where he remained until his illness and retirement.[19] The civil judges normally sat three to a session and heard cases that included contested wills, paternity suits, legal separations, negligence charges, and copyright violations.[20] The Tribunal de la Première Instance, in addition to being the entry-level court in civil and criminal matters, served as an appeals court for the justices of the peace and had correctional-service authority in cases that required police surveillance or restraining orders.[21] Auguste Manet listed his income independent of his salary as twenty thousand francs; the last salary recorded for him as head of personnel was twelve thousand francs.[22] A study of judges and magistrates in nineteenth-century France looked at a range of independent fortunes they held, and ranked incomes of more than ten thousand francs a year in 1850 as constituting the highest income bracket for the profession, called "fortune très considérable."[23]

Manet's mother came from a no less illustrious family, if one with more drama in its history. Named after the queen of Sweden, Eugénie-Désirée Fournier was born 12 February 1811 in Gothenburg, Sweden.[24] Her godfather was Charles Bernadotte, the French Napoleonic maréchal who had become the crown prince of Sweden the previous year, thanks in part to her father's efforts on his behalf. Bernadotte ascended the throne in 1818 and founded a new ruling house in his adopted country, whose language he never learned to speak.

Eugénie-Désirée Fournier was the daughter of Jean-Antoine Fournier (1761–1824) and Adélaïde de la Noue (1779–1851), the youngest of four children and the only goddaughter of the ascendant royal

couple. Jean-Antoine epitomizes the myth of the self-made entrepreneur sometimes associated with the Napoleonic epoch. His father had held the noble title of *conseiller du roi* (there were hundreds of such venal offices) and was the keeper of the Domains and Forests in Grenoble. In 1786, the twenty-five-year-old Fournier started an import/export business in Sweden, where his three younger children were born. He became an *émigré* when he found his trade in a stranglehold during the Revolution. His father Jean-Louis was massacred at Claix, near Grenoble, on 6 June 1790. He struggled financially, and wrote to the minister in the Département des Relations Extérieures about his commercial successes, which had furthered the two countries' alliance. He became vice-consul of France in Sweden.[25] His real claim to fame, however, came when he presented himself to his countryman, the Basque phenomenon Bernadotte, after the death of the Swedish crown prince in May 1810. Fournier, with his knowledge of French-Swedish relations, became a kind of campaign manager for Bernadotte. Despite the fact that he had gone bankrupt, despite his fake passport and total lack of any government mandate, he had the right personal qualities for the job. Fournier addressed the Swedish foreign ministers; he published articles as well as a biography of the French maréchal; he organized rallies to play up Bernadotte's war experience and his Protestant sympathies. He got the job done. With Napoleonic fever sweeping Europe, Bernadotte became the adopted crown prince of Sweden in 1810. Jean-Antoine Fournier died in Brétigny, 24 October 1824, when Eugénie was just thirteen.

Manet's mother, then, grew up in a household that brushed up against poverty as well as royalty. Her family history was imprinted with the kinds of reversals of fortune that determine the plots of so many Balzac novels. One brother of Eugénie was killed in a duel; another, Edmond Fournier, a decade older than Eugénie (1800–1865), became an artillery officer and *aide-de-camp* for the duc de Montpensier. He also lived with the Manets on the rue des Petits-Augustins, and biographies of Manet do not fail to mention his encouragement of the artistic leanings in the young Édouard: he took the boy to the Louvre and even paid for drawing lessons at the Collège Rollin, where Édouard was a pupil. Eugénie, too, had her artistic side and was an accomplished singer who performed in many salons of her day, notably that of the comtesse de Sparre, whose husband, a general, was of French and Swedish descent.[26] Upon the marriage of Eugénie and Auguste Manet (fifteen years her senior) on 18 January 1831, the young couple received gifts from the royal Swedish house: six thousand francs and an ornamental clock, which figures in some of Manet's paintings.[27] Mme Auguste Manet received women friends on Tuesdays and her sons' friends at the famous Thursday *soirées*.[28]

Out of loyalty to the house of Orléans, Edmond Fournier offered his demission after the Revolution of 1848. His political position brought on a quarrel with Auguste Manet, no doubt already irritated by Fournier's influence on his eldest son.[29] Fournier moved out of the rue des Petits-Augustins and retired at Pontcelles, north of Paris near the Forêt de Montmorency. Their differences were to be irreconcilable. When Fournier's only son was killed in the siege of Sébastopol in 1855, Édouard more or less crossed enemy lines to offer his condolences, as a kind letter of thanks from Fournier makes clear.[30]

Édouard Manet's voyage to Rio de Janeiro, from December 1848 to June 1849, represented a last-ditch effort by Auguste Manet to secure a naval career for a son who was clearly not studious enough to

pursue law. Édouard had already failed his naval entrance exam once in 1847, and he was rapidly approaching the age limit of eighteen with no nautical experience behind him. When the Navy announced that a voyage south of the equator could also serve as a qualification, Édouard registered for a voyage on the *Le Havre et Guadeloupe*. By the time of Édouard's return to Paris—and a second failed examination—he was determined to study painting, and he would even reject Auguste's influence with Charles Blanc, Ministre des Beaux-Arts under the Second Republic, to gain entrance to the École des Beaux-Arts. He instead enrolled in the studio of Thomas Couture, a respected teacher with something of a radical appeal after the success of his *Romans of the Decadence* of 1847. Édouard's cousin Jules de Jouy, meanwhile, was emerging brilliantly as the keeper of the family torch, especially after his appointment as a lawyer to the imperial court in 1849.

The year 1851 was fraught with difficulty for Auguste Manet. Édouard's choice of careers was looking more permanent, much to the chagrin of Auguste. Eugénie lost her mother, an event which without doubt preoccupied her and may even have taken her away from her husband and sons for a time.[31] On 29 January 1852, Suzanne Leenhoff, the music teacher of Édouard and Eugène, gave birth to an illegitimate boy whose paternity remains unknown but is likely to have been Auguste's.[32] Although Suzanne was over the age of consent when Léon was conceived, Auguste would have found himself in a precarious position, legally as well as socially. The birth of the child put many things at stake: his reputation, the name of the Manet family in the Paris bar, his Legion of Honor award, his salary, his retirement. The Code Pénal prescribed a lifetime sentence of forced labor for persons guilty of rape if they had been in positions of authority, such as teachers, ministers, and public functionaries.[33] Judges whose illicit behaviors came to light most often resigned or took early retirement before submitting themselves to proceedings, which would invariably embarrass their colleagues and family members as well as dishonor the profession itself. A range of sanctions could be levied against magistrates guilty of vice or wrongdoing; everything from warnings to suspension and displacement was available to the authorities, and they preserved a certain flexibility in exercising these options depending on the crime and on the person's position.[34] With these matters hanging over him, it is not so surprising that later in 1852, Auguste was in poor health.[35]

The summer after Léon's birth, Édouard undertook a voyage to the Netherlands. An art student and an admirer of Dutch art, Manet was a registered visitor to the Rijksmuseum in Amsterdam.[36] Considering the timing of the trip, however, it seems likely that the more urgent business would have been a visit to Suzanne's family to offer news and reassurances about her welfare. He and Eugène would travel again in 1853, when they visited Venice and Florence.

For Auguste Manet, things were less than ideal in the world of the Paris bar, and they would stay that way for the next several years. The judge had apparently been promised a promotion to the Paris court of appeals, a step up which never came.[37] In a letter surviving from 1856, Auguste Manet is vehement about his disappointment. Another stressful event of 1856 was that one of the Manet sons—it is not known for certain which—was apparently ill in Algeria, and Manet *père* applied for a leave of absence to visit him.[38] All of the Manet sons were of age to have been in military service, but the son in

question seems most likely to have been Gustave.[39] We have documentation of a couple of disputes that may have been related to Auguste Manet's professional rivalries and unfulfilled ambitions.[40]

According to the Tribunal Parquet, or public prosecutor's office, Auguste Manet ceased to report to his chambers as of 18 December 1857, having been stricken with a paralysis.[41] A letter signed by the imperial prosecutor Cordoën attests that the elder Manet regained his strength after several months and was able to walk long enough distances every day without undue fatigue. The former judge, however, never recovered command of his intellectual faculties to the knowledge of those around him. Cordoën specified that only with great effort could Auguste Manet utter a scarcely intelligible word. Cordoën's letter requested Manet's replacement after a thirteen-month absence with no hope in sight for recovery. The Manet *dossier* includes such poignant testimony of his condition as a letter in Mme Manet's hand, asking for a temporary extension of leave, to which he could only affix a trembling signature.[42] Her letter of January 1859, asking on her own behalf for his demission, movingly describes his weak state.[43] His official retirement began as of 26 February, 1859, and his pension of 3,587 francs was approved on 11 April 1860.[44]

A family friend from the Parisian bar, Charles Limet, describes the judge as paralyzed a few months after the wedding of Émile Ollivier and Blandine Liszt, daughter of the composer and Marie D'Agoult (who wrote under the pseudonym Daniel Stern). Édouard Manet had been among the witnesses to the Ollivier-Liszt ceremony, held in Florence on 22 October 1857.[45] The couple returned to Paris after Christmas of that year, and sometime soon thereafter, a celebratory dinner was held at the Manet house: "I should say chez Mme Manet," writes Limet, "since the honorable judge, her husband, was already afflicted with the beginning of the paralysis that kept him from participating in the celebrations."[46]

During his paralysis, Auguste Manet was under the care of the renowned surgeon Jacques Gilles Thomas Maisonneuve,[47] of the Hôpital de la Pitié. His notarized letter requesting a medical leave of absence certifies that Manet "was stricken with a cerebral congestion [stroke] from which he is currently convalescent."[48] In this case, "cerebral congestion" is likely a euphemism for what we would now call tertiary syphilis.[49] Dr. Maisonneuve was a recognized authority on venereal diseases: in 1853 he had published a handbook on such illnesses.[50] The treatment of the time was limited to an ineffective therapeutic regimen of mercury or potassium iodide.[51] Maisonneuve's own work devoted attention to fibroplastic muscle degeneration, which he distinguished from muscular atrophy caused by myositis or cancer. Syphilis could affect the entire body, slowing the reflexes and hardening muscle tissue; it could also attack certain limbs, arresting movement.[52] It is noted in modern medical literature that remissions like the elder Manet's may occur, but death follows.[53] His obituary, published in the *Gazette des Tribunaux* of 28 September 1862, attributes his illness to overwork and his demission to his loss of verbal abilities.[54] He was buried at the Montmartre cemetery in the Manet family crypt.

Manet executed his *Portrait of the Artist's Parents* in 1859–60 (fig. 12), and it was greeted with a certain amount of favorable criticism at the Salon of 1861.[55] According to Adolphe Tabarant, the sitters were pleased with the likenesses.[56] With the information we now have about Auguste Manet's condition, however, we are better able to understand the artist's pictorial strategies. If Manet *père* were unable to

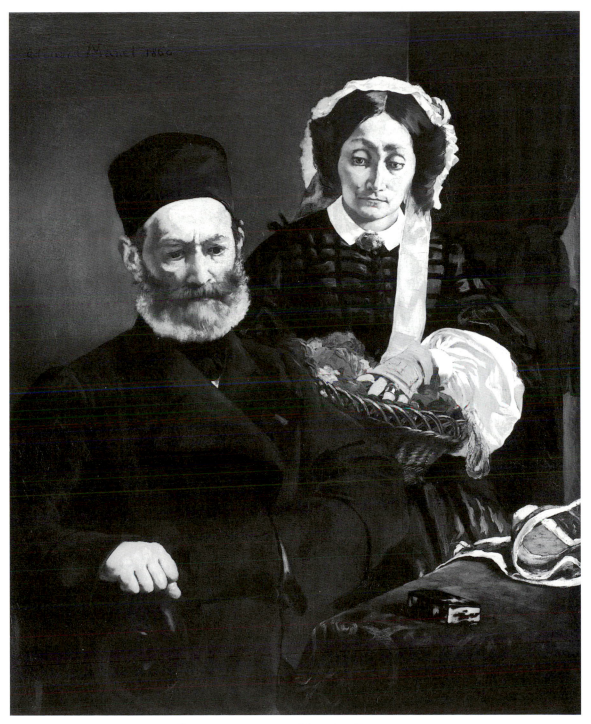

Fig. 12. Édouard Manet, *Portrait of the Artist's Parents*, c. 1859–60.
Oil on canvas, 44 x 35 3/4 in. (111.5 x 91 cm). Musée d'Orsay, Paris

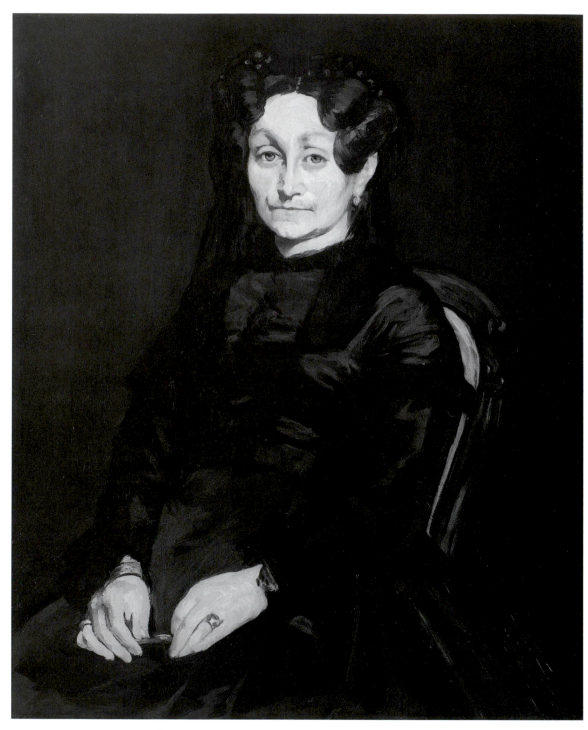

Fig. 13. Édouard Manet, *Portrait of the Artist's Mother*, c. 1863. Oil on canvas, 38 9/16 x 31 1/2 in. (98 x 80 cm). Isabella Stewart Gardner Museum, Boston

speak and engage with those around him, this presented the painter with various problems. Auguste Manet's condition necessitated a degree of modesty and even reticence of pose and expression. A comparison with the portrait of Manet's mother in mourning after her husband's death (fig. 13) might be in order, taking into account the post-1862 date of the latter.[57] Had Manet painted only his mother looking out of the picture, such a forceful, penetrating gaze, such involvement with the spectator, would have made Manet's father appear troubled and withdrawn. By having both of his sitters look down, Manet was able to memorialize his father as if the judge were pausing, gathering his thoughts to speak.

Comparisons with the preparatory drawing (fig. 14), an X-radiograph of the painting (fig. 15), and an etching of his father probably done after the painting (fig. 16), reveal Manet's solutions to several pictorial problems. Manet's red-chalk drawing of his father remains wholly unresolved. The left half of Manet *père*'s face, in shadow, has not been realized. The right eye almost detaches itself from the face and floats out of the picture, leaving the uncertain jawline and beard Manet was still working out in the earlier state of the painting. The finished painting uses strong illumination to define the face: it highlights the wrinkled brow and creates an effect of thought and concern. More diffused light effects, such as those in the drawing, would have run the risk of making him appear mentally vague. The approximate jawline of the drawing reappears in the painting as a darker brown-gray portion of the beard, with the full fringe of white beard fanning out past the jawline. The underpainting (visible in the X-radiograph) and drawing suggest Manet first depicted his father wearing mutton-chop style side-whiskers; in the finished painting, he has a full-face beard. The fuller beard may well be a product of the physical limitations he faced due to his attack of paralysis. In Manet's composition, the volume and silhouette of the beard complement the heightened line of his judicial hat. In Manet's etching, apparently based on yet another sanguine drawing,[58] the father's glance out of the picture fails to engage the viewer. The eyes' somewhat bizarre asymmetry in the etching makes the father's downward glance in the painting appear all the more authoritative in its reserve.

Although the different images of Manet's father present striking variations, Eugénie Manet's letter to the justice minister provides still another description. She wrote that the minister might have been moved to tears if he had seen her husband's unhappiness, if he had seen "the expression of sadness which is painted on his face."[59] The artist gives us a tense, reserved look, which can be described as reflective seriousness. The father's downward glance enables us to imagine what an outward glance could never have shown us.

The Gardner Museum portrait Manet did of his mother after her husband's death is one of the most striking and penetrating images in Manet's oeuvre. Eugénie, wearing her hair in the *bandeaux* fashionable at the time of her marriage in the early 1830s, looks out of the painting, commanding the spectator's attention. Her black dress and the veil behind her head, as well as gold or costume jewelry, suggest the etiquette of mourning attire in the latter part of the first year after the husband's death. During the four-and-a-half-month period of high mourning, no jewelry except a belt buckle was to be worn. This was then superseded by six months of black silk dresses and leather gloves with some jewelry.[60]

Fig. 14. Édouard Manet, *Portrait of the Artist's Parents*, c. 1859–60. Red chalk, 12 1/4 x 9 3/4 in. (31 x 25 cm). Cabinet des Dessins, Musée du Louvre-Orsay, Paris

Fig. 15. Édouard Manet, X-radiograph, detail of Fig. 12

Fig. 16. Édouard Manet, *Portrait of the Artist's Father*, 1860. Etching, 7 3/8 x 6 1/8 in. (18.7 x 15.6 cm)

Fig. 17. Édouard Manet, *Les Hirondelles*, 1873. Oil on canvas, 25 9/16 x 31 7/8 in. (65 x 81 cm). Bührle Collection, Zurich

Fig. 18. Édouard Manet, *In the Bellevue Garden*, 1880. Oil on canvas, 32 5/16 x 25 9/16 in. (82 x 65 cm). Private collection, Paris

Manet's mother was viewed by the younger generation with reverence and some awe. Anne Higonnet's biography of Berthe Morisot documents the trepidation with which the distinguished and intelligent artist approached the woman who became her mother-in-law.[61] Of the relationship between Édouard Manet and his mother, Léon Leenhoff wrote: "Édouard Manet eut toujours pour sa mère non pas une affection filiale ordinaire, mais une véritable culte."[62] According to Léon Leenhoff, Mme Manet rarely accepted invitations after her husband's death, as was typical for widows at the time.[63] She enjoyed playing cards and stayed in the company of her daughter-in-law, Suzanne Leenhoff. After the death of Auguste, Eugénie received a third of the pension to which he was entitled, or 1,195 francs.[64]

Another branch of the Fournier family settled in La Sarthe. It is often mentioned in the art-historical literature that in 1865, Manet visited some of the Fourniers at the Château de Vassé, near Sillé-le-Guillaume.[65] On 30 September 1796, Eugénie's uncle, Jean-Louis-Laurent-Casimir Fournier, Paris banker, rue de Clichy, purchased at auction the pillaged château, its chapel, grounds, and several windmills.[66] Laws pertaining to *émigré* property that became "national assets or property" allowed its sale at three-quarters of its estimated value, which is what he paid, approximately 44,450 francs. The Château de Rouessé-Vassé still stands and merits a mention in a modern tourist guide for its fourteenth-century towers and Louis XIII enclosed courtyard.[67] It is an irony typical of the post-Revolutionary period that while the part of the Fournier family that held onto the titles and positions of the *ancien régime* fled the country or paid with their lives, the banker cashed in on *émigré* vacancies. Jean-Louis's son Adolphe (1794–1875), Eugénie's cousin, also born in Gothenburg, Sweden, had a distinguished military career and lived in the château all his life.[68]

The description from the sale records of the buildings, chapel, and windmills on a vast prairie makes a temptingly close match with *Les Hirondelles* (fig. 17), one of the pictures Manet sent to the Salon of 1874. In the painting, Mme Manet *mère*, dressed in widow's black, leans decorously on an elbow while reading a book on the grass; Suzanne Manet, at right, observes the swallows' flight; cows wander in the far distance. The grouping of figures roughly recalls the composition of *Le Déjeuner sur l'herbe*, although one would have to say that in *Les Hirondelles*, the composition is more placid and the subjects are not at odds with one another. The ladies' veiled hats are but one feature that marks the painting's decorum, as opposed to *Le Déjeuner*'s brazenness. Such placidity, however, perhaps characterizes another version of the family romance. Manet also depicted his mother in a highly sketchlike picture of 1880, in which she appears in profile *In the Bellevue Garden* (fig. 18). In July 1883, less than three months after Édouard Manet's death, Eugénie suffered a stroke which paralyzed her and from which she never recovered. According to Higonnet, Eugène and Gustave stayed with her.[69] Yet Gustave's health was poor, also. She died in January 1884, without learning of the death of her youngest son a month earlier.

Manet's brother Eugène was born on 21 November 1833, just 22 months after Édouard. Eugène became a devoted supporter of Berthe Morisot, whom he married in 1874. He and Édouard appear to have been close in their younger days. They traveled to Italy together when the art student was making

his first copies of Old Master paintings. Léon Leenhoff recalled that Eugène had spent a lot of time with him and his mother Suzanne before her marriage to Édouard. In fact, when the couple took their wedding trip to the Netherlands in 1863, it was Eugène and Suzanne's brother Ferdinand (pictured in *Le Déjeuner sur l'herbe* of 1862–63) who took the eleven-year-old Léon to a boarding institution for boys, Marc Dastès, in the Batignolles.[70]

Eugène never had much of a career, but according to Anne Higonnet, his unfailing support of Morisot's art was crucial for her success. He did write a novel, *Victims!*, published in 1889, which is semi-autobiographical.[71] The political convictions of the hero somewhat resemble the republicanism of the Manet brothers, and Higonnet draws a parallel between the heroine's independence and artistry, and that of Berthe Morisot.

Eugène appears in several early Manet paintings but later becomes a less frequent model. The earliest Manet scholars give conflicting accounts as to which brother posed for *Le Déjeuner sur l'herbe*: Tabarant claimed it was Gustave; Moreau-Nélaton claimed Eugène; Proust's memoirs suggested that the brothers posed in turn.[72] Proust may be correct: the man at right has Gustave's dark hair, but Eugène's finer features. Eugène appears in *La Musique aux Tuileries* of 1862 (fig. 19).[73] There, he bows politely. He dons the disguise of one of the series of *chiffonniers* (ragpickers) called the *Philosophers* of 1865 (fig. 20).[74]

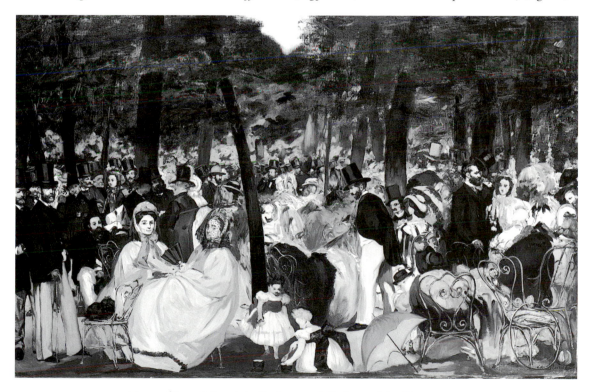

Fig. 19. Édouard Manet, *La Musique aux Tuileries*, c. 1862. Oil on canvas,
30 x 46 1/2 in. (76 x 118 cm). National Gallery of Art, London

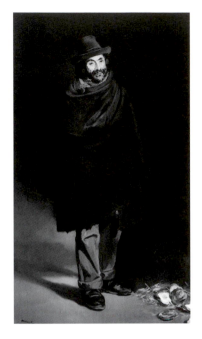

Fig. 20. Édouard Manet,
Philosopher, 1865–67.
Oil on canvas, 73 3/4 x
42 1/2 in. (187.3 x 108 cm).
The Art Institute of Chicago.
Arthur Jerome Eddy Memorial
Collection (1931.504)

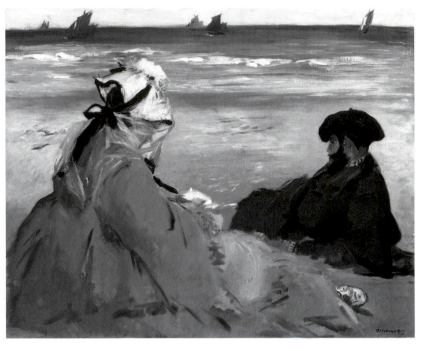

Fig. 21. Édouard Manet, *On the Beach*, 1873. Oil on canvas,
23 1/2 x 28 7/8 in. (59.6 x 73.2 cm). Musée d'Orsay, Paris

Recapitulating the *Déjeuner* pose, he wears a béret and leans on one arm, opposite Suzanne, in *On the Beach* of 1873 (fig. 21). Eugène Manet died on 13 April 1892.

Born 16 March 1835, Gustave is the only Manet son to have followed somewhat in his father's footsteps. He became a lawyer but devoted himself more to politics than to legal practice. During the Commune, he joined a league of republican Parisians who tried, according to Philip Nord, to bring about a peaceful solution through negotiation.[75] In the 1870s, he ran for office in his *arrondissement* and was twice elected to the Montmartre municipal council. He introduced Édouard Manet to Clemenceau, and was friends with Gambetta's ally Eugène Spuller. Gustave posed for the *Young Man in the Costume of a Majo* (fig. 22), which was exhibited alongside *Le Déjeuner sur l'herbe* and *Mlle V. . . in the Costume of an Espada* (fig. 23) at the Salon des Refusés of 1863.

The matter of Suzanne Leenhoff's relation to the Manet family is complex and goes to the heart of his subjects' nature and significance. Born 30 October 1829 in Delft,[76] Suzanne was introduced into the Manet family as the music teacher of Édouard and Eugène.[77] There has been much speculation as to when her liaison with Édouard began, and as to who fathered her son Léon, passed off in society as her youngest brother. Although many art historians suspect that Édouard, who married her on 28 October 1863, was Léon's father, Mina Curtiss published an allegation that it was Auguste.[78] In chapter 4, I will

discuss circumstantial legal evidence that I believe substantiates the allegation. When the Suzanne Leenhoff situation presented the Manets with a dilemma, however, the reputation that needed to be protected would certainly have been that of the civil judge, not the art-student son.[79]

When Édouard announced his imminent marriage to Suzanne, the event came as a surprise to Manet's close friend Baudelaire.[80] Baudelaire's letter is worth quoting in French: "Manet vient de m'anoncer la nouvelle la plus inattendue. Il part ce soir pour la Hollande, d'où il ramenera sa femme. Il a cependent quelques excuses; car il paraîtrait que *sa femme* est belle, très bonne, et très grande artiste. Tant de trésors en une seule personne femelle, n'est-ce pas monstrueux?"[81] ("Manet just gave me the most unexpected news. He is leaving tonight for Holland and will be bringing back his wife. He nevertheless made certain excuses; it would appear that his wife is beautiful, very kind, and very artistic. So many treasures in one female person—isn't it monstrous?") The picture we get is one in which Manet was somewhat feebly offering various excuses for the marriage or trying to cast it in a good light against the shock or protestations of Baudelaire. In fact, the only evidence we have that Édouard Manet and Suzanne were living together around 1860 (which, it should be noted, is well after Léon's birth in 1852 and after the paralysis of Manet's father in late 1857) is a copy of a document by Léon Leenhoff.[82] Whether or not Manet and Suzanne were living together in secret a few years prior to their marriage does not, in fact, reveal anything about Léon's parentage. Furthermore, many young male painters had longstanding relationships and *enfants naturels*—children born before a marriage but legitimized after it. A letter from Monet to Bazille in 1868 refers to "the one who will be Mme Camille Pissarro," despite the fact that Pissarro and Julie Vellay did not marry until 1871.[83] Although many art historians have assumed that certain issues of propriety were sticking points for Manet, it should be noted that Manet's relationship with Suzanne was not commonly acknowledged in their circle, and thus was perhaps not as well established as has often been presumed.

Before the marriage, Suzanne lived with her younger brothers, the sculptor Ferdinand and the painter Rudolph, and their grandmother, who came from Holland, so it appears, to help her struggling granddaughter care for the new infant.[84] According to Léon, Suzanne's sister Mathilde and her husband, the sculptor Joseph Mezzara, lived nearby. This text has consistently been read to suggest that Édouard and Suzanne were living together before their marriage, but it is far from unambiguous:

> I remember having been at his studio on the rue de Douai for New Year's Day. It was from there that I reported to the little office on the rue Rollet, today rue St.-Louis. I was living with Grandmother and Ferdinand, then Rudolph. The Mezzaras lived on the rue St.-Georges. After the death of Grandmother, the three of us lived on the rue de l'Hôtel-de-Ville in the upper apartment with a balcony.[85]

Since Léon mentions living with two uncles in succession as well as his great-grandmother (and, implicitly, his mother), it could well be that "the three of us" referred to one uncle who remained with Suzanne and Léon when they moved to the rue de l'Hôtel-de-Ville after the grandmother's death. Léon mentions that both Eugène and Édouard were frequent visitors to the Leenhoff household before the marriage.[86] It is also significant that not one of Manet's friends who left memoirs or letters seemed to

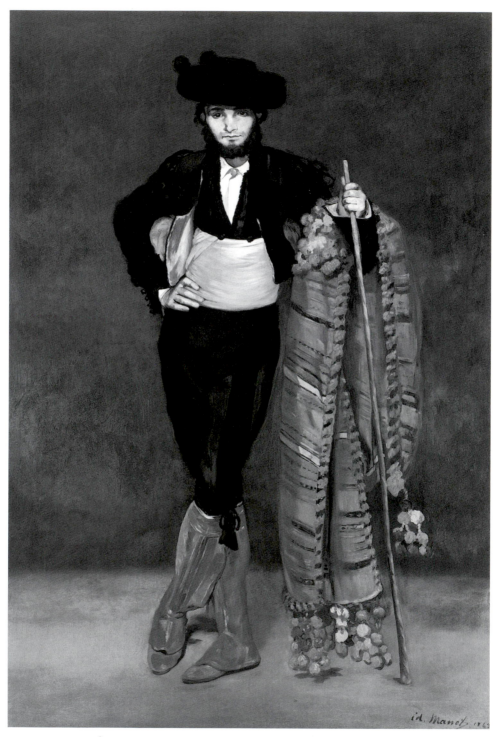

Fig. 22. Édouard Manet, *Young Man in the Costume of a Majo*, 1862. Oil on canvas,
74 x 49 1/8 in. (188 x 124.8 cm). The Metropolitan Museum of Art, New York.
H. O. Havemeyer Collection, Bequest of Mrs. H. O. Havemeyer, 1929 (29.100.54)

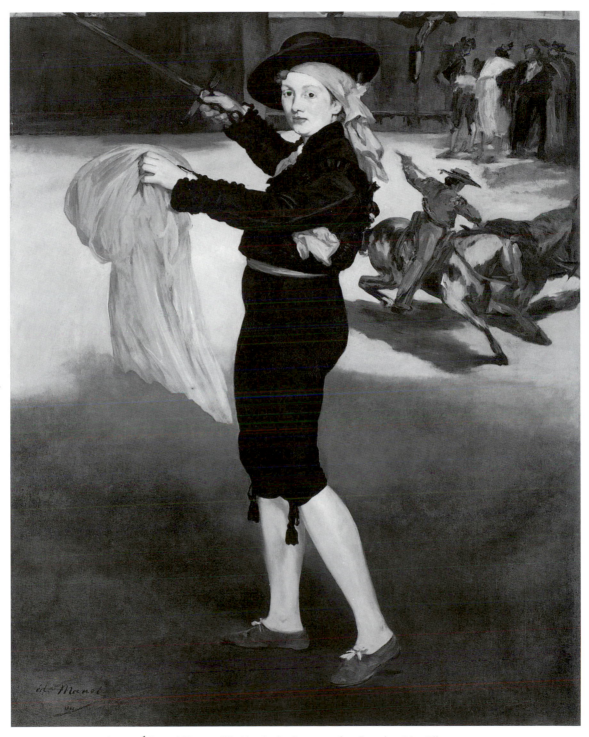

Fig. 23. Édouard Manet, *Mlle V... in the Costume of an Espada*, 1862. Oil on canvas,
65 x 50 1/4 in. (165.1 x 127.6 cm). The Metropolitan Museum of Art, New York.
H. O. Havemeyer Collection, Bequest of Mrs. H. O. Havemeyer, 1929 (29.100.53)

know about the alleged secret liaison between Édouard and Suzanne. If the painter were in fact trying to be discreet about his relationship with her, one wonders how it was that not one friend was told, and that decades after their marriage and Manet's death, no one described the marriage as the regularization of a secret union to which some were privy.

According to the Manet-Leenhoff marriage contract, Eugénie gave the young couple a wedding gift of ten thousand francs. She reserved the right to reclaim it if her son were to precede her in death and leave no heirs. A letter from Manet's youngest brother Gustave to their cousin, the lawyer Jules de Jouy, quotes Manet's mother on the subject of the unfortunate birth of Léon and what appears to have been a dispute over issues of inheritance: "There are certain things I will not reconsider, such as the crime commited out of the affection she has for this good boy, who is only the victim of his sad birth. She wanted more than she should have, that's the punishment for her crime: she must suffer it!"[87] Mme Manet *mère* here suggests that she held Léon blameless in the affair (although of course the civil code

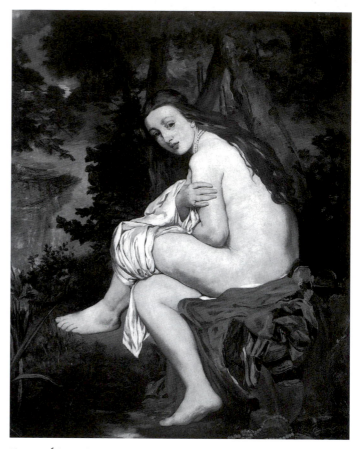

Fig. 24. Édouard Manet, *La Nymphe surprise*, 1859–61. Oil on canvas, 57 1/2 x 45 in. (146 x 114 cm). Museo Nacional de Bellas Artes, Buenos Aires

did not), but would not shy away from exerting legal and financial pressure to protect her own family from opportunism of any kind. One wonders whether Mme Manet *mère* would have referred to the birth of her first grandchild—even an illegitimate one—as "triste," and whether she would have reacted so negatively to the matter of Suzanne's portion of the inheritance, had Suzanne been the mother of Édouard's child. Nevertheless, after Suzanne's marriage to Édouard in 1863, the young Dutchwoman would be treated as a member of the Manet family.[88] Suzanne and Édouard had no children, although the artist, in a letter to his friend Astruc in 1865, congratulates the latter on his expected heir and adds: "we wish we had the same luck."[89]

There are certain echoes of the Manet family story in Eugène Manet's political novel, *Victimes!* The character of Jeanne, a freemason's daughter who plays the piano brilliantly, falls into the care of a well-to-do royalist family in Clamecy when she is twenty years old, approximately the age when Suzanne came to be the Manet family music teacher. She becomes the object of the affection of a priest,

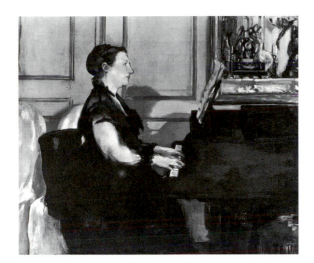

Fig. 25. Édouard Manet, *Mme Manet at the Piano*, 1867–68. Oil on canvas, 15 x 18 in. (38 x 46 cm). Musée d'Orsay, Paris

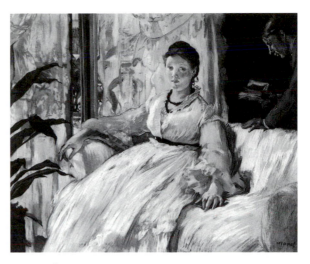

Fig. 26. Édouard Manet, *La Lecture*, c. 1865–73? Oil on canvas, 24 x 29 1/2 in. (61 x 74 cm). Musée d'Orsay, Paris

the Abbé de Chavigny, who is himself the product of a tragic adulterous union ("a young woman of the best society who threw herself into the arms of a married man, himself the father of three children").[90] Chavigny was forced to become a priest when no one could care for him after the death of his mother in childbirth. The other character is that of Eugène Mallot, "fils préféré de sa mère," whose republican ideals bring him into conflict with the royalist godparents of Jeanne.

There are, then, quite a few facts and circumstances pointing toward the complications of the Manet story. Equally striking, however, is the shift in portrayals of Suzanne Leenhoff dating from before and after the marriage. In early paintings such as *La Nymphe surprise* (fig. 24), she appears as an object of desire.[91] In paintings such as the portrait of Suzanne at the piano (fig. 25), or in *La Lecture* (fig. 26)—not to mention the portraits in the 1870s—she is modestly and decorously dressed and posed. In the post-marriage pictures, she appears in a bourgeois domestic space, whereas in *La Nymphe*, she appears unclothed in a landscape that is a fantasy reworking of an Old Master painting.[92] *La Lecture*, a portrait of Suzanne and Léon, which Manet appears to have reworked over a period of several years (probably 1866–72), offers one of the most subtle and sensitive portrayals of Suzanne as Mme Manet. Careful attention is paid to her soft eyes and full lips; light coming in through lattice curtains models her face in the manner of Vermeer. By contrast, a portrait of her at the piano, apparently executed after Manet literally cut Suzanne's image from a similar painting by Degas, is less flattering.[93] Appearing in profile, her nose appears long, her face extremely full, her arms and hands chubby. This manner of portrayal is more consistent with the way Suzanne is described by the mother of the slender Berthe Morisot, who once went so far as to write that Manet was "at home making a portrait of his wife and laboring to make of that monster something slender and interesting!"[94]

The person by the name of Léon Koëlla-Leenhoff is, of course, central to the story. Born 29

January 1852, Léon grew up calling Suzanne his mother ("Moedge," or "little mother") *en famille*, but was asked to claim he was her youngest brother when they were in society.[95] According to a letter he wrote to Tabarant, he never knew who his father was, and he claimed that it never bothered him. He always referred to Édouard Manet as "parrain" (godfather), and did not even know the name "Koëlla" appeared on his birth certificate as the name of his father until he volunteered for military service at age twenty.[96] The name may have been a French transcription of the Dutch "Koele," the equivalent of the English "Cole." One could assume, then, that it was a name supplied by the Leenhoffs and probably invented as part of the concealment of Léon's paternity.

Léon began to use the name Koëlla as an adult. Even at Suzanne's funeral, 11 March 1906, engraved cards referred to him as her youngest brother.[97] He eventually married and established a business selling rabbits, fowl, and fishing-gear.[98]

By now it should be apparent that representations of Manet's immediate family have a certain prominence in his art; at the same time, it makes sense to look at a great deal of Manet's early subject matter in relation to his family and their social world. A key characteristic of that subject matter is Manet's interest in gypsies, ragpickers, street singers, and beggar boys. It is noteworthy that the artist does not paint just any street types, but by contrast, paints recognizable individuals over and over again. *The Old Musician* not only includes a recognized gypsy violinist, Jean Lagrène, but also Manet's own *Absinthe Drinker*, the boy who posed in *Boy with Dog* (fig. 27), and the very young girl with a baby, who also appears in an etching after the painting (fig. 28).[99] At least one of the ragpicker-philosophers from the large 1865 series had appeared in the crowd in *La Musique aux Tuileries*.[100] Victorine Meurent, his model in many of the key early paintings, is the recognizable *Street Singer* (fig. 6). It remained a family tradition that Eugène Manet posed for one of the *Philosopher* series, the one who appears most upright and aloof.[101] The themes of the *majo* and *maja* should be considered a related trend of significant cross-class dressing, as the Spanish upper-class affectation for gypsy-style dress became fashionable in Manet's Paris.[102] Manet paired Victorine and his other brother Gustave as the *Espada* and *Majo* who flanked *Le Déjeuner sur l'herbe* in the 1863 Salon des Refusés. And Ewa Lajer-Burcharth has convincingly argued that we could look at Manet's *Absinthe Drinker*, rejected from the Salon of 1859, as a kind of self-portrait of the artist at the margins of

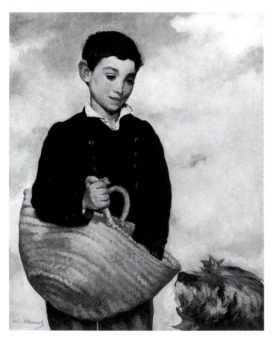

Fig. 27. Édouard Manet, *Boy with Dog*, 1860–61. Oil on canvas, 36 1/4 x 28 1/4 in. (92 x 72 cm). Private collection, Paris

society.[103] In her view, Manet was deliberately court-
ing a certain kind of marginality by making *The
Absinthe Drinker* his first Salon submission and as it
were, a personal artistic manifesto. I would like to
look into the relationships between Manet's early
depictions of family members and his depictions of
various marginal characters, beginning with Manet's
first canvas destined for the Salon jury.

Manet's *Absinthe Drinker* depicts a man known
to have been an alcoholic named Colardet posing in
secondhand cloak and hat, half sitting and half lean-
ing near a glass of absinthe on a ledge; at his feet is
an overturned wine bottle.[104] Although the man's
slightly ragged clothing and intoxicated expression
suggest that Manet achieved a level of ruthless natu-
ralism in the image, the painting distances itself from
the possibility of being a straightforward documen-
tary of the ragpicker's milieu. The setting, for instance,
is nondescript: it does not appear to be a street cor-
ner and is not definitively indoors or out. Although
the figure has been related to the popular imagery
of the *chiffonnier*, he is far too individualized to be
seen as a mere type.[105] Lajer-Burcharth relates this
picture to other early Manet costume pieces and dis-
cusses Manet's interest in masquerade and disguise as
integral to his early work as well as to notions of modernity.

Fig. 28. Édouard Manet, *Young Girl with Baby*,
1861–62. Etching, 8 1/8 x 4 5/8 in. (20.7 x 11.8 cm).

Looking at the image, we notice the way the cloak conceals the man's body. The legs are strangely
awkward: there is a certain degree of control exhibited in the pointing of the feet, yet the legs appear
spindly and not fully functional. Manet represents the legs in such a way that we cannot resolve whether
we should read the figure as sitting or leaning on the ledge. The drinker's right knee (viewer's left)
extends forward slightly, with the heel close to the ledge. His left thigh and knee appear to be pointing a
bit to the left, yet he dangles his calf and points his toe quite far to the right. As has often been
remarked, Manet's rendering of the tapering of the feet is such that the left and right feet appear to have
been reversed.[106] Commentators have also noted the inexplicably disparate shadows and the spatial dis-
continuity of the ledge on either side of the drinker.

The expression on the face of the drinker cannot be easily ascribed either to the physiognomy of
intoxication nor to Manet's typical way of handling an absent gaze. The shadow on the face, the tilt of
the hat, and the lack of crisp detail on the face all contribute to the viewer's difficulty in reading the gaze

of the figure.[107] Lajer-Burcharth's argument that part of Manet's strategy in 1859 was to assume the disguise of the ragpicker, which "stands rather for his longing to be independent, to thrive on the condition of rejection from society," is a compelling reading of how the artist may have wanted the public to see his art as distinct from Courbet's, for instance.[108] Yet there is another frame of reference we ought to bear in mind. *The Absinthe Drinker*'s blurred gaze—the expression of someone not quite there—as well as the extreme awkwardness of his legs, suggest another reference: to Manet's father, paralyzed and unable to speak since December of 1857. If we look at the painting, as Lajer-Burcharth suggests, as the assumption of a disguise, as the taking of an avant-garde stance of marginality,[109] we should also consider the level at which both the pose of marginality and this particular configuration of it have resonances in the private domain.

I would like to imagine the father as the imaginary spectator of *The Absinthe Drinker*, and I will be pursuing this line of thought with several early Manet paintings. In a sense, how could a painting of a character like the *Drinker*—especially as a would-be Salon début—*not* have been at some level aimed at Manet's social group, at the society the Manet family received weekly? What would it mean to think of the father as the spectator of the painting?[110] Well-dressed, well-bred Édouard, having eschewed the law as a profession and having twice failed his naval exams, spends years copying the Old Masters and then paints a large-scale portrait of a street person, a character about as far removed as one could get from the Manet family circle. It is an understandable strategy. It is, as Lajer-Burcharth argues, a *pose*, a disguise, an identity I think Manet wanted to claim in 1859. It is also, I will argue, an instance of *negation* in a psychoanalytic sense of the word.

Freud defined negation as a particular type of wish formulation in which the subject associates the fulfillment of a repressed wish with another fact or condition he wishes to deny.[111] His overt signs of resistance to admitting the latter reveal to the analyst the existence of a hostile or inadmissible wish buried within the denial. Earlier in the chapter, I noted that the downcast gaze of the father in the *Portrait of the Artist's Parents*, painted about a year after *The Absinthe Drinker*, probably was chosen to circumvent the problem of the father's gaze in his aphasic state. It was in *The Absinthe Drinker* that Manet had taken on the problem of depicting the gaze of one who is not fully aware of his milieu, someone who is intoxicated, *aliéné*, other. What Lajer-Burcharth calls Manet's "longing" to "thrive on the condition of rejection from society" as an artist finds him face-to-face with precisely the one whose rejection mattered—that of the father. For there is no doubt that Manet's father's illness also severed him from society. *The Absinthe Drinker* not only at some level represents Manet assuming the disguise of the *chiffonnier*; it also represents Manet assuming aspects of his father's condition even as he lays claim to his own territory as an artist.

A case can be made that not only does Manet picture members of his own family as gypsies or street types, but the so-called gypsy or street types recur in his work like a loose-knit but discernible family. Manet himself and his family are imagined as marginal figures, even while "real" marginal figures from art school and the neighborhood are included. Sándor Ferenczi postulated that some subjects—especially those from illustrious and well-known families—were prone to invent a family mythology of lower social origins:

A whole series of observations on young children has shown me that many children feel much more at home with the peasant class, with the house-servants and people of lowly origin, than in their own more cultivated milieu. Frequently this takes the form of a longing to lead a nomad gypsy life, or indeed to be turned into some creature or other. An untrammeled love-life (incestuous, of course, in addition) has an irresistible appeal for these children; to attain this freedom they are prepared to sacrifice rank and position. One might in this sense speak of helpful underlings and gypsies who abet the child's sexual needs just as helpful animals are spoken of in fairy-tales. As is well known, this tendency to return to nature is sometimes carried out in reality; innumerable stories are told, and repeated with alacrity, of affairs between countesses and coachmen or chauffeurs, or between princesses and gypsies. The great interest such tales arouse has its origin in tendencies common to all.[112]

Ferenczi's account of common human desires for erotic adventure amongst a group of lower social rank has many implications for analysis of the nineteenth-century obsession with prostitutes, gypsies, and servants, themes that have been well examined in the art-historical literature.[113] Social class still exerts a powerful attraction, albeit in reverse. As we shall see, the nature of the fantasy, just as in the imagining of noble parentage, remains incestuous, and the individual seeks what he or she perceives as sexual freedom and fulfillment.

Tanner's argument about the nineteenth-century novel, as well as psychoanalytic arguments such as Ferenczi's, would point not only toward the social and political significance of Manet's early portrayals of street types, but also toward a new reading of them. I would like to suggest that the repetitiousness in Manet's approach to the subjects is meaningful, that the set of recognizable models has a personal meaning in addition to evidencing an interest in the plight of a particular marginal group. Manet, out of his interest in the street subcultures of his time, circumscribes his representations of them by making disparate types into a cohesive unit. A private layer of meaning emerges through an interest in the margins of public life. We might look, for instance, at the early etching *The Travelers* of 1860 (fig. 29).[114] Like *La Pêche* (fig. 30), the landscape here is based on studies in and around the family property at Gennevilliers. The persons pictured, who are probably Bohemians, have their possessions in bundles on their beast of burden or tied to sticks on their shoulders. Tents can be seen in the foreground at right, and in the middle ground at left. This picture of Bohemians on the move is circumscribed by the Gennevilliers property, recognizable through the spire which recurs in *La Pêche*.[115] Family property and social marginality here are superimposed in a way that makes a definitive reading difficult.

Manet's early work repeatedly features persons on the margins of society. I would like to turn now to *The Street Singer* of 1862–63, initially looking with some historical and legal detail into the life of the street entertainer. Such an account is of interest not simply as historical fact or interpretation of fact, but also in terms of our imagining the distance—social, economic, psychological—between a family like Manet's and the hand-to-mouth existence of the itinerants. The myriad laws concerning street entertainment are particularly intriguing because of the involvement of Manet's father and Manet's cousin

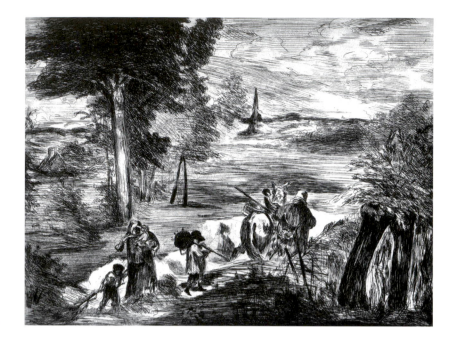

Fig. 29. Édouard Manet, *The Travelers*, 1860–61. Etching, 9 5/16 x 12 1/2 in. (23.6 x 31.8 cm). S. P. Avery Collection, Miriam and Ira D. Wallach Division of Art, Prints and Photographs, The New York Public Library. Astor, Lenox and Tilden Foundations

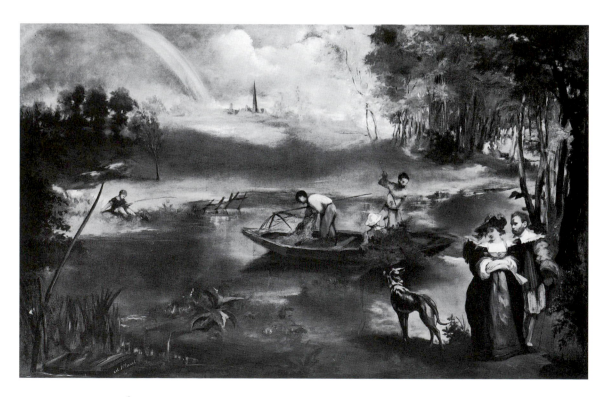

Fig. 30. Édouard Manet, *La Pêche*, c. 1861. Oil on canvas, 30 1/4 x 48 1/2 in. (76.8 x 123.2 cm). The Metropolitan Museum of Art, New York. Purchase, Mr. and Mrs. Richard J. Bernhard Gift, 1957 (57.10)

(who was an attorney at the Paris court of appeals) in cases affecting the singers.

The difficulties aggressively imposed on street performers and beggars during the Second Empire have been vividly described by T. J. Clark in his work on Daumier's *saltimbanques*.[116] Although the accession to power of Napoleon III and the prefect of Paris, Baron von Haussmann, brought on an escalation of the social repression of gypsies and street entertainers, persecution of a similar order did exist under prior governments. For example, in December of 1846, an existing police order was reinstated as café owners were prohibited from engaging singers and musicians on a fixed basis; an 1866 ruling prohibited them from advertising singers in advance of their appearances unless the songs to be performed were in the public domain.[117] These laws in effect forced the singers to move from place to place. Their roots, as Clark argues, were in the government's drive to block the political popularity of the singers as well as the entertainers' potential to incite unrest. It was fairly routine for street entertainers to be arrested on such charges as begging and disturbing the peace. The popular literature on street types, such as the *Physiologie du musicien*, makes such arrests sound like positively banal facts of life in Paris at mid-century.[118]

Illicit begging and disturbing the peace were not the only charges brought against street singers, as evidenced in Edmond Texier's *Tableau de Paris* of 1853:

> Some years ago, outside the correctional tribunal, we saw this dean of street singers loafing, this troubadour in tatters, alternately tenor, bass, or baritone, serious or sweet, whose charms have echoed in every public square, whose reputation was universal. This happy old minstrel had been accused of violating copyright laws: the publishers at the patent office alleged that as he was selling their songs to workers, to children's nursemaids and to working girls, he had interfered significantly with their sales. Their lawyer assessed 500 francs of damages against the delinquent who, invoking the name of Euterpe, was happily acquitted at 25 francs.[119]

As exaggerated as Texier's tale may sound, there are many cases like it on the books. Whether copyright law fell under the jurisdiction of civil law or criminal law depended on the nature of the complaint and the amount of damages sought.[120] The copyrights themselves, as well as the estate of the artist, were civil matters. Cases first came before the Tribunal de la Première Instance, at which, we recall, Auguste Manet was a civil judge for seventeen years.

Many copyright cases that came before the Paris civil tribunal dealt with street performances. One composer named Bourget sued two *limonadiers*, or café owners, in two years and won both times.[121] He claimed that the café owners were singing his songs in front of their establishments without his permission. Another case that had an effect on itinerant musicians and sideshow artists was that of *Bayard versus Plantade*, one of many complaints dealing with vaudeville adaptations of songs. The civil tribunal ruled: "Ordinarily it is wrongful to neglect to request permission of the author before using his tunes in a vaudeville. But those vaudeville artists who find such usage already established could believe themselves authorized to follow suit, could plead that they acted in good faith, and there is cause to grant

them a sufficient extension that they could find other tunes to replace the ones they did not have the right to appropriate."[122] The need for written consent, even in the case of vaudeville songs, cropped up repeatedly in the Paris courts. Another example was *Marquerie et al. versus Dormeuil et al.*, a case that Manet's cousin Jules de Jouy argued before the Paris court of appeals in 1853.[123] The composer Marquerie was awarded damages of one hundred francs after his compositions—which fell under the category of light music, *chansonnettes* or airs—were used without his permission in performances at the Palais Royal and at the Théâtre National du Cirque.

I would like to consider how these cases inflect Manet's painting of Victorine Meurent as *The Street Singer*. Although his account has been disputed, Manet's friend Théodore Duret claimed that Manet met his model Victorine Meurent inside the Palais de Justice, where his father worked.[124] It is quite possible that Manet first saw her there because transients like her were probably hauled into the tribunal at least once. More important than where Manet met Victorine Meurent, or whether she was really a street singer during this period (as some claim she was in later years),[125] is that for Manet, she came to represent an entire subculture of itinerant artists who faced persecution by the police as well as prosecution and judgment by the colleagues of Manet's father. Even if Auguste Manet himself ruled more on contested wills and paternity claims than copyright infringements by street singers,[126] it is a rich Oedipal irony that Manet would devote so much of his early work to depicting—on a monumental scale—the sorts of people who eked out a living by escaping the surveillance of the police and the justice ministry. Early in his career, Manet's cousin Jules de Jouy addressed an audience of Parisian barristers with a proposed piece of legislation that would bring back the "haute police"—whose name still connoted the *lettres de cachet* of the *ancien régime*—for surveillance of ex-convicts.[127] He argued that the Orléaniste monarchy had gone too far in its reforms in allowing freedom of movement for those released from prison; these should be assigned a domicile instead of being made into vagabonds by the government.

The Ministère de la Justice had a close working relationship with the prefectures and the police commissioners. In 1858, justice minister Delangle instructed the police commissioners to think of themselves as agents of administrative authority, as officers of the judiciary police, as an auxiliary of the Procureur Impérial.[128] Instituting the reforms advocated by Manet's cousin in 1839, a circular dated 18 May 1858 from the justice ministry to the Procureur Générale, or district attorney, brought all vagabond suspects—French and foreign—under special surveillance of the newly authorized "haute police."[129] In the ongoing concern over driving Bohemians out of France, which Marilyn Brown describes, the prefects were asked to cooperate completely with the Justice magistrates in order to facilitate the most "energetic application" of the police surveillance laws.[130]

The Street Singer (fig. 6) was first exhibited at the Galerie Martinet in 1863 with thirteen other canvases, including *The Gypsies* (later cut up by the artist) and *The Old Musician*, which also deal directly with itinerants. The nearly life-sized figure of Victorine Meurent emerges from a café of some sort; she is clutching her guitar and a wrapper full of cherries. Inside the café, we can see two figures, hats hanging on the wall, smoke wafting away from them. Our view of the head of the top-hatted man is blocked by

the elbow of a waiter, all but obscured except for a startlingly crisp white apron and a white cloth in hand. Outside the café, tall potted plants can be discerned as they frame the entrance. Victorine Meurent is no troubadour in tatters: her hat may be oversized but she wears delicate earrings; the color of her dress may be gray, but its bell sleeves, black trim, and long, wide silhouette conform to the fashions of the day. The aspect of the painting that would make the viewer think of the furtive street singer's precarious vocation is the gaze of Victorine Meurent as she lifts two cherries to her mouth. Eating on the run as she exits the café, the expression on her face is blank; it is between moments of focus. It is the look of someone who had assumed no one was looking and has only just noticed the presence of the viewer. One eye looks vacantly out of the picture, the other eye (her right), whose axis angles down just slightly, looks downward and catches the viewer's glance. The painting offers some uncanny simultaneous contrasts of looks: self-consciousness or awareness of being looked at breaks in on a lack of such awareness; furtiveness coexists with elusiveness. The viewer is reminded of those strange experiences of staring at someone on the street who looks familiar, only to find that he or she is a stranger.

Another compelling and peculiar feature of the painting is her seemingly artless gesture of lifting cherries to her mouth. We can just barely make out the corners of her mouth, to the right of the cherries and at the edges of her fingers. Manet draws us into the picture by depriving us of one of the most expressive features of figure painting—a woman's lips. The heavy shadows around her eyes create a very strong contrast between the upper and lower halves of her face; they effectively accentuate the way the lower half becomes an opaque, expressive void, concealed by her gesture. We are reminded of the strangely emphatic gesture of Manet's mother in the *Portrait of the Artist's Parents*, in which she insistently burrows her hand into an embroidery basket. The visual tease also prefigures the famous hand of *Olympia*, which presses down as it covers her genitals.

The Street Singer's hand blocks our view of her neck as well as of her mouth. In fact, Manet's handling of the neck area is very problematic. To the left of her hand, we can barely glimpse a wedge of neck, as well as the round neckline of her dress. But the right side is a different story. We see no neck at all, and the neckline of the dress is pushed significantly lower. Manet deliberately leaves this area ambiguous. It protrudes too much to be her chest, yet it is flesh color; it is not the gray or white one would expect for a shirt collar. This ambiguous area oscillates visually between having the color of exposed flesh—being something revealed—and having the appearance of something she is holding in her hand.

Her gesture with the cherries is strangely ill-suited to the task of eating them. Although this hand appears to be more three-dimensional and naturalistic than the limp, somewhat distorted hand that clutches the guitar and supports the wrapper of cherries, close examination reveals that the gesture is most unlikely. Looking just below the top cherry, we detect a rosy-brown form, which appears to be the pad of her thumb. She places her thumb between her middle fingers. If we consider what would probably be the natural, efficient way to pick up a couple of cherries, we would say that the thumb ought to be pressed against the forefinger, or in any case the first two fingers. To place the thumb in between the middle and ring fingers requires that the fingers be curled—as are hers—and that the entire hand be

cupped in a way which has little to do with the action of picking up cherries. Not to mention the fact that she is not opening her mouth to eat the cherries, but rather is simply holding them against her lips.

The more we consider the role of the cherries in the painting, the less sense they make iconographically. Since cafés are not known for selling cherries, it seems unlikely that she would have gotten them inside; they have no obvious role in the narrative of her exit from the café and her encounter with the viewer. Although her gesture smacks of the gracelessness of pure hunger, it seems unlikely that an artist in the 1860s would try to communicate dire poverty by showing the devouring of cherries as opposed to, say, bread. The viewer learns nothing about the woman's real social status, character, or personality from the cherries. They become an example of what Roland Barthes called "the reality effect," a detail that serves no apparent narrative purpose, that only enhances the texture of the work.[131] They have a visual, rather than an iconographic or narrative necessity. In fact, it appears that the cherries, though they were present when the work was first exhibited, were probably not part of the original conception of the work. Close analysis reveals that the bright yellow wrapper has been painted over her sleeve. Her gesture of holding the guitar also makes more sense if she were not simultaneously supporting the cherries, which are tilted so much toward the viewer that, as she steps toward us, they should fall right out of the wrapper.[132]

Considering the complex exchange of glances between the woman and the viewer, however, a different reading emerges. There is an undeniable sensuousness, even suggestiveness, to the cherries. The inclusion of ripe, red cherries and the unnatural way in which she presses them against her lips, rather than opening her mouth to eat them, would point in the direction of an erotic reading: a cupped hand, an organic object, real bodily contact being represented.

Baudelaire's "À une passante," included in the section of *Les Fleurs du mal* called "Tableaux parisiens," would provide a possible parallel example.[133] In the poem, as in Manet's painting, a woman lifts her skirt as she steps onto the sidewalk. Manet's figure also lifts her skirt—although the gesture is scarcely revealing—as she negotiates the transition from café to street. The visual experience of Baudelaire's *flâneur* (passerby) becomes undeniably sexual: the scalloped hem of the skirt appears labial; the woman's gaze promises a full range of meteorological effects from pale skies (he looks at her eyes), to a storm (he feels a stirring), to lightning (she looks back), to darkness (she passes). Manet's figure too, engages the viewer and simultaneously looks elusively away. Yet the two encounters, Manet's and Baudelaire's, are quite different. Baudelaire's *passante*, for one thing, is an elegant widow—not a street musician eating on the run. More important, however, the subject in Baudelaire's poem not only imagines a woman who might have become a great love; he also feels an orgasmic release in the lightning that flashes between them and becomes downright hysterical: he is "crispé comme un extravagant," he trembles, he cannot act; he can only romanticize the experience afterward. Baudelaire might construct a scenario that on the surface positions a subject, presumably male, who views a vulnerable woman who unwittingly offers him a suggestive look; however, the putative man on the street certainly does not emerge as a figure in control of his visual environment. Like the subject in the prose poem "Le Vieux saltimbanque" who "felt the terrible hand of hysteria grip my throat," the subject here has a sex-

ual experience, but it would seem to be a solitary one.[134]

Without question Manet charged his painting with something more than the detail of the social documentary. In an era when a proper woman would never lift a fruit to her lips in public, the picture cannot be devoid of suggestiveness. There is, however, something the picture is *not*, and that is coy. A simple comparison with a contemporary advertisement for Chanel perfume (fig. 31) perfectly makes the point. The Chanel model lifts something—a pearl?—to her painted lips, and the knowingness of her gaze makes it absolutely clear that the gesture, and the whole look of the image, is meant to be flirtatious. A viewer can tell this in a split second. The viewer of Manet's painting, however, would have some difficulty deciding what the gesture might communicate. Her gaze refuses to confirm a reading that she is flirtatious, or merely hungry, or merely posing, or even merely going about the normal affairs of a street musician.

Fig. 31. Chanel, Inc., advertisement for Chanel No. 5, 1995. 12 x 10 in. (25.6 x 30.6 cm). *The New York Times Magazine*, 17 December 1995

Manet's interest in the appearance of a woman coming out of a café was documented by his friend Antonin Proust. According to Proust: "Where the rue Guyot begins, a woman was coming out of a sleazy café, picking up her skirt, holding a guitar. Manet went up to her and asked her to come and pose for him. She went off laughing. 'I'll catch up with her again,' cried Manet, 'and if she still won't pose, I've got Victorine.'"[135] From the first, Manet's interest in the subject of a street singer appears to have involved a complex restaging of a street encounter, one that almost depended on a familiar model as well as an interest in the marginalized itinerant entertainer, or in the rhapsodic idealization of such an encounter in the work of Baudelaire.

I would now like to turn to several early pictures as well as various drawings, prints, and preparatory sketches done between 1861 and 1863: *La Pêche, La Musique aux Tuileries, La Nymphe surprise* and again to *Le Déjeuner sur l'herbe. La Pêche* (fig. 30) depicts a trio of fishermen in the middle ground of a Rubensian landscape. Léon Leenhoff angles in the background at left, and Manet and Suzanne Leenhoff stand in the foreground, dressed in seventeenth-century Flemish costume. The picture has been interpreted by Theodore Reff as an allegory of marriage.[136] I will suggest that the picture does entertain notions of allegory, although I do not see the idea of marriage as providing the key. Since the marriage of Édouard Manet and Suzanne Leenhoff did not occur until 1863, and was in some sense contingent on the death of Manet's father, it seems a bit improbable that marriage should encapsulate the

Fig. 32. Schelte Adam Bolswert, *Landscape with Rainbow*, after Peter Paul Rubens, n.d. Engraving. Bibliothèque Nationale, Paris

whole meaning of the picture, probably completed earlier.[137] Additional evidence against the notion that the picture represents an allegory of marriage is that Suzanne wears neither engagement nor wedding band, as she does in the later picture *La Lecture*. Unlike her presentation in *La Nymphe surprise*, she is no temptress in *La Pêche*, but neither does she appear as Madame Édouard Manet, a role that Manet took pains to portray after the marriage.

In *La Pêche*, it is true that Manet and Suzanne replicate the poses of Rubens and his second wife in *Landscape with Rainbow* (fig. 32), a Louvre painting also reproduced in engraving in Charles Blanc's *Histoire des peintres*.[138] Although in the Rubens painting the artist shows us himself and his second wife, Helena Fourment, I think it would be difficult to support a claim that Manet intended his own picture as a direct parallel. We should not neglect the fact that in many of Rubens's paintings, Helena Fourment appears as an unforgettably coy and sensuous figure—something which is bound to have impressed Manet. In the Rubens *Landscape*, the figure of Rubens bends slightly and guides her as they survey the scene. In the Manet painting, by contrast, Manet represents himself escorting Suzanne, but the pair are turned frontally as they look sideways, not at the landscape. There is much less intimation of the pair *entering* the landscape in the Manet: they merely appear in it.

La Pêche is an early example of Manet's interest in spatial ambiguities. The dog looks intently across the water, apparently at Léon, judging from the angle of the dog's head. Just above the dog is a bush. This bit of shrubbery hardly appears set back in space from the dog, as it actually must be. The bush obscures part of our view of the boat, which is terribly shallow, and of the seated man in it, who appears too large to fit his lower half into the boat. The greenery also renders the actions of the man at right somewhat ambiguous, although he is probably using the pole to push off the embankment. It is hard to know how steep the embankment is: again, the unruly little bush proves to be deceptive, a spatial marker that only casts doubt over the river bank it is supposed to demarcate.

The property in the picture is probably that of the Manet family, or nearby. Suzanne Manet, in her account-book, refers to the painting as "Saint-Ouen," or the Seine at the Ile Saint-Ouen, near Gennevilliers. As they had for two centuries, the Manet family still held 150 acres of land with houses there and used the property as a weekend retreat.[139] In the center of the painting, one of the fishermen prepares to use a net. It should be noted that a *manet* was a type of fishing net, a very fine one. Manet himself could hardly have been unaware of this homonym. Although we have no record of any direct reference to this little play on names, that is not surprising since the picture did not leave the Manet

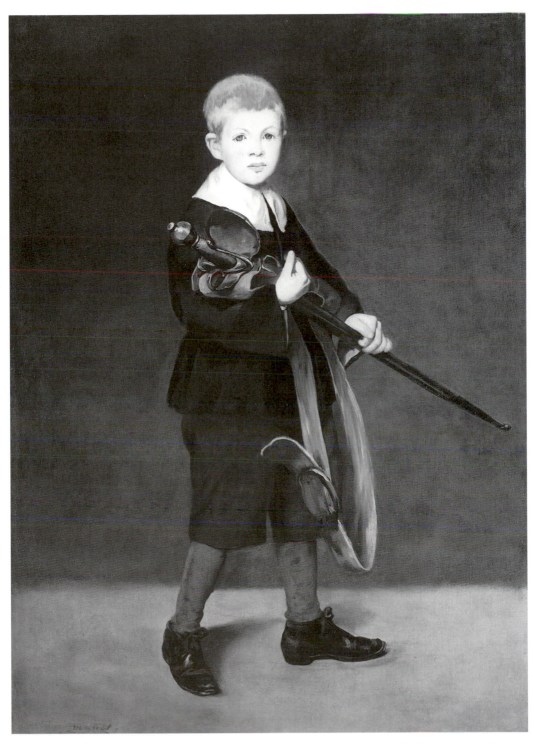

Fig. 33. Édouard Manet, *Boy with a Sword*, 1861. Oil on canvas, 51 5/8 x 36 3/4 in. (131.1 x 93.3 cm).
The Metropolitan Museum of Art, New York. Gift of Erwin Davis, 1889 (89.21.2)

family until 1897. If we balance the fact that the Manet family name is visually inscribed in the center of the picture against Reff's argument that the painting is an allegory of marriage, we might conclude that the picture concerns itself not so much with "marriage" as with the family name—who has it, who gets it.[140] Léon, holding a long fishing-rod, remains a small figure in the background. He belongs not quite with the fishermen, yet not quite with the costumed couple. The frontality of Manet and Suzanne—who do not look toward him, but out into the viewer's space—combined with the compositional arrangement, which places them on opposite sides of the riverbank, means that the picture, if anything, equivocates on the relationship of the three.

Before we conclude our discussion of *La Pêche*, it might be useful to compare the self-portrait in costume with another early self-portrait, that of *La Musique aux Tuileries* (fig. 19) of 1862. Again, the dating of the picture is questioned in the literature: I am here supporting Beatrice Farwell's chronology, which places it in the middle part of 1862.[141] In fact, I think some internal evidence suggests early autumn 1862, as I will explain. The ostensible subject of the painting is a gathering of the Parisian *monde,* specifically those who frequented the Thursday receptions at the Manet's, in the Tuileries gardens for a concert. Identifications of known personages in the painting continue to grow since Nils Gösta Sandblad's landmark study.[142] In fact, there are so many figures who were in Manet's social circle that it is next to impossible to imagine them all assembled in the Tuileries on a particular day. In this light, it is not surprising that Juliet Wilson-Bareau has discovered Manet's use of a *carte-de-visite* photograph as the basis for his portrayal of his friends Eugène Brunet and his wife.[143] Many of these persons show up on the list Léon Leenhoff compiled—no doubt with inaccuracies—of the regulars at the Manet's.[144] Manet himself appears at the left margin of the picture, behind a representation of the monocled artist Albert de Balleroy, who shared his studio.

Just to the right of center of the picture, a bearded man standing, facing left, bends slightly as he converses with a seated woman. He has been identified as Eugène Manet.[145] Behind Eugène and just to his left is the figure of the widow recently proposed to be Manet's mother, her veiled face juxtaposed with Eugène's top hat.[146] A small blond boy, dressed in black with a white collar, leans toward her. It makes sense that next to Eugène, Manet would paint his mother, who became a widow in September of 1862. The boy seeking comfort resembles Manet's early paintings of Léon Leenhoff, especially *Boy with a Sword* (fig. 33), *The Little Cavaliers* (fig. 34) and even later appearances such as *The Balcony* (fig. 35). Recent X-radiographs show that these two figures were not present in the earliest dry layer of oil paint, which would support a hypothesis that they were added late in 1862, after Auguste Manet's death.[147] The woman in blue, seated and pointing an umbrella in the direction of Eugène, is quite possibly Suzanne Leenhoff, veiled and wearing a black cape.[148] This identification becomes possible in light of the emergence, in the center of the painting, of a family group, consisting of Manet's brother and young half-brother, his mother and the mother of Léon. We should note, however, the fact that it would not have been proper for Manet's mother to attend a public concert during the six-month period of high mourning following Auguste's death. Manet here could be projecting the widow's eventual return to society. Just as we would not expect all the persons pictured in *La Musique* to have been in the Tuileries

Fig. 34. Édouard Manet, *The Little Cavaliers*, 1861–62. Etching, hand-colored, 9 5/8 x 15 3/8 in. (24.8 x 39 cm). Museum of Fine Arts, Boston. Lee M. Friedman Fund

on a particular day, it is possible, and I think likely, that Manet could have painted such a scene before his mother was actually appearing in public.

Although our understanding of the picture should not hang on these identifications, which are quite plausible but ultimately not verifiable, we would be foolhardy to ignore possible relationships between the picture's subject matter and the death of Manet's father. We might also consider the importance of children in general in this picture of adult sociability. One of the studies for *La Musique aux Tuileries*, an India ink wash drawing from a notebook (fig. 36), in the Bibliothèque Nationale in Paris, shows Manet interested in a portrayal of children at the gardens. Another study, an oil sketch in the Museum of Art at the Rhode Island School of Design (fig. 37), features a governess at right directing several children, and the notebook sketch has some of the same elements. An ink wash sketch in a private collection (fig. 38), however, includes more of the adult figures as well as the basic compositional scheme of the finished painting. The figures of Eugène, looking left and leaning politely, and the woman with a parasol whom I have identified as Suzanne, are the two most finished in the sketch. Nevertheless, behind Eugène the figure of Mme Manet *mère* can be discerned. It is a matter of conjecture, however, whether any of the forms around and behind her could be read as a preliminary sketch of Léon or of the little girls who walk past him.

The young girls who pass by the figures I suggest are Mme Manet *mère* and Léon appear somewhat older than the other children in the painting. They wear ribboned *châpeaux de paille*, in contrast with the little girls in the foreground, who are playing with shovel and pail. These young ladies exemplify why Hippolyte Taine, a few years after this picture was painted, described the Tuileries Gardens as a kind of salon in which girls practiced the manners and attitudes society would later expect from them.[149] One of the older girls turns slightly toward Léon. Although it is possible that the girls are merely saying "hello" to Mme Manet, in light of their turned profiles and the hint of snobbishness we read in that turn away from the pained Léon, the reading that comes to mind is that they have just called the boy a name.[150]

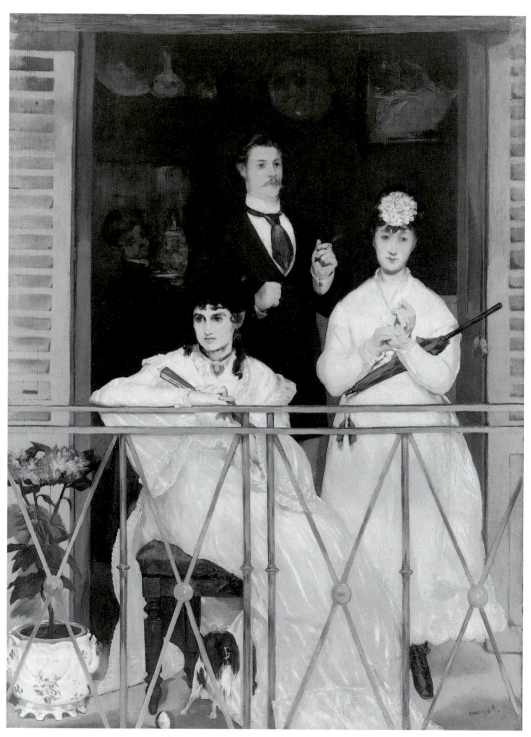

Fig. 35. Édouard Manet, *The Balcony*, 1868–69. Oil on canvas,
66 1/2 x 49 1/4 in. (169 x 125 cm). Musée d'Orsay, Paris

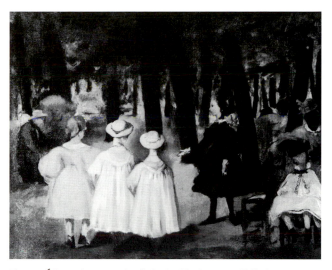

Fig. 37. Édouard Manet, *Study for La Musique aux Tuileries*, 1862. Oil on canvas, 14 15/16 x 18 1/8 in. (38 x 46 cm). Museum of Art, Rhode Island School of Design, Providence. Museum appropriation

Fig. 36. Édouard Manet, *Corner of the Tuileries*, 1862? India ink wash, 7 1/8 x 4 3/8 in. (18 x 11.2 cm). Bibliothèque Nationale, Paris

Fig. 38. Édouard Manet, *Study for La Musique aux Tuileries*, 1862. Wash drawing, 7 1/8 x 8 7/8 in. (18 x 22.5 cm). Private collection, Paris

There is little doubt that Léon had to endure some name-calling in real life, most likely the charge that he was a bastard.[151] The boy never knew who his father was, according to a letter to the scholar Adolphe Tabarant.[152] It is hard to imagine that a boy ignorant of his paternity, in such a society, could have escaped moments like the one I am suggesting may be intimated here. Manet's painting is certainly not trying for narrative determination; the boy rushing to the woman is one *tableau* among many in the picture.

La Musique and *La Pêche* have much in common. Both paintings, despite the frontality of so many of the figures, make use of a type of pictorial space Svetlana Alpers has characterized as descriptive (as opposed to dramatic).[153] The pictures' edges seem arbitrarily placed; the scene seems to continue laterally on either end outside the pictures—in contrast with so many of Manet's paintings, which demonstrate a more dramatic, limited, stagelike space. Both paintings include self-portraits of the artist, and in both cases Édouard Manet appears as a small figure near one of the margins, a device the artist did not use again.[154] A key point to seeing the paintings as pendants is the fact that they are almost exactly the same size.[155]

La Pêche and *La Musique* can be seen as pendants in many respects if we consider the time at which the paintings were executed and the relative rarity of the self-portraits. Auguste Manet died in September 1862, and we now know that since December 1857, he had remained unable to speak. It is my argument that Auguste Manet is the imagined or imaginary spectator of these two paintings. They represent two aspects of the elder Manet's world, and his survivors. One is, of course, the childhood home of Auguste: the paternal property, a place that remained the family retreat outside Paris. The other is the Parisian social scene. The family outings have contrasting backdrops: the quotidien (fishermen) and the elegant (the fashionable concertgoers). Édouard Manet represents himself in costume as Suzanne's escort, and in *La Musique* as a Parisian artist and dandy. Léon is shown in *La Pêche* off by himself and in *La Musique* seeking comfort from Auguste's widow: he is shown as an orphan. Manet represents his mother as a widow, probably for the first time. Manet, his mother, brother, Suzanne, and Léon are painted in Gennevilliers and Paris: they are those whom his father had left behind. And just as we cannot imagine all those friends and intimates gathered in the Tuileries gardens on a particular day, there is a level of unreality in *La Pêche*, with its fantastic conjunctions of history and the present moment, of particular family members and anonymous fishermen.

Le Déjeuner sur l'herbe and *La Pêche* are based on Manet's studies of the family property near Gennevilliers, as previously mentioned. One other pertinent fact is that in August 1863—just prior to Édouard's marriage to Suzanne Leenhoff in October—the three Manet brothers sold a fraction of this property and divided the money among themselves as part of the paternal estate. The transaction is noted in detail in the Manet-Leenhoff marriage contract.[156] The brothers sold, in two parcels, approximately twenty-four acres, or about fifteen percent of the complete Manet holdings. Several art historians have noted that when Manet painted *Le Déjeuner*, he may have recalled time his family spent at the suburban retreat.[157] Considering the sale of the property at approximately the same time as the execution of the pictures, the appearance of the property probably means more than a simple reminiscence. Looking

beyond personal meanings, to the broader social context of the type of property pictured, we might note several pertinent developments. The Second Empire, as is well known, was a period of conspicuous consumption. One of the high-level trends in the 1860s was a renewed interest in country property and country houses. The *nouveaux riches* who did not have a family *château* developed an interest in acquiring one. Classified ads, long since an innovation of the London *Times*, began to proliferate in the Paris dailies, most frequently to sell property outside Paris. The six biggest daily newspapers—*Le Siècle*, *La Presse*, *Le Journal des Débats*, *Le Constitutionnel*, *Le Pays*, and *La Patrie*—offered a special low price to the property seller who wished to advertise in all six.[158]

Once one had the country house, one had to find things to do while there. Periodicals devoted to the subject of country living began to appear, such as *La Vie à la Campagne*. In contrast to the populist almanacs and guides such as Joigneaux's *Almanach d'un paysan*,[159] aimed at traditional small farmers, new kinds of guides were issued for the weekend cultivator of the 1860s. Pierre-Charles Joubert's *Le Parfait Jardinier-Potager: guide de l'horticulture et de l'amateur de légumes de pleine-terre et de primeurs* was in fact a series of pamphlets on herbs, flowers, chickens, and all manner of fruits and vegetables.[160] Ranging in price from 50 centimes to 1 franc 50, they all contained a special segment for the leisure-time home gardener. Under the *Le Figaro* rubric of "Bourgeois Silhouettes," Eugène Chavette published the "unbelievable but true" story of the purchase and renovation of what was called a "modeste asile."[161] The narrator—a prosperous *rentier* who abhors *aristos*—succumbs to his wife's desire to keep up with friends, and to his own ambition to enjoy a glass of milk fresh from the cow, in a quiet, rustic setting. What begins as a seventeen-hundred-franc investment in a weekend retreat ends as a 1.5 million-franc renovation nightmare, finally sold for a mere seven hundred thousand. Chavette's story is just one example of a distinct sub-genre of quotidian fiction: tales of country houses for sale and the rage for *châteaux* crop up repeatedly in the newspapers of the 1860s.[162]

Perhaps the most fitting commentary on the trend comes from Arnould Frémy, who deplored the contradictions of what he called the "aristocratic bourgeois":

> Château life is just a fragment of an older mode of living which we are trying to resuscitate after having razed all the old châteaux, puerile and illogical generation we are! The mania for the château has engendered a misplaced vanity about the country [. . .]. This taste for the country [. . .] is an affair of show and of the vanity of the *parvenu*. One wishes for fresh air and to live close to the earth, always to ape the nobility. Since one can no longer say "my peasants," "my vassals," one loves being able to say "my warden," "my farmer," "my gardener."[163]

Frémy's criticism carries on with other aspects of contemporary taste and what he sees as the ostentatiousness of his society. Manet's painting *La Pêche*, with its seventeenth-century costumes and appropriation of Rubens's *Château de Steen*, like Frémy's piece, comments on the discontinuities between the *ancien* attitude toward family property in the country and the modern or *nouvelle* fashion. What remains the subject of fantasy and invention in *La Pêche*, however, is not the existence of family

Fig. 39. Édouard Manet, *Moses Saved from the Waters*, 1860–61. Oil on board, 14 x 18 1/8 in. (35.5 x 46 cm). Nasjonalgalleriet, Oslo

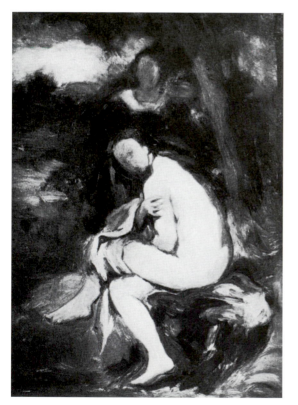

Fig. 40. Édouard Manet, *Moses Saved from the Waters*, 1860–61. Oil on board, 13 13/16 x 9 13/16 in. (35 x 25 cm). Private collection, Paris

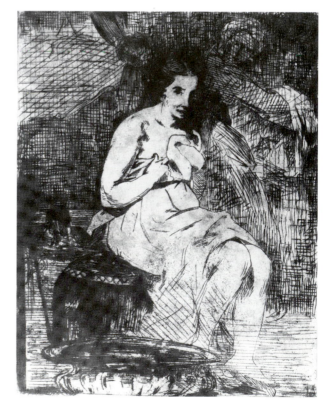

Fig. 41. Édouard Manet, *La Toilette*, 1861. Etching, 1st state, 11 1/4 x 8 7/8 in. (28.7 x 22.5 cm). Collection of Mr. and Mrs. R. Stanley Johnson, Chicago

property, but the legitimacy of the relationships pictured: those of Manet, Suzanne, and Léon to the property that generations of Manets with noble titles had owned.

Manet's early paintings of the family property must be seen in light of the private status of the property as well as the contemporary interest in country life. Gennevilliers itself was in Manet's time becoming more and more of a suburb of Paris, more a weekend retreat for Parisians with country property there, and less a village with its own identity.[164] We might even say that the faddishness itself of a revival of interest in *châteaux* can be seen as the bourgeoisie's family romance, as the desire of a social group to define itself by inventing a noble family history. In Manet's case, an obsession with the seventeenth century is especially marked in the early paintings, our next example being *La Nymphe surprise* (fig. 24).

Studies by Rosalind Krauss, Beatrice Farwell, and Giovanni Corradini have greatly enriched our knowledge of the painting's construction, sources, and pivotal position in Manet's early work.[165] More recently, Juliet Wilson-Bareau has made extensive use of some recent and surprising X-radiographic studies and has proposed a convincing chronology for the many versions of the bather theme.[166] She argues, for instance, that the oil sketch in the Oslo Nasjonalgalleriet, sometimes called *Moses Saved from the Waters* (fig. 39), should probably be considered to be a bathing scene rather than an illustration of the biblical story. In the picture, the nude bather, seated on a rock, is accompanied by two female attendants. Bareau points out that it was traditional to depict Pharoah's daughter "sumptuously attired and attended by her ladies-in-waiting": a nude bather was usually not included.[167] This work, painted over a reclining nude visible in X-radiographic images, appears to have led to another oil sketch (fig. 40) of the nude and one attendant. A fascinating discovery was the existence of yet another painting of a reclining nude, possibly modeled by Suzanne Leenhoff, over which *Mlle V. . . in the Costume of an Espada* was painted.[168] The nude's pose resembles that of Bathsheba. In a related etching (fig. 41) known in two states, the scene is placed indoors, with the nude seated near the foot of a canopy bed. At her feet is a bathtub. In the upper right, a bonneted maid reaches into a linen bag.[169]

A maid had remained in the final Buenos Aires canvas, but Manet painted out the figure. X-radiographs published by Corradini give a distinct picture of the maid, with her full features, who stands behind the bather and styles her hair. This maid's position in the picture and the angle of her head, like those of the maid in the etching, recall the placement of Manet's mother in the 1860 double portrait of the artist's parents. In the earlier state of the painting, known through X-rays, the face of the nude was much more dependent on the Rubens source.

Manet sent the picture to St. Petersburg, under the title *Nymph and Satyr*, in late 1861.[170] It has been suggested that he painted in a satyr in order to make the painting conform to more conservative standards in Russia. Tabarant alleges that a "voyeur indiscret" was once to be seen in the picture, behind the tree trunk.[171] This "voyeur" can readily be seen in Lochard's photographs of the painting, now in the Bibliothèque Nationale and in the Pierpont Morgan Library. Corradini's 1983 study, which somewhat revises his earlier conclusions, includes a chronology concerning what he calls "the constellation of the satyr," thinly painted and added subsequent to the painting-out of the maid. The satyr was then effaced

and replaced by foliage. Corradini proposes that Manet may have done this upon his return to his studio after the Franco-Prussian War, and that the Lochard photograph was taken earlier.[172] Beatrice Farwell concluded in 1975 that it is impossible to establish who painted out the satyr; she discovered a reference to it in unpublished notes by Edmond Bazire.[173]

La Nymphe surprise, as has been well established, draws on, and even conflates, paintings of the "Moses" theme, the "Susannah and the Elders" theme, and the "Bathsheba" theme, especially paintings by Rubens and Rembrandt. Rosalind Krauss suggested that Manet gradually eliminated attendant figures, thereby creating a more direct, non-narrative and hence modernist painting.[174] We should keep in mind, however, that in Manet's oeuvre, the artist's non-narrative devices do not depend on an elimination of secondary figures, but rather on such effects as "freezing" the figures or focusing the gaze at the spectator. One could hardly claim, for instance, that the cat and the maid in *Olympia* make it less modernist. I would argue that Manet was deliberately conflating the three themes because they are related. Manet eliminates secondary figures as he concentrates his attention on the relationship between the nude and the viewer. As Manet incorporates aspects of the "Moses," "Susannah," and "Bathsheba" themes, he is able to focus on the moment of discovery and on the knowledge that is collusively exchanged between the woman and the spectator.

As an image of Suzanne Leenhoff, *La Nymphe surprise*, along with the etchings and studies, stands alone in Manet's oeuvre. In no other extant oil painting does she appear nude, or even with her hair down. This needs to be considered alongside the three thematic ideas for the painting, namely themes of the secret upbringing of a foundling and incidents of voyeurism. I have already suggested that Manet's father is the imagined spectator of *La Pêche*. If we compare *La Nymphe* as an image of Suzanne with the bland decorum of other images of her in Manet's oeuvre—in such paintings as *Mme Manet au piano*—it begins to seem possible to think of Manet's father as the imaginary spectator of the bathing picture. *La Nymphe*, as I hope to show, is Manet's (Oedipal) attempt to imagine his father's desire for the woman who was his mistress. I would now like to speculate on what such an imagining might entail in the construction of a picture.

Returning momentarily to the argument of Rosalind Krauss, Manet's elimination of the attendant figures in the picture led to a composition in which the spectator of the picture becomes the voyeur, in place of the elders, the satyr, or King David. If we follow this line of thought, we might then ask, who is this spectator? Could it be the painter? Would all the members of a typical Salon audience be the intended voyeurs?[175] Male and female? Upper-middle class and lower-middle class? How are we to interpret the gaze of Suzanne, as modern nude bather or as Susannah/Bathsheba, reacting to the presence of this voyeur?

In the biblical story of Bathsheba, the woman was not only the object of the king's desire: she also reciprocated it by responding favorably to David's letter. The act of bathing in which she was glimpsed by David, then, carried desire both ways—her desirability for David, and her own assent. It would be plausible to argue that Manet's choice to cast Suzanne Leenhoff in this role carried with it a projection of her desirability to his father, and even an imagining of her reciprocation. If this is the underlying

impulse for the composition of *La Nymphe*, we might ask not only what such an imagining means in Oedipal terms, but also how it is played out in the picture.

The composition of *La Nymphe surprise* not only echoes that of certain "Susannah" pictures by Rubens and Rembrandt, but also recalls another modern bather, the *Valpinçon Bather* of Ingres. In fact, Manet's etching with the bather indoors includes a view of a distant waterspout very much like that of Ingres. Whereas the white skin of the Ingres bather is almost porcelainlike, Manet has painted his model to appear ample in figure, with a more Rubensian fleshiness. Manet has turned the *Valpinçon Bather* around, so that instead of being turbaned and aloof, the nude bather has let down her hair as she gazes at the viewer. The bather is yet another example of the insistent frontality of Manet's figures.[176] There are further signs of an intimacy between viewer and bather. In *La Nymphe*, the bather's unstyled hair as well as her direct gaze at the viewer make it apparent that we are to understand some kind of sexual engagement between the woman in the picture and the spectator of the picture.

What happens as a result of this apparent relationship between the viewer and the central figure? From the perspective of the artist, the picture at some level represents an imagining of the desirability of the father's mistress, and her potential consent. The psychological engagement between the spectator—let us say the father—and the woman, his mistress, becomes key to the painting. The shift observed by Krauss, in which the viewer becomes the voyeur in the Susannah and the Elders theme, becomes extremely significant, but in my view, it does so in a way that differs from Krauss's original line of argument. For it is not just any viewer of the actual canvas who becomes the voyeur; the voyeur is a specific personage at whom Suzanne gazes—we could say for whom she lets down her hair and makes herself desirable—and that voyeur is Manet's father.

Yet it will not do to leave it at that. For one thing, I have argued all along that we are not looking for biographical solutions to what are pictorial and representational problems. Furthermore, the bathing woman is looking out of the picture at the spectator, and the spectator, regardless of status or gender, *does* become complicit in the exchange of looks. What happens, then, is something else. Manet's spectator, or rather, Manet's construction of the spectator of the painting, has to *stand in for* the spectator who is *truly* implicated by the woman in the painting, that spectator being Manet's father. It is, I believe, this invention of a spectator who stands in for the father that gives the painting its particular force and complexity and that becomes a determining device in so much of Manet's early work—paintings such as *La Pêche*, *La Nymphe surprise*, *La Musique aux Tuileries* and *Le Déjeuner sur l'herbe*, to which we will return presently. Needless to say, the presence of this special form, or position of "spectatorship"—let us call it seeing (or imagining) *what the father would have seen*—is crucial to my argument that we can observe an Oedipal family drama at play in Manet's early work. The confrontation with Oedipal desire entailed by *La Nymphe surprise*, then, is not direct: by contrast, it involves layer after layer of substitution. The impulse to portray the father's illicit extramarital desire, his betrayal of the mother, begins with a look to relevant biblical and mythological subject matter. As these tropes are discarded, however, the resulting nude bather composition does not bring the painter face-to-face with the father's object of desire, which of course remains at some level inadmissible. The representational solution to this Oedipal dilemma,

then, is what I am calling the invention of a spectator who stands in for the father; the picture becomes a view of what the father would have seen.

There is, after all, a degree to which *La Nymphe surprise* is a picture in which neither the painter nor the viewer unabashedly takes pleasure in the nude woman. Despite her turn toward the viewer, we see nothing like Bathsheba's breasts as painted by Rembrandt, or even Ingres's uninterrupted view of the *Valpinçon Bather*'s backside. Manet's variation on Rubens's more modest pose entails a certain refusal of visual, sensual pleasure in the painting. This denial to look more fully at the body, combined with the ambiguous, frozen gaze of Suzanne, gives us an image of the father's object of desire in which the son's engagement with that desire remains, at most, ambivalent.

Manet painted *Le Déjeuner sur l'herbe* (fig. 1) during the period immediately following his father's death. It was exhibited at the Salon des Refusés just months after the event. I have already suggested some of the ways in which *Le Déjeuner* could be seen as a dream image, and the ways in which dream images were seen in the nineteenth century to embody repressed desires and to animate the involuntary life of the mind. One of the features of *Le Déjeuner* that has long engaged viewers is the explicitness of its relationship to the art of the past. I shall argue here that even the ways in which Manet takes on the art of the past are intricately connected to a family drama.

As I have suggested elsewhere, when Manet told his friend Antonin Proust about his interest in doing a nude after Giorgione, he probably had in mind not only the Louvre *Concert*, but also *La Tempesta* (fig. 42).[177] According to the popular guidebook by the German art historian Ernst Förster, *La Tempesta* was hanging at the Palazzo Manfrin as early as 1840; thus it was almost certainly on view when Édouard and Eugène Manet traveled to Venice in the fall of 1853.[178] There are several striking parallels between the two works. Manet would surely have admired the sensuousness of the landscape and the painterliness of Giorgione's handling of the medium. The pose and ample figure of Manet's model, Victorine Meurent, recall the figure in the Giorgione.[179] Both works depict landscapes with figures just large enough so that the pictures

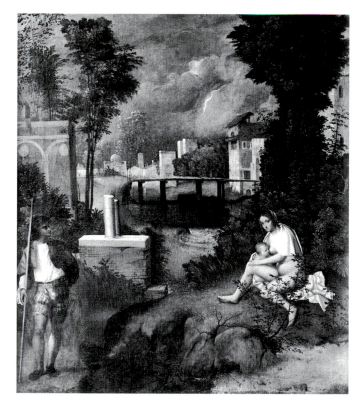

Fig. 42. Giorgione, *La Tempesta*, c. 1506. Oil on canvas, 32 5/16 x 28 3/4 in. (82 x 73 cm). Accademia, Venice

cannot be easily categorized either as pure landscape or figure paintings.

La Tempesta—sometimes called *The Family of Giorgione* in the nineteenth century—positions a man, possibly a sentinel, at left; on the opposite side of the embankment is a woman—nude except for a shawl—who is nursing a baby.[180] It is most likely the intimacy and casualness of the scene, as well as the lack of a clear narrative program and of any obvious iconographic scheme, that could give rise to the notion that the painting is some sort of family scene or even an allegory of Giorgione's illegitimacy or illegitimate child.[181] The possibility that some verses out of Byron's *Beppo* of 1817 referred to *La Tempesta* ("'Tis but a portrait of his wife, and son / And self, but such a woman! love in life!") provides further evidence that nineteenth-century viewers saw the painting as a family scene.[182] In the painting, some question of certainty with regard to the child's parentage is perhaps intimated in the way the woman and the man appear to be unconnected, and in the atmosphere of furtiveness that surrounds the mostly nude woman nursing a baby out in the woods in a stormy setting.

Manet, whose lack of narrative clarity in *Le Déjeuner sur l'herbe* is matched or perhaps exceeded by that of *La Tempesta*, would surely have been drawn to this scene, which simultaneously encourages interpretation while thwarting traditional narrative readings.[183] What promotes a narrative reading of *La Tempesta* is the way the man looks in the direction of the woman but does not clearly represent someone who is guarding or caring for her, while the woman, already in a vulnerable position, looks out of the painting directly at the viewer. The visual force of her gaze and the impression it makes on the beholder are singularly and powerfully imitated in Manet's painting.

Manet's realization of his own version of the "painting of modern life" in the early 1860s repeatedly featured a familiar milieu and a familial cast of characters, and this is the case in *Le Déjeuner*. The painting features the Gennevilliers landscape, and even makes it appear peculiarly enclosed, almost womblike. X-radiographic studies of the painting have revealed that in its original conception, the painting included an open vista in the left background.[184] Manet's changes in the landscape make the viewer focus more on the grouping of figures as they are framed in a dark triangle. In a reprise of *La Nymphe*, there is a bathing woman shown at the water's edge. She does not resemble Suzanne Leenhoff, although I would argue that her role in the composition is analogous to the role of Suzanne Leenhoff both in *La Nymphe surprise* and in the family drama. The three central characters form a visual unit; their models' actual relations to Manet and Suzanne should be considered. Manet's brother, at right, gesticulates without receiving a clear response from either of his immediate companions. Ferdinand Leenhoff, who posed for the man at left, was the eldest Leenhoff son. With his sister an unmarried mother, and their mother no longer living, his responsibilities to see after Suzanne's welfare increased. Manet's brother Eugène was also close to the Leenhoffs during this period. And Victorine Meurent, I have argued, came to represent the bohemians and itinerants who not only drew Manet's sympathy, but also became a kind of alternative family in his art. Although the average spectator at the Salon did not know the models' identities, she or he would have confronted the doubling of these figures in the costume pieces that framed it. On one side of *Le Déjeuner*, there was the swarthy self-assured brother who assumed a striking contrapposto; on the other, the brazen female model who posed in the same bolero;

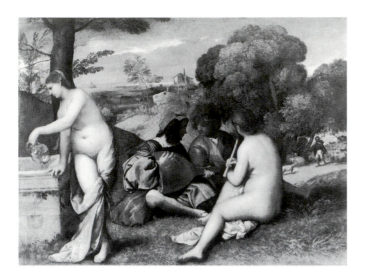

Fig. 43. Titian, *Le Concert champêtre*, c. 1508. Oil on canvas, 43 x 54 in. (110 x 138 cm). Musée du Louvre, Paris

on one side, the *majo* cult of male beauty; on the other, a travesty—a woman in *culottes*, not a bullfighter. The costume pieces come across as posed, and they in turn highlight the extent to which *Le Déjeuner* was posed, stage-lighted, not a real picnic.[185]

A social-historical account that restricts itself to Manet's attention to contemporary life, his concerns with a set of public meanings, and his explicit Realist commitments might appear to exclude consideration of the private meanings I propose as attached to certain sitters. Yet an adherent of this approach would nevertheless concede that a viewer in 1863 could have been struck by the repetition of faces and costumes and could have come away from the painting with the feeling that it was something of a riddle or an enigma, perhaps a private drama. Indeed, such was the response of Louis Étienne, who called the picture "ce logogriphe"—that cipher—in which a couple of students "played at being men."[186] The possibility that the picture was some sort of private joke was clearly one of its public meanings in 1863.

The spectator of Manet's painting in many ways can only apprehend the painting's drama and its mode of depicting a world by experiencing several distinct spectatorial positions within the painting.[187] Perhaps first and foremost, the gaze of Victorine invites the spectator to identify with her and to attempt to reconcile his or her own feelings of shock and embarrassment with the model's lack of them, with her presence amongst the clothed males. It is an experience of what could be called an inhibition of exhibitionism; it is the experience of the dream of being naked in a social situation and being frozen in place.[188] In this sense the painting replicates the experience of *La Tempesta* in which the woman's nudity and enigmatic gaze are inexplicable, in which there is a dreamlike lack of logic when we are led to expect a narrative. On another level, the painting reworks the Louvre *Concert champêtre* (fig. 43) and is a reflection on the subject of a reminiscence of four figures in nature. *Le Concert* depicts a harmonious eclogue and suggests a relationship among the figures, the town, and the landscape which was perhaps meant to have the character of a reminiscence of something that never was. Manet's painting substitutes the setting of a childhood retreat, now irrevocably altered by circumstance. If this is a picture of a paradise, as several commentators have claimed, it is in my view one that has already been lost and is recognized as never to be regained.[189] The viewer's experience of the stark presence of Victorine Meurent, the way her creamy white figure stands out so harshly against the dark greens of the landscape, makes it impossible to see the relationship between the figures and nature as a harmonious one.

The enigma of the painting's real subject, however, remains key to its effect: the foreground trio

appears to be in on something—I suggest something like a family secret—with which the spectator might or might not be expected to collude. Thinking back to one of the picture's models, the foreground figures occupy the position of the river gods in Raphael's *Judgment of Paris,* who were watching as something else took place; in the original story, a choice is made, and a woman given in marriage. In many ways, the themes and effects of *Le Déjeuner* hover around the acts of desire, protectiveness, reminiscence, and secrecy that characterize an actual "family romance" of Manet. These themes can also be seen to animate the Renaissance paintings Manet admired, aspects of which he sought to replicate in his painting of 1862–63. *La Tempesta,* in particular, insofar as it appeared to represent an allegory of *The Family of Giorgione,* could have provided Manet with a complex model for suggesting relationships among the figures without resolving them, for emphasizing the sensuousness and materialism of the landscape, and for in some way picturing a family while entrusting its secret to a nude woman's gaze out of the painting. I see these themes and histories not in terms of a set of unconscious motivations and biographical facts somehow taking precedence over the more public, professional ones; I see them as profoundly connected to Manet's project as a painter of modern life.

Manet's early figure paintings surely appear too idiosyncratic—and *odd*—to be seen as purely documentary in their attitude toward modern life.[190] My account here, with its emphasis on the relation between the social world of his family and that of the gypsies, ragpickers, and street entertainers he depicted, as well as my suggestion of a family romance embedded in his choices of subjects, models, and compositional arrangements, need not be seen as an assertion of the personal at the expense of the social. Of course Manet's work had social ambitions and meanings. In my view the historian can properly understand Manet's social aims by attending to the highly subjective framework through which he viewed contemporary society. With regard to paintings such as *La Pêche, La Musique aux Tuileries, La Nymphe surprise,* and *Le Déjeuner sur l'herbe,* we can speak of the paintings being structured around what Sartre called "the Other's look": in this case, that of the father. To paraphrase Sartre, the father's look is "the immense, invisible presence" that "embraces" Manet's early figure paintings "on every side."[191] What Michael Fried calls the "facingness" of the central figures in these works can perhaps best be understood in this light: it is to the father that such diverse figures as the old musician, the nude Suzanne Leenhoff, and Victorine Meurent are turned. In the next chapter, I will turn to the unfolding role of Victorine Meurent in staging this drama.

3 THE SPACE OF OLYMPIA

Adultery is the plague of the bourgeoisie, just as
prostitution is that of the people.

Zola

IN *LES COMPLEXES FAMILIAUX*, which Lacan wrote as an encyclopedia article, he describes the act of desiring as an act of identification with one who *already has* the desire and suggests that in the process of this identification, the original object of desire slips away.[1] Desire is not so much for an object as for the other's desire—this is what Lacan learns from Kojève and makes central to his reading of Freud. It is a powerful account of human volition; it suggests that what we really want has mostly to do with how we appear in others' eyes, with status vis-à-vis others. Lacan's theory has implications for an account of representation insofar as representation itself is mimetic and identificatory, and insofar as it involves the staking out of an identity in the public realm. It has particular pertinence in our period of the rise of modernity, as it can be argued that in mid-nineteenth-century Paris, a cultural notion of "the modern" comes to stand for a set of forms and practices that have everything to do with the conjuring of an allure, with the economics of such conjuring, and the images that engineer them. *Il faut être de son temps* commands one to want to be modern, which essentially involves wanting to be like another who already *is* modern because he, too, wants to be. Lacan's account of desire, then, is really a social theory as much as a psychoanalytical one in its significance. The notion that desire is not for an object (a person, of course) but for a desire—that of the other—means that if we look at a painting of desire (*Olympia*, for example), we might expect to find desire inscribed elsewhere than on its ostensible object: not on the body of the nude but in the space around it, which in the case of *Olympia* (fig. 11) is at least as elusive as the body.

Recent art-historical accounts of Manet's *Olympia*, of its subject matter and of the scandal it created at the Salon of 1865, have concentrated in varying ways on the extent to which Manet's painting represented a contemporary prostitute of some kind. Manet's painting was surely an unholy alliance that coupled things normally kept discrete: the art of Titian and the techniques of contemporary photography and printmaking, the goddess and the whore, the body and money. In chapter 2, I suggested that it brought figure painting together with society and sexuality in a way that few pictures of its time attempted. Although *Olympia* has often been considered as a representation of prostitution, or as an example of the genre of the nude, part of almost every account has embraced the notion that the painting disturbed its audience because it was some sort of union of opposites, even if only in the technical sense of stark lights and darks. *Olympia* has in some sense, then, always been considered *adulterous*, at least in the sense of adulteration. In this chapter, I will argue that Manet's representation of prostitution

and the female nude was reminiscent of adultery in more than one sense.

Manet's model reclines in a manner that makes her appear to be "on display" to the viewer. Over the finery of the white bed linens there is an embroidered shawl or coverlet; it is stitched in floral motifs and adorned with gold fringe. The pillow shams are ruffled. Behind the model is a papered wall or partition, patterned with rosettes in a diamond design on a brown ground. Gold trim frames the wall. Beyond this short wall, behind the maid is a heavy green curtain; another green curtain is tied back over the model's head. The sheets are pulled up to reveal part of the mattress and its braided trim.

The model is naked except for a pink ribbon with which she has pulled back her hair to leave shoulder-length tresses just brushing her left shoulder. The pink bow looks very much like a flower pinned in her hair. She wears delicate drop-earrings, a thin black choker tied in a bow, with a charm, and a thick gold bracelet, from which dangles a locket. The only other things she wears—one on, one off—are satin mules, medium heel, with blue and gold trim. The satin mules are of the closed-toe style, and the toes of her bare foot extend just past the shod one.

A black maid enters the room, carrying a large bouquet of flowers still in their paper wrapper. A black cat stands at the foot of the bed and arches its back. The naked model looks out at the viewer and her hand covers her genital area.

What are we seeing? Critics of the time ascribed various neighborhoods and identities to *Olympia*, none of them quite right, as T. J. Clark has argued. The interior is hers: the maid and cat know her, so she is no streetwalker. Her accessories and maid are worthy of a bourgeois home, as opposed to a bordello. Yet her nudity and her look out at the viewer, even as the gift of flowers arrives, would suggest that she is perhaps between customers, and thus not a kept woman and probably not a high-class call girl, either. *Olympia* seems less to recall the brothel than to foreshadow the *maison de rendez-vous*, the decorous class of later nineteenth-century Parisian houses of prostitution that emulated the bourgeois home. According to Alain Corbin, it maintained a veneer of respectability from the outside and was opulently furnished to accommodate the client and the women inside. Introductions were made in the salon, after which the "couple" repaired to one of the bedrooms. "The gentleman of course then left a gift. Men who frequented these places were willing to pay for the illusion of fashionable adultery. They were men who coveted their friends' wives but who lacked the charm to seduce them."[2] It is this type of sexual transaction that I suggest informs the interior of *Olympia*; it is a space somewhere between the richness and decorousness of a bourgeois *salle* and the vague disreputability of the brothel. It gives itself away to the extent that it is only slightly

Fig. 44. Anonymous, *Maison de rendez-vous*, late 19th century. Photograph

overdone, only slightly theatricalized. What interested the *maison* client was the illusion of adultery, something made possible by the upscale setting.

A photograph (fig. 44) of one of the *maisons* on the rue de Londres shows striking reminiscences of the décor of *Olympia*.[3] Gold trim edges decorative wallpapers. Everything is covered and patterned. Unlike Edgar Degas's brothel monotypes with their nude women waiting with legs spread, this photograph shows a bevy of modestly covered—if somewhat immodest—women. Their hair, like that of Manet's model, is loosely pinned up. The fact that they are not *femmes honnêtes* can be gauged by the leg-revealing openwork panels of the garments and the overdone makeup, as well as by their projection of a certain physicality and exuberance in place of propriety and decorum.

The *maison de rendez-vous* differed from the *maison close* in its deliberate imitation of both the bourgeois home and the apartment of a kept woman or an illicit liaison. Its very nature was imitative, and hence sham. Its emphasis on "discretion" as opposed to mere accommodation of the fantasies of the first comer reveals that it was more than a purveyor of sexual services; it was evidence that any aspect of the life of a gentleman (if we care to use that word here), even his love affairs, could be copied in a cut-rate form. As for the female personnel of these houses, were they in fact just *filles publiques* who had been transported to a fancy interior and who expected to receive a gift while the madam handled the dirty cash?

The *maison de rendez-vous* was not an established feature of the topography of Parisian prostitution in 1863; these houses began to multiply in the late 1880s and reached their peak after 1900. But the movement by which older bordellos transformed themselves into such houses—where the prostitutes did not actually live—was well under way in Manet's time.[4] The *maison de rendez-vous* was a more refined version of the *maison de passe*, a house where the rooms were used for a *passe* (a brief encounter) as well as the *maison à partie*, a house where one might eat, drink, and gamble as well as consort with a prostitute; some of these specialized in arranging particular situations and catering to specific tastes.[5] An English study of prostitution published in 1839 refers to such houses in Paris (also translated euphemistically as "assembly houses"): "where *dames des maisons*, not without education, good manners, and much capacity for intrigue, give breakfasts and dinners, where monied debauchees assemble, to find the more agreeable of such prostitutes. These are dangerous women, whom the police cannot consider as prostitutes [. . .]. Some of these houses are kept most expensively by women whom the police cannot get at, and preserve the appearance of the utmost modesty and respectability."[6] The English author Michael Ryan relies heavily on Parent-Duchâtelet's 1837 study of Parisian prostitution and warns that at the "phrenzied" orgies of the *maisons à partie*, thieves were in league with the women who saw to it that "enormous sums [were] lost and won."[7]

As the Second Empire progressed, a perception grew that sexuality was changing, and perceptions having to do with the domain of clandestine prostitution changed most of all. A study of Second Empire prostitution published in 1887 compared the contemporary clandestine prostitute with the *grisette* of old.[8] The girl who procured cash, meals, and drinks from day to day, but spent nights and Sundays with her regular boyfriend was a nostalgic fantasy from decades past. What had taken its place

was a fantasy of an unregistered prostitute who was distressingly public and ostentatious, and indistinguishable from *les filles publiques*. "As much as one hid oneself formerly, one makes oneself seen today."[9] Even what was meant by "clandestine prostitution" had changed: no longer did it mean hidden prostitution, but rather simply unregistered prostitution (uncontrolled, and perhaps increasingly out of control).

Alain Corbin, in his thoughtful analysis of prostitution and its regulation in the later nineteenth century, suggests that for all the mythologizing of the sexuality of the so-called *classes dangereuses*, changes in sexual behavior did not originate with the lower classes. They instead began with the bourgeoisie's "borrowing of aristocratic models of sexuality," which gained wider practice through the "*embourgeoisement* of the new social strata and the moral integration of the working classes."[10] These developments affected not just the practice of prostitution, but every aspect of life in the nineteenth century, as T. J. Clark argues in *The Painting of Modern Life: Paris in the Art of Manet and His Followers*. Clark analyzes the modernization of Paris as an embourgeoisement of the city, as a process by which certain patterns of consumption were held up as "modern," and scaled-down versions of them were made seductively available to a new social class, the petite bourgeoisie. Bourgeois desires and the ways of life by which they might be attained thus come to take the place of the working-class, and revolutionary, aspirations of the earlier nineteenth century.

The implications of *embourgeoisement* for sexual practices are already perceptible in Flaubert's *L'Éducation sentimentale*, in which Frédéric Moreau covets both the wife and mistress of M. Arnoux. As the drama is played out, Frédéric idealizes Mme Arnoux to the point of never touching her, even when she offers herself to him; he visits the *maison close* but "does" nothing, and he takes up with the mistress of Arnoux—Rosanette, alias "La Maréchale." Frédéric's perception of Arnoux's status and his wish to occupy that place are completely bound up with his perception of Arnoux's relations to the women in his life.

On the surface, *L'Éducation sentimentale* presents a classic example of the nineteenth-century compartmentalization of women into "wives" on the one hand and "mistresses" on the other. It is a well-known fact that the double standard concerning adultery in the nineteenth century made it acceptable for men to have mistresses, and even to be seen with them in public, as was Jacques Arnoux. Men like Arnoux had mistresses specifically to enjoy an erotic life, which was strictly banished from their relationships with their wives. Yet what drives the narrative of *L'Éducation sentimentale* is not Frédéric's desire for Rosanette, but rather his desire for Mme Arnoux. His first glimpse of her is almost a religious sighting of the Madonna:

It was like a vision:
She was sitting in the middle of the bench, all alone; or at least he could not see anybody else in the dazzling light which her eyes cast upon him. Just as he passed her, she raised her head; he bowed automatically; and stopping a little way off, on the same side of the boat, he looked at her.
She was wearing a broad-brimmed straw hat, with pink ribbons which fluttered behind her in the wind. Her black hair, parted in the middle, hung in two long tresses which brushed the ends of her thick

eyebrows and seemed to caress the oval of her face. [. . .]

A negress with a silk scarf round her hair appeared, holding a little girl by the hand. The child, who had tears in her eyes, had just woken up. The lady took her on her knee.[11]

From the beginning of the novel, Mme Arnoux is represented as a mother; this, however, only incites Frédéric's desire for her. The novel in effect conjoins—in the fantasy of the younger man—what would appear to be the separate compartments of the erotic life of the older man. It does so, however, by making the maternal figure both eroticized and unattainable. It is important to note, then, that whatever social pressures and practices drove the fantasy of the mistress were not necessarily exclusions of erotic affection for the wife or "mother." As Foucault, or indeed Freud, might say, they were but acts of repression which worked to reinforce the implicit desirability of the mother (as well as, I think, the desirability of her unattainability as an erotic object).

In the penultimate scene of the novel, Mme Arnoux pays a final visit to Frédéric Moreau. Farewells are bid after the years of unconsummated love, which marked Frédéric's coming of age:

She stood there, leaning backwards, her lips parted, her eyes raised. Suddenly she pushed him away with a look of despair; and when he begged her to speak, she bowed her head and said:

"I should have liked to make you happy."

Frédéric suspected that Madame Arnoux had come to offer herself to him; and once again he was filled with desire, a frenzied, rabid lust such as he had never known before. Yet he also had another, indefinable feeling, a repugnance akin to a dread of committing incest. Another fear restrained him— the fear of being disgusted later.[12]

Flaubert's earlier intention, as evidenced in his notebooks, was to name the older woman Mme Moreau.[13] The "dread of committing incest," which makes its appearance at the would-be lovers' farewell, in effect transforms her into Madame Moreau *mère*:

"Good-bye, my friend, my dear friend! I shall never see you again. This was my last act as a woman. My soul will never leave you. May all the blessings of heaven be upon you!"

And she kissed him on the forehead like a mother.[14]

When Mme Arnoux so much as appears to be offering herself—when the boundaries begin to be blurred between Mme Arnoux as *femme honnête* and as *courtisane*—the taboo of adultery becomes the taboo of incest. She kisses him like a mother, and in a final gesture reminiscent of maternal fetishism,[15] she cuts off a long lock of her white hair and gives it to Frédéric.

Flaubert's representation of Mme Arnoux is far from the only instance in which we see the eroticization of the mother in the nineteenth century. Although it is certainly the case that women were subjected to highly constraining categorization in the nineteenth century, those same categorical

terms—*femme honnête, cocotte, mère, courtisane*—are figures of fantasy; they are in Lacanian terms "imaginary" identifications.[16] On the surface, these categories might seem to be cultural structures, yet properly speaking, they belong to the Lacanian Imaginary, or the unconscious realm of desires and identifications. One might have to work to maintain them—whether one was concerned about one's own appearance or someone else's—but that conscious awareness does not change the categories' essentially irrational and unconscious import. The fact that the terms are "imaginary" and fluid explains how a Jacques Arnoux can have his *femme honnête* and his Rosanette-who-is-not-*honnête*, and how a Frédéric can have his Rosanette while fantasizing that he will make a mistress out of a *mère*.

As T. J. Clark has argued, it was during the Second Empire that categories such as *femme honnête* and *courtisane* were perceived as becoming more unstable. Clark suggests that during the Second Empire, "the old distinctions between urbanity, sexual tolerance, *galanterie*, adultery, debauchery, and prostitution" were breaking down.[17] Zola in 1881 went so far as to write that "adultery is the plague of the bourgeoisie, just as prostitution is that of the people," thereby virtually equating the two phenomena across class lines.[18] Certainly there were new anxieties about the status of the *courtisane*, or the possibility that the *courtisane* and the *femme honnête* were no longer as distinct as they once were; and the ramifications of this blurring of the boundaries involved the devaluation of the bourgeois woman and the rise in high society of the courtesan.

The appearance of the prostitute, especially a representation that disturbed the normal order of things by taking the prostitute out of the enclosed milieu in which she was supposed to be kept, would connote a manner of adultery by respectable men.[19] Whereas some reformers complained that prostitutes were indecently soliciting young men in front of their mothers and sisters—"imagine the effect that their lubricious language will have on the imagination of our youth!" cried Antoine Granveau in 1867[20]—for others, the more insidious danger was the prostitution that went on undetected and unregulated. At a time when syphilis had no curative treatment, public health officials had reason to worry that an increase in clandestine prostitution would mean a continued rise in disease. But how to stop what went on in furnished rooms, in the back rooms of cabarets, or in the fitting-rooms of so-called *modistes*?

What we must have before all else, that is the ability to harass and to get at clandestine prostitution in the place where it carries out its acts of debauchery, so dangerous for the public health. This place is the cabaret, it is the furnished room, it is also the lodging where, thanks to the connivance of the proprietor or of the concierge, the clandestine prostitute, housed among her things, can openly carry on her repugnant occupation. [. . .] Prostitution in cabarets is the exception to the rule, if one compares it to that which goes on in rented rooms, at the landlord's. This one has a thousand reasons which don't need to be explained and which everyone knows or can guess. It is thus the furnished room which is above all the great refuge and the place of debauchery for the greatest number of clandestine prostitutes.[21]

C. J. Lecour, a former division head at the prefecture of police, knows something of his subject. The moral tone of his language might be typical of nineteenth-century reformers and men of authority, yet perhaps what is most striking here is the way in which for him prostitution is less a moral failure or a social phenomenon, and more an activity of debauchery, which has somehow been *displaced* from where it should be. For Lecour, the red-light district known by the police is a thing of the past. Prostitution, no longer in the *maisons de tolérance* where one might expect to find it, now looks for cheap hotels and cabarets; it goes on less because there are women who will turn to it and more because there are proprietors and concierges who look the other way. By 1870, a Parisian writer who wishes to claim expertise in moral behavior claims neither to read the customs and habits of people walking down the street, nor even to be able to map the city's neighborhoods; by contrast, he sees such behavior being channeled into the spaces that open up everywhere around it. This surely marks a shift from the readability of faces and streets in the Paris of Balzac and of the physiologies of the 1840s.[22]

The space and accessories pictured in *Olympia* are crucial to the painting's effect. The setting could be equally important in the novel of adultery, as Tony Tanner explains: "while the act may not be described, the setting invariably is. One could almost say that the description has been displaced into the setting and must be read there."[23] And perhaps that "displacement" involved other displacements of its own, as we have seen: from the Quartier Bréda, to a furnished room; from the *fille publique*, to the *insoumise* who could have rented that embroidered shawl for ten francs a day.[24] (Lecour quotes prices of fifteen francs per day for rental of an expensive bracelet, ten for a ring or broach, thirty for an ensemble.)[25] Thus not only would prostitution be readable in the setting of the painting; it would be readable in the very mundanity of that setting, in the extent to which it displayed not the hallmarks of the good old brothel, but rather the tawdry furnishings of the *garni* in the slightly insistent presence of the woman's bracelet, choker, earrings, shawl, and satin mules.

Clandestine prostitution, then, relied on the games of imitation and travesty, which it could play better than the brothels. It could seek out different furnished rooms, rent different pieces of jewelry, stage different scenarios. It could create illusions—of relationships, of status—which were neither possible nor desired in the regulated *tolérances*. As Corbin writes: "The prostitute's client now demanded some semblance of seduction, of feeling, even of attachment; this involved a certain continuity in the relationship. In any case, the mass consumption practiced in the popular brothel was now found repugnant, unless it was accompanied by a technical specialty. [. . .] These feelings explain the repugnance for anything smacking too much of professionalism and a preference on the part of men for the clandestine."[26] According to Corbin, such was the cachet of clandestine prostitution that it even became common during the Second Empire for registered prostitutes to pretend to be unregistered.

If one of the illusions made possible by clandestine prostitution, with its rented rooms and games of seduction, was the illusion of upper-class adultery—if indeed adultery was to the bourgeoisie what prostitution was for the people—then certainly there was more than one kind of adultery mimed by prostitution or more than one kind of fantasy of adultery that was imagined to be going on. "One can say that in Paris the gallant woman is everywhere," wrote Louis Martineau in 1885.[27]

> It is a matter of women who practice clandestine prostitution because their situation in the world does not furnish them with the money needed to satisfy their luxurious taste, their unrestrained love of their toilette, their desire to eclipse their companions, their friends and their rivals. In the *lionnes pauvres*, one sees married women accepting from a lover the resources which her husband cannot provide for her, who makes adultery the price of her luxury. Furthermore, there are even women consumed by these same needs who satisfy them without the accompanying impulses of the heart or of feeling, which would explain their degradation; there are some—one must say it—who would find it compromising to take a particular lover, and thereby take an anonymous one.[28]

A tract on prostitution in 1885, even one by a doctor who regularly treated clandestine prostitutes at the Hôpital de Lourcine, is not to be taken as proof that such women existed in any numbers, if even at all. But if what interests us is less the actual practice of prostitution in the Second Empire and early Third Republic than the way in which it was perceived, then Martineau's account takes on more importance. Just as Lecour cites the "*insoumise* of the boulevards who smokes and solicits in the storefronts of the most well-known cafés," who is "luxuriously dressed and gloved,"[29] Martineau writes of women who are driven by their culture's taste for luxury and display to the point where even married women became adultresses in order to satisfy their desires for fashion, for things their husbands could not afford. The remarks in these tracts should be understood as facets of the mythology of clandestine prostitution in the period, a mythology I would characterize as encompassing a certain confusion between the private indiscretion called "adultery" and the larger, more public matter called prostitution. In a history of representations, it is the gray area between fantasy and practice that should be of greatest interest. Foucault described his project in *The History of Sexuality* volumes to an interviewer this way: "I try to make an archaeology of discourse about sexuality, which is really the relationship between what we do, what we are obliged to do, what we are allowed to do, what we are forbidden to do in the field of sexuality, and what we are allowed, forbidden, or obliged to say about our sexual behavior."[30] In the mid-nineteenth century, prostitution's fantasy of adultery—the fluid categories and shifting definitions that fueled the fantasy and the mythology—constituted a part of the critical terrain against which *Olympia* would have been seen.

Manet's model gazes out of the painting, in the direction of the viewer. It is the model's gaze that brings the viewer into the painting's orbit; the viewer is colluding, or intruding, or on the receiving end of a confrontational look. Perhaps the writer on Manet who has most convincingly explored and described this aspect of his work is Michael Fried, who has written: "It's also at least arguable that one effect of Manet's strategy, and doubtless also a principal cause of the extreme provocation that his paintings typically offered to contemporary audiences, is that the beholder sensed that he had been made supererogatory to a situation that ostensibly demanded his presence, as if his place before the painting were *already occupied* by virtue of the extreme measures that had been taken to stake it out."[31] With the viewer's position thus paradoxically "demanded" but "already occupied," as Fried has so aptly remarked,

it is all but impossible for that viewer to remain neutral. One becomes aware of oneself looking at *Olympia*, much the way one is aware of oneself looking into a mirror; according to Fried, however, it is as if the viewer shockingly confronts another reflection, another presence already there.

Manet's *Olympia* creates these paradoxical conditions of beholding in part because of the model's gaze but also because of its narrative structure. With the model's nakedness set off by such accessories as the choker and the shawl, the viewer approaches the canvas with reason to think that this is an erotic tableau (à la Baudelaire's "My darling was naked, or nearly, for knowing my heart/ she had left on her jewels"), or that the model represents a prostitute.[32] The cat looks in the direction of the viewer, and the maid brings in flowers to present to the model. Because the model looks out at the viewer and not at the maid, who is ostensibly requiring attention and directions from the nude model (it is as if she is saying "These just arrived," or "Where shall I put these?"), the narrative created by the picture would appear to involve the viewer but is not completed by clues within it. Since the viewer was in all likelihood not the sender of the flowers, he or she is forcefully made aware of the existence of another viewer (or admirer, or customer, or lover)—one who has already been there. As Fried writes, the viewer's presence is at one and the same time being demanded by the picture and already coming into conflict with that of some- one else (here betokened by the flowers). With the subject being a nude woman, what might ordinarily be a complex or ambiguous narrative structure implicitly becomes an erotic conflict.

When Fried wrote of the structure of beholding in Manet's art, he was addressing the major can- vases of the 1860s as a group; his reading turns on several consistent aspects of Manet's paintings. Many of them are figure paintings, life-sized or almost so, and this in itself dramatizes the figures' relationship with a beholder. Many of Manet's central figures are frontally oriented and even facing out of the pic- ture, making the viewer's position even more problematic. The paintings are also highly staged, with the action frozen. All these aspects can be cited in support of a Friedian reading of *Olympia*; it so happens that the mini-drama with the flowers and the maid adds a further twist to the beholder's involvement with the picture.

It is surely the model's gaze that creates a paradoxical self-awareness on the part of the viewer of *Olympia* and multiplies the possible genders of its *dramatis personae.* Shoshana Felman has argued that in Honoré de Balzac's novella *La Fille aux yeux d'or*, the reflectiveness of the gold in the golden eyes of the title character Paquita serves to reflect the male character Henri's own image as desired. Henri describes the gold as an "amorous gold, gold that wants to come into your pocket"; the gold both reflects the desiring male subject and expresses a kind of erotic volition of wanting to be in his pants. Felman concludes that the text "grants the golden eyes of femininity a phantasmic masculine—phal- lic—role. Ironically enough, femininity itself thus turns out to be a metaphor of the phallus."[33] The female thus signifies, reasons Felman, and refers to the male; the female *signifies* the male. Insofar as the viewer of Manet's *Olympia* is drawn into the work by the gaze of Victorine Meurent, the viewer becomes self-conscious, much in the way of the experience of a literal reflection. Caught in the ambigui- ties of the gaze's asymmetry, the viewer becomes uncertain as to the position of dominance in the viewing experience.

"The girl with the golden eyes is thus the very name of woman and of femininity *as a fantasy of man*," continues Felman.[34] And indeed, the name "Olympia" also suggests a fantasy. As Beatrice Farwell has written, "Olympe" was a pseudonym in use among nineteenth-century prostitutes.[35] Manet's friend, the poet and critic Zacharie Astruc, composed a poem which accompanied the painting in the Salon livret, and it is to his poem that the painting title is most closely connected. There are other possible literary sources and connotations, including the novel *La Dona Olympia* by Étienne Délécluze, the character Olympia in E.T.A. Hoffman's "The Sand-Man," and the courtesan Olympia in Dumas's *La Dame aux camélias*.[36] Just as Balzac's "la fille aux yeux d'or" was named "by a group of men—Henri's friends," as Felman writes, "Olympia" appeared in the Salon livret as named by one of Manet's friends, perhaps with reference to one of these other characters. The name is not commonplace; by contrast, it is mythological, pseudonymous, literary. In 1865, there was no consensus on what it signified, but we may assume that it provided a jarring contrast with the immediacy of the representation of the nude female body. Imagine one of Manet's *chiffonniers* entitled *Jupiter* or *Theseus*.

Most critics, and probably most viewers, did not concern themselves too much with the possible literary references of the title when they were confronted with Manet's painting. T. J. Clark has traced the attempts of some seventy critics to assign an identity to the female figure. She was the "wife of the cabinetmaker," the "coal lady from the Batignolles," "a redhead from the Quartier Bréda," "from the rue Mouffetard," "a woman of the night out of Paul Niquet's," "a sort of female gorilla, a grotesque in India rubber."[37] There is no doubt that many viewers of the picture in 1865 either thought they could identify her type, or wanted to try. These identities, according to Clark, are contradictory; on the one hand, they point to the alarming fluidity that was now part of the trade of prostitution; they also point to the painting's failure to signify. "The images of sickness, death, depravity, and dirt all carried that connotation [that Olympia 'came from the lower depths'], but they stayed as passing figures of speech precisely because the critics could not identify what in the picture told them where Olympia belonged."[38] It is significant that the critics did try to locate her identity in the encyclopedic hierarchy of Parisian life and that they failed. It signifies that the picture provided enough of a sense of contemporaneity and familiarity that the critics were guided by the appearance of the body, the space, and the accessories—not by the literariness of the title—in an attempt to connect her with the life of the city. It also suggests that *Olympia* embodies what police chief Lecour observed: namely, that prostitution was becoming more difficult to associate with a particular neighborhood of Paris, with one type of establishment, or even with the social or marital status of the prostitute (even "la femme de l'ébéniste" was suspect; perhaps the cabinetmaker himself was one of those men who looked the other way).

The viewer in 1865 had a difficult time with the picture. According to Fried, "he had been made supererogatory to a situation that ostensibly demanded his presence"; according to Clark, Manet's figure "is likewise not quite creature of fantasy and not quite social fact; neither metaphor nor violation of one, neither real nor allegorical."[39] It is not hard to imagine that Manet might have wanted to paint a picture of a nude which responded both to Titian and to some aspects of contemporary life; it is also not hard to imagine that the resulting picture might rub people the wrong way or touch on changes

in the practice and perception of prostitution. But these phenomena do not account for what Fried finds so noteworthy: why would the painter so involve and complicate the viewer's position vis-à-vis the picture?

For Fried, the answer lies partly in the extent to which the beholder, in Manet's art, should sometimes be construed as the "painter-beholder"; Manet's projection of himself into the paintings might account for the extremity and complication of viewer involvement.[40] Fried understands Manet's art "to underscore, in a sense to dramatize, what I have called the primordial convention that paintings are made to be beheld," yet the forcefulness of the paintings' insistence on being beheld cannot be separated from the contradictory nature of their being beheld—their tendency to "exclude" as well as involve the viewer.[41] The kinds of concerns with theatricality and spectatorship that Fried analyzes in French painting up to Manet were surely at some level operative in the painting culture into which Manet entered. Yet when we look at the art of the mid-nineteenth century, we must consider not only the French tradition but also the very real break with it engineered by Courbet and Manet; we must not forget that theatricality or anti-theatricality in the painting of modern life would have different concerns and consequences from the representation of historical subject matter. A modern-life painting which "dramatizes" the position of the beholder creates a problematic consubstantiality between painter and beholder, and it conjures a world whose immediacy demands that the viewer enter the world of the painter, rather than the world represented by painting in general or one painting in particular. Furthermore, Manet's particular construction of the beholder refuses to confer a position of power on that viewer. In contrast to those readings of Manet that have either emphasized an overall empowerment of Manet's female figures or a perpetuation of a typically nineteenth-century male view of the social world, I would say that what is noteworthy in Manet's art is his multiplication of the possibilities of reading positions of gender, sexuality, and power in his highly charged images.[42]

Although looking at art can often involve meditations on the past or on the artist's life, viewing Manet's paintings, it would seem, brings on a particular ontological experience. The idea that Manet's art asks the viewer to enter the world of the painter has been a feature of several different—and even contradictory—art-historical approaches. If positivist social historians work from this assumption in order to investigate the fabric of everyday life, so too do those art historians who would proclaim their differences with social history. Not only has Michael Fried explored the notion of the beholder's being thrust into the staging of the pictorial action, but also a writer such as James H. Rubin, who sees Manet as a Mallarméan painter, has stressed the notion that the painter's arrangements of motifs inevitably leave telltale signs of their own cultivatedness.[43] Thus even writers not expressly interested in the social world around the artist find the viewer of Manet's paintings brought into the painter's studio or milieu in a very specific fashion.

If Manet's art thrusts the viewer into his world, we should take care to consider how we are to describe that world: that combination of modern Paris, fashionable society, artist friends, and various (recurring) marginal figures. I maintain that Manet's "world" was one populated by a recognizable cast of characters which comprised his family and friends. The famous jokes, visual puns, deliberate mistakes

Fig. 45. Édouard Manet, *Woman with a Parrot*, 1866. Oil on canvas, 72 7/8 x 50 5/8 in. (185.1 x 128.6 cm). The Metropolitan Museum of Art, New York. Gift of Erwin Davis, 1889 (89.21.3)

in his art, which have been the subject of so much criticism, are best described as references that could have had meaning or significance (not necessarily profound) within that circle. Once again, the painting of modern life, regardless of its public ambitions or consequences, begins as the painting of the family, and once painting takes it upon itself to represent the family, it assimilates the various social pressures (internal and external) on the family.

When Manet started to paint *Olympia*, he was painting a model, Victorine Meurent, whom he had already painted many times. She became a regular in his art, someone whom critics could recognize, someone who had already posed alongside his brothers. Théodore Duret remarked on her familiarity as an aspect of Manet's art that brought him criticism: "The face [in *Woman with a Parrot*, fig. 45] belonged to that type which recurs like a family likeness in Manet's portraits—one of his peculiarities which always exasperated the public."[44] Yet despite the fact that her recognizability remains consistent in Manet's portrayals of her, the artist's wish to transform her via many guises—from street singer, to model in dressing gown, to bullfighter—could be considered the paintings' central feature.

Although Victorine is easy to identify as the model of a suite of paintings—*The Street Singer*, *Portrait of Victorine Meurent* (fig. 46), *Mlle V. . . in the Costume of an Espada*, *Le Déjeuner sur l'herbe*, *Olympia*, *Woman with Guitar* (fig. 47), *Woman with a Parrot*, *The Railroad* (fig. 48), *The Croquet Party* (fig. 49)—she appears quite different in each. If Paul Mantz complained that in *The Street Singer*, "because of an abnormality we find deeply disturbing, the eye-brows lose their horizontal position and slide vertically down the nose, like two commas of shadow," in the *Portrait*, Victorine has clearly defined reddish eyebrows.[45] If in the *Olympia* she has jet-black pupils and black lashes (the latter with the aid of newly fashionable mascara), the *Portrait* reveals green eyes and blonde lashes. The lean, delicate oval of a face in *Woman with a Parrot* looks to be that of a woman several kilos lighter than that of the full-figured woman in *Déjeuner sur l'herbe*: Michael Fried points to the heavy, almost inexplicable "folds of flesh at the back of Victorine's neck" in *Le Déjeuner*.[46] The creamy, matte quality of her face in the *Portrait* and the *Woman with Guitar* contrasts with the more translucent spherical face in *The Railroad*; the full lips of *Mlle V.* and *Le Déjeuner* should be compared with the rather thin lips in the *Woman with a Parrot*. Even the cleft in her chin veers in different directions: in the *Portrait*, toward the left; in *Mlle V. . .*, toward the right.[47] Manet's transformations of Victorine, then, are not merely sartorial; by contrast, they extend into her very physiognomy and figure.

If Manet considerably altered Meurent's appearance from picture to picture, why would Duret associate "une marque de famille"—a family trait or likeness—not only with the pictures of Meurent, but with their uneven reception? What unites these pictures, not only with one another, but with Manet's art as a whole?

One would have to say that the most striking characteristic of these paintings is the gaze of Victorine Meurent: a gaze out of the painting and at the viewer, a gaze that registers the awareness of being seen by the viewer. This is without doubt the aspect of the paintings of Meurent that has engaged the attention of so many writers on Manet. It is true that a few figures in other paintings gaze compellingly out of the painting and at the viewer—one thinks of *The Old Musician*, for instance—and of

course individual Meurent pictures have companion pieces, if not pendants, in Manet's oeuvre: *Young Man in the Costume of a Majo*, *Young Woman Reclining, in Spanish Costume* (fig. 50), *Portrait of Jeanne Duval* (fig. 51). Yet above and beyond the paintings of similar styles, costumes, or expressions, there is one image whose kinship to the Meurent pictures perhaps best recalls Duret's "marque de famille": the *Portrait of the Artist's Mother*, probably executed in 1863 (fig. 13).

The portrait of Manet's mother shows her in mourning after her husband's death. The period

Fig. 46. Édouard Manet, *Portrait of Victorine Meurent*, 1862. Oil on canvas, 16 7/8 x 17 3/16 in. (42.9 x 43.7 cm). Museum of Fine Arts, Boston. Gift of Richard C. Paine in memory of his father, Robert Treat Paine II

Fig. 47. Édouard Manet,
Woman with Guitar, 1866.
Oil on canvas,
26 x 32 5/16 in. (66 x 82 cm).
The Hill-Stead Museum,
Farmington, Connecticut

Fig. 48. Édouard Manet,
The Railroad, 1872–73.
Oil on canvas, 36 3/4 x
45 1/8 in. (93 x 112 cm).
National Gallery of Art,
Washington, D.C. Gift of
Horace Havemeyer in
memory of his mother,
Louisine W. Havemeyer

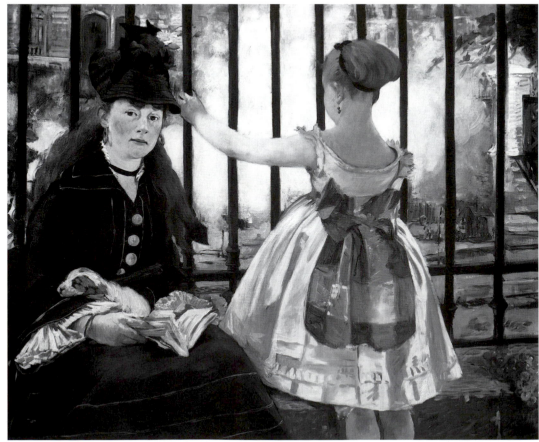

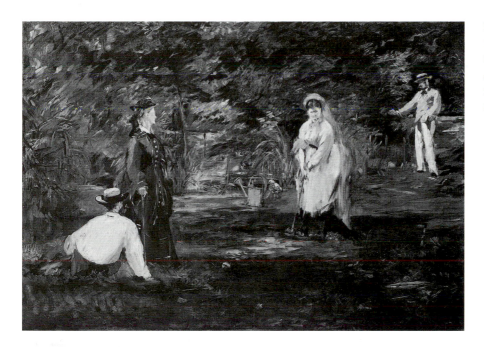

Fig. 49. Édouard Manet, *The Croquet Party*, 1873. Oil on canvas, 28 5/16 x 41 3/4 in. (72 x 106 cm). Städelsches Kunstinstitut, Frankfurt

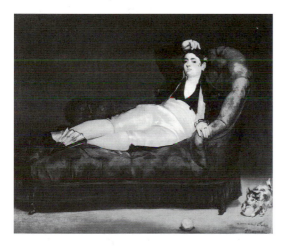

Fig. 50. Édouard Manet, *Young Woman Reclining, in Spanish Costume*, 1862. Oil on canvas, 37 x 44 1/2 in. (94 x 113 cm). Yale University Art Gallery, New Haven, Connecticut. Bequest of Stephen Carlton Clark, B.A. 1903

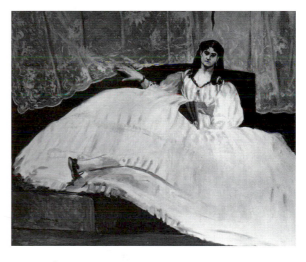

Fig. 51. Édouard Manet, *Portrait of Jeanne Duval*, 1862. Oil on canvas, 35 1/2 x 44 1/2 in. (90 x 113 cm). Szépmüvészeti Múzeum, Budapest

around and after the death of Manet's father was to be one of the most productive in his career, so it is no surprise that if the portrait were indeed painted in that period, it would bear some stylistic similarity to other key works from 1862–63. At the same time, a striking likeness emerges between the portraits of Meurent and that of his mother. Comparing *Mlle V. . . in the Costume of an Espada* to the *Portrait of the Artist's Mother*, a few details immediately come to the viewer's attention. Both have the same asymmetrical cleft in the chin; both have small folds at the corners of the mouth. Manet portrays their eyes and eyebrows in remarkably similar ways: there is a certain emphasis on the openness around the right eye—the skin is well-illuminated, the arch of the eyebrow is gentle; whereas the left eyebrow is shown with a more dramatic arch. As we have already noted the freedom with which Manet altered the darkness and shape of Meurent's eyebrows in different paintings, it stands to reason that the similarity here is a contrived one, which points to something in the nature of Manet's representations of each. (In other words, we should not concern ourselves overmuch with the question of their possible resemblance in real life.) The manner in which Manet shadows the underside of the chin, the manner in which he shapes the cheek and smudges the paint on the nose—all are points of genuine similarity. Although one might argue that these could all be devices which are simply characteristic of Manet's gestures, drawing, and paint handling, it should be remembered that no other female figure is represented in this way—not Suzanne Leenhoff, not Jeanne Duval, not the model for the *Woman in Spanish Costume*. Somehow, in painting the portrait of his mother, Manet came upon a highly personal mode for representing mourning, and he subtly incorporated aspects of this expression into the major paintings of Victorine Meurent, the model who for him came to epitomize modernity.

It is possible, of course, that one or more of the major paintings of Meurent had already been undertaken when the portrait of the mother was executed. Which representation came first hardly matters; the period of some of the major Meurent pictures coincides with the period of mourning after the father's death (the mourning being Manet's and his mother's). In *Le Déjeuner*, for example, one sees again the small creases at the corners of the mouth and the extra arch in the left brow. The creases are even more apparent in the *The Street Singer*, as the hand with the cherries blocks the view of most of the mouth. As in the portrait of the mother, the handling of the illumination of the face emphasizes the open area around the eye nearest the viewer. The cleft in the chin, so characteristic of the mother's portrait, can be seen again on Victorine in *Woman with Guitar*. If Mme Manet had relatively thin lips, one notes that Victorine appears to have them in the *Woman with a Parrot*. Out of this series emerges a certain expression, and with it, I would argue, a way of looking at women in modernity.

I have already touched on the significance of Victorine's wearing the same costume as Manet's brother, and most likely meeting the artist at the Palais de Justice, where Auguste Manet worked. On the surface, *Olympia* would seem to have little to add to this run of pictures. A resemblance between a costume piece and a mourning-portrait is one thing, but a nude courtesan? Yet *Olympia*'s role in the relationship between the portrayals of Victorine Meurent and Manet's mother is in fact pivotal. According to Julie Manet, the painter's niece, the bracelet worn by Manet's model in his infamous canvas was his mother's keepsake bracelet, which contained a lock of Édouard's baby hair.[48]

Olympia is wearing the mother's bracelet and posing in front of a chestnut wall or screen partition; it has gold trim. Beyond it, a heavy green curtain is drawn back. There is but one other painting by Manet in which we see this same configuration of wall decoration and drapery: in the *Portrait of the Artist's Parents*. Although there is no articulation of decoration on the wall or screen in the double portrait, the similarity of trim and curtain remains. Due to the paralysis of Manet's father when this picture was undertaken, it is likely that the artist painted them in their own home. It is possible, then, that the *Olympia* is not only wearing the mother's bracelet, but also posing in the family home (or in front of a studio arrangement that deliberately or not simulates the family home).

What to make of this Freudian situation? What is the significance of a resemblance between a favored model and the artist's mother, or of a controversial image of a nude prostitute who is wearing the mother's jewelry (that fetishizes the artist himself)? And what if this favored model is the central subject of a group of paintings undertaken at a feverish pace, many of them in the year or so after the father's death, in which the model appears in roles and costumes ranging from itinerant to courtesan to travestied bullfighter? What would Freud say?

Freud wrote compellingly about the little boy's discovery of the nature of the sexual act and the mother's "betrayal" of him for his father:

> Then, when he cannot any longer maintain the doubt that claims exception for his own parents from the ugly sexual behaviour of the rest of the world, he says to himself with cynical logic that the difference between his mother and a whore is after all not so very great, since at bottom they both do the same thing. [. . .] In the light of this new knowledge he begins to desire the mother herself and to hate the father anew for standing in his way; he comes, as we say, under the sway of the Oedipus complex. He does not forget that the mother has given the privilege of sexual intercourse with her to the father instead of to him, and he regards it as an act of infidelity on her part. If these feelings do not rapidly pass, there is only one way in which they can find an outlet—the way of phantasies, in which the mother is represented in sexual situations of the most manifold kind [. . .]. [P]hantasies of the mother's infidelity are by far the most favoured; the lover with whom the mother commits the act of unfaithfulness almost invariably bears the features of the boy himself [. . .].[49]

According to Freud, the boy who experiences the Oedipus complex first blames the mother for having already given herself to the father, hence degrading her to the status of whore, and then goes on to elaborate a series of fantasies in which the mother's "infidelity," now connected with desirability, is enacted in different scenarios. There is a direct connection between the realization of the father as rival and the invention of fantasies of the mother as a prostitute.

Freud's structures are clearly dependent on nineteenth-century European literature and culture, whence they derive their point of view, biases, and limitations with regard to gender, race, class, and sexual orientation. In many ways the ideal arena for their explanatory power is the literary or artistic work, and certainly the cultural productions of upper-class heterosexual men in major urban centers of later

nineteenth-century Europe would fit the bill. I bring up these issues not merely as political disclaimers, but rather to point to the very cultural developments which gave rise to Freud's ideas or myths. It would not be difficult to compare, for instance, the "taboo of incest" sensed by Frédéric Moreau upon Mme Arnoux's availability, a text of 1869, with Freud's text of 1910. Nor would it be particularly difficult to weave together Freud's text with Manet's painting of 1863.

If one wished to undertake a Freudian reading of Manet's *Olympia*, it might go something like this: the structure of beholding of Manet's nude is highly problematic and places the viewer in an awkward situation. The model appears to be covering herself mostly as an unwanted consequence of the viewer's presence; she is not made to appear at ease with her situation, which somehow implicates the viewer. The beholding of the model becomes an accidental and consequential sight: it becomes a primal scene—or if not an actual scene, then a primal fantasy, a staging of a sight of sexual activity, which unfolds onto the drama of sexual knowledge. Insofar as Manet's nude courtesan wears his mother's bracelet and emphatically covers her genital area, the scene could be described in Freudian terms as a fantasy of discovery of the mother's momentous "betrayal." Freud would have confirmed that the Friedian subject "sensed that he had been made supererogatory to a situation that ostensibly demanded his presence"; Freud would have added, I imagine, that just as Fried suspected, the viewer's place had indeed already been occupied—by the father.

A crucial role in this staging of a drama of sexual discovery is played by the maid. As she enters the room with the flowers, the nude looks out at the viewer. Since the gift of flowers appears to come from someone else (a previous customer), this tribute would most likely be seen as connected with payment for services rendered: the "gift," psychoanalytically speaking, is money. By virtue of her position in the room, her social position, and her activity, the maid is thus the purveyor of a very specialized kind of knowledge. A connection between the activities of the maid and the sexual awakening of the male child was certainly made easily enough in the nineteenth century. Freud also speculated that for many members of his own class, the source of the family romance fantasy was the female servant: "Where does the material for creating the romance— adultery, illegitimate child, and the like—come from? Usually from the lower social circles of servant girls. Such things are so common among them that one is never at a loss for material, and it is especially apt to occur if the seductress herself was a person in service."[50] Here, we not only see Freud's blatant class bias; we also see operative the notions of childhood seduction Freud had not yet overturned in favor of the Oedipus complex. The historian Anne Martin-Fugier exposes the myth, so prevalent in the nineteenth century, that the "corps étranger" of the maid was the root of evil in the family: she was the outsider who threatened to seduce the young boy or the husband.[51] In reality, as Martin-Fugier demonstrates, it was usually the young woman who was in danger of being seduced (if not raped) and impregnated by the males in the household.

Servants could play other key roles in the formation of family romance fantasies. A child's observation of a liaison between a parent and a servant could provoke a fantasy of one of the siblings' illegitimacy. It could also awaken feelings of guilt over the wish to reproach the parent or console the opposite-sex parent. Freud toyed with these notions, again equating lower social status with lower morality, in another letter to Fliess:

An immense load of guilt, with self-reproaches (for theft, abortion), is made possible by identification with these people of low morals who are so often remembered, in a sexual connection with father or brother, as worthless female material. And, as a result of the sublimation of these girls in fantasies, most improbable charges against other people are contained in the fantasies. Fear of prostitution (fear of being in the street alone), fear of a man hidden under the bed, and so on, also point in the direction of the servant girl. There is tragic justice in the circumstance that the family head's stooping to a maid-servant is atoned for by his daughter's self-abasement.[52]

According to Freud, the father's or brothers' dallying with the servants could bring on guilt and self-reproach in the daughter, who comes to associate sexuality with a social and familial delinquency. Such a scene observed by the young boy could in Freud's view also deepen Oedipal feelings for the mother who would have appeared to have been wronged by the father's indiscretion.

The fact that the servant is black is not inconsequential. The association in Caucasian European minds between African-ness and sexuality has been amply demonstrated. Sander Gilman notes the contemporaneity of the appalling literature on the so-called "Hottentot Venus," whose extremely large buttocks embodied the European notion of African sexual excess.[53] If servants were generally suspected of being purveyors of sexuality in bourgeois families, then a black servant was doubly likely to invoke such visions.

Yet it is the relationship between maid and mistress that is more significant in the case of *Olympia*. Their intimate proximity imitates a scenario found in many harem-fantasy photographs and pornographic lithographs in which the visual conceit was a contrast of skin tones and in which the ideological conceit was a carefully constructed hierarchy that suggested the white woman's well-tendedness with strong overtones of sensuality.[54] Insofar as the harem photographs *Olympia* emulates invoke not only a fantasy of an exotic land but also a European colonial household, we might consider the extent to which the very positing of the white woman's cultivation was contingent on a "supporting cast" of maids, governesses, and others, as Ann Stoler has persuasively argued.[55] For Stoler, Foucault's notion of the development of the nineteenth-century bourgeois self and its "technologies of sexuality" needs to be seen in relation to the conditions that provided its urgency, namely the proximity of colonial whites and native servants: "What is at issue in the discourse of sexuality is not only the unproblematic cultivation of a bourgeois self *already formed*, but [. . .] a more basic set of uncertainties about what it means to be bourgeois, about the permeability of its distinctions, and what constituted its vulnerabilities."[56] In Stoler's view, a context of imperialism and orientalism necessarily drives and underpins what Foucault saw as anxieties about bourgeois sexuality. The relation between the figures in *Olympia*, then, becomes more than a two-stepped hierarchy of class or race alone: it points to a larger instability in the culture, one that Clark's analysis of the painting's reception certainly indicates.

Perhaps it would clarify the relation between the figures in Manet's painting to look to its analogues in contemporary photography. Certain rhetorical devices typified the photograph of the white or light-skinned woman with the darker-skinned servant. The indolence and luxuriance of the central

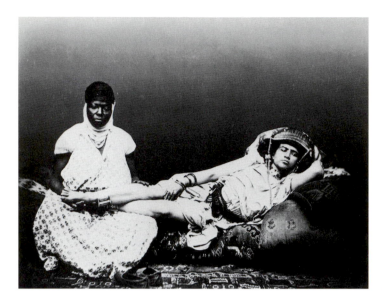

Fig. 52. F. Jacques Moulin, *A Moorish Woman with Her Maid*,
c. 1865. Albumen print, 7 1/8 x 8 31/32 in. (18.2 x 22.8 cm).
The J. Paul Getty Museum, Los Angeles

figure are made possible by the attendance-in-service of the other; the possible baseness of the nude is ameliorated, in nineteenth-century European thinking, by the lower social status of the maid. Yet it is not at all the case that the mistress was always a picture of radiant sensuality. In F. Jacques Moulin's photograph of two Algerian women (fig. 52), for instance, taken at about the same time as *Olympia*'s exhibition, the reclining figure almost scowls at the viewer while the black woman also gazes at the viewer, not at the mistress.[57] Moulin's photograph shows the harshness of the woman's look, the angularity of her body, the contrast between an exotic setting and a female figure who does not embody luxuriant sensuality. Manet's picture parallels Moulin's hardness and harshness in the reclining figure; Manet's maid figure, however, is a gentler presence than the dour maid in the Moulin. It is interesting to compare the two images in racial terms. Moulin pictures a black maid next to a Moorish woman; Manet's central figure is white. In nineteenth-century terms, the rhetorical device of the black maid might both stand for and deflect the reclining woman's potentially overabundant sexuality. Yet for a French audience, the Berber/Arab model in the Moulin would necessarily remain "other"; whatever sexuality is intimated by her pose, bare feet, and bare legs would be considered an attribute of her nonwhiteness. By contrast, Victorine's gaze is as direct as the Moorish woman's, and the maid in *Olympia* neither absorbs nor deflects the model's eroticism. The painting introduces racial questions without using race to soft-pedal the white woman's sexuality.

A Freudian reading of Manet's stark revelation of the nude's body could be connected with the painting's racial hierarchy and with the social history of the *embourgeoisement* of prostitution. If prostitution in nineteenth-century Paris included a distinct strand of workers and customers who were aping "fashionable adultery," as Corbin suggests, would it not make sense that a psychoanalytic reading of such cut-rate adultery involved a reenactment of desire for the original love object? Is it not the case that Freud's account of object choice reads like a description of the futility of the search for gratification in the arena of paid sex? Freud writes in his 1912 essay "The Most Prevalent Form of Degradation in Erotic Life":

> I think the possibility must be considered that something in the nature of the sexual instinct itself is
> unfavorable to the achievement of absolute gratification. When we think of the long and difficult evolu-

tion the instinct goes through, two factors to which this difficulty might be ascribed at once emerge. First, in consequence of the two "thrusts" of sexual development impelling toward choice of an object, together with the intervention of the incest-barrier between the two, the ultimate object selected is never the original one but only a surrogate for it. Psycho-analysis has shown us, however, that when the original object of an instinctual desire becomes lost in consequence of repression, it is often replaced by an endless series of substitute-objects, none of which ever give full satisfaction.[58]

If Manet's painting can be seen as courting the incest-barrier, it is not hard to reconcile the representation of a known model as a courtesan with Freud's notion of the substitute-object. Indeed, it is almost banal.

Yet, the banality of the Freudian hypothesis, the tiresomeness by which that thesis must be buttressed with claims about its racism and sexism, its suitability to a limited range of European myths—these are, in a sense, the least of its problems. A viewer unconvinced by the represented resemblance between Victorine Meurent and Manet's mother would wonder why the issue of the boy's devastation over the mother's "betrayal" needs to be broached. A reader more interested in the female model's point of view (or the servant's, or the cat's) would disregard the phallocentric Freudian construction of the primal fantasy, based as it is on a notion of the boy's fear of castration.[59] A historian might validate the adduced sociological texts that embroider the myth of the married woman turning to prostitution, or the literary texts that construe the sexual appeal of a woman fantasized as a mother, or even assorted keepsake bracelets with (undoubtedly fetishized) locks of baby hair; yet that historian might feel uneasy about joining these bits of cultural evidence to a narrative which is itself a dated piece of mythography. In other words, psychoanalysis might be a powerful hermeneutic tool, but if its scientific basis is either irrelevant (because we are analyzing a painting, not an artist-patient), or discredited—or both—how can it possibly play a role in an art-historical account of the painting's genesis?

Before answering this question, I would like to turn to another nineteenth-century text, one composed by Balzac in 1843. This text has been acknowledged for some time as a possible source for the title of Manet's *Olympia*: one of several, to be sure, but one of those sources mentioned and not much examined.[60] It is not a legitimate *text*, even in the current polysemous sense of the word, but a fragment, a parody, a ruse, a contrived bit of literary debris, which makes its appearance about halfway through *La Muse du département*.[61] The novel itself is the story of a provincial literary woman, Dinah de La Baudraye (née Piédefer), into whose Sancerre salon enter two native sons, now sophisticated Parisians: a doctor named Bianchon and a writer named Étienne Lousteau.[62] At a pivotal point in the novel, the writer Lousteau intends to show off a set of printer's proofs for his latest review to the assembly of regulars to the La Baudraye soirées. He finds that his proofs have arrived wrapped in the waste-pages of a romance novel called *Olympia, ou les vengeances romaines*. He begins to read a page from the novel to the group.

The Parisian writer's reading of *Olympia* turns into a parlor game. Pages are missing. Printer's marks reveal that it is a second edition (a commercial success, then). Vignettes and gaps interrupt the

narrative flow. Lousteau discourses on the shortcomings of character development and other stylistic devices in the literature of the Empire. Bianchon puts forth medically informed hypotheses about the ages, personalities, and health of the characters. Dinah de La Baudraye deduces key motives and urges on the reading, while the remaining provincials mostly gasp in astonishment or remain perplexed by the fragment.

The first page of the novel heard is numbered 204, and it allows a glimpse of the movements of a bandit named Rinaldo. The next scene (actually page 197) reveals Olympia, the duchess of Bracciano, and a lover named Adolphe. Olympia's beauty and coquetry are established. Rinaldo manages to steal a key from the duchess, as he is intent on stealing the Bracciano treasure. But what he finds securely locked away is not ducal gold but the duke himself. With a final, dramatic run of consecutive pages, the Sancerrois are treated to a breathtaking revelation of Olympia's imprisonment of a husband who had discovered her adultery. She had maintained him in confinement for some thirty months in a carefully rigged cage below her bedroom. Every night the husband was mechanically raised from the cage, fed, and made to behold her regally in bed with her lover. The last available page (labeled "Conclusion") has the duke freed and ready for his own revenge as he mounts to the bedroom:

CONCLUSION

Never had the duchess been so pretty; she issued from her bath clothed like a goddess, and seeing Adolphe lying voluptuously on piles of cushions:

234 OLYMPIA,

"You are very beautiful," she said to him.

"And you, Olympia!—

"You love me still?"

"Always better," he said.

"Ah! It is only the French who know how to love!" cried the duchess.—"Will you love me well tonight?"[63]

The fragment continues with ambiguous clues as to the husband's possible revenge. In this novel-within-a-novel, "Olympia" is a married woman (and no "femme de l'ébéniste," one might add) who engineers a very particular structure of beholding for her own adulterous acts.

It is certainly likely that Balzac's fragment is a very real source for Manet's painting. Ultimately, the character in Balzac, as Theodore Reff suggests, herself has sources in various accounts of La Dona Olympia, the Renaissance courtesan and corrupter of popes.[64] Even so, however, I am less interested in these other versions than in what the *reading* of the fragment provokes, in the novel itself and in the space around it. Only after Balzac's characters react to this tale do Bianchon and Lousteau read the susceptibility of Dinah to Lousteau's advances. The novelistic tale of adultery precedes the real tale of adultery, in which Dinah follows Lousteau to Paris and has two illegitimate children by him. Ill-treated

by the writer, she ultimately returns to her husband, who will accept paternity of the offspring.

Dinah's "corruption" by the novel emblematizes the real concerns of legislators and moralists in the period. *La Muse du département* was the subject of government debate about morality in the serial novel.[65] The scene that most troubled the censorship-minded in 1843 was one which closely follows the reading of the *Olympia* fragment: a scene in which Dinah de La Baudraye and Étienne Lousteau are alone in a carriage.[66] Lousteau realizes that Dinah is wearing a dress made of organdy, the only fabric that, once wrinkled, can never be properly restored. He reads this as a resistance on her part to advances he has not yet even made. Sensing that a young male admirer of Dinah's was close at hand (on horseback), he mischievously rumples her dress to create the appearance of impropriety. He later delights in colluding with her over the cover-up. This scene would certainly have been a reference point for Flaubert's *Madame Bovary*, in which the carriage ride is a genuine scene of lovemaking witnessable only through Léon's command to the driver on the other side of the curtain ("Drive on!").

During the Second Republic debates on morality and literature, Baudelaire expressed his admiration for Balzac.[67] In "Les Drames et les romans honnêtes," a text published in direct response to moralizing attacks on Balzac in *La Semaine Théâtrale*, he mentions *La Muse du département* and makes the arguments he will later make in defense of *Madame Bovary* after its obscenity trial in 1857: namely, that it was up to the reader to supply his own philosophical and religious guidelines, while it was the duty of the artist "to depict vices as they are, or not to look at them at all."[68] In the censorious artistic climate of mid-century Paris, this became a basic tenet for proponents of art that dealt with modern life.

Art itself is a subject for Balzac in *La Muse*, as it would be for Flaubert in *Madame Bovary*. If *Olympia, ou les vengeances romaines* were not built around certain clichés and conventions of the genre, then reading a few random pages out of it would not be an entertaining parlor game. The figure of the artist-writer Lousteau must be constructed as one who can fancy himself superior to this level of art. Likewise the very genre of the romance novel affects and effects the narrative (and by implication, contemporary society). In *Madame Bovary*, the romance novel could be cited as a cause for a relatively simple woman's dissatisfaction with life and her "descent" into adultery; in *La Muse*, the romance novel already occasions a clever man's way of testing the waters with a married woman (who is not duped by novels, as Emma Bovary will be, but who is duped by a man who understands their conventions). The idea of seduction through literature is certainly central to *La Muse*, and the seduction works, curiously enough, through a group dynamic of the reading of the fragment. As William Paulson points out, the soirée reading of *Olympia* devolves into a dialogue among Lousteau, Bianchon, and Dinah de La Baudraye.[69] As the other provincial attendees are unable to piece together the story, to unravel the clues provided by illustrations and page numbers, to fill in the missing stock descriptions of locales, or to speculate about the characters' relationships, the reading in fact separates Dinah from the other Sancerrois. She will become convinced that Paris is the place for her literary ambitions, and she will leave her husband on account of this. The group reading of *Olympia* opens up a space of interpretation, the exercise of which will separate insiders and outsiders, those who understand and those who do not.

Manet may well have recalled the curious duchess who is beheld, perhaps for the last time, by her lover stretched out on piles of cushions and by her husband, who enters the bedchamber with dagger in hand and revenge in mind. The Parisian painter may well have been aware of prostitutes who made it part of their stock in trade to imitate the kept woman in the homey, bourgeois interior. Yet he was almost certainly building enough visual and referential ambiguity into his painting that it would surely become a precarious construction suggestive of prostitution, the nude, adultery, the fantasy photograph, and a quality perhaps best summarized by the Baudelairean phrase (quoted by one of Manet's critics): "C'est l'esprit familier du lieu."[70] Just as Balzac's novel-within-a-novel actually shapes a space of reading, Manet's painting opens up an interpretative space around it. The viewing of *Olympia* at the Salon of 1865 would become a kind of reenactment of the reading of the *Olympia* fragment at the La Baudraye Salon. Some critics produced the names Goya, Poe, Baudelaire; some only invoked "the horror of the morgue"; some, like the provincial prosecutor's wife, only expressed shock and astonishment. If the structure of beholding in Manet's *Olympia* re-creates the scenes of voyeurism and discovery in Balzac's *Olympia*, it would do so insofar as Manet creates a space for beholding, a space for interpreting.

Yet unlike Balzac's "Olympia," who emerges radiant from the bath, Manet's "Olympia" was seen as never having bathed. Bertall's caricature in *L'Illustration*, "La Queue du chat, ou La Charbonnière des Batignolles" (fig. 53) would spell that out: "Everyone is admiring this beautiful coal-woman, whose modest outlines have never been outraged by water, that banal liquid."[71] Bertall's potent drawing includes a pipe stashed under the pillow, a chamber-pot under the bed, and a cat who might be up to more than arching its back. "*Olympia*'s" hand looks distinctly as if it bears the impression of more wayward activities than a mere gesture of modesty. The grostesquely caricatured maid brings in a huge tribute of flowers wrapped in *Le Grand Journal*, accompanied—as T. J. Clark has shown—by a *commandement*, a court order.[72]

La queue du chat, ou la charbonnière des Batignolles.
Chacun admire cette belle charbonnière, dont l'eau, liquide banal, n'a jamais offensé les pudiques contours. Disons-le hardiment, la charbonnière, le bouquet dans du papier, M. Manet, et son chat, sont les lions de l'exposition de 1865. Un bravo senti pour M. Zacharie Astruc.

Fig. 53. Bertall, caricature of Olympia "La Queue du chat, ou la charbonnière des Batignolles," 1865. Wood engraving, reproduced in *L'Illustration*, 3 June 1865

Property owners could obtain a summary order injunction if they had proof that a tenant was a registered prostitute or had sublet to a prostitute, a vagabond, or other *malfaiteur*.[73] The order, which followed a set form, authorized landlords to expel prostitutes, to place their belongings on the street (or to withhold them until all rent was paid), and to install new tenants in the meantime. Bertall was not making

that up. Whether or not any readers of *L'Illustration* could have pondered that the putative landlord would have applied to the Tribunal de la Première Instance, where Auguste Manet sat in civil chambers until 1857, for the desired *ordonnance de référé*—well, that card should perhaps be reshuffled into the Freudian deck.

I tell you all this because I know you well,
my son. These things one does not tell the
public, nor the notary, nor the parish priest.
That done, everybody knows it, but don't
speak of this except in utter necessity. So, no
strangers in on the secret, no one but the
family, because the family is all of us in one.
You understand?
Yes, father.
You promise?
Yes, father.
You swear?
Yes, father.
I pray you, I beg of you, son, don't forget.
I am holding you to it.

Guy de Maupassant, "Hautot père et fils"

A well-known man just married his mistress'
sister. That way, he's going to legitimize his nieces!

Le Lorgnon, Journal d'Aurélien Scholl, *1869*

IF SOCIETY COLUMNISTS found humor in the topic of the legitimation of bastard children, it
is perhaps an indication of the topic's currency in 1869.[1] Discussion of it was hardly unique to
that year, however; "le mythe de la paternité" can be seen as a theme that runs all through Balzac's
La Comédie humaine, for instance.[2] Rumor had it that Napoleon III himself was not a Bonaparte at
all.[3] Illegitimacy, though, was rarely an easy social matter in the nineteenth century. Even a wealthy
family, which might have had little trouble with the financial support of an illegitimate child, faced
the problems of damage to reputation. Finding themselves in this situation, the Manets confronted
it by presenting society with what Anne Higonnet calls "an unbreachable front."[4]

 Léon Koëlla, called Leenhoff (1852–1927) had a prominent place in Manet's art. Léon was one of
Manet's most frequent models, from the earliest pictures through the mid-1870s. Unlike models such as

Eugène Manet and Victorine Meurent, and young boys such as Alexandre, Léon never appeared as a bohemian or low-life type: as a boy, he posed in seventeenth-century costume; as a young man, he posed as a dandy, in dignified attire. Although Édouard Manet married Léon's mother, Suzanne Leenhoff, in 1863, Léon Leenhoff was never recognized as a Manet. I would like to consider some legal and circumstantial evidence to support the allegation, published sometime ago, that Auguste Manet fathered Léon. Like Maupassant's Hautot *fils*, with Édouard stepping into the role of godfather and unofficial guardian of Léon, the place of Léon in the Manet family drama becomes highly charged with the ambivalence characteristic of the situation's Oedipal implications.[5]

In the latter part of the chapter, I would like to consider more general issues of the portrayal of sons and fathers in Manet's art. The artist's religious pictures, for example, consistently feature the theme of Christ's Passion, or Jesus' confrontation with his mission as the son of God. I would also like to consider the theme of Hamlet and the father's ghost, as it emerges in Manet's art in the Baudelairean mid-1860s, and then again more than a decade later. For Manet, the theme of Hamlet involves an explicitly Baudelairian engagement with the Oedipal theme of the struggle with the specter of the father.

The literature on Manet has been almost univocal in its presumption that Édouard Manet probably fathered Léon Leenhoff but wished not to acknowledge the paternity. A brief review of the legal aspects of legitimation, however, calls this assumption into question.[6] The Napoleonic Code had ample accommodations for the legitimation of a child whose parents married after his birth (the "marriage of reparation"):

> Marriage alone legitimizes the child previously recognized by one of the conjugal pair, and indicated on the birth certificate as the issue of the spouse, if annexed to this indication are the facts in proof of the child's civil status as being that of the spouse.[7]

As one study puts it: "A natural, non-adulterine child could be legitimated by subsequent marriage and was from then on placed on the same footing as legitimate children."[8] To cite an example that illustrates this provision: the Paris court of appeals declared Pierre-Napoléon Fleu—— to have been legitimized by the subsequent marriage of his parents, Denis-Noël Fleu—— and Valentine Coz, in 1846.[9] The provision that both parents must recognize the child exempted men from paternity suits based on *creditur virgini*, or the mother's declaration of paternity.[10]

The Napoleonic Code also prohibited paternal filiation proceedings, or *recherche de la paternité*.[11] Whereas in the *ancien régime*, bastards were openly acknowledged, for they stood to gain no inheritance, the civil code instituted the possibility of inheritance once paternity was established. Behind this thinking, there was a perceived need to protect "honorable" men from scandal, which is another way of saying that dishonorable men only had to disavow paternity in order to guarantee their freedom from responsibility. As Marie-Josèphe Gebler observes, this aspect of the Napoleonic Code was clearly written to address the status of the children of single women and married men.[12]

The abolition of privilege and primogeniture, which originated as an attempt to create a more democratic system of property inheritance, led to a system in which a different kind of privilege, or "private law," was operative. The protection of property and rights of succession led to a peculiarly nineteenth-century secrecy about the illegitimate. A man of means could see to it that his name did not appear on the birth certificate of his bastard child and that no one discovered the paternity. He was supported by a legal system that saw paternity as impossible to establish with certainty and that ignored allegations of the mother and of the child unless some written proof existed. "How does one penetrate the impenetrable secret of nature?" reads the legal text: "We understand that it is impossible to establish positive proof of the mysterious fact of paternity [. . .]."[13]

The kinds of paternity suits that did come before the civil tribunal involved issues such as defaulted promises of marriage or financial support, allegations of adultery, or putative physical or mental conditions that may have interfered with the soundness of the marriage or birth certificate. Women who had been wronged and unsupported illegitimate children had few legal avenues for their grievances.[14] The situation is directly linked to the post-Revolutionary system of inheritance.

According to the civil code, in the absence of a will, property was transferred to the offspring, not to the surviving spouse. In the absence of legitimate offspring, property was transmitted to the husband's blood relatives up to the twelfth degree, which is to say following a direct line of descent or ascent to a common ancestor. Under such a system, not only would paternity research encroach on the inheritance of a man's legitimate offspring, but also on that of a female spouse who was named in a will.

In the case of the Manets, who were very well-off financially, the principal problem posed by the birth of Léon Leenhoff was its potential to tarnish Auguste Manet's reputation as a civil judge. It is not hard to imagine how such a social scandal could have brought dishonor to the name of one whose duty was to rule on just such issues, and the attitude of the magistrature in the nineteenth century, which to some extent persists, was that the profession itself had to be protected from scandal.[15] The fact that the paternity was not socially acknowledged, even decades after Auguste Manet's death, attests to the seriousness of the potential allegation. Although we have no record of animosity between the Manets and Suzanne Leenhoff's family, and although the legal system carried heavy biases in favor of the adulterous male, it would be foolhardy to ignore the potential for charges of criminal wrongdoing. The Code Pénal assessed heavy sentences on persons in positions of public, religious, or familial authority who were found guilty of raping or molesting someone under their jurisdiction.

Édouard Manet's will is interesting in light of what we believe to be Léon's paternity. Had no will existed, Édouard's estate would have been divided among his legitimate brothers. Had Édouard legitimized Léon—which, had he been Léon's natural father, would have been almost automatic upon his marriage to Suzanne—his estate would have passed to Léon. In his will, Édouard does leave his residuary estate to Suzanne Leenhoff with the stated understanding that she would in turn bequeath it to Léon. The will, in part, reads:

> I hereby appoint Suzanne Leenhoff, my lawful wife, as my general devisee and legatee. She will

bequeath, by testament, everything I have left to her to Léon Koëlla, called Leenhoff, who has cared for me most devotedly, and I believe that my brothers will find these dispositions quite natural. A sale of pictures [. . .] From the total proceeds of the sale of my pictures will be deducted a sum of 50,000 francs which will be given to Léon Koëlla, called Leenhoff. The rest will go to Suzanne Leenhoff, my wife. [. . .] If I die before my properties at Gennevilliers are sold, I would like for my wife to continue to live with my mother. [. . .] Drawn up in Paris and completely written in my hand, 30 September 1882. Édouard MANET. It is agreed that Suzanne Leenhoff, my wife, will leave by testament to Léon Koëlla, called Leenhoff, the estate I have left to her.[16]

One does not have to strain to hear the repeated provisions for Léon Leenhoff, and the fact that his brothers, who were well-off financially, would "find these dispositions quite natural." The language in itself proves nothing, but it is suggestive in light of the fact that it would not have been difficult, or scandalous in Manet's artistic circle, for Édouard to legitimize Léon. Leon's care for Édouard notwithstanding, the will, it seems, gives Léon the share of the Manet property he could not inherit from Auguste.

If Léon were Édouard's son, nothing would have stood in the way of his legitimization, even before the marriage. At the time of Léon's birth, for instance, when Édouard was technically a minor, such an acknowledgment would have been possible, since minors could be named as fathers of the illegitimate (or *enfants naturels*).[17] And what, one wonders, would a well-to-do, twenty-year-old art student have to lose by allowing his name on the birth certificate? It is clear from the will that Édouard wanted to provide for Léon, and rights of succession were a principle point involved in the establishment of paternity.

It is possible, however, that Léon was not eligible for legitimization. According to the Napoleonic Code, Article 331, children who were the offspring of adulterous or incestuous unions could *never* be legitimized, even upon the subsequent marriage of the parents.[18] Adulterine children were defined as such if one of the parents were lawfully married to someone besides the child's other parent, at least three hundred days prior to his or her birth. The existence of such children was seen in the eyes of the law as "a violation of the moral laws on which societies rest," and "a ceaseless protest against the sanctity of marriage"; as such, they were denied many of the rights of the legitimate.[19] This law did not change until 1955, when adulterine children were finally given the legal rights to establish paternity, with accompanying benefits such as the right to receive child support.[20] The fact that Léon was not legitimized even as he was well taken care of by the Manets suggests that legitimation may have been impossible; the civil code was hard on adulterers who wanted to recognize and take care of illegitimate children.[21] This circumstantial evidence, in my view, points to Auguste as the father. Even if Manet *père* had wanted to claim Léon as his son, such an avowal would not only have been a social and professional disaster: it would also have been legally null and void.[22] Such children could not legally inherit, and even a will that proclaimed paternity and legacy could be nullified under the provision of "false or illicit cause."[23] The only allowance made was for provisions in a will for child support (*legs d'aliments*),

including the bequeathal of property whose value did not exceed that of a support settlement. This was considered the relief of the adulterer's conscience and was protected by law.[24] Édouard Manet's careful provisions for Léon in his will make no reference to Léon's parentage. Manet's father was stricken with aphasic paralysis from the time when Léon was not yet six, and this may have made any deathbed confessions or changes in the will impossible.

What of the hypothesis that Édouard Manet needed or wished to conceal a liaison with Suzanne Leenhoff from his father? This supposition animates most accounts which assume that the painter was the unacknowledged father of Léon. An excellent comparison would be Paul Cézanne, who hid his relationship with Hortense Fiquet from his father out of fear that he might be disinherited. When the son of Paul Cézanne and Hortense Fiquet was born in Paris, the artist was named as the boy's father in the registry of births.[25] If Manet were aiming for discretion on his own behalf, it would seem that his main focus would have been to keep Suzanne and Léon away from the family (which appears not to have

happened). In that case, as in Cézanne's, Manet would probably have sought a way to move his clandestine family away from Paris, and he would probably not have withheld his name from the birth certificate. Instead we find Manet never (legally or socially) recognizing Léon well into his marriage to Suzanne, and sometimes even confessing to friends that the couple wished for a child of their own. Many writers on Manet, since Zola's first writings on the artist, have stressed his maintenance of a façade of respectability. For a man in Manet's position in the nineteenth century, such a concern would have led to legitimation, not artful dodging.

The name "Koëlla" on Léon's birth certificate has long been regarded by art historians as false. In fact, on the birth certificates of the illegitimate, the substitution of another name in place of the father's could be validated by the civil tribunal.[26] A widow, on the other hand, was powerless to remove her late husband's name from birth certificates of legitimate or illegitimate children he recognized.[27]

In Manet's work, Léon is the Manet-that-wasn't; he is like a foundling whose appearances in Manet's reworkings of the Old Masters are part of a distinct campaign to "legitimize" him artistically. Manet's depictions of Léon in costume pieces after

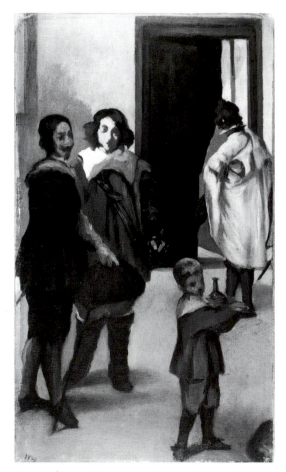

Fig. 54. Édouard Manet, *Spanish Cavaliers and Boy with a Tray*, c. 1860. Oil on canvas, 17 3/4 x 10 1/4 in. (45 x 26 cm). Musée des Beaux-Arts, Lyons

Rubens, Velázquez, Goya, and Chardin are, I hope to demonstrate, distinct from the parodic travesties such as *Mlle V . . . in the Costume of an Espada*. Léon is also a frequent spectator: he is the young man who attends the races, the Universal Exposition, croquet parties, luncheons at Manet's studio. These roles make him the quintessential male figure in Manet's work: he dresses up, shows up at a particular place, and usually gazes out of the picture but away from the viewer of the picture. Manet included or featured him in at least seventeen canvases; as a model he surpasses Suzanne Leenhoff and Victorine Meurent in the number of appearances.

Manet's paintings of Léon Leenhoff are clustered in three brief periods in Manet's work: 1859–62 (four canvases), when Léon was between seven and ten years old; 1867–69 (eight canvases), when he made the transition from boarding student to employee; and 1871–72 (five canvases), when Léon was about twenty. The Franco-Prussian War of 1870, in which Manet fought, and the tumultuous period of the Commune of 1871 had strong negative effects on his work. Dating Manet's scarce output in this time is difficult; we do know he produced only a few drawings and lithographs of the war experience and nothing at all for a time. Some of Manet's earliest canvases after the wartime hiatus are of Léon and Suzanne in interior settings. Léon, then, figures prominently in several phases of Manet's work, beginning with early paintings after the Old Masters, and the post-war period of work can in one sense be characterized by the figure of Léon as a reference point.

Spanish Cavaliers and Boy with a Tray (fig. 54) may have been done as early as 1859, although some chronologists place it at 1860.[28] The painting is loosely based on Manet's various etchings (see fig. 34) after a painting thought to be by Velázquez. In the Lyons canvas, Léon Leenhoff poses in the foreground, carrying a tray with a carafe. He wears knickers, a tunic, and a large white collar. This motif, taken from Zurbarán's *Circumcision of Christ* (fig. 55, Musée de Grenoble; formerly in the Pourtalès Gallery in the Louvre during the reign of Louis-Philippe),[29] as well as Titian's *Girl with a Fruit Dish*,[30] would recur in the 1868 painting *The Balcony*. Léon wears the

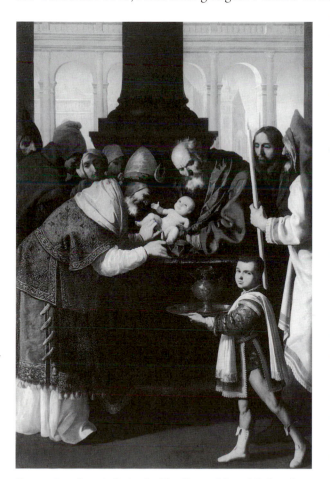

Fig. 55. Francisco de Zurbarán, *The Circumcision of Christ*, 1639. Oil on canvas, 102 3/4 x 68 15/16 in. (261 x 175 cm). Musée de Grenoble

same costume in *Boy with a Sword* and in *La Musique aux Tuileries*. At the time Manet painted the *Spanish Cavaliers* and the *Boy with a Sword*, he was also copying Delacroix, Titian, Tintoretto, Rembrandt, Brouwer, and other artists. These "copies" in many ways bear the imprint of Couture's teaching: they exhibit Couture's technique of working from a middle-value earth-tone ground both to darks and to lights, a procedure that accounts in part for the strong value contrasts present.[31] As might be expected, the studies look very much like Manets: they exhibit heavy impasto and a stasis of pose that would become hallmarks of Manet's early style.[32] But *Cavaliers*, unlike other copies, is perhaps the earliest painting in which Manet used a known model to pose in a copy of an Old Master painting. The device, notorious in *Le Déjeuner sur l'herbe*, appears to have had its origins in the representation of Léon Leenhoff.[33]

Much has been said about Manet's early paintings that involve the placement of a known model in a pose from an Old Master painting: the focus is usually on *Le Déjeuner sur l'herbe* and *Olympia*, the two paintings that center on the nude Victorine Meurent and her provocative gaze. The early nude painting of Suzanne Leenhoff, *La Nymphe surprise*, is another such example. These paintings are considered landmarks in Manet's discovery of his own version of the painting of modern life, as the model Victorine Meurent, her gaze and pose, gradually claim more of the spectator's interest than the Old Master inspiration. *La Nymphe*, we might recall, has been described by Rosalind Krauss as exemplifying an elimination of narrative devices in favor of a modernist focus on the spectator-model relationship.[34] Yet this is surely only part of what interested Manet. His early copies of Fra Filippo Lippi, Andrea del Sarto, Tintoretto, Rubens, and of course, Velázquez, attest to the fact that in some cases Manet sought specifically to imitate the figure's gaze out of the painting. The early adaptations of figure types from Goya, Watteau, and Murillo likewise emulate those masters' handling of the figure who gazes out of the painting.

Manet's early paintings of Léon demonstrate not that Manet was searching for an available accessory in his striving to move away from dependence on Old Masters toward a painting of modernity; on the contrary, in the paintings of Léon, we see the way modernity itself is inscribed by the kinds of private laws exemplified by Léon's place in the Manet family drama. In other words, it is not out of Manet's desire to free himself from the Old Masters that he chooses to paint Léon Leenhoff; rather, it is out of Manet's painting of Léon Leenhoff in compositions after the Old Masters that his version of modernity is envisioned.

In the first group of pictures of Léon, done between 1859 and 1862, Léon poses in seventeenth-century costume. Léon's costumed appearance can be seen as connoting nobility and legitimation, but with plenty of room for ambivalence. Like Victorine's cross-dressing and her costumed appearances as a low-life or prostitute, the noble costume of Léon presents contradictory possibilities: the costume might ennoble even as it is obviously fake, obviously a masquerade. In the *Spanish Cavaliers and Boy with a Tray*, the cavalier at far left appears to be pointing to and looking at the boy with the tray. The cavalier's pointing hand is in fact holding a hat. The figure is taken from the *Little Cavaliers* etching retouched with watercolor: there, he faces left and holds his hat in the air. Fourth from right in the

Little Cavaliers, he stands between the two figures who also appear in the Lyons canvas: the rose-cloaked figure (reversed in the Lyons picture) and the man in red who stares out of the picture and into the viewer's space. In the Lyons canvas, then, the glance and gesture of the figure at the far left, who stands close to the figure looking out of the picture, make it appear as if the two men are talking about the boy with the tray. The boy can be seen either as a costumed member of the nobility or as a misfit seen as such by the cavaliers.

Ambivalence is central to Léon's appearances in *La Musique aux Tuileries* and *La Pêche*. In *La Musique*, the figure of Léon leaning toward the widowed Mme Auguste Manet can be seen as seeking refuge from the comments of the two older girls walking past. In *La Pêche*, Léon is isolated, and in a position to be looked at and talked about by the other figures, although only the dog looks in his

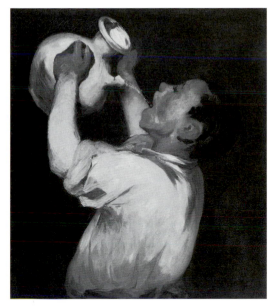

Fig. 56. Édouard Manet, *The Guzzler*, 1862. Oil on canvas, 22 7/16 x 16 15/16 in. (57 x 43 cm). The Art Institute of Chicago. Bequest of Katharine Dexter McCormick (1968.303)

direction. In light of the awkwardness of Léon's position in the real family drama, these compositional choices are significant. The early multifigure pictures that include Léon all position him among others who point, whisper, and rebuff.

Léon is the focus of *Boy with a Sword*, the large painting that was so well-liked by Zola. Here, it would seem, Manet follows in the footsteps of the court portraiture of Velázquez and Goya, who both did large-scale portraits of royal children. It might seem as if this dignified presentation of the costumed Léon would stand in marked contrast to the readings proposed above for the multifigure pictures. Yet in a comparison of *Boy with a Sword* with the other paintings of small boys in Manet's early work—*Boy with Dog*, *Boy with Cherries*, the beggar boys in *The Old Musician*, *The Guzzler* (fig. 56, a fragment from the destroyed canvas *The Gypsies*)—*Boy with a Sword* stands alone.[35] Of all the other pictures, one could say "boys will be boys": they are mischievous, possibly low-life types; they tease, hide, steal, beg; they are careless with the food and drink they proffer. In the Metropolitan Museum canvas, by contrast, Léon timidly (but not sheepishly) tries for his part to hold the sword erect and to pose properly. The costume and tone are serious. He is not self-consciously showing off or playing a game with the viewer: he wears a costume and holds an impressive sword, but he is not asking the viewer to look at what a big boy he is. It is as if he is trying—too hard—to do what the artist is asking him to do. To do as he was told was very much the real-life story of Léon, called Leenhoff: in society he had to pretend he was his mother's brother. *Boy with a Sword* has a further irony. To carry a sword had been one of the honorific privileges of the nobility.[36] Whether or not bastards were entitled to any offices or dignities of their noble parents

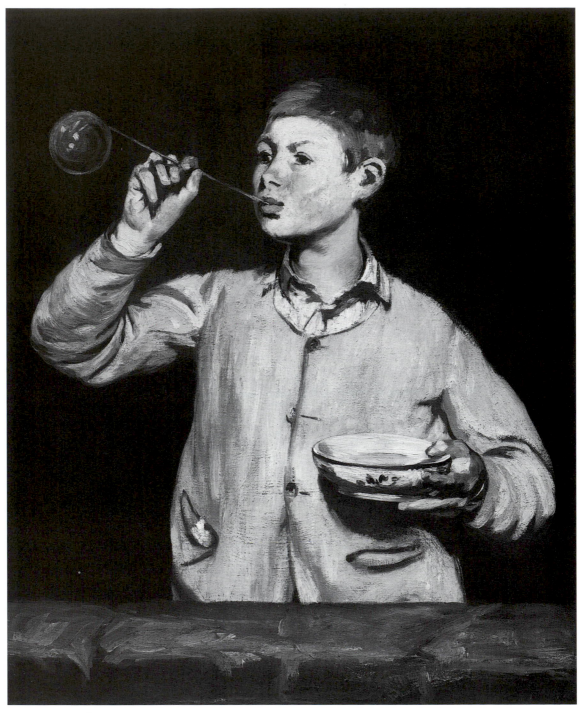

Fig. 57. Édouard Manet, *Boy Blowing Soap Bubbles*, 1867. Oil on canvas, 39 5/8 x 32 in. (100.5 x 81.4 cm). Museu Calouste Gulbenkian, Lisbon

was, like so many aspects of nineteenth-century nobility, debatable.[37] For Édouard Manet, who came from a long line of *gens de robe*, to paint the illegitimate Léon carrying the sword that does not fit him is an irony very much in keeping with the other early depictions of Léon.

Boy with a Sword makes use of a pictorial structure usually deployed for portraits of young heirs to the throne. The work's tonality, as has often been said, makes it an homage to Velázquez.[38] Yet there is a possible contemporary reference, which has been overlooked. Léon Leenhoff was born in 1852, the year of Napoleon III's imperial proclamation and the *senatus consultam* that established the Second Empire and sanctioned Louis Napoleon as Emperor of the French.[39] The Napoleonic lineage would henceforth shift to him and to his heirs. The right to the throne of Louis Napoleon's son was officially validated but still subject to question, as Anne Wagner argues in her analysis of Carpeaux's portrait of the imperial prince of 1865.[40] Insofar as Manet's portrait of Léon holding a sword suggests the status of a young prince, with the sword clearly too large for its bearer, Manet may be making a veiled comment on a lack of imperial legitimacy as well as finding a private visual language for Léon's ambiguous status in the Manet family.

After these pictures were executed, Manet married Suzanne Leenhoff, and Léon was sent to boarding school. The next group of pictures was done when Léon returned from school and started to work, when the boy was between fifteen and seventeen years of age. These pictures are quite varied, and Léon appears as a boy in some and as a young adult in others. Quite out of keeping with his age and probable physique, for instance, he appears in the background of *The Balcony* as the familiar boy with a tray; Manet was likely to have been working from the older painting, the etching after it, or perhaps a photograph. Two of the pictures appear to be portraits through which we can gauge the changes in Manet's representations of Léon in this period. Léon is somewhat older, but still a juvenile, in *Boy Blowing Soap Bubbles* (fig. 57), a picture of 1867 after Chardin; two years later, a more mature Léon is sporting a beard in the Chardinesque composition *Young Man Peeling a Pear* (fig. 58). Manet's interest in reworking Chardin's still-life and quiet genre pictures remained constant throughout his career; this constancy enables us to be more attentive to the physical features of the boy. The appearance of Léon in the *Pear* helps us to date the profile of Léon in *La Lecture* (fig. 26), a picture Manet reworked over a period of years. The image of Suzanne is soft and youthful, and the brushstrokes more tightly worked in her portrait; by contrast, the bearded Léon was done in a much looser style.

In Manet's *A View of the Universal Exposition* of 1867 (fig. 59), Léon assumes the role that characterizes the pictures after this point: he becomes a spectator. In *Exposition*, he appears in the lower right, dressed as a dandy; a large dog tugs hard at his leash. Manet emphasizes the disconnectedness and social comedy of the fair through his additive, piecemeal composition that juxtaposes diverse social types. The picture includes a quartet of women, a gardener, some guardsmen in uniform, a couple of beggars, and several well-dressed persons: a man and woman, two men, and a woman on horseback. The spectators form discrete units; their lack of interaction becomes one of the picture's main features. Manet suggests the makeshift character of the fairgrounds by extending the foreground garden all the way to the left margin of the picture, as if it were built out over the Seine, like the bridge in the middle ground at left.

Fig. 58. Édouard Manet, *Young Man Peeling a Pear*, 1869. Oil on canvas, 33 7/16 x 28 in. (85 x 71 cm).
Nationalmuseum, Stockholm

Fig. 59. Édouard Manet, *A View of the Universal Exposition*, 1867. Oil on canvas, 42 1/2 x 77 1/8 in. (107 x 197 cm). Nasjonalgalleriet, Oslo

In this spectacle, this parade of different social types taking their leisure in a world's fair, Léon is just another stroller. Here, he can dress up and fit in without people pointing and whispering. Here, he can walk the dog and dress like a bank employee; he does not have to pretend to be his mother's younger brother.

My argument here might appear to run the risk of conflating painting and biography, and I would like to address that issue. It is a characteristic of Manet's representations of Léon that in the early pictures, Léon is positioned to be pointed at, talked about, rebuffed; by contrast, in the pictures after 1867, he appears either in private, domestic settings, or in the types of public settings where his identity could be established through dress rather than reputation. At the racetrack, at the world's fair, on the beach, it matters not whether one knows one's father. One can take part in the spectacle without engaging in the nuances of the drawing room.

It has been well rehearsed in the art-historical literature that Manet painted modern public settings such as the café and the racetrack, and that the charting of the territory of modern public life was an essential part of his agenda. As T. J. Clark has argued, spaces such as the café-concert, the opera ball, and the department store were notorious for the ways in which, for instance, *demi-mondaines* could blend in with *femmes honnêtes*. The visual tension in *Un Bar aux Folies-Bergère* in part depends on the way the mirror is almost, but finally is *not*, a faithful reflection of the barmaid and her milieu; the subtlety of Manet's achievement was to represent a certain kind of instability side by side with the possibility for the scene's legibility.[41] My argument here attempts to amplify some of these

previous ones. Manet's Paris is a place where people recognize one another, where a large number of one's friends and intimates might congregate on a particular day at the Tuileries gardens, where even the street people look familiar. His inclusions of Léon, then, should be seen in the context of the potential recognizability of Léon's illegitimacy. I look upon Manet's frequent portrayals of family members and intimates as inscriptions that have a powerful effect on his art. The private inscriptions in fact become circumscriptions, structuring his famous "mistakes," ambiguities, gestures, and poses. It aug-

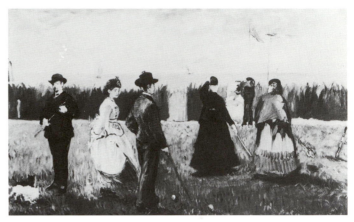

Fig. 60. Édouard Manet, *The Croquet Party at Boulogne-sur-Mer*, 1871. Oil on canvas, 18 1/2 x 28 3/4 in. (47 x 73 cm). Private collection, Switzerland

ments and supports an argument that Manet's depictions of modern Paris are laced with ambiguity to show that a spectator at the races or on the fairgrounds is the recognizable Léon, one who was pointed at and perhaps even mocked in the earlier pictures. An integral part of Manet's point about the social world of the *Universal Exposition*, as opposed to the kind of sociability depicted in *La Musique aux Tuileries*, is that among the disconnected social units on the fairground is the bastard who dresses as a dandy and walks his dog, unnoticed.

There are two pictures—*The Balcony* of 1868–69 (fig. 35) and *The Croquet Party at Boulogne-sur-Mer* of 1871 (fig. 60)—in which Léon appears with *le monde*. In *The Balcony*, Léon is the familiar *Boy with a Tray* from the *Cavaliers* and from the 1862 etchings. A working title for the picture, *Gens du monde à la fenêtre*,[42] is more descriptive of its content. Three of Manet's artist friends—the painters Berthe Morisot and Antoine Guillemet, and the violist Fanny Claus—pose on the balcony. Although the picture was actually painted in Manet's summer studio in Boulogne, the green louvre doors and painted wrought-iron railing are typical of the buildings in Manet's Batignolles neighborhood. The three are fashionably dressed and look out in different directions; they are apparently preoccupied. The painting is a reworking of Goya's *Majas on a Balcony*, a painting in which persons dressed in gypsylike costumes pose on a balcony. In the Goya painting, the figures' gestures and poses bring them together: they appear to be sharing a secret, not separated by different thoughts like Manet's figures.

Manet himself professed fascination with the balconies he saw in Rio de Janeiro on his 1848 voyage.[43] The balconies on which women made occasional, veiled appearances suggested one of the few similarities between Rio and Paris. While in Brazil, the painter missed the promenades of the Parisian women. His careful notation of the social class of women who appeared in public in Brazil suggests that he would not pose just anyone as a member of *le monde* at the window. Here too, then, Léon's position in the shadows of the interior is significant, as is the fact that Léon appears as a boy in costume rather than as the young adult he was becoming.

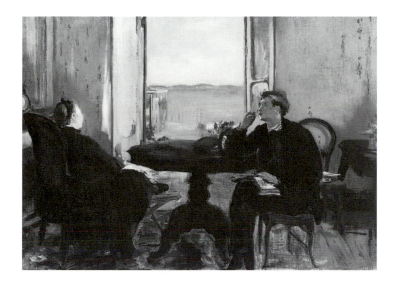

Fig. 61. Édouard Manet, *Interior at Arcachon*, 1871. Oil on canvas, 15 1/2 x 21 1/8 in. (39.4 x 53.7 cm). Sterling and Francine Clark Art Institute, Williamstown, Massachusetts

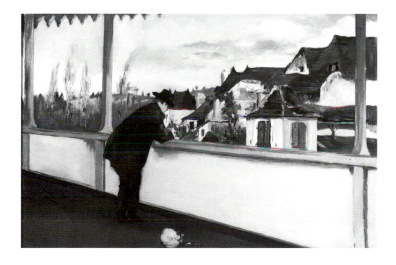

Fig. 62. Édouard Manet, *Oloron-Sainte-Marie*, 1871. Oil on canvas, 15 3/4 x 23 5/8 in. (40 x 60 cm). Bührle Collection, Zurich

Léon's appearances in Manet's art, then, are special. Manet's early choice of dressing him in seventeenth-century costume, as well as his choice of seriousness over low-life mischievousness, can be seen as a search for an artistic language of legitimation. Whereas Léon is set apart from others, pointed at in *Cavaliers* and mocked almost to the point of tears in *La Musique aux Tuileries*, in the later pictures he becomes the *flâneur* or the spectator in those types of social situations in which he could remain anonymous rather than become the subject of gossip.

There is a third type of representation of Léon that characterizes Manet's work immediately after the Franco-Prussian War. In pictures such as *Interior at Arcachon* (fig. 61) and *Oloron-Sainte-Marie* (fig. 62), Léon appears in one of the houses away from war-besieged Paris where Manet sought refuge for his family. These are quiet, contemplative pictures in which Léon and Suzanne look out the window. At a time when Manet was recovering from the horrors and deprivations he suffered while fighting with the

National Guard, these quiet, domestic scenes typify his work of the period.

After 1871, his oeuvre includes such works as *The Croquet Party at Boulogne-sur-Mer*, the first of two croquet party scenes Manet painted. Léon plays alongside Manet's friends Paul Roudier and Jeanne Gonzalès, but it should be noted that the scene takes place at a seaside resort, not amongst the Parisian *monde*. Léon does not, in my opinion, appear in the 1873 Frankfurt canvas (fig. 49) in which Roudier, Victorine Meurent, and Alice Lecouvé play croquet in the Paris garden of Alfred Stevens (at one time the protector of Meurent), although the identity of the seated figure Tabarant names as Stevens remains unclear.[44] In a register of photographs of Manet's works compiled after his death, Leenhoff's own annotations to the painting identify the three standing figures, without mentioning the seated one; it should be noted that Leenhoff characteristically identified himself in these annotations, especially in group paintings.[45]

Léon's roles as public spectator and in domestic interiors merge in two pictures in which he is a spectator in the artist's studio. One such picture, which is something of an anomaly in Manet's work, is *Eva Gonzalès Painting in Manet's Studio* (fig. 63), probably done when the two artists were in close contact in very late 1869 or early 1870. Léon is seated on a table at right, wearing a Spanish costume.[46] His pose is reminiscent of another Manet work, *Young Man in Toreador Costume* (fig. 64), a painting done after a Devéria lithograph of a work by José Dominguez Bécquer.[47] Like *Mlle V. . . in the Costume of an Espada*, the picture makes use of familiar models in a reworking of another artist's design.[48] The narrative explanation for Léon's costume is perhaps the studio setting: Eva Gonzalès could be painting the young man. If Manet is indeed meaning to suggest that Gonzalès is painting the costumed Léon, this motif would only reinforce the argument that Léon was depicted in situations in which dress could establish identity.

Le Déjeuner dans l'atelier (fig. 65) is the most complex painting of Léon Leenhoff; the setting is a luncheon table at

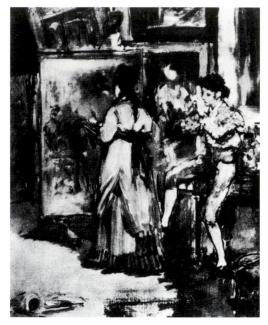

Fig. 63. Édouard Manet, *Eva Gonzalès Painting in Manet's Studio*, 1870. Oil on canvas, 22 1/16 x 18 1/8 in. (56 x 46 cm). Private collection, Paris

Fig. 64. Édouard Manet, *Young Man in Toreador Costume*, 1869. Oil on canvas, 26 x 16 15/16 in. (66 x 43 cm). Private collection, New York

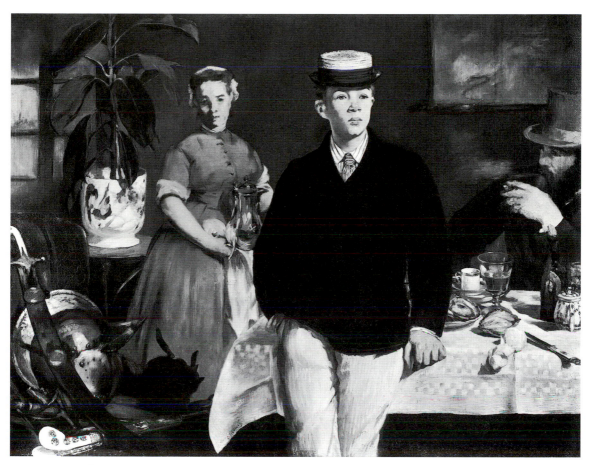

Fig. 65. Édouard Manet, *Le Déjeuner dans l'atelier*, 1868. Oil on canvas, 46 1/2 x 60 5/8 in. (118 x 153.9 cm). Bayerische Staatsgemäldesammlungen, Munich

Manet's summer studio in Boulogne. The top-hatted man at the table, Manet's artist neighbor Auguste Rousselin, relaxes with a cigarette as the maid enters. She is carrying a coffeepot painted to look as if it might bear an "M" monogram; perhaps the "M" is merely a trick of the light. Léon leans on the table; he looks out of the picture, past the spectator. The young man wears the dandyish clothes seen in the *Universal Exposition*, but here depicted in crisp detail: pin-striped slacks, striped shirt and tie, straw hat and black jacket. On the chair at left are items familiar to Manet's viewers. The sword, here with helmet, is the same carried by Léon in *Boy with a Sword*: Manet had borrowed it from his friend Charles Monginot. The black cat, here cleaning itself rather than glaring at the viewer, recalls that of *Olympia*. The table with oysters and lemon is also familiar from the still-life paintings à la Chardin of the mid-1860s.

X-radiographs of the painting show that large studio windows were originally quite prominent in the picture: they extended from Léon's head to the right margin of the canvas.[49] In the finished painting, Manet has painted out the windows and replaced them with a small picture. He also brought Léon

forward, closer to the viewer; this might explain the ambiguity of his leaning posture. Léon's hand is closed instead of open. These changes have the effects of making the represented space more confined and making the entire scene appear slightly less accessible to the viewer.

The setting is such that the viewer cannot help but wonder about the relationships of the persons depicted. "Luncheon" in nineteenth-century French society denoted an intimate meal rather than a gathering of acquaintances; it was typically a family affair. Manet calls it "Luncheon in the Studio," yet as he modified the painting, he minimized what might have been the relatively spacious look of the studio in favor of the restricted space of the dining area. Unlike the painting of Léon and Eva Gonzalès, there is no painting in progress, and Léon is not wearing a costume which could conceivably accompany the armor. The maid does her duty, holding the coffeepot at a respectful distance. The artist blows smoke and does not appear to be communicating with anyone. Léon's gaze is blank; Manet gives sharp definition to a look that is completely undefined.

The poses of the three figures in *Le Déjeuner dans l'atelier* are reminiscent of the foreground trio in *Le Déjeuner sur l'herbe*: the bearded man at right looks left but at no particular person, the woman looks out at the viewer, and the Leenhoff in the center looks blankly out of the picture space. The triangle here is reversed, with Léon Leenhoff in front of the others, whereas in the earlier picture, Ferdinand Leenhoff had posed behind Victorine and Eugène. The parallels between the two *Déjeuners*, and their implications, are not to be ignored. Just as the viewer of *Le Déjeuner sur l'herbe* remains baffled by what is going on and what is being shared by the figures, especially the status of the vividly depicted nude and the bathing woman in the background, the viewer of *Le Déjeuner dans l'atelier* is kept guessing as to the relationships of the persons depicted. The ways these ambiguous relationships are read in the art-historical literature often emphasize either the *déjeuner*, the gathering of Léon's family, or the *atelier*, a "real allegory" or representation of Manet's studio. For instance, some art historians suggest that the artist and maid symbolically represent the parents of Léon: in those accounts, Édouard Manet and Suzanne.[50] T. J. Clark proposes that the studied indifference of the artist could be seen as part of a narrative in which the painter waits to hear the reaction of Léon to a picture he has just unveiled.[51] Part of Clark's argument involves a complex tracing of the theme of the allegory of painting as it might occur in *Le Déjeuner*, and he reads the look of Léon as reminiscent of the confrontation with the self that self-portraiture entails. From another angle, the richness of the details and the still-life, juxtaposed with the ambiguous expressions of the figures, leads Raquel Da Rosa to emphasize the determining character of the still-life over the picture's unresolved narrative.[52]

In my view, one of the main features of the painting is its air of familiarity. The triangular composition, the recognizable Léon, the proximity of still-life, cat, and sword practically turn the painting into an anthology of Manet motifs. The familiarity of persons and objects, however, does not make the narrative legible either as a luncheon or as an allegory of painting. From the X-radiographs, we know that Manet foreclosed on at least one aspect of the look of the studio in favor of a more intimate and domestic setting. Yet intimacy, too, is limited, as the three persons pictured appear to be between moments of sociability: they are unconnected and preoccupied. Although there is neither canvas nor easel pictured

in *Le Déjeuner*, it can be seen as a kind of allegory of Manet's painting. Manet always intended for his works to be considered as a whole. In the year after his 1867 one-man exhibition, Manet here reworks several signature motifs—*Le Déjeuner sur l'herbe*, Leenhoff as spectator, the armor, black cat and oysters, the artist-dandy in the margins—with an unmistakable self-referentiality, which surpasses that of other Manet canvases.

Léon is once again a spectator, not sitting at the table, not conversing with the other man. He appears as a visitor leaning against the table, while the maid carries the coffeepot bearing the "M" monogram. Léon might be dressed up and maturing, he might be well taken care of, well connected for his new position, but he will never be a Manet. The man at right can indeed be seen as a father-figure to Léon: he is "Auguste," he is an artist-dandy like Édouard Manet, and at the same time, he is someone else altogether, a stranger who has no connection to Léon.

Léon's illegitimacy is subtly inscribed in Manet's representations of him. The pointing and whispering, the monogrammed coffeepot he does not hold, the places he strolls where his anonymity is assured—all must be considered alongside the recognizability of the Manets' social circle. The look on Léon's face in *Le Déjeuner dans l'atelier* is one of the most singular, most noteworthy characteristics about him. To examine that look is to attempt to describe the nondescript. What we have in *Le Déjeuner* is a well-defined blankness, a look of not belonging, on a familiar face, in a setting chock full of familiar motifs.

It is my argument here that the key to *Le Déjeuner dans l'atelier*, like the key to *Le Déjeuner sur l'herbe*, involves more than the degree to which the painting describes or obscures the facts of a contemporary luncheon in a modern summer studio. What dominates the painting is the precision with which Manet paints the absent, unknowing, blank look on the face of Léon in a picture otherwise terribly familiar. In my view, the social context of the painting is this conjunction of familiarity and estrangement, the fact that the central figure of the *Luncheon in the Studio* is neither seated and dining, nor posing in the studio. The tone of estrangement in the painting is even more unmistakable than that of the period legal texts, which held that the illegitimate were "strangers in their families."[53] If the sword Léon carries in the 1861 painting *Boy with a Sword* embodies the privileges that will never be his, the reappearance of the sword here underlines the point. Léon's fashionable clothes and his aloof posture, as well as his separation from the sword, create an image of Léon as the familiar outsider who merely looks in on the world of the Manet family.

Léon twice appears in the proximity of an artist's studio: in *Le Déjeuner dans l'atelier* and in *Eva Gonzalès Painting*. Léon's identity in the studio pictures would seem to be suspended among the roles of friend, family member, and model. Here, too, his identity and parentage were not an issue. In the studio, as at the World's Fair, clothes make the man; there is a degree of social freedom involved in these appearances. Nevertheless, with that freedom come no certainties, no semblance of belonging, no determinants of identity regardless of the improvised familiarity. Such a loss of belonging is central to Manet's vision of modernity.

If representations of Léon can be characterized as simultaneously involving invocations of

familiarity and indeterminacy, then one way of contextualizing that phenomenon for Manet's world is to examine the remarks of Manet's friend Edmond Duranty; he comments on just such a concurrence in the dream, which he compared with the art of painting. For Duranty, dreams were never inventions *ex nihilo*; rather, they worked from the known motifs of everyday life. "The imagination is not at all completely free to create the unknown [in the dream]," wrote Duranty. He spoke of "friends created by the dream," of the sources in daily life for dream motifs, and of the limitations of the personality in the dream—bound to reproduce the hostilities, wishes, and desires of waking life. The freedom of expression experienced in the dream was combined with a kind of circumscription of its imagination. Unknown persons in the dream were always based on the known, and moreover, they took on an eerie familiarity and importance in the dream.

One of the most striking things about Duranty's account of dreams is his description of the coexistence of the familiar with the vague and indefinite:

> This state of vagueness and indeterminacy becomes even more disturbing, even more baffling, when it pertains to persons and things *we know* which seem to appear to us in a dream. But, whatever the illusion of the dreamer, neither the persons nor the things we know appear to us exactly, identically. Our friends, our parents, the places we live, in the dream have no resemblance to the real human beings and things. Nevertheless our mind accepts them as such.[54]

Duranty found that in a dream, not only does our imagination create "friends" and places that reproduce those of our waking lives, but also, when already-known persons and places appear in a dream, they often appear different. The world of the dream at once breaks the rules and protocols of our social lives, yet is dependent on real life for its driving force and for its content. The world of the dream is at once familiar and unfamiliar; it is what Freud would later call the *unheimlich*, the uncanny.

Critics who saw *Le Déjeuner dans l'atelier* and *The Balcony* at the Salon of 1869 were, above all, struck by the lack of narrative coherence. They found the figures awkward and uncommunicative, and the situations somewhat illogical and inappropriate. The critic Castagnary, for instance, wrote in *Le Siècle*: "What is the young man doing in the *Déjeuner*, who is seated in the foreground and who seems to be looking at the public [. . .] where is he? In the dining room?"[55] Castagnary saw "too much arbitrariness" in Manet's compositions, and he advised artists to strive for a feeling of propriety, of things going together, of each person playing a logical role, as in a theatrical production.[56]

At the center of *Le Déjeuner*'s incoherence was Léon, seen as an ill-mannered lad whose pose and expression were unfathomable. A critic by the name of Jean-Paul, for instance, was not generous in his description of poor Léon: "Nevertheless the painter of *Olympia* and her cat seems to have laboriously plumbed the lowest depths of human ugliness to procure the distressing figure which he shows us in the foreground of his *Déjeuner*."[57] Whereas Jean-Paul commented on Léon's ugliness, Armand Silvestre called him a *jobard*, a gullible one or sucker: "And the *Déjeuner*! In truth, nothing is less interesting than this tall sucker, fashionably dressed, who would have been better off staying in the plate of oysters, from

which he seems to have gotten loose in order to take on a human form. But the accessories which are piled up on the chair constitute a still-life of incredible truth."[58]

Like Castagnary, Arthur Bagnères saw a certain impropriety in the picture. He also found Léon's table manners somewhat lacking: "*Déjeuner* is a young man, very badly brought up, who keeps his straw hat on his head and who sits down in a plate of oysters. An unusual way of eating them! you say. No good saying that the meal is finished, the oysters are there wide open, being used as a cushion."[59] The reader might say that these remarks are just typical of the way critics always described Manet's paintings as being unappealing and awkward, his figures as uglier than the real-life models, and the spatial transitions as disjointed. My argument here is that the *gaucherie* pinpointed by the critics is not only integral to the subject matter of Léon's luncheon at the Manet studio, but perhaps precisely what Manet was trying to depict.

In Maupassant's "Hautot père et fils," published in 1882, a dying father tells his adult son that since he had become a widower, he had carried on a clandestine affair with a young woman. He asks the son to visit her and look after her. The son calls on her on the regular day of the rendez-vous and breaks the news to the struggling young woman. He discovers that she and his late father are the parents of a small boy. Hautot *fils*, Maupassant tells us, *regarda son frère avec une émotion confuse, forte et pénible* ("looked at his brother with strong emotion, confusion, and pain").[60] "The poor boy, he is an orphan now," she tells Hautot *fils*. "I am, too," he replies. He looks at his father's girlfriend and son with care as well as some detachment: they are like an optional family with an opening for him if he chooses. As the story closes, Hautot *fils* agrees to see the girlfriend the following week, on the regular day of his late father's visit. The tale is fictional, but this particular family romance is not implausible. Hautot *fils*, upon the death of his father, gains an opportunity—along with a hint of obligation—to step into the father's shoes, to take for himself the father's mistress, to claim, or not claim, a half-brother who would be like a son to him. It is not unlike the Manet-Leenhoff situation: only the social status of the Manets mandated that the paternity question remain tightly under wraps. I have entitled this chapter "Manet père et fils," because the arrival of Léon, as well as the death of Auguste Manet, create conditions in which Oedipal ambivalence could take palpable form.

According to André Green, the passing of the Oedipus complex provides the individual with a transition from the family group to society, from his earliest feelings of attachment, jealousy, and identification to his later ability to substitute outsiders for family members in his constellation of love objects. For Green, the Oedipus complex marks "not familialism, but the opposite, the passage from family to society."[61] Michel Foucault would take Green's account one step further, in my view, suggesting that the form of the family invariably exerts a centripetal force on sexuality:

> that since the eighteenth century the family has become an obligatory locus of affects, feelings, love; that sexuality has its privileged point of development in the family; that for this reason sexuality is "incestuous" from the start. It may be that in societies where the mechanisms of alliance predominate, prohibition of incest is a functionally indispensable rule. But in a society such as ours, where the

family is the most active site of sexuality, and where it is doubtless the exigencies of the latter which maintain and prolong its existence, incest—for different reasons altogether and in a completely different way—occupies a central place; it is constantly being solicited and refused; it is an object of obsession and attraction, a dreadful secret and an indispensable pivot.[62]

For Green, Oedipal desires frame the relations between the family and society at large. For Foucault, sexuality is born of the family, and the social prohibition of incest serves to reinforce the very centrality of an inherently incestuous sexuality.

Although Green and Foucault have different emphases here, their accounts of sexuality especially ring true for the mid-nineteenth-century upper-class Parisian family. "The family" at mid-century increasingly meant the nuclear family. As Auguste Manet's professional life revolved around the Parisian courts rather than the cantonal politics of suburban Gennevilliers (as had that of his father), the nuclear family was less connected to the extended family. In the Fourniers' case, the Revolution had brought about a break between Eugénie's generation and that of her father. The nuclear family by nature dramatizes differences between the generations. By the mid-nineteenth century, the transition from family to society of which Green speaks had to be achieved through the (Oedipal) nuclear family.

Foucault's point is crucial for my argument. Foucault characteristically sees the social circumscription and proscription of sexuality as the very forces that magnify it. Just as putting a lid on a pot traps the heat inside, the lid of silence clapped over the revelation of certain behaviors served only to make them "hotter"; their concealment became more and more critical. Only the family could manage to keep the lid on. Society could not be trusted: society had published the proceedings of George Sand's legal separation from her husband in *Le Droit*.[63] Society anxiously awaited the next transcript from the trial in the Bainville murder, a case that hinged on a son's jealousy over a father's prospective remarriage.[64] The newspapers could be filled with things no respectable family would let out. But if the family had to keep the lid on, it became increasingly difficult to keep the pot from boiling over.

Manet only attempted religious paintings at an early stage of his career. It appears that his experience at the Salon of 1865, at which he exhibited *Olympia* and *Jesus Mocked by the Soldiers* (fig. 66), sealed the fate of his last attempt at a religious subject. Manet's first viewers, in the wake of the controversy surrounding the publication of Ernst Renan's *La Vie de Jésus*, found Manet's renderings overly materialistic, too vulgar to be religious.[65] Manet's religious paintings, then, are few and special, and they highlight the characteristics of his painting style, which presented the viewers of the time with difficulty, regardless of the subject.

Manet's choices of religious subjects can be easily summarized: in the religious paintings, Manet was first and foremost interested in the Christian motif of the Christ and his relationship to God the Father. Aside from the sketches for the *Finding of Moses* and *Susannah and the Elders*, which eventually formed the basis for a modern nude bathing woman, and aside from two paintings of a monk and of a family friend, the Abbé Hurel, the religious pictures all involve the Christ, and as we shall see, he is

Fig. 66. Édouard Manet, *Jesus Mocked by the Soldiers*, 1865. Oil on canvas,
75 1/8 x 58 3/8 in. (190.8 x 148.3 cm). The Art Institute of Chicago. Gift of James Deering (1925.703)

pictured at those moments when he confronts the painful and difficult mission to which he must submit. Manet is, I believe, especially interested in conveying the tension between Christ's divinity, or the will of his Father, and the suffering which his human body must endure.

Two of Manet's earliest religious pictures are portraits or bust-length studies of Jesus: the oil on board *Christ with a Reed* (fig. 67), and *Christ as a Gardener* (fig. 68), both preparatory studies for a *Noli me tangere* that Manet apparently never completed. Orienti dates them at 1856. Dating the work from the 1850s is especially difficult; nevertheless, a considerable change occurs in Manet's rendering of the gaze of the Christ between *Christ with a Reed* and the study of the Christ as a gardener. Whereas Manet's rendering of the facial expression in the earlier study is focused and dramatic, in the "gardener" picture Manet begins to explore the blankness of expression that characterizes so much of his work.

The gaze is not the only aspect of the paintings that foreshadows Manet's later work: the gesture and the compositional implications of the *Noli me tangere* theme can be seen as leitmotifs for so much of what was to come. It is easy to imagine Manet in 1860 doing a Rubensian landscape for his *Christ as a Gardener*, and the theme seems particularly suited to his early pictorial thinking. In the *Gardener* study, Manet is already creating a highly charged relationship between the frontally depicted figures in the painting and the viewer, who in this case assumes the position of the Magdalen. The Christ's prohibitive gesture of "Touch me not" as a response to the presence and gesture of the Magdalen calls attention to the mystery of his resurrected body. Manet's focus on the body of the Christ provides a sharp contrast with Cézanne's religious subjects: *Christ in Limbo and the Penitent Magdalen*; *Lot and his Daughters*; *The Temptation of St. Anthony*—compositions in which figures are isolated in their sin, repentance, or resistance to sin. The theme of *Noli me tangere*, by contrast, can be characterized as a pictorial moment in which one of the

Fig. 67. Édouard Manet, *Christ with a Reed*, 1856. Oil on board, 17 9/16 x 14 3/16 in. (45 x 36 cm). Private collection, Stuttgart

Fig. 68. Édouard Manet, *Christ as a Gardener*, 1856. Oil on canvas, 26 3/4 x 22 7/8 in. (68 x 58 cm). Private collection, Stuttgart

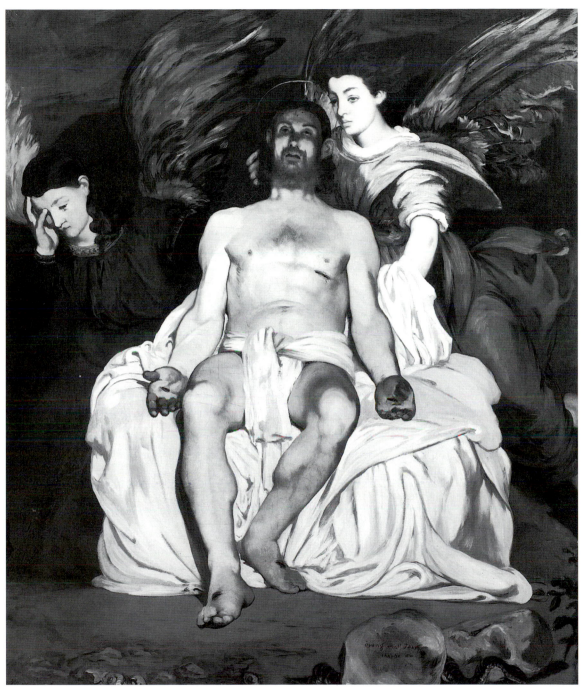

Fig. 69. Édouard Manet, *Le Christ aux anges*, 1864. Oil on canvas, 70 5/8 x 59 in. (179 x 150 cm).
The Metropolitan Museum of Art, New York. H. O. Havemeyer Collection,
Bequest of Mrs. H. O. Havemeyer, 1929 (29.100.51)

central paradoxes of Christian faith is crystallized, a scene in which the physical body of the divine figure is visually conjured and materially withheld.

The early religious sketches illustrate a fundamental fact about Manet's art: from the very beginning, he is interested in painting moments that might be described as suppressions of disclosure, and in staging those suppressions in and around the picture's central figure and his or her relationship with the viewer. This thesis is put to the test in the next major religious picture which is extant, *Le Christ aux anges* of 1864 (fig. 69).

Le Christ aux anges is not only an awkward picture, but one with bizarre qualities unmatched in Manet's oeuvre. Commentators have often noted that the scene does not match the verse from the Gospel of John inscribed in the picture's lower right corner ("chap. XX, v. xii"), in which two angels in white sit in the empty tomb after Jesus' resurrection.[66] In John 20:11–13, Mary Magdalen is weeping, and she sees the empty tomb and the angels. In Manet's picture, not only is the body of the Christ still in the tomb, but also the angels, pictured in robes of burnt sienna, are weeping at the sight of his wounds. It is an invented scene: a conflation of the initial moment of his resurrection and the moment before the arrival of the Magdalen at the tomb.[67] The viewer's position is such that he or she can, in effect, *become* or stand in for the Magdalen; he or she can empathize with the angels in weeping for the suffering of the Christ, yet the viewer is also allowed to view the body in a state that the Magdalen never saw.

Christ's body is posed as if in a sculptural mandorla; even the angle of viewing involves a tilting-back of Christ's body, which is analogous to the viewing angle of a visitor looking up to a cathedral tympanum. At the same time, the viewer has unimpeded visual access to the stigmata. Dramatic lighting from below gives the figure of Christ the unearthly quality that appropriately characterizes the resurrection scene. Manet uses tremendous contrasts of black and white, as well as intensely abbreviated modelling, to silhouette the body of the Christ against the bright folds of white drapery, which must have been wrapped around his body for the burial. The white drapery is ribbonlike and matte; paradoxically, it has little illusionistic depth and little surface interest or luminosity. Manet paints the blunt materiality of Christ's unearthly light flesh against the white drapery in such a way as to draw in the viewer, who must contemplate the suffering and death of the physical body of the Christ. His humanity is thus emphasized and given palpable form. The angels, too, are humanized: they are reacting as sorrowful friends would react; they are not performing their biblical functions of acting as messengers and guardians.

Unlike the imminent prohibition and disclosure of the studies for the *Noli me tangere*, the moment pictured in *Le Christ aux anges* is the moment just as the Christ is delivered from death. His suffering and death are still present on and in his physical body, which is just beginning to show signs of life; for instance, the eyes are just beginning to open, as Jane Mayo Roos has written.[68] It is a strange pictorial choice for Manet: it is as if there is too much humanity, too much physicality in the picture; too much is revealed all at once to the viewer. The problem is not so much the way of painting the figures with such emphasis on the bodies' palpability. It is, rather, a peculiar mixture of physicality and non-physicality, a juxtaposition of an envisioning of particular features about Christ and the angels as if

they were human, with other aspects that are meant to look unearthly. Manet paints the last moment in which the physical body of the Christ weighs down on him. Only hinted at visually are his divinity and his imminent resurrection, which remain abstract ideas. There is a subtle but pronounced shadow over Christ's face, which adds an otherworldly quality. Courbet's famous claim that he would not paint an angel because he had never seen one[69] is answered here by Manet, who attempts to depict angels as human beings. In the end, perhaps the painting supports the validity of Courbet's point of view, since the difficulties of the Realist religious work are evident.

Jesus Mocked by the Soldiers of 1865 can be described as a Realist reinterpretation of Titian's rather more grandiose *Christ Derided* in the Louvre. The ignoble types who humiliate the Christ are indeed vulgar. Unlike *Le Christ aux anges*, in which an unreal, unearthly scene is depicted with intense physicality, the *Jesus Mocked* is a picture in which Jesus is shown at his most physically vulnerable moment, a scene in which humanity and humility are key. The scene does not match perfectly with any of the biblical texts on the mockery of Christ. When Pilate scourged him, according to the Gospels, he responded that his kingdom was not of this world. When Jesus is mocked by the soldiers, the scene becomes a rehearsal for his crucifixion: he neither speaks nor acts, but must submit to a kind of theatrical mockery. The soldiers act out their enmity. Two are looking at him; one points his spear to Christ's side, a foreshadowing of the pierced lung he would endure on the cross. The soldier at right holds a cloak around Jesus' shoulders. The cloak is, we recall, an accessory in the derision: along with the crown of thorns Christ is wearing, it was to be his royal raiment as King of the Jews. The soldier who holds it looks toward the viewer's space, and his mouth opens crudely, as if to call out an affront. Christ's wrists are tied, blood drips from the crown of thorns, his body remains passive as his eyes look toward heaven. Manet paints Christ's legs and knees as small and ugly, his shoulders cave in as he yields to the mockery. These features emphasize Christ's humanity and the frailty of human flesh. Unlike Titian's heroic Christ, who twists dynamically and appears ready to strike back, Manet's Christ assumes a submissive posture. This lack of heroism in the body, however, contrasts with the facial expression of Manet's Christ. He holds back as if to suppress the cry of *lamma sabachtani* which he would utter on the cross. Having to abandon his access to divinity, he silently confronts this abandonment, this "why hast Thou forsaken me." Manet paints a gaze that expresses the difficulty of accepting the will of the Father. As the story of the Passion is meant to teach the way the heavenly kingdom will supplant the earthly kingdom, so Christ must not reveal the extent of his divine aspect as he endures the sufferings of his human body. The gaze, which suppresses a disclosure of divinity, also reveals the painfulness of Christ's contemplation of his Father's will.

Not only do Manet's religious paintings reflect on the nature of the father-son relation: so too does a major literary subject in Manet's work, the theme of *Hamlet*. At two separate moments in Manet's career, 1865 and 1877, he became interested in the theme of actors as Hamlet.[70] As is often the case with Manet's art, he looked for a subject which was already "staged," already a theatrical construction for the spectator. This particular theme, I shall argue, is the most overt case of the subject of powerlessness in the face of the father's wish. We recall that the Leenhoff pictures are characterized by a

Fig. 70. Édouard Manet, *The Tragic Actor*, 1865–66. Oil on canvas,
73 3/4 x 42 1/2 in. (187.2 x 108.1 cm). National Gallery of Art,
Washington, D.C. Gift of Edith Stuyvesant Gerry

portrayal of Léon's obliviousness to his own parentage, and the Christ pictures by a portrayal of the conflict between divinity and humanity in the realization of the father's will. The theme of *Hamlet* presented Manet with an opportunity to face the subject's ambivalence toward the course of action that the father's ghost impels.

As many writers have commented, Didier Anzieu among them, *Hamlet* presents a more fully formed example of the Oedipus complex than does *Oedipus Rex*. Anzieu observes: "[W]hereas the Oedipus of legend had no complex (he fulfilled his wishes in an innocent, almost natural way, and encountered problems only afterwards), Hamlet is typical of someone grappling with that complex, haunted by unconscious guilt feelings because of that twofold wish, and paralyzed by them in his actions, emotions, and life in general."[71] Although the Oedipus complex as such had naturally not been formulated in Manet's day, there was already some recognition of the importance of the Oedipus legend: in 1857, Alfred Maury describes the story of Oedipus as one that had given poetry an inexhaustible theme and the popular imagination something to embellish.[72] Furthermore, the connection between Hamlet and Oedipus was also already made. As Xavier Ambryet, a writer and acquaintance of Manet's,[73] wrote in 1860: "Hamlet is the most fully formed representative of modern fatality, just as Oedipus is the best representative of antique fatality."[74] The article goes on to describe the malady of Hamlet—his inability to act, his fear, "le Doute"—as the malady of the nineteenth century.[75]

Hamlet was already becoming the focus of some case studies on psychological phenomena in the early 1860s (there would be several more in the mid-1870s); yet it also became something of a political hot potato at the time of Manet's portrait of Philibert Rouvière, *The Tragic Actor*, 1865–66 (fig. 70). David Solkin has convincingly demonstrated the painting's element of homage to the aging actor,

Fig. 71. Édouard Manet, *Hamlet Confronting the Ghost of His Father*, 1877–78. Pastel, 18 1/8 x 22 1/16 in. (46 x 56 cm). Burton Agnes Hall

no longer a major force in the Paris theater in the 1860s.[76] In Solkin's view, it would have been one intention of Manet's to "remind" the public of Rouvière's talents. Baudelaire, Solkin tells us, had organized an auction to benefit Rouvière in February 1865. In addition, Manet could have regarded the picture as an alternative self-portrait, since the painter had endured so much criticism over his submissions to the Salon of 1865. Solkin points out that Manet depicts the actor with hands crossed, the traditional pose of Christ as the Man of Sorrows. Solkin's point is worth taking a bit further. There is indeed an element of self-portraiture in *The Tragic Actor*, as there is in *Jesus Mocked by the Soldiers*, even beyond

the question of Manet's feeling persecuted at the Salon of 1865.[77]

The idea of self-portraiture takes hold at the level of the subject's confrontation with the father's will. The theme of the father's ghost was recognized at the time; writing on the painting, Théophile Gautier emphasized "this sacred horror in face of the task imposed by the paternal specter."[78] Manet may well have intended the inference; indeed, the artist later executed a pastel, *Hamlet Confronting the Ghost of His Father* (fig. 71)—apparently never realized as an oil painting—in which Hamlet, on one side of the picture, recoils as he glimpses the father's ghost, sketched only as an empty blur on the paper. The father, absent from the other paintings, becomes the spectator of the *Hamlet* pictures; he is then portrayed as a literal absence in the pastel, his presence suggested by white space.

There is also a way in which the portrait of Rouvière can be seen as a portrait *manqué* of Baudelaire. Eric Darragon has written about Rouvière's Baudelairean identity.[79] Not only did Baudelaire plan to write "a psychological melodrama on drunkenness," starring Rouvière, but also the situations of the poet and actor are comparable in the 1860s. Rouvière was ailing and past his prime; Baudelaire, though not aged, faced mounting debts, syphilis, and eventually, exile. The Oedipal dimension of the *Hamlet* theme would have been well suited to a portrayal of Baudelaire: the poet made no secret of his hostility toward his stepfather, General Aupick.[80]

There was another occasion in 1864 that linked the poet and the actor. On 23 April 1864, there was to have been a grand celebration of the tricentenary of Shakespeare's birth. One of the events was a literary banquet, presided over by the absent (exiled) Victor Hugo, also celebrating the publication, that month, of Hugo *fils'* translation of the complete works of Shakespeare. After the banquet there was to have been a performance of highlights from several Shakespeare plays; one was a presentation of *Hamlet*, starring the actor who had come to be inextricably associated with Hamlet, Rouvière. Baudelaire was outraged that he had been excluded from the banquet and that the statesman Guizot (who had published a book on Shakespeare) had been invited.[81] The entire affair, including the appearance by Rouvière, was canceled by Napoleon III, after France found itself on shaky ground vis-à-vis Denmark and England while Prussia was at war with Denmark over Schleswig-Holstein. Suddenly, both the implications of a contemporary reading of corruption in the kingdom of Denmark, and the idea of a cozy, joint French-English celebration of the great bard, became politically overdetermined. A congratulatory telegram sent by Napoleon III to the king of Prussia the day after Prussia's victory at Düppel appears to have been the straw that broke the camel's back in the Shakespeare affair.[82]

The brouhaha over the Shakespeare banquet in 1864 may have fueled Manet's interest in Rouvière as a disenfranchised political subject, yet the disarmed pose and disarming expression of Rouvière in the painting deserve particular scrutiny. "Here is a life, troubled and twisted," wrote Baudelaire of Rouvière in 1856, comparing the actor to a gnarled tree "whose sap has not flowed for a long time."[83] Manet's painting expresses a similar compression of personal force, a similarly troubled holding back from the spectator. Although the sword is on the floor, it is not impotence we see on the face so much as an overwrought, unexpressed hostility, a profound disturbance in the staged pose.

Manet had another opportunity, more than a decade later, to examine the theme of *Hamlet*. In

1876, Jean-Baptiste Faure, who had been one of Manet's outstanding patrons in the early 1870s, commissioned the painter to portray him in the operatic role of Hamlet which had brought the baritone success in 1868 (fig. 72). The portrait was to mark his farewell to the operatic stage after a last performance of Ambroise Thomas's *Hamlet* in 1876. For this project, Manet executed two large oil paintings, an ink drawing, and the pastel mentioned above. Manet exhibited the oil painting now in the Kunsthalle, Hamburg, at the Salon of 1877, and according to Orienti, later executed the painting of the same size, now in the Folkwang Museum, Essen (fig. 73), in which the figure occupies more of the canvas.

Of the Hamburg canvas at the Salon of 1877, Henry Houssaye wrote: "The portrait of M. Faure in the costume of Hamlet, veneered figure, without proportion, without depth, without air, without life, and who has no balance on his legs, demonstrates definitively the inanity of the supposed temperament of M. Manet and the inadequacy of his early studies. This ridiculous portrait brings to a conclusion the numerous series of sensationalist portraits at the Salon of 1877."[84] The picture received a lot of criticism for the way the left leg of the singer appeared too short, almost like a wooden leg

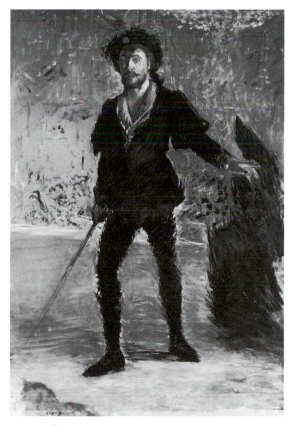

Fig. 72. Édouard Manet, *Faure as Hamlet*, 1877.
Oil on canvas, 77 3/16 x 51 3/16 in. (196 x 130 cm).
Kunsthalle, Hamburg

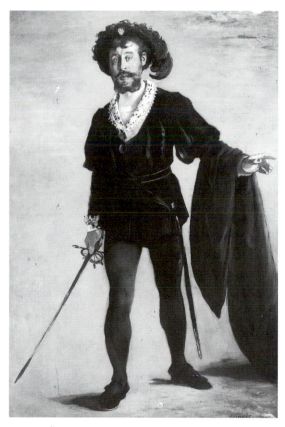

Fig. 73. Édouard Manet, *Faure as Hamlet*, 1877.
Oil on canvas, 77 3/16 x 51 3/16 in. (196 x 130 cm).
Folkwang Museum, Essen

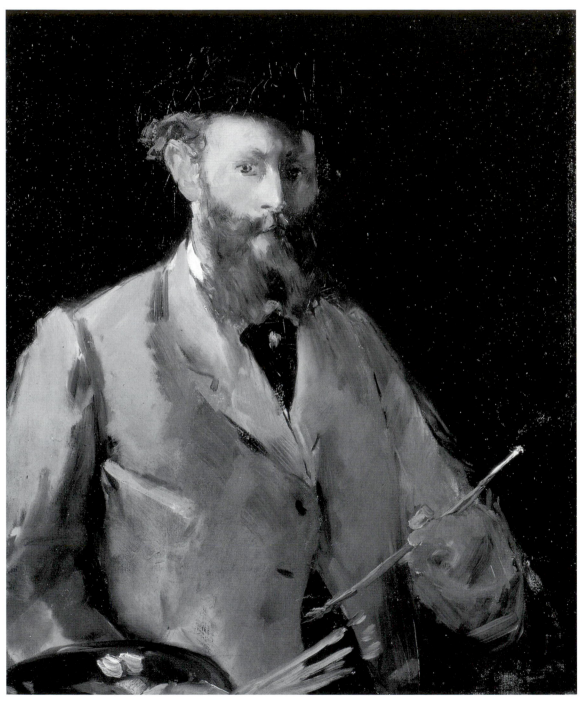

Fig. 74. Édouard Manet, *Self-Portrait with a Palette*, 1878–79. Oil on canvas, 32 5/8 x 26 3/8 in. (83 x 67 cm).
Private collection

dragging behind him as he steps toward the spectator. The blank, bewildered expression did not help matters. "Une oeuvre d'halluciné," wrote one critic,[85] perhaps influenced by a recent medico-psychological study that characterized Hamlet's dialogue with Horatio as the most succinct definition of the hallucination.[86] One interesting facet of the Faure portrait compared with the Rouvière one (and this was noted by the critics) was the way Manet shows Hamlet advancing toward the spectator, who is of course occupying the place of the father's specter. Philippe Burty wrote: "M. Faure, sword in hand, rushes toward the phantom who is virtually next to the spectator—an ingenious and theatrical arrangement."[87] The specter of the father becomes one with the spectator as Hamlet advances with the sword. What is most revealing, however, is that in place of Rouvière's staged, recoiling disturbance, we find Faure's blank expression of ambivalence. It is a look that Manet would re-create two years later in his *Self-Portrait* (fig. 74), in which the brush replaces Hamlet's sword. The struggle to confront the will of the father emerges as a theme in both the Christ pictures and the *Hamlet* pictures, and it shapes Manet's representation of the self. Manet in fact hung his two *Self-Portrait* canvases of 1879 on either side of the later *Hamlet* painting in his studio.[88]

There are remarkable similarities between the *Self-Portrait* and the *Hamlet* pictures with regard to the handling of the gaze. Manet's pose in the *Self-Portrait*, as has been noted many times, replicates that of Velázquez's appearance in *Las Meninas*. The seventeenth-century painting is a royal family portrait in which the parents, the king and queen, stand in the vicinity of the spectator and appear in the painting reflected in a mirror. To what extent might Manet's invocation of Velázquez also create a complex relationship with a particular spectator? To what extent might the father hover here in the space of the spectator? It had been through the medium of Velázquez that Manet had envisioned his *Philosophers*, his *Old Musician*, his early monumentalizations of a world judged by his father.

The reference to Velázquez in the *Self-Portrait* is reminiscent of Manet's inclusion of his self-portrait with Suzanne in *La Pêche*, a representation in which the couple clearly steps into the places of Rubens and his wife in the seventeenth-century landscape. Despite the frequency of Manet's portrayals of various family members and friends, there are apparently no self-portraits between the time of *La Musique aux Tuileries* and the two self-portraits of 1878–79. I will argue in the next chapter that it was through the portrayal of Berthe Morisot that Manet for a time explored a set of issues associated with self-portraiture. Yet the absence of explicit self-portraits in Manet's oeuvre is notable. So, too, is a certain lack of substance in the portrayal of the body in the waist-length self-portrait (fig. 74). There is a masterful handling of light on the philtrum, and the subtle differentiation of beard from background also characterizes the hair of *Olympia*. The summary handling of the jacket and the hand, however, are such that the painting remains an *ébauche*. This, too, needs to be considered: why is the self-portrait not more fully realized? Earlier I quoted Sartre to the effect that poets at mid-century—he names Poe, Baudelaire, and Mallarmé—were "sons," that is, they had highly charged relationships with parents and with earlier generations. It is indisputable that Manet sees himself in a complicated relation to his family as well as to the artists of earlier centuries, and I would attempt to echo Sartre in saying that the consciousness of self as "son" rather than master informs the tentativeness of Manet's take on Velázquez

here. In the fresh, broad marks that make up the *Self-Portrait*, Manet at forty-six almost sees himself through the lens of the court painter posed behind his easel and in front of a mirror. Almost—but not quite. Perhaps the reflection cast a bit too much glare.

I agree with you, the young Morisot girls are charming, it's a pity they're not men.

Édouard Manet to Henri Fantin-Latour

Madame Bovary, c'est moi, d'après moi.

Gustave Flaubert

MANET EXECUTED AN ETCHING and a lithograph of the artist Berthe Morisot (figs. 75 and 76), both apparently after the oil on canvas portrait with violets of 1872 (fig. 77). While a friend and I were looking at examples of the prints, she made a provocative suggestion—somewhat casually but also in seriousness. She ventured that Manet's etching portrayed Morisot with a look reminiscent of a self-portrait.[1] What she meant, as she drew on her art-school background to explain, was that during the painting of a self-portrait, as one looks in the mirror, it finally becomes necessary to contrive the symmetry of the eyes, as it is nearly impossible to fix one's gaze on both eyes. Manet's Morisot, she said, has that look.

What would it mean, I wondered, for Manet to paint Morisot as "himself," or himself as Morisot? How and why would a (male) painter in Manet's position at that point in his career even think of investing portrayals of her with a degree of "self"?[2] The idea fascinated me insofar as it appeared to go against some assumptions underlying more recent scholarly reexaminations of Morisot's life and relationship with Manet. These reappraisals have variously hailed Manet's portraits of Morisot as "entirely generated by her presence," "entirely devoted to her—her person, her moods, her eyes, her hair, her clothing." In other words, they try (too hard) to activate Morisot's role in creating Manet's portrayals of her; that is, when they have not castigated Manet's choice to present her "as a well-brought-up young woman sitting inactively, not

Fig. 75. Édouard Manet, *Berthe Morisot with a Bouquet of Violets*, 1872. Etching, 4 11/16 x 3 1/8 in. (11.9 x 8 cm). The Baltimore Museum of Art. George A. Lucas Collection (BMA 1996.48.5142)

engaged in work," or his attempt to "eroticize" Morisot; that is, when they have not overplayed the idea that Manet was the "active" male painter and Morisot the passive female object, never represented as a working artist in Manet's canvases.[3]

Several things can be said, first off, about Manet's portraits of Morisot as a group. They cluster during a period of work that was surely the most uneven in Manet's oeuvre in terms of sheer output, the years from 1868 to 1874, punctuated as those years were by the Siege of Paris, the Franco-Prussian War, and the aftermath of the Commune.[4] Of the dozen or so pictures of Morisot, only two are Salon-sized: *The Balcony* (fig. 35) and *Le Repos* (fig. 78); the others scarcely exceed two feet on a side. The titles of the others sound more as if they have been clipped from the newspaper society pages: *Berthe Morisot with a Muff* (fig. 79), *Berthe Morisot in a Veil* (fig. 80), *Berthe Morisot in Pink Slippers* (fig. 81); the list continues like a chronicle of fashion. It seems surprising that these pictures actually outnumber the representations of Victorine Meurent; yet unlike those breakthrough paintings of the early 1860s, (and in fact, unlike the society pages), their appeal as a series derives from their private character.

The series of Morisot pictures poses questions unlike Manet's series of Meurent canvases and his portrayals of Léon Leenhoff. Whereas Leenhoff's familial identity was deliberately ambiguous, and Victorine Meurent usually wore a costume or acted a role, Morisot always appeared as herself. Although Manet apparently painted only one *portrait* of Victorine Meurent, and although all eighteen or so Leenhoff pictures are properly understood as genre or modern-life paintings, all the paintings of Morisot—even *The Balcony* and *Le Repos*—can be seen as portraits. And the question of "familial" identity must be posed somewhat differently, since Morisot became a member of the Manet family when she married Édouard's brother Eugène in 1874, at which point her sittings for Édouard properly came to an end.

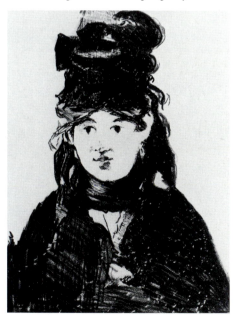

Fig. 76. Édouard Manet, *Berthe Morisot with a Bouquet of Violets*, 1872–74. Lithograph, 9 7/8 x 6 7/8 in. (25.1 x 17.5 cm). The Baltimore Museum of Art. George A. Lucas Collection (BMA 1996.48.5170)

Manet met Berthe Morisot, so it appears, through Henri Fantin-Latour in 1868.[5] Just as Manet dove into a campaign of paintings of Victorine Meurent in 1862, so too did the artist pursue a series of at least four paintings of Morisot, including the two large ones, in that year and into the next. Commentators have remarked on the renewed vigor that spurred Manet to work after Morisot became a friend and model, and Eva Gonzalès a pupil at the same moment, a situation that sometimes irritated Morisot.[6]

Like his early conceit for Victorine Meurent, Manet's first plan to represent Berthe Morisot featured her in another "party of four"—this one not on the grass but in a more urban setting. According to Tabarant, Manet sought

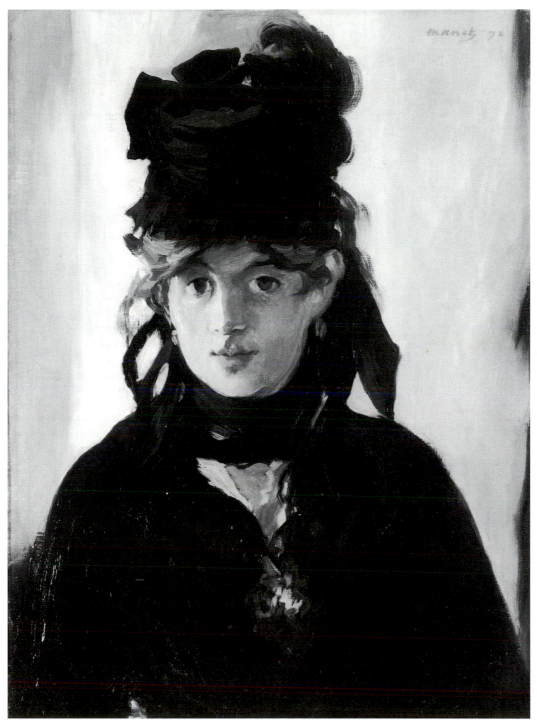

Fig. 77. Édouard Manet, *Berthe Morisot with a Bouquet of Violets*, 1872. Oil on canvas, 21 3/4 x 15 in. (55 x 38 cm). Musée d'Orsay, Paris

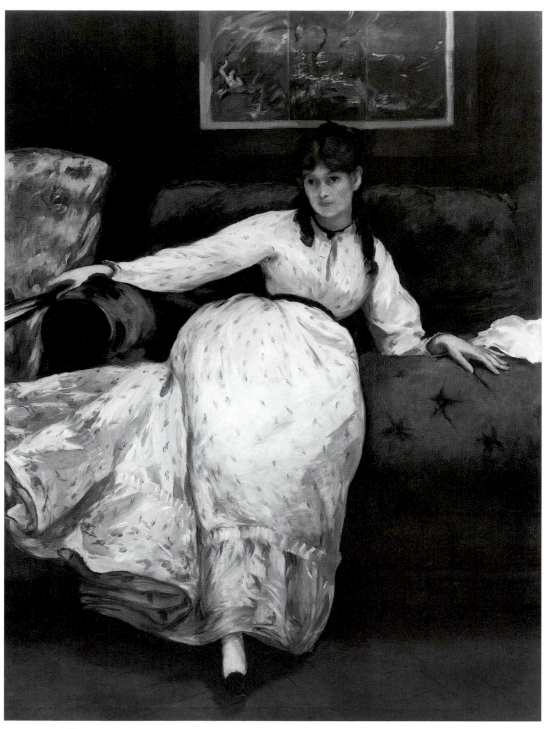

Fig. 78. Édouard Manet, *Le Repos*, 1870. Oil on canvas, 58 1/4 x 43 3/4 in. (147.8 x 111 cm). Museum of Art, Rhode Island School of Design, Providence. Gift of the Estate of Mrs. Edith Stuyvesant Vanderbilt Gerry

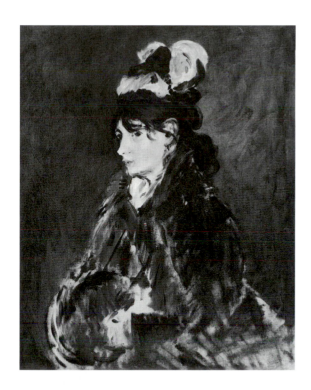

Fig. 79. Édouard Manet,
Berthe Morisot with a Muff,
1868–69. Oil on canvas,
28 3/4 x 23 5/8 in. (73 x 60 cm).
Cleveland Museum of Art. Bequest
of Leonard C. Hanna, Jr. (1958.34)

Fig. 80. Édouard Manet,
Berthe Morisot in a Veil, 1872.
Oil on canvas, 24 x 18 1/2 in.
(61 x 47 cm). Musée du Petit
Palais, Geneva

Fig. 81. Édouard Manet, *Berthe Morisot in Pink Slippers*, 1872. Oil on canvas,
18 1/8 x 12 9/16 in. (46 x 32 cm). Hiroshima Museum of Art

her opinion on his compositional idea before securing her as a model, and her mother chaperoned her sittings in Manet's studio.[7] In *The Balcony*, three friends—the painter Antoine Guillemet, Morisot, and musician Fanny Claus—pose in the main area of a shuttered, railed balcony, while Léon Leenhoff appears with a serving tray in the dark interior. As has been well established, the picture is in part a reworking of Goya's *Majas on a Balcony*, known firsthand or through an engraving in Charles Yriarte's 1867 monograph (fig. 82).[8] Yet the use of shutters, doorways, ledges, and windows is more prevalent in Manet's work than this one reference to Goya would suggest. *The Absinthe Drinker* stands in front of and leans on a ledge which is discontinuous from one side to the other, and which is ambiguously placed in space. *The Boy with the Cherries*, as if in a rather crude imitation of Jean Baptiste Siméon Chardin's *Boy Blowing Bubbles*, leans over a ledge. *The Reader* (fig. 83) likewise appears as if seen through a street-level window, with the cracked horizontal band of stone ledge deliberately obstructing a view of the reader's desk or table. *The Street Singer* moves through a pair of green shutter-doors, possibly based on those of Manet's own studio on the rue

Fig. 82. After Francisco de Goya, *Majas on Balcony*, 1867. Engraving, 5 11/16 x 3 3/4 in. (14.5 x 9.5 cm). From Charles Yriarte, *Goya*

Guyot. In another picture based on Chardin, Léon Leenhoff appears behind a ledge in *Boy Blowing Soap Bubbles* (fig. 57). These pictures all attempt to position the viewer vis-à-vis the model in the picture. They evoke the Paris street, the glimpse of a figure in a window or doorway. As modern reworkings of older genre scenes, the compositions also respond to the rectangular shape of the canvas. The slightly askew ledge in the *Soap Bubbles* picture, for instance, both adds a sense of depth and establishes a slight tension with the rectangularity of the canvas support.

 The Balcony, like all these pictures, is a view into a window or doorway, this time into Manet's summer studio in Boulogne-sur-Mer. Moreau-Nélaton notes that it was the first picture conceived in Boulogne after Manet's return from London.[9] It draws on the importance of the window as a framing device in the other pictures; yet it is also fundamentally different. There is certainly an aspect of the painting that asks the viewer to see the three friends of Manet as "gens du monde à la fenêtre," with their fashionable clothing and accessories, and I have pointed out the significance of the fact that Léon Leenhoff does not appear *with* them on the balcony. Yet there is a sense in which, once again, the individual gazes of the threesome remain separate and discrete; they may be *gens du monde* but they do not come together to constitute a subset of *le monde*. And the most overpowering gaze of all, the look that acts as the picture's fulcrum, is Berthe Morisot's. It is evident from even a cursory examination of the physical canvas that Manet heavily reworked the head of Morisot. It is her gaze that takes in the view that includes the spectator—whether standing in a street, near the ocean, or on some neighboring

balcony. Of course, Fanny Claus also gazes in the general direction of the spectator. Yet her gaze projects almost no concentration; she seems absentminded rather than rapt in thought. Morisot's gaze, by contrast, is so concentrated as to lose itself, to lose the self-consciousness that absorbs nearly all of Manet's figures. It is the gaze of an artist rather than a model, a subject rather than an object. The perpendicular lines of the balcony railing and shutters, rather than framing Morisot for the viewer, seem to allow Morisot to frame the world at which she gazes.

This last point may strike some readers as spurious. After all, is Antoine Guillemet not also standing poised with a cigarette, as if surveying his own canvas in progress? And Fanny Claus tucks her umbrella in the crook of her arm just the way the violist (as she was) holds the instrument during a pause in practice. I am not trying to claim that all three artist friends somehow emblematize their arts while being fashionable *gens du monde* at the same time. What in-

Fig. 83. Édouard Manet, *The Reader*, 1861. Oil on canvas, 40 3/16 x 31 7/8 in. (102 x 81 cm). Saint Louis Art Museum

terests me, rather, is that even in an oeuvre filled with as many memorable gazes as Manet's, the gaze of Morisot in this picture stands out as particular, and distinct. In *The Balcony* and in Manet's later representations of Berthe Morisot, she emerges not only as a distinctive model, but also as a distinctive subjectival presence. This is the principle difference between the images of her and those of Victorine Meurent. I would like to argue that in representing Morisot, Manet explored the very nature of subjecthood, of what might constitute "self" and "other."

Several writers have commented upon the gulf that separates the series of paintings of Victorine Meurent, paid model and lower-class woman, from those of Berthe Morisot, who was basically Manet's social equal.[10] Most have noted that since Morisot neither commissioned a portrait nor would have dreamt of receiving payment for modeling services, certain restrictions circumscribed the paintings of her (Mme Morisot's presence as chaperone being just one). It is true that by paying Victorine Meurent, Manet also had license to ask her to pose in the nude, in male costume, and in whatever else he fancied (his mother's jewelry); by contrast, by not being able to treat Berthe Morisot as a paid model, he would

have been limited to the poses, costumes, and accessories deemed acceptable for a proper woman of her social standing. The actual social and marital status of both Morisot and Manet, then, remain imprinted on the portraits of her; they remain inescapable circumstances of production—something that cannot be said of Manet's other models and series. Many writers have recognized this and have veered onto the biographical track in writing about how the Manet-Morisot relationship was somehow itself represented in the paintings.

In examining the portraits, then, the historian enjoys at least some license to look to biography but must also, of course, turn to the history of etiquette and to the history of women in the nineteenth century. Fashions in fans and veils, and dictates about the proper attire for mourning, will certainly have a place in any historical account of these paintings. As today's viewer looks back at nineteenth-century women and men, however, it is perhaps worth pointing out certain things. There is no doubt that as an upper-class woman in the nineteenth century, Berthe Morisot faced

Fig. 84. Paul Gavarni, *Lorette in a Dressing Gown with a Parrot*, c. 1840–42. Lithograph

restrictions on her comportment and obstacles in the way of her artistic ambitions. Her accomplishments are all the more remarkable in this context. Yet the reconstruction of this life and friendship a century later need not devolve into a predictable script about a worldly male artist and a vulnerable female one. As we approach Manet's representations of Morisot and his friendship with her, I think it important to remember that a nineteenth-century woman's imagination did not face the same restrictions as her career or movements. An analogy might help illustrate my point. Many married persons today, female or male, might choose to hold marriage vows above fleeting attractions. The fact of being married might prevent them from acting on some interest or desire, but it in no way keeps their imaginations from being fired by that attraction. The strictures surrounding the proper nineteenth-century woman's behavior might be manifold, but the principle is the same. If Manet wanted to depict Morisot in a particular dress, or if her mother supervised her sittings in the artist's studio, that does not make Morisot into a passive object vis-à-vis the fantasies of the male artist Manet; rather, these are mere manifestations of bourgeois etiquette in the period. Morisot's intelligence and desires remained her own. It is essential that the modern historian not lose sight of that and unwittingly handicap Morisot in hindsight by not granting her the imaginative autonomy that properly belongs to all persons, and certainly to artists.

Recent biographies of Manet and of Morisot have not been able to deduce much more about the actual relationship of the two artists than had long been known to readers of the little surviving correspondence and to viewers of Manet's paintings.[11] No evidence of whether their relationship went

beyond great mutual admiration, real friendship, and obvious romantic if not erotic interest has emerged. Yet as the relationship has been examined more closely, not only by the biographers but by scholars of the paintings, it has only become more apparent that the aforementioned qualities of admiration, friendship, and interest were truly intense in spite of Manet's marital status. In 1869, for instance, we find Berthe Morisot anxiously contemplating Manet's every gesture in her direction; bouts of melancholia, difficulties in painting, and a period of eating disorders all seem clearly connected to her keen interest in Manet and the frustrations of what she called her "impossible" situation.[12] When Morisot married Manet's brother Eugène in 1874, she described her choice as a kind of compromise, ending the years of living by "chimeras" with a reasonable, practical decision.[13] It is quite evident that the decision to marry Eugène came with the realization that her feelings for Édouard had no future.

In a sense, then, some of the best contextual material we have in which to situate Manet's paintings of Morisot has to do with Morisot's real feelings for Manet. It follows that the historian might attempt to produce an analytical method not out of what might be read of the artist's intentions, but rather, out of a reverse-intentionality hypothesis of sorts: the impact of the sitter's intensity of feeling. Instead of asking: what does it mean to paint certain family members again and again, one might ask, what does it mean to paint a woman in love with you, a woman who marries your brother?

The Balcony was exhibited at the Salon of 1869 bearing the title *Le Balcon*. The title recalls a poem from *Les Fleurs du mal*, although the tone of the painting is no longer as Baudelairean as that of the paintings from the early part of the decade. The theme not only recalls Goya's foursome, but also one of Manet's memories from his trip to Rio: "For the somewhat artistically minded European [Rio de Janeiro] offers a cachet all its own; in the street one meets only blacks; the Brazilian men go out little and the Brazilian women even less; one only sees them going to mass or in the evening after dinner; the women are seated at their windows; it is then permitted to look at them more at your ease, for in the daytime if by chance they are at their windows and catch you looking at them they withdraw quickly."[14] Manet was seventeen when he described the discretion of white Brazilian women, who did not support a culture of others' pleasure in gazing (or perhaps did, but in a more rarified way than Manet imagined the women of his own culture). Regardless of whether *The Balcony* was actually painted entirely in Boulogne or meant to comment on Haussmannian balconies in Paris, the models present themselves without the secrecy, veiling, and modesty suggested by Goya in his Spanish painting, or by Manet in his account of Brazil.

As she leans forward and looks intently out the window, Berthe Morisot holds the consummate object for concealing the face—the fan—but she keeps it folded here. Whereas Goya's female figures lean toward each other and their veils as well as the masks of the male figures behind them create an air of quiet communication and discretion, Manet's figures do not appear interested in sharing secrets. No flirtatious games are being played at the moment; Morisot's fan is at the ready, casually clasped by fingers improbably lengthened to curl around each other and the wrought-iron railing of the balcony. Manet paints the full intensity of the face, a visage that virtually beams its gaze out of the picture.

Given Manet's own musings on balconies as places where women in particular could station

themselves or retreat from public view, I think it is not overstating matters to stress Morisot's bold presence here. The artist-model does not impart anything of the self-consciousness of being the object of the spectator's gaze that is characteristic of so many Manet images of women, certainly those of Victorine Meurent. Take, for instance, the example of Meurent in *Woman with a Parrot* (fig. 45). In that painting, the model toys with an object directly associated with the activity of looking: a monocle. In her other hand, Victorine holds a bouquet of violets, flowers that would later figure in several images of Berthe Morisot. With Victorine outfitted in a dressing gown, the picture suggests a context of intimacy. All these points make it an ideal comparison with the images of Morisot.

Woman with a Parrot was painted in 1866 but exhibited at Manet's one-person show in 1867 and at the Salon of 1868. Like the *Woman with Guitar*, it signals an interest in seventeenth-century Dutch genre pictures. Like so many of Manet's large single-figure paintings and unlike most genre pictures, however, the accessories seem to be mere props for a genre scene somehow stripped of its contextual or narrative purpose. Neither parrot, nor monocle, nor dressing gown, nor violets can make the picture cohere as a genre painting. Manet does imply the presence, or recent visit, of a fashionable man, via the tiny bouquet of violets (seemingly a gift) and the monocle—a man's accessory, as women of the time wore lorgnettes.[15] These items, however, command far less visual interest than the pink peignoir. As Carol Armstrong has observed, the peignoir is the visual and conceptual pièce de résistance of the painting; it serves to cover up a body last seen naked at the Salon of 1865 even while it paradoxically shows Meurent *en déshabillé*; it plays flesh tone against a painterly display of fabric that nevertheless remains a flourish of pure paint.[16]

The scenario resembles that of one of Paul Gavarni's naughty-but-nice *lorettes*, such as the modest *Lorette in a Dressing Gown with a Parrot* (fig. 84) from the *Physiologie de la femme*, or one of Labiche's comic plays, in which a prim young woman earnestly tries not to appear to be flattered by a suitor's gift of violets (she does not allow herself to get too close to them), and is embarrassed by the vulgar utterances of her parrot.[17] These contemporary vignettes, however, will not do as contextual frames of reference; the interaction between Manet's model and the implied spectator of the painting finally cannot be understood as a dialogue in a comedy of manners. The model toys with the monocle: her left hand, drawn as if to appear almost pawlike in its crudity,[18] clasps the fine chain or string on which it hangs as a pendant. If the monocle indeed belongs to a man, say a man standing in the spectator's space, then perhaps she toys with him as much as the monocle, since presumably he cannot take leave of her without reclaiming it.

The *Woman with a Parrot* is not the first image of Victorine Meurent that suggests an exchange of some sort with an implied spectator; *The Street Singer*, *Le Déjeuner sur l'herbe*, and *Olympia* all deployed it powerfully. Yet the scenic elements in *Woman with a Parrot* have been pared down: there is no décor to speak of, and only the bird and a few items accompany her. It follows that Manet was tightening his focus on the figure, and on the viewer's relationship with the figure. With Victorine holding a monocle and bouquet, and appearing in a peignoir, that relationship is certainly intimate, and perhaps even flirtatious. Meurent holds the tiny bouquet of violets as high as her face. Violets can connote many

things, but here, considering her dressing gown, a good possibility is an après-theater scene.[19] Perhaps the violets were bought just outside the opera, and now another kind of performance is unfolding between a woman in a dressing gown and the viewer, as the woman holds the (man's) monocle and the flowers given hours earlier. The situation itself is sensuously rich and extremely suggestive. Is she about to brush the violets against her cheek? Or about to sniff their fragrance? The marvelous openness of her hand invites the spectator to look closely at violets, cheek, and hand. Like Cinderella's coach at the stroke of midnight, however, the violets turn out to be mere pigment, brushed in next to strokes of flesh-toned cheek in such a way that the viewer cannot confirm their placement in space. The Cinderella story aptly emblematizes Carol Armstrong's rich formal analysis of the painting's self-reflexivity: that which most solicits the enjoyments of the senses of sight and smell and touch just as powerfully turns back into paint.

Yet the painting unravels not only as an illusion but also as a situation. Ultimately it is Meurent's facial expression that ought to confirm coyness or flirtation, and here is where the painting refuses to play the game of genre or narrative. Just as *The Street Singer*'s gesture of holding cherries to her lips suggests—but falls short of confirming—the furtive signals of the fleeting encounter, so too the expression of *Woman with a Parrot* fails to secure the easily readable countenance that is the keystone of nineteenth-century genre pictures.

What prevails in *Woman with a Parrot*, then, as with the other pictures of Victorine Meurent, is a self-consciousness of being the object of the spectator's gaze.[20] The context of intimate dress/undress here becomes just another role for which Victorine Meurent poses or auditions. It would be a mistake, however, to associate being the object of the gaze with passivity. I have already alluded to the Lacanian notion of the object of desire as a kind of mirage: more aura than substance, the object of desire eludes possession. It would likewise be a mistake to compare the activity of looking or gazing upon the object of desire to a vector emanating from the empowered to the powerless. For Lacan, the gaze transfixes or suspends the one *doing* the gazing. Lacan's rejection of the active/passive dyad around the gaze would not be foreign to Baudelaire, for whom the *flâneur* was often paralyzed by his own overwhelming sensation. Even the nineteenth-century man could consider the spectator to be mastered, overpowered by the gaze itself.

To say that in Manet's art, Victorine Meurent was the supreme object of the spectator's gaze, then, is not to say that she was a passive object. By contrast, it is to say that for Manet, she so completely embodies the role of being the object of the gaze that his representations of her *hold* or *suspend* the spectator in the very act of looking.

Manet's paintings of Berthe Morisot are another story. Let us take, for example, the picture her nephew Paul Valéry most admired, *Berthe Morisot with a Bouquet of Violets*.[21] When we look upon this portrait, we are far removed indeed from the costumes and props of the Meurent pictures. This is a *parisienne*; this is one of the *gens du monde*. Manet might characteristically deploy one of his subtle bits of painterly sleight-of-hand in the inclusion of the tiny bouquet, hardly perceptible against her black dress, or in the framing of her face with ribbons, hair, hat, and scarf encircling her throat. Yet unlike the

Fig. 85. Édouard Manet, *Berthe Morisot with a Fan*, 1872. Oil on canvas,
23 5/8 x 17 11/16 in. (60 x 45 cm). Musée d'Orsay, Paris

pictures of Meurent, there is no foreclosed narrative, no strange freezing of the action. Morisot does not pose, self-consciously, in costume; she is not playing a part. By contrast, she very much is the part of the *parisienne* who knows how to tie a scarf, how to flatter her face with a beribboned hat.

The Morisot pictures are closely involved with details of fashion. In *Berthe Morisot with a Fan* of 1872, for instance (fig. 85), Morisot also appears in a black dress, with black ribboned choker and sheer sleeves partially revealing her arms. She is seated, legs crossed; she purposely extends one foot in such a way that the hem of her dress audaciously rides up her leg. These bits of revealed ankle and arm, however, merely underline the principle effect of the picture: Berthe Morisot concealing most of her face with a semitransparent fan. She holds the stem of the fan just above her chin; the sides of the fan parallel her revealed jawline; the opaque black portion of the fan projects above her head like some hat out of a Domenico Tiepolo Venetian carnival. Through the fan we can still make out Morisot's features, but just barely.

In her indispensible guide to the proper deployment of fashion accessories, the Baronne Staffe described the fan as an accessory easily adaptable to the needs and situations of individual women. Its communicative versatility enabled the holder to send messages discreetly in the most complicated social situations: one could say "I love you" or "I'm mad at you" to a lover, even with one's brother watching.[22] It would appear that painter/viewer Manet and model Morisot are alone here. A message is being sent, certainly. Given the fact that we can glimpse an eye through the fan, however, it appears that Morisot can see Manet more clearly than Manet can see her. It is Morisot's gaze that embodies the picture's meaning; Morisot is the subject, not the object, of the gaze.

My reading of the Morisot pictures goes against several prevailing views in its emphasis on Morisot as subject. Beatrice Farwell judiciously describes the way the paintings (*Le Repos* in particular) "render formal and decorous portraiture into something informal and intimate"; the paintings conjure images of the reclining woman-as-libertine sort, but precariously balance that reference with a measure of propriety.[23] Anne Higonnet sees a "dialogue" of "two intelligences" in these works and explores the notion that Morisot's responses to Manet's art make their way into his paintings of her.[24] In contrast to Higonnet's emphasis that Morisot's intelligence influences Manet's representations of her, Marni Reva Kessler finds that it is Manet as master manipulator who is behind what she sees as the masking, veiling, and ultimately the effacement of Morisot. She reasons that the "crucial significance of Manet's depictions of Morisot lies in this continual shifting of her identity—she looks different from canvas to canvas."[25] Where Higonnet sees dialogue, Kessler sees competition: rivalry with Morisot as painter, and rivalry with Eugène for her affection, both of which contribute to the gradual painterly transformation and "obliteration" of Morisot's identity.[26]

All three authors draw connections between the Morisot-Manet relationship and the pictures' meaning, whether drawing on biography to illuminate the paintings or relying on the pictures to understand the relationship. In this sense, Kessler's analysis becomes the most problematic of the three, as she suggests that Manet apparently "had to continue to assert his control over Morisot, even if not consciously, while his brother gradually won her affections"; Morisot's daughter, no less, recalled that it had

Fig. 86. Édouard Manet, *Before the Mirror*, 1876. Oil on canvas, 36 1/4 x 28 1/8 in. (92.1 x 71.4 cm). Solomon R. Guggenheim Museum, New York. Thannhauser Collection, Gift, Justin K. Thannhauser, 1978 (78.2514 T27)

been "oncle Édouard" who spoke at length to Morisot about the advantages of the marriage to Eugène.[27] Although Morisot was an accomplished artist and no longer a student by the time her friendship with Manet intensified, there is little evidence from paintings and correspondence to support the idea that Manet would have felt very threatened by Morisot as a painter. My thesis does agree with one biographer's, however. Anne Higonnet's biography of Morisot also proposes that Manet's paintings of Morisot "are about how she looks, not just in the sense of her appearance but also in the sense of how she gazes at him."[28] Higonnet wants to underline the importance of Morisot as painter herself—Morisot as one who possesses a powerful gaze of her own. I have already alluded to Morisot's gaze as a key point of difference between Manet's myriad transformations of the model Victorine Meurent when compared with the distinctive emergence of Morisot as subject in the series of paintings of her.

An account of Manet's series paintings of women necessarily encounters the terms of "to-be-looked-at-ness," a discourse inaugurated by Laura Mulvey's essay, "Visual Pleasure and Narrative Cinema."[29] Although this landmark essay was concerned with spectatorial identification and voyeurism on a cinematic scale, for feminist analysis in its wake, it became something of an assumption—not to say a cliché—to rail against the "male gaze," and hence to consider feminine "to-be-looked-at-ness" as something of an undesirable phenomenon that feminism would eventually transcend. Kessler's analysis, for example, which has considerable strengths where it concerns the cultural material of fashion, becomes somewhat problematic in its gendering of artist and model as necessarily active (male) and passive (female). It is interesting that Kessler sees Manet as altering Morisot's actual appearance from picture to picture, as many would analyze the Meurent pictures this way. Perhaps the first account of Manet's discovery and representation of such endless malleability in a model comes in Baudelaire's 1864 prose poem "La Corde": the model there, however, was not a woman but a young boy.

In much art-historical writing since the mid-1970s, the oft-encountered equation between the active gaze and the scopophilic drive has remade the viewer into a voyeur where images of women are concerned. Lacan's analysis of voyeurism is useful in questioning the gendering of the gaze of pleasure. "What occurs in voyeurism?" asks Lacan. "At the moment of the act of the voyeur, where is the subject, where is the object?"[30] "[I]s the activity/ passivity relation identical with the sexual relation?" Lacan queries.[31] His complex musings on voyeurism come out of his reading of Freud's renowned case study of the Wolf Man. Lacan proclaims that the active/passive binary relation is merely a covering metaphor for "that which remains unfathomable in sexual difference." The masculine/feminine relation, says Lacan, "is never attained" in Freud's text.[32] For Lacan, metaphors of activity and passivity in the Wolf Man case denote sadomasochism, not gender. To look for masculine and feminine ideals at work in the psyche, he says, look to Joan Rivière's

Fig. 87. Édouard Manet, *Nana*, 1877. Oil on canvas, 60 3/4 x 45 1/4 in. (154 x 115 cm). Kunsthalle, Hamburg

notion of the masquerade: a performance of "femininity" in the realm of culture that conceals and encodes unconscious anxieties, usually having to do with the father.[33]

If one were interested in an analysis of Morisot and the masquerade, Manet's paintings would offer no shortage of material. Berthe Morisot wears, in various pictures, a muff, a feathered hat, a black hat, a speckled veil, pink shoes, and a fan. Compare the strange deliberation of Victorine Meurent's pose in *Woman with a Parrot* to the graceful self-assurance with which Berthe Morisot clutches her throat and extends her light shoe out from under her dress in *Berthe Morisot with Pink Slippers*. She enigmatically rests chin in hand in *Berthe Morisot in a Veil*. A scarf or choker adorns her neck in all but one of the pictures. If Morisot did not also project such intelligence in these pictures, one might be tempted to describe her as either a slave to fashion or as someone overly concerned with femininity in her appearance—as someone performing or masquerading womanliness as compensation for her masculine activity as a painter.

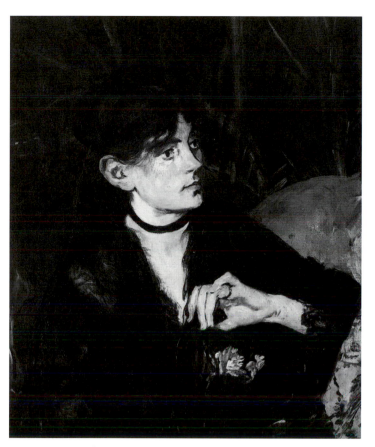

Fig. 88. Édouard Manet, *Berthe Morisot with a Fan* (three-quarter view), 1874. Oil on canvas, 24 x 19 11/16 in. (61 x 50 cm). Private collection, Paris

Yet my analysis here is not of Morisot's possible psychic disposition, but of Manet's paintings, and here some comments by Carol Armstrong are extremely revealing. Armstrong suggests that Manet's late work, notably *Before the Mirror* of 1875–76 (fig. 86), is deliberately Morisotian in facture and signals a kind of identification with the feminine.[34] She sees Manet shifting his focus in his late work toward a "feminized facture which stands *in place of* the gazed-at female body." Manet's lighter palette and more feathery, sketch-like style from the mid-1870s on suggests, for Armstrong, an identification "of the painter's process of production *with* the commodity of femininity: *with* the feminine process of producing femininity rather than with the 'male gaze' onto it."[35] This argument adds refinement and precision to one made by Jean Clay, who took up Mallarmé's suggestion that Manet's was an art of colored ointments, of makeup, of pigmented powders.[36] Mallarmé's language in turn evokes Baudelaire's celebration of the artifice of women's makeup, surely not lost on the painter of *Olympia* and *Nana* (fig. 87).[37] Yet here as elsewhere in Armstrong's work on Manet, the accent falls not on the identification with the feminine itself but on the notion that Manet's painting is fundamentally about painting. Thus, despite her sophisticated expansion of Greenbergian modernism, the allusive possibilities of an "identification with the feminine" are left behind in favor of a renewed claim to painting's self-reflexivity.

Armstrong is surely right to pursue Manet's exploration, in his late work, of "painterly illusionism, femininity, and commodity culture," and to substantiate the suggestion of Manet's painterly debt to Morisot at the level of facture.[38] What she sees as his Morisotian facture, however, comes into being as a response to Morisot's own artistic innovations, and hence typifies his art *after* the series of portraits of Morisot had concluded in 1874. It remains to be seen whether an "identification with the feminine" or with Morisot herself might be enacted by the works from 1868 until her last sitting for him (fig. 88). That last picture shows her in three-quarter view; she decorously holds a fan and understatedly displays an engagement ring.

On the surface, Édouard Manet seems like an unlikely candidate for anything like "identification with the feminine." To him we cannot attribute anything comparable to Mallarmé's fashion articles and elaborate menus in *La Dernière Mode*, written under feminine pseudonyms such as "Miss Satin" and "Olympe, Négresse."[39] But let us return, for a moment, to the scene of painting. Berthe Morisot poses in Manet's studio. Manet is looking at her looking at him. Let us say—for purposes of the argument here—that Morisot's look embodies feelings of love for him, love that exists in an "impossible" situation, obstructed by Manet's status as a married man, his potential interests in other women, the surveillance of Morisot's mother chaperoning the sittings. (These are not unreasonable readings of Morisot's preoccupations as gleaned from her correspondence.) Manet begins to try to paint that look. It is a look that positions Manet as the (love) object. In entering into a dialogue of gazes with Morisot, Manet paints a subject gazing at an object (himself); Manet paints a reflection of sorts: a return of his own gaze that mirrors it, flatters it, enlarges it. By painting Morisot, Manet was looking back at himself, painting himself in the feminine.

The argument I would like to make here positions Morisot both as a subjectival presence in Manet's art and as a kind of feminine *reflection* of a male subject. Morisot's image, of course, would not represent anything like a literal self-portrait or mirror image, but rather, the projection of an ideal, or what Freud called an ego ideal. Narcissism in Freudian terms involves a damming-up of the libido within the self, in place of what would be a desire "to attach the libido to objects."[40] Yet narcissism, in a way, is not the same thing as love of the self. It is a love of the self in the other; it is a projection of an ideal onto that image of the self-in-the-Other. As Freud wrote:

> This ideal ego is now the target of the self-love which was enjoyed in childhood by the actual ego. The subject's narcissism makes its appearance displaced on to this new ideal ego, which, like the infantile ego, finds itself possessed of every perfection that is of value. As always where the libido is concerned, man has here again shown himself incapable of giving up a satisfaction he had once enjoyed. He is not willing to forgo the narcissistic perfection of his childhood; and when, as he grows up, he is disturbed by the admonitions of others and by the awakening of his own critical judgment, so that he can no longer retain that perfection, he seeks to recover it in the new form of an ego ideal. What he projects before him as his ideal is the substitute for the lost narcissism of his childhood in which he was his own ideal.[41]

According to Freud, in narcissism, there is an attempt to recover—in the process of setting up an ideal ego in an Other—an infantile state in which the subject was his own ideal. Narcissism, in Freud's own text, is less a state of *recognition* of the self in the Other, and more a state of *projection* of something the self has not been or cannot be (although it may imagine it has been or could be). The act of seeing the self, or the ideal ego, in the Other or in the image, becomes an act of foreshadowing, wishing, projecting; it is anything but a regressed or static fixation on the self.

One could say that in Manet's paintings of Berthe Morisot, there is a projection of the self onto

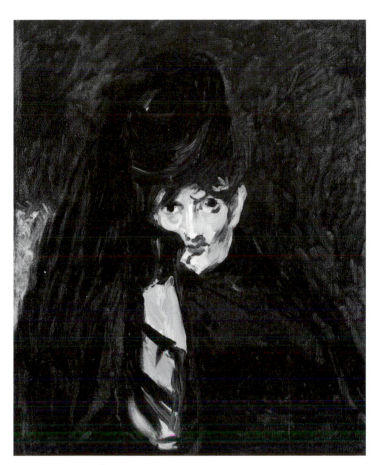

Fig. 89. Édouard Manet, *Berthe Morisot with Hat, in Mourning*, 1874. Oil on canvas, 24 1/2 x 19 3/4 in. (62 x 50 cm). Private collection, Switzerland

a portrayal of the Other's gaze at that self, and that projection becomes legible in the act of viewing. The viewer comes to stand in the place of the self who sees himself/herself in the Other. The sitter's look out of the picture and at the viewer becomes a transcription of the painter's look in the mirror, and at that armature of the self which always remains somewhat foreign, somewhat Other. The representation of the model's gaze is, in fact, the gaze of the self as Other inviting the viewer to assume its otherness.

An act in which the self confronts its own otherness is, in this case, not only tied in to narcissism, but also to an encounter with death. Jean Clay has a memorable description of Manet's *Portrait of Berthe Morisot with Hat, in Mourning* of 1874 (fig. 89), a highly unfinished painting that depicts her in mourning after her father's death: "something like a portrait from death—already substituted for the death it foreshadows. An image in the future perfect tense, where mourning begins: I paint while knowing that this portrait will survive you; I paint what you will have been."[42] In the act of painting a portrait, Clay seems to be saying, the artist imagines the portrait surviving the sitter; the painting becomes a memorial even as its subject is the sitter's own mourning of her father. I would extend this idea a bit to include the artist's self-reflection in a portrait. Because the portrait is not only a likeness of the sitter, but also the artist's conception of a spectator—not necessarily himself—who looks at the sitter looking at the artist-spectator, the portrait involves both the artist's self-reflection and his projection of a spectator who will take his place in front of the picture, viewing the sitter looking out. The portrait of Morisot in mourning, then, is not only Manet's attempt to depict her contemplating her father's death, but also an evocation of the spectator's contemplation of death, whether that means the painter-as-spectator or the spectator who will stand in his place.

Because of the unfinished state of the portrait, one can see aspects of Manet's technique that are not always apparent in other canvases. One can see with an astonishing degree of clarity, for instance,

the way Manet is always defining form by simplifying and abbreviating it, while he is simultaneously being excessive, going over the boundaries suggested by contours he is elsewhere at pains to impose. In the unfinished portrait, a few strokes of light flesh tones, with a maximum of white, define the nose and the plane of the left cheekbone. Recessed areas below the nostrils and mouth are suggested by unblended strokes of a warm burnt sienna. Manet has begun the process of blending the right cheek: above the cheekbone, there is a blended flesh tone which keeps to the definition probably made originally with more white, as on the left side; there is also, below the cheekbone, the beginnings of blending in which the shadow below the bone itself eventually meets the more illuminated area of the chin. Looking at the left cheek—sharply captured by two almost-white strokes, one C-curve and one S-curve—one could say that these strokes, this kind of drawing, come almost from the realm of caricature. The right side of Morisot's face is clearly different, in part because Manet has begun the process of blending light and dark. Morisot's chin is still a diamond shape, as Manet has not yet fashioned it into a more organic form. This angular form suggests a line that would form her jawline; it is more or less a continuation of the line of her chin. Yet below the suggestion of this jawline, which is the jawline of a slender, youthful woman, are strokes of paint that blur its definition. Shadows from below the cheekbone are blended in such a way that they merge with what must be her neck. Manet paints a kind of Cézannian *passage* in which a few strokes of paint come to stand for jawline, neck, and the shadow below the cheekbone in such a way that the contour of the face has been completely blunted. The exaggerated, hyperdefinition of the left side of the face manages to coexist with what seems to be the impossibility of definition at right.

The painting was one that remained in Manet's studio. We can only speculate about the reasons for its remaining unfinished. Most of the portraits of Morisot—seven, in fact—remained in Manet's inventory, and two were gifts to Morisot. Even the ones sold went to friends and collectors who were practically handpicked.[43] These facts attest to the personal importance of the paintings for both artist and sitter, and perhaps the extent to which Manet cared deeply about the paintings' future. Portraits, as Jean Clay implies, are very much about the memorial act: at some level they attempt to evoke the sitter for posterity. Considering the uniqueness in Manet's oeuvre of such an ambitious and experimental range of portraits as those of Berthe Morisot—all of which are, above all, *portraits* as opposed to modern-life genre scenes or histories—one can hardly dismiss Clay's suggestion that the mourning-portrait might have been painted with a view toward its survival of the sitter. Yet the portrait is a record not so much of the way Morisot revealed to Manet an aspect of herself, but a record of Manet's revealing what he saw Morisot revealing to him as if she were herself revealing it to the spectator. In an act of painting that simultaneously brings Morisot into focus in a highly exaggerated way, even while it suspends the possibility of resolution of its portrayal, the portrait, it seems, *wants* to highlight not just its sitter, but also some exchange between the artist and his sitter. And in light of what I see as Manet's imparting of subjectivity, and even selfhood, to the portraits of Morisot, the portrait represents more than the projection of a memorial of Morisot. It is also a memorial of Manet.

To return to Jean Clay's remarks: Manet paints "where mourning begins," which is with the self.

For Clay, the portrait "already substitutes for the death it foreshadows"; I would add that the foreshadowing holds for artist as well as sitter. We might thus quote Clay again with another substitution: "I paint while knowing that this portrait will survive *us both*." The portraits of Morisot are, of course, not the first portraits of a woman in mourning in Manet's art. One might compare *Berthe Morisot with a Bouquet of Violets* to the painting that must be regarded as Manet's foundational mourning-portrait, that of his mother (fig. 13). I have already noted the effect of the asymmetry between the two halves of the face in the portrait of his mother: the way one half of the face projects a particular engagement with the spectator even as the other half registers a self-conscious awareness of the spectator's gaze. There is a similar asymmetry in the Morisot portrait, though in my view there is not the same kind of self-consciousness in the Morisot pictures. Both faces, however—Mme Manet's and Morisot's—are encircled by black. Unlike the modish entanglement of ribbons and scarves around Morisot's face, there is a sea of black engulfing the face and hands of Manet's mother. It appears that at least one of Manet's preoccupations in the maternal portrait is an exploration of subtle distinctions among the various blacks that make up the painting: the dress, background, veil, ribbon, trim, belt, buckle. The mother's face and hands become even more imposing as the flesh tones project forward against the black ground. Comparing the two paintings, the flesh of Mme Manet has a weight—the weight of age, perhaps—which that of Mlle Morisot lacks; there is a tremendous contrast between the thin, narrow lips and thick facial hair of the older woman and the beautiful, full lips and light, supple skin of the younger. What remains the dominant tone in both paintings, however, is the way the woman's face practically floats out of the painting, encircled by black. The uncanny visual effect of decapitation achieved in the Morisot picture is first accomplished in the portrait of Manet's mother.

In Manet's other paintings of Morisot, one notices a pattern of accessories and poses that have a similar visual effect of severing or isolating the face. Look at the emphatically thicker layer of pigment tracing Morisot's hair, hat, and green choker, encircling her face, in *The Balcony*; look at the unusual placement of her hand covering her throat in *Berthe Morisot in a Veil* and *Berthe Morisot with Pink Slippers*. As we have seen, the face is almost completely concealed in *Berthe Morisot with a Fan* and never quite revealed in the unfinished mourning-portrait. Manet's interest in the face of Berthe Morisot is clearly something quite distinct from the costume fantasies of Meurent. It surely goes beyond the simple sexual metaphors of Baudelaire's "Les Promesses d'un visage," in which details of eyes and head of hair tell of flesh and hair elsewhere on the body, yet to be uncovered. Kessler is right to deconstruct the function of the veil in the visual culture of Manet's time, as the veiling effects in the Morisot pictures eroticize even as they decorously drape the female model. To plumb the depths of decapitation-fantasies, we have to move forward decades in time to Surrealist photography and *Documents*, to the musings of Michel Leiris on the full-face leather mask as reminiscent of the decapitated queen, her body revealed by the complete covering of her face: the masked woman as the *caput mortuum*, the death's head.[44]

Although there is undeniably an interest in the culture of mourning and death to be felt in some of the Morisot pictures, it is not a leitmotif for them all. The carefully represented instances of mourning-

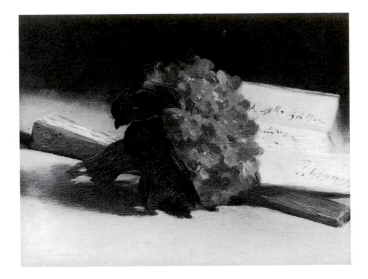

Fig. 90. Édouard Manet, *Bouquet of Violets and Fan*, 1872. Oil on canvas, 8 3/4 x 10 3/4 in. (22 x 27 cm). Private collection, Paris

attire or muffs or veiled hats do tell us, however, that even if these works are portraits, they also function as paintings of modern life. To the extent that the painting of modern life in general is bound by the ideologies of family and class, it becomes in a sense a fiction: a representation meant to dream, to imagine transgressions of societal or familial sanctions.[45] Think of the Morisot pictures, with their experimental range and playful intimacy, somehow stacked alongside a portrayal of the decorum of bourgeois marriage. Manet images an intelligent, cultivated, beautiful woman of means who can be seen to represent a freedom not unlike that of Isabelle Archer in the first half of Henry James's *Portrait of a Lady*. And even as Morisot is a figure of the upper-class educated woman, she is also, in pictures like *Berthe Morisot with a Bouquet of Violets*, an upper-class woman in mourning, a figure reminiscent of Manet's mother after his father's death. Somehow Morisot becomes all of these things: available and desirable while proper (not like Meurent), the woman in mourning after the death of the father (Manet's or Morisot's), and the woman who can represent Manet himself—charming and an artist (too bad she's not a man).

To dream of transgressions of societal and familial sanctions is almost certainly part of the brief of the Morisot pictures, yet the dream is only nurtured and kept alive by its own impossibility. Evidence of an oscillating response to the potentially compromising appearance of the situation can be found throughout the pictures. The association of Morisot with invitations and violets exchanged by lovers, as in *Bouquet of Violets and Fan* (fig. 90), connotes a flirtation kept within the boundaries of the proper.[46] Manet's decision to alter Morisot's position from a sideways recline to a slight leaning in *Le Repos* spells out a concern with propriety, as does his cropping of *Berthe Morisot Reclining* (fig. 91) so that it is little more than a bust-length portrait.[47] These are surely not simple matters of pictorial exigencies. They are real instances of the intrusion of the gaze of Others. Manet acts to avoid the appearance of exposing Morisot. In painting her, he becomes the object of the gaze of others—of the Morisot and Manet families, and of society itself. In some sense, the gaze that matters most of all in determining the shape and

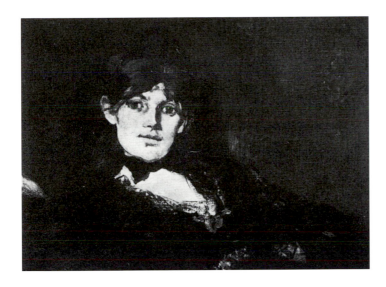

Fig. 91. Édouard Manet, *Berthe Morisot Reclining*, 1873. Oil on canvas, 10 1/4 x 13 3/8 in. (26 x 34 cm). Musée Marmottan-Claude Monet, Paris

form of these pictures is neither the gaze of Morisot as subjectival presence nor of Manet as artist, but instead the gaze of others who made the situation "impossible."

My contention that Manet painted himself *as* Morisot could be taken as an outrageous one, in need of the most deft practitioner of queer theory to elaborate. After all, it is one thing for Rosa Bonheur to paint in trousers; another for a male artist to create an alter ego *in* a female one, then paint a series of pictures of her/him "with a muff," "in pink slippers," and so on. The stories about Manet's overdetermined relationship to clothing, although they are traditionally "masculine," would lend support to his (self-) interest in Morisot's fashions. This from Morisot herself: "Manet spent his time during the siege changing uniforms."[48] And Proust reported that Manet, after challenging Duranty to a duel (over the latter's terse review of Manet's paintings on exhibition), recounted: "I can't tell you what trouble I went to, the day before the duel, to find a pair of really broad, roomy shoes in which I would feel quite comfortable. In the end, I found a pair in the Passage Jouffroy. After the duel, I was going to give them to Duranty but he refused them because his feet were larger than mine."[49] Manet's behavior can be seen as typical of the nineteenth-century male dandy, although that too is open to analysis as to gender ambiguities. I would not be doing queer theory any justice, however, if I pressed this line very far: I neither mean the claim literally, nor would I like to use it alone to account for the pictures' erotics, their construction of self and Other.

If to paint oneself as another is not in this case wholly to be understood as a gender reversal, what then would be involved in the look by the male artist into the eyes of the female one as part of a search of "self," for identity? Out of the vast territory that might be thought of as women's experience, and the specific one that was the experience of a woman who traversed into the territory of the (male) art world, what was selected, what would have constituted that identification?

For one, "to-be-looked-at-ness" was surely part of the attraction of an identification with the

feminine. The culture of commodified femininity Armstrong explores in Manet's late work is ample evidence that Manet was attuned to this world. It can be said to be such an integral part of the social construction of "woman" that most women took it for granted. Even a woman who did serious creative work and wanted it seen on its own terms, like Berthe Morisot, accepted the culture of to-be-looked-at-ness as a given. Witness what happened when she found herself in a culture somewhat foreign to her own: among the Franco-Spaniards in Saint-Jean-de-Luz, she felt virtually invisible: "Heaven knows here I don't have to protect myself or be afraid of admirers. I am surprised at being as unnoticed as I am; it is the first time in my life that I am so completely ignored. The advantage of it is that since no one ever looks at me, I find it unnecessary to dress up."[50] Morisot expected to be looked at, and dressed up in anticipation of it. Unlike the model who was paid to undress or wear a costume, a woman like Morisot would have provided a feminine version of Manet's own attitude to dress, as she was acutely conscious of how to play the game.

Yet the fashions and plays of looking, the lifting of hems and the peeking through fans had its limits in the sittings. No matter how subtle the language of fans, corsages, and jewels decoded by the Baronne Staffe and her ilk, the book was only open in the drawing room, with others present; the language runs out when private doors are closed. In that sense, the woman of social standing like Berthe Morisot could practically symbolize, or represent, the constraints that surrounded Manet's own life. Her very self-presentation as a society woman made those constraints palpable.

It is the nature of a concern with social appearances to defer to the judgments of others. Indeed, behind a concern with appearances is a perpetual voice-over of the opinions and judgments of society. To look for oneself in the eyes of another is sometimes to find only the self *in others' eyes*—that is, only what others think. The nineteenth-century woman, whether she acknowledged it or not, was expert on the subject; that was perhaps part of the appeal of particular women as models for Manet. Morisot was unconventional in that she was an artist; she represents not the deliberate flouting of mores that a model or prostitute would stand for, but rather a defiance that lurked deeper, under the surface of the cosmetics, the beribboned hats, the fashions. She could stand for a defiance that was genuine, one of spirit and ambition, but also ultimately one of compromise with appearances and surface respectability. In her, Manet could see the extent to which his own life also remained one of deep defiance and surface respectability.

Every act of painting is at some level an attempt to constitute the self. It is an act of facing countless points of resistance, from the pressure of prior masters to that of peers, rivals, friends, family. It is an encounter with these influences and anxieties even while one attempts to make a mark, to paint a face or a street or a flower. For Manet, every act of painting was grounded in resistance to everything for which his family name stood: there was the authority of the judge, the property, the income, the receptions, tradition, the family honor. Manet took on all this in many ways. It is an obvious affront to align oneself with Baudelaire and paint the *chiffonniers* and the street singers, or to take on Raphael and Giorgione in cheeky parody. But it is also flirting with disaster to paint Berthe Morisot allowing the hem of her skirt to ride up her leg. For every picture of Morisot that toys with such conventions of

morality, there is another like *Le Repos* that is utterly constrained by them. The sartorial freedom Morisot alternately demonstrates and censors (or encourages Manet to censor) emblematizes the process by which the gaze of Others—of society—objectifies the subject (Morisot or Manet). There is still an inescapable family romance; it is bounded not only by the name of the honorable judge, but also by the wills of two families to protect a strong, independent, single woman.

It comes down to what happens in the act of looking. The (male) artist looks at the (female) model: in the example of Manet's paintings of Morisot, two haut-bourgeois artists look at one another. Any way one puts it, the dice are loaded: looking is not neutral. In this instance, however, one cannot speak of a conventional case of power residing on the side of the upper-class male artist; what takes priority instead is the gaze of Others looking in on the artist, a gaze that thrusts the artist into the position of object. As Sartre put it: "By the mere appearance of the Other, I am put in the position of passing judgment on myself as on an object, for it is as an object that I appear to the Other."[51] It is the omnipresence of Others around the relationship of Manet and Morisot that ultimately shapes a male artist's identification with a female one who bears the imprint of the social constraints that weighed on them both.

It would be all too easy to try to suggest that Manet's portraits of Berthe Morisot are about desire. But to do so would also be to maintain that in that desire—Manet's or Morisot's, fulfilled or unfulfilled—lies the truth of the works, their claim as representations of a world. The world they represent is the private domain of two artists with the leisure to pursue poses with fans and pink slippers, and the confidence to make innovative and compelling pictures out of them; it is also a world in which desire was entertained and probably kept at bay. Desire has a way of fixing identity, as Michel Foucault observed, whereas pleasure has ways of blurring it.[52] Foucault maintained that the liberation of desires would not lead to more freedoms; the exploration of more pleasures, however, would. Sometimes a loss of identity is desired, as is an avoidance of desire. The extent to which Morisot and Manet created a domain of pleasures made of reimaginings of identities via the aesthetic materials of clothing, makeup, and paint may be as radical, and as free, as their art ever got.

CONCLUSION

MY ATTEMPT TO RECONSTRUCT some nineteenth-century familial myths around Manet's art is, at some level, aimed at rescuing an essential feature of Manet's art from the literalness of a certain brand of art history that concerns itself only with Manet's subjects and motifs in a material sense. It is, in part, a reminder that the social history of art can accept within its purview not only the social history of the family, or of a particular upper-class Parisian family, but also the history of identifications, aspirations, desires, and relations, which in turn act as ideological fields. The story that remains to be told involves the painting of modern life as a whole: it involves aspects of memory, fantasy, and familial sanctions, which inflect the private life of the "new painting."

Realism did not set out simply to recast traditional genres with up-to-date figures and décor. Its goals were different; its forms were new. Paintings such as Courbet's *Young Ladies of the Village Giving Alms to a Cowherd* (fig. 92) and Manet's *Le Déjeuner sur l'herbe* did not conform to contemporary expectations for landscape, history painting, or genre painting. But the forms taken by the painting of modern life, as T. J. Clark has suggested, are inseparable from its content; in the case of Courbet,

the combination of epic form and specific figures and moments was crucial to the effect of his paintings. The three fashionable girls are the painter's sisters. The revelations of class distinctions, which carried such pungency in the 1850s, depend in part on the context of familiarity from which they are derived. Courbet's project to represent a cycle of provincial life was deeply rooted in the representation of his own family and its social position.

Monet's early forays into the painting of modern life led him to subjects that were not simply "modern," but also familiar and familial. The *Terrace at Ste.-Adresse* (fig. 93) configured its crisp decorum around Monet's father and cousin; *Le Déjeuner* (fig. 94) imagined its fiction of domestic life

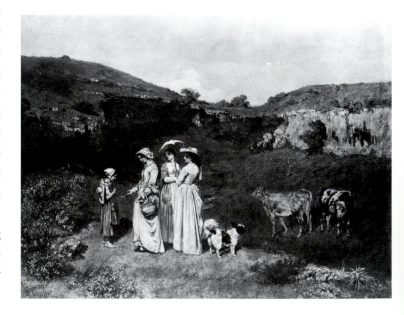

Fig. 92. Gustave Courbet, *Young Ladies of the Village Giving Alms to a Cowherd*, 1855. Oil on canvas, 76 3/4 x 102 3/4 in. (195 x 261 cm). The Metropolitan Museum of Art, New York. Gift of Harry Payne Bingham, 1940 (40.175)

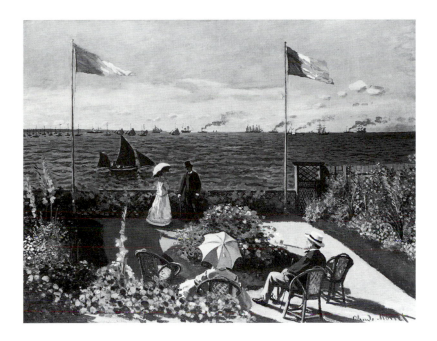

Fig. 93. Claude Monet, *Terrace at Ste.-Adresse*, 1867. Oil on canvas, 37 7/8 x 50 3/8 in. (98.1 x 129.9 cm). The Metropolitan Museum of Art, New York. Purchase, special contributions and funds given or bequeathed by friends of the Museum, 1967 (67.241)

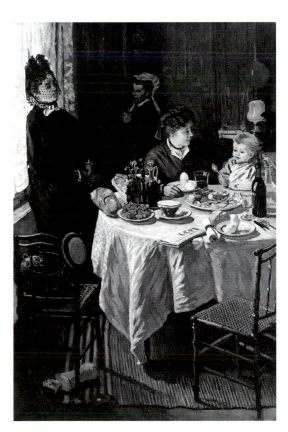

Fig. 94. Claude Monet, *Le Déjeuner*, 1868. Oil on canvas, 75 3/8 x 49 1/4 in. (230 x 150 cm). Städelsches Kunstinstitut, Frankfurt

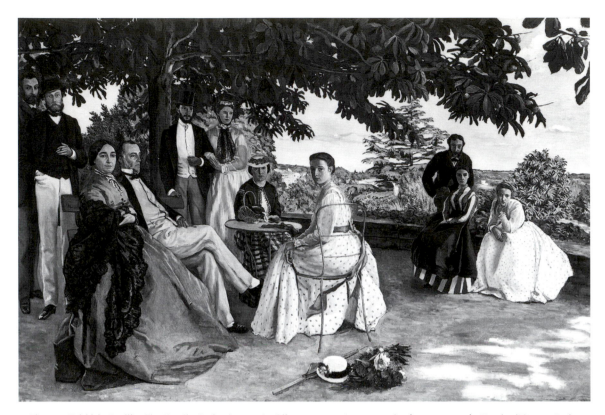

Fig. 95. Frédéric Bazille, *The Family Gathering*, 1867. Oil on canvas, 60 3/4 x 91 in. (152 x 227 cm). Musée d'Orsay, Paris

Fig. 96. Frédéric Bazille,
Study for *The Family
Gathering*, with sketch
of Saint Sebastian,
1867. Drawing. Cabinet
des Dessins, Musée du
Louvre-Orsay, Paris

around his girlfriend, Camille Doncieux, and their natural son, Jean. In painting leisure on the paternal terrace and harmony and plenitude around the breakfast table, Monet was surely painting a fiction, as his father had urged the painter to abandon the pregnant Camille, and Monet's financial situation in those years drove him to the brink of suicide. Anne Wagner has suggested that "it is because *Le Déjeuner* marked the difficult point of intersection between unresolved aspects of Monet's identity—painter, father, son, lover, rival, realist—that it turned out to be his last figure painting: the last of his pictures to aim at imaging both the form and the contents of modern life."[1] Once again, the painting of modern life attempts to represent the "modern"—the contemporary manners and mores of the seaside town and the well-kept household—and in doing so, necessarily paints the family and encounters the family romance; here the fiction of order and propriety. Wagner's argument is bold and important because it suggests not only that matters of identity are bound up with the modern-life painting project, but also that the implications of this turning point in Monet's oeuvre extend well beyond the fate of canvases yet to be painted in Argenteuil or Giverny.

A figure like Frédéric Bazille is also a case in point. On the surface, *The Family Gathering* of 1867 (fig. 95) appears to be an attempt to put into practice a distinctly Monet-inspired focus on light effects; as an image of a well-to-do family it resembles a photographic portrait, as Dianne Pitman suggests.[2] Pitman also analyzes, however, a preparatory drawing for the family portrait that Bazille juxtaposed with a sketch of Saint Sebastian (fig. 96), a figure she relates to the great standing figure who leans languidly against the tree in the *Summer Scene* of 1869 (fig. 97).[3] The latter picture is an ambitious modern-life painting of eight young men bathing, resting, undressing, and wrestling by the water's edge. The homosocial atmosphere of the scene is unambiguous: alongside the camaraderie of the wrestling figures and the man helping another step out of the water is the repose of the reclining figure in the middle ground and the man who leans against the tree. The passivity of these static figures seems calculated not just to provide a counterpoint to the activity of the others, but also to offer real visual pleasure to the viewer: Kermit Champa calls the painting "a highly contrived construct" that features "relentless same-sex gazing."[4] The left-hand figure's status as a modern-life version of the traditional Saint Sebastian does connect the figure to a growing subcultural construction of the saint as an icon of homosexuality.[5]

The standing figure in the *Summer Scene* may also be, as Pitman argues, a stand-in for Bazille himself.[6] Had Bazille already likened himself to Saint Sebastian in the preparatory drawing, when he depicted the aftermath of the first (failed) martyrdom of the saint, with Irene caring for his wounds? What does it mean that this Sebastian, whether Bazille or not, suffers and is rescued literally under the surveillance of the entire family, all posed to look out of the picture? It seems beside the point to argue, as Pitman does, that there is little evidence as to Bazille's actual sexual orientation (she in fact reads the evidence to suggest that he was heterosexual).[7] The images tell the story: in one image of male bonding and male beauty, the major figure reads as a Sebastian to a small audience that wants to see him there; in the drawing, another figure enacts the role of Sebastian, and the artist—deliberately or unconsciously—stages that drama with his entire Montpellier family there to watch.

In the writing of art history, I would propose a necessary distinction between interpretative maneuvers based on biography and those that suggest an artist's formal choices are somehow interconnected with matters of self-fashioning. To introduce questions of identity apropos of the modern-life painting project is in fact to return to principles broached in Baudelaire's "The Painter of Modern Life." Foucault stressed the idea that Baudelaire's notion of an encounter with modernity had radical implications for art because it involved both a transfiguration of reality and a transformation of the self. For Baudelaire, the painter of modern life was more than a recorder of modernity; he was also a dandy—someone who made himself into a work of art. Foucault summarized it this way: "Modern man, for Baudelaire, is not the man who goes off to discover himself, his secrets and his hidden truth; he is the man who tries to invent himself. This modernity does not 'liberate man in his own being'; it compels him to face the task of producing himself."[8] The artist carves out a space of freedom both in the work carried out on "reality" and in the act of inventing the self. A theory of the painting of modern life, or an approach to the writing of its history, must do justice to both. Most art historians would reason that the artist's representation of a world is not a neutral thing and that historical work reveals the gaps between reality and representation. Foucault's second point, however more elusive for the historian, is equally important: what constitutes the work of producing the self? What are the analytical tools for understanding that work? Foucault's reading of Baudelaire, I should add, occurs at a key point in the essay "What is Enlightenment?" when Foucault characterizes Kant's famous text of that name in terms of a turning point in the philosophical attitude toward modernity. "It is in the reflection on 'today' as difference in history and as motive for a particular philosophical task that the novelty of this text appears to me to be," he wrote.[9] One could make a similar claim for the painting of modern life; Michael Fried did some time ago with his designation of Manet as the "first post-Kantian painter." Fried's moniker opens onto Foucault's double reading of Baudelaire: something in the encounter with modernity leads artists, notably in the 1860s, to a new consciousness of self, a novel kind of exploration of self and identity.

The word "identity" is perhaps the wrong word here: it sounds too much like a subscription to a preexisting template of self and style. What I am trying to say here is that for the early painters of modern life, it is precisely in the domain of what might be called "identity" that a maximum of change, reconfiguration, realignment of self and world occurs. Because the encounter with modernity involves an attitude toward it—an attempt to see the self within the flux of the changing present—that encounter also brings a confrontation with new and shifting aspects of the social, the familial, and the personal. "Identity-formation" captures, if a bit awkwardly, the idea of ongoing transformation and unfinished work I have in mind. For Foucault, the real import of Baudelaire's essay is to be seen in the work carried out on the self, and the work always yet to be done. As David Halperin has elegantly shown, for Foucault, "The self is a new strategic possibility, finally, not because it is the seat of our personality but because it is the *point of entry of the personal into history*, because it is the place where the personal encounters its own history—both past and future."[10] Our understanding of Manet's *Le Déjeuner sur l'herbe* and *Olympia* must surely encompass such a notion: that the real site of the painter's

consciousness of modernity is personal. It is *there* on the face of Victorine Meurent, it is *on* the family property, it is the mother's bracelet; and it is from there that Manet stakes his claims about contemporary life and about Titian and Giorgione.

I began these reflections on Manet with a Foucauldian construction of the family as a complex and volatile mechanism with regard to the development of sexuality. Foucault, interestingly, burned an unfinished manuscript about Manet shortly before his death.[11] He did write and publish much about the nineteenth century, however, including the claim that "the great obsession of the nineteenth century was history": theories of history, the rise of the museum, and the connections between the novel and the library or archive; he considered Manet to be the first "artist of the museum" in the sense of Manet's palpably strong relation to the art of the past.[12] Foucault's construction of the past carried into his writings on ethics. The philosopher was intellectually wary of tying a notion of self-construction to the weight of the past: the confession of the past should not determine the course of the future, or even perception of the present.[13] Nowhere is this more clear than in his writings on (or *against*) desire. For Foucault, sexual desire was not to be regarded as an ultimate secret, which, if divulged, would in any significant way illuminate the life of the individual or knowledge of the self. If desire, like ambition, can act as an ideological field or shaping force, the self should not be understood as a mere receptacle of either. In trying to highlight Baudelaire's conception of the artist's twin confrontations with modernity and self, I have tried to underline the ways that our account of desire's role in the production of artworks should not reduce either the work of art or the self to the status of an effect of desire.

One of Manet's first champions tried to deflect attention away from the artist's controversial subject matter by insisting on his interests in form alone. The reductiveness of that position was clearly spawned by the reductiveness of critics who had already made Manet into the "painter of *Olympia*," and specifically, the painter of certain would-be obscenities in that work. In understanding this complex history, Foucault's work is also indispensable. Foucault argued in his *History of Sexuality* that since the seventeenth century, bourgeois society had instituted a great repression around sex, and that rather than silencing or prohibiting certain behaviors, this repression had given rise to ever more ways of representing sex. The history of sexuality in modern culture somehow had to admit both the repression and the obsession: that along with censorship came the proliferation of more scientific studies, more terms, more books, more criticism, more interest. The reception of *Olympia* is perhaps only understandable in this light—that in the painting, Manet gave visual form to aspects of sexuality that society regarded as inadmissible, even while its suppressions garnered so much attention.

The law plays a central role in Foucault's characterization of the modern construction of sexuality. As Joan Copjec has written, for Foucault the law actually works to incite forbidden desires by proscribing them.[14] Such a view has radical implications for the early nineteenth century, the society of Manet's father Auguste, and for the moral legacy inherited by Édouard. One factor is key: post-Napoleonic France became a state in which the illegitimate could inherit. This shift, in addition to facilitating so many plotlines by Balzac, ushered in an epoch of secrecy about the illegitimate, a different attitude toward the social consequences of adultery, a newly staunch protection of familial interests. Even a

family that wanted to do the right thing by a bastard child, and had the means to do so, had to undertake such care in a precarious social atmosphere and with a precise knowledge of the law. The story of the Manet family should not be regarded as the key to his art, but rather as a cultural symptom that reveals another layer of conflicting interests already inflected by class and sex.

"Chagrin d'enfant principe d'oeuvre d'art," Baudelaire underlined in his lecture notes on De Quincey.[15] Baudelaire and De Quincey were not alone in speculating that an infant's experiences shaped the work of the adult artist, as it was a commonplace of nineteenth-century biographies of artists to stress this, even if it meant fabrication. At the same time, the work of Baudelaire and De Quincy also bears witness to the idea of the family romance.[16] It may be the case that more or less everything Freud would

Fig. 97. Frédéric Bazille, *Summer Scene*, 1869. Oil on canvas, 63 x 63 1/4 in. (160 x 160.7 cm). Fogg Art Museum, Cambridge, Massachusetts. Gift of Mr. and Mrs. F. Meynier de Salinelles

ever write about children and sexuality would be, and remain, controversial, from the shock of his contemporaries over his postulations on polymorphous perversity to the debates in our own era about his abandoned seduction theory and his phallocentric notions of the castration complex, penis envy, and Oedipal desire. Yet in many ways even Freud's child pales beside those of Baudelaire in the prose poems: there are, for instance, the brothers who engage in a near-fratricidal struggle over a piece of bread in "Le gâteau," and the boys who dream of bedding the nursemaids and sleeping among drunken vagabonds in "Les vocations." Baudelaire articulates not only *les chagrins d'enfance* as significant for the adult artist, but also the actual violence and sexuality of the child's real life. Insofar as Baudelaire's art was an important lead for Manet, the poet's view of children forms part of the context for Manet's construction of "modern life," the Paris that included the boys in *The Old Musician* and the boy at the center of the very real family drama. Baudelaire's phrase should not be taken as a license for biographical criticism, but rather as evidence taken from a culture that discovered *les chagrins d'enfance* and took them seriously.

Baudelaire's painter—his "Manet" in "La Corde"—discovers the extent to which he is duped by familial interests in general and maternal love in particular.[17] But one should say more properly that it is the painter's art that bears the brunt of the disenchantment. Baudelaire's painter, like Manet, made a profession out of reading faces in the crowd and transforming them in the studio. The painter had faith

not only in his own ability to create illusions that were true to life, but also in the ability of painting itself to sustain them. As it turns out, the overlapping territories of family, money, and love had already outstripped the illusions created in his art. The "family romance" of Manet is not the ultimate secret of his life or his art: it is the configuration in which they both exist and cannot attain complete knowledge of each other. Such is the nature of the painting of modern life: it is a realm in which art and life coexist uneasily and hover in each other's blind spots. Baudelaire's painter somewhat ruefully confessed this inevitability; Manet went on painting it.

NOTES

INTRODUCTION

1. Charles Baudelaire, *Paris Spleen*, trans. Louise Varèse (New York: New Directions, 1970), 64–67. I am following the Varèse translation here with the exception of the phrase "mother-love" for "l'amour maternel," rendered here as "maternal love." Except where otherwise noted, translations in the text are mine. For the French text, notes are to *Oeuvres complètes*, ed. Marcel A. Ruff (Paris: Seuil, 1968).

2. Louis Althusser, "Freud and Lacan," in *Lenin and Philosophy*, trans. Ben Brewster (New York: Monthly Review Press, 1971), 189–220.

3. See Althusser's idea of the dimension of horror contained in his notion of the "ideology of the family" in *The Future Lasts Forever: A Memoir*, ed. O. Corpet and Y. Moulier Boutang, trans. R. Veasey (New York: New Press, 1993), especially 104–5.

4. From Althusser's letter to the translator dated 21 February 1969, apropos an English translation of "Freud and Lacan" in *New Left Review*. See *Lenin and Philosophy*, 190.

5. Émile Zola, review of the Salon of 1866 first published in *L'Événement*, 7 May 1866; the text is reprinted in Zola, *Pour Manet*, ed. J.-P. Leduc-Adine (Brussels: Éditions Complexe, 1989), 71.

6. Michael Fried, *Three American Painters: Kenneth Noland, Jules Olitski, Frank Stella* (Cambridge, Mass.: Fogg Art Museum, 1965), 4–10.

7. T. J. Clark, *The Painting of Modern Life: Paris in the Art of Manet and his Followers* (New York: Knopf, 1984), 254. Here, and throughout the text, bracketed ellipses "[. . .]" will denote those that have been added; unbracketed ellipses are original.

8. Clark, *Painting of Modern Life*, 139.

9. A. Vernier, "Causerie Scientifique," *Le Temps*, 29 April 1869, 1. Vernier refers primarily to Littré's journal *La Revue de philosophie positive*.

10. Paul Ricoeur, *Oneself as Another*, trans. K. Blamey (Chicago: University of Chicago Press, 1992), 128.

11. Richard Wollheim, *Painting as an Art* (Princeton: Princeton University Press, Bollingen Series, 1987), 141.

12. For Freud's study of Leonardo, see *The Standard Edition of the Complete Psychological Works of Sigmund Freud*, trans. James Strachey, 24 vols. (London: Hogarth Press, 1953–74), 11:63–137. On the interpretative errors and other historical facets of this work, see Meyer Schapiro, "Freud and Leonardo: An Art Historical Study," *Theory and Philosophy of Art: Style, Artist, and Society, Selected Papers* (New York: George Braziller, 1994), 153–92, and in the same volume, "Further Notes on Freud and Leonardo," 193–200.

13. See Jeanne Wolff Bernstein's discussion of both essays in "Enframing the Gaze: A Psychoanalytic Exploration of the Works of Édouard Manet," (Ph.D. diss., The Wright Institute, Berkeley, 1985), 11–41.

14. Meyer Schapiro, *Modern Art, 19th and 20th Centuries, Selected Papers* (New York: George Braziller, 1982), 1–38.

15. James Elkins refers to Wittgenstein's critique of Freudian dream interpretation in his "Conversations on Freud." See Elkins's review of Hal Foster, "Compulsive Beauty," *Art Bulletin* 76, no. 3 (September 1994): 545 n. 8.

16. See, for instance, Jack J. Spector, "Delacroix: A Study of the Artist's Personality and Its Relation to His Art," *Psychoanalytic Perspectives on Art*, ed. Mary Mathews Gedo (Hillsdale, N.J.: Analytic Press, 1985–88), 2:3–68; John E. Gedo, *Portraits of the Artist: Psychoanalysis of Creativity and Its Vicissitudes* (New York: Guilford Press, 1983).

17. Lynn Hunt, *The Family Romance of the French Revolution* (Berkeley: University of California Press, 1992), and Carl Schorske, *Fin-de-Siècle Vienna: Politics and Culture* (New York: Vintage/Random House, 1981).

18. Elkins, review, "Compulsive Beauty."

19. Bernstein, "Enframing the Gaze."

20. Martine Bacherich, *Je regarde Manet* (Paris: Adam Biro, 1990).

21. Steven Z. Levine, *Monet, Narcissus, and Self-Reflection: The Modernist Myth of the Self* (Chicago: University of Chicago Press, 1994). Levine has also turned to Manet's work for an even more personal set of reflections; see "Manet's Man Meets the Gleam of Her Gaze: A Psychoanalytic Novel," in *Twelve Views of Manet's 'Bar,'* ed. Bradford R. Collins (Princeton: Princeton University Press, 1996), 250–77.

22. Along these lines, see for instance, David Carrier, "Art History in the Mirror Stage: Interpreting 'A Bar at the Folies-Bergère,'" in *Twelve Views of Manet's 'Bar,'* 71–90, and Bradford R. Collins, "The Dialectics of Desire, the Narcissism of Authorship: A Male Interpretation of the Psychological Origins of Manet's 'Bar,'" *Twelve Views of Manet's 'Bar,'* 115–41. An allusive consideration of reader/viewer participation can be found in Constance Penley, "Feminism, Psychoanalysis, and the Study of Popular Culture," in *Visual Culture: Images and Interpretations*, ed.

Norman Bryson, Michael Ann Holly, and Keith Moxey (Hanover, N.H.: Wesleyan University Press and University Press of New England, 1994), 302–24.

23. Whitney Davis, "Erotic Revision in Thomas Eakins's Narratives of Male Nudity," *Art History* 17, no. 3 (September 1994): 301–41; Anne Wagner, *Three Artists (Three Women)* (Berkeley: University of California Press, 1996).

24. Briony Fer, "Bordering on Blank: Eva Hesse and Minimalism," *Art History* 17, no. 3 (September 1994): 447, n. 29; 436.

25. See, for instance, Ellen Handler Spitz, *Art and Psyche: A Study in Psycho-Analysis and Aesthetics* (New Haven: Yale University Press, 1985). Along these lines, see the study of *Olympia* by C. van Emde Boas, "Le Geste d'Olympia," in *Livre jubilaire offert au Dr. Jean Dalsace par ses amis, ses collègues et ses élèves* (Paris: Masson, 1966), 128–35.

26. Michael S. Roth, *Psycho-Analysis as History: Negation and Freedom in Freud* (Ithaca, N.Y.: Cornell University Press, 1995).

27. Michel Foucault, "On the Genealogy of Ethics," *The Essential Works of Michel Foucault, 1954–1984*, ed. Paul Rabinow, 3 vols. (New York: New Press, 1997–), 1:262.

28. Michel Foucault, *The History of Sexuality: An Introduction*, trans. Robert Hurley (New York: Vintage/Random House, 1990), 108.

29. David Carrier proclaims the need for an approach to Manet's work that somehow accounts for his portrayals of family and friends, and of circumstances in his life generally treated by biographers and ignored by art historians; see his review of Michael Fried, *Manet's Modernism, or, The Face of Painting in the 1860s* (Chicago: University of Chicago Press, 1996) and of James H. Rubin, *Manet's Silence and the Poetics of Bouquets* (Cambridge: Harvard University Press, 1994), *Art Bulletin* 79, no. 2 (June 1997): 334–37.

30. Foucault's supreme example was Baudelaire; see "What is Enlightenment?" in *Essential Works*, 1:310–12.

31. Jean-Paul Sartre, *Being and Nothingness*, trans. Hazel Barnes (New York: Washington Square Press, 1956), 475.

32. René Girard, *Things Hidden Since the Foundation of the World* (Stanford: Stanford University Press, 1987), 83, 17.

33. Girard, *Things Hidden*, 295.

34. Freud, "A Difficulty in the Path of Psychoanalysis" (1917), in *Standard Edition*, 17:143.

35. Max Milner, *La Fantasmagorie: essai sur l'optique fantastique* (Paris: PUF, 1982), 257: "[. . .] rêver de se mettre à nu, c'est à la fois encourir le risque de la réprobation et de la dérision et s'affirmer [. . .] et déposséder le père (charnel ou intellectuel) de sa paternité." Milner discusses Gérard Bonnet's work on what he calls the binary pair exhibition-inhibition, specifically Bonnet's analysis of Freud's dream of the stairway. See Gérard Bonnet, *Voir—être vu: études cliniques sur l'exhibitionnisme*, 2 vols. (Paris: PUF, 1981), 1:147–201.

36. John Barrell, *The Infection of Thomas De Quincey: A Psychopathology of Imperialism* (New Haven: Yale University Press, 1991).

37. Manet's brother Eugène owned *The Boy with the Cherries* (Lisbon, Museu Calouste Gulbenkian); a notebook of Berthe Morisot's describes the painting and recounts that the model hanged himself in her brother-in-law's studio. See Paul Jamot and Georges Wildenstein, *Manet*, 2 vols. (Paris: Les Beaux-Arts, 1932), 1:117–18, cat. 33. For a more extensive account of the painting and the Baudelaire poem, see my essay, "Baudelaire's 'La Corde' as a Figuration of Manet's Art," in *Between Rousseau and Freud: Visual Representations of Children and the Construction of Childhood in the Nineteenth Century*, ed. Marilyn Brown (London: Ashgate/Scolar Press, forthcoming).

1 THE COUCH OF ORESTES

"Mon père, me répondit-il, j'ai fait un rêve si étrange que j'ai véritablement quelque peine à vous le découvrir: c'est peut-être l'œuvre du démon; et . . .—Je vous ordonne, lui répliquai-je; un rêve est toujours involontaire, ce n'est qu'une illusion. Parlez avec sincérité.—Mon père, dit-il alors, à peine étais-je couché, que j'ai rêvé que vous aviez tué ma mère, que son ombre sanglante m'était apparue par demander vengeance, et qu'à cette vue j'avais été transporté d'une telle fureur, que j'ai couru comme un forcené à votre appartement, et, vous ayant trouvé dans votre lit, je vous y ai poignardé."

(Anthelme Brillat-Savarin retells Duhaget's story in Physiologie du goût [Brussels, 1839].)

1. Thomas De Quincey, *The Collected Writings of Thomas De Quincey*, ed. David Masson, 14 vols. (Edinburgh: Adam and Charles Black, 1890), 3:377.

2. De Quincey, *Suspiria de Profondis* (1845) in *Collected Writings*, 13:348–49. Baudelaire translates: "Oui, lecteur, innombrables sont les poëmes de joie ou de chagrin qui se sont gravés successivement sur le palimpseste de votre cerveau, et comme les feuilles des forêts vierges, comme les neiges indissolubles de l'Himalaya, comme la lumière qui tombe sur la lumière, leurs couches incessantes se sont accumulées et se sont, chacune à son tour, recouvertes d'oubli. Mais à l'heure de la mort, ou bien dans la fièvre, ou par les recherches de l'opium, tous ces poëmes peuvent reprendre de la vie et de la force. Ils ne sont pas morts, ils dorment. On croit que la tragédie grecque a été chassée et remplacée par la légende du moine, la légende du moine par le roman de chevalerie; mais cela n'est pas. A mesure que l'être humain avance dans la vie, le roman qui, jeune homme, l'éblouissait, la légende fabuleuse qui, enfant, le séduisait, se fanent et s'obscurcissent d'eux-mêmes. Mais les profondes tragédies de l'enfance,—bras d'enfants arrachés à tout jamais du cou de leurs mères, lèvres d'enfants séparées à

jamais des baisers de leurs soeurs,—vivent toujours cachées, sous les autres légendes du palimpseste. La passion et la maladie n'ont pas de chimie assez puissante pour brûler ces immortelles empreintes" (Baudelaire, *Oeuvres complètes*, 611–12). Although Freud wrote about "screen memories," Bertram D. Lewin introduced the psychoanalytic concept of the "dream screen," or unperceived symbolization of the mother's breast in the dreams following feeding. See his 1946 essay, "Sleep, the Mouth and the Dream Screen," in *Selected Writings*, ed. Jacob A. Arlow (New York: Psychoanalytic Quarterly, 1973), 87–100; also Jean Laplanche and Jean-Bertrand Pontalis, "Fantasy and the Origins of Sexuality," reprinted in *Formations of Fantasy*, ed. Victor Burgin, James Donald, and Cora Kaplan (New York: Routledge, 1986), 124.

3. See also the analysis of this theory, and Freud's, in Alina Clej, *A Genealogy of the Modern Self: Thomas de Quincey and the Intoxication of Writing* (Stanford: Stanford University Press, 1995), 97–98. Freud's "mystic writing-pad" figures prominently in Jacques Derrida, "Freud and the Scene of Writing," in *Writing and Difference*, trans. Alan Bass (Chicago: University of Chicago Press, 1978), 196–231.

4. Michael Fried makes the case for Manet's complex involvement with the art of the past in *Manet's Modernism*.

5. Malcolm Bowie, *Psychoanalysis and the Future of Theory* (Cambridge, Mass.: Blackwell, 1993), 11.

6. On the identification of the figures and the relevant scholarship, see Theodore Reff, *Manet and Modern Paris*, exh. cat. (Washington, D.C.: National Gallery of Art, 1982), 174–75. See also Anne Coffin Hanson, *Manet and the Modern Tradition* (New Haven: Yale University Press, 1977), 66.

7. Wollheim suggests that Manet's paintings equate a cluttered ground with an undifferentiated ground in a manner reminiscent of the nocturnal dream (*Painting as an Art*, 163–64).

8. Ibid., 161.

9. Théodore Duret, *Manet*, trans. J. E. Crawford Flitch (New York: Crown, 1937), 20, or *Histoire d'Édouard Manet et de son oeuvre*, 4th ed. (Paris: Bernheim-Jeune, 1926), 21.

10. On the question of later nineteenth-century French constructions of Spain as "other," I refer to a lecture by Janice Mann, "Medieval Spain and Early Twentieth-Century American Art History," King Juan Carlos I of Spain Center at New York University, 28 April 1997.

11. Reff, *Manet and Modern Paris*, 19–20, 171–91; and Marilyn R. Brown, "Manet's 'Old Musician': Portrait of a Gypsy and Naturalist Allegory," *Studies in the History of Art* 8 (1978): 77–87.

12. Antonin Proust, *Édouard Manet: souvenirs* (Paris: H. Laurens, 1913), 90–91.

13. De Quincey, *Collected Writings*, 13:362–69.

14. Baudelaire, *Oeuvres complètes*, 160–61. The prose poem was first published in *La Presse*, 24 September 1862.

15. De Quincey, *Collected Writings*, 13:363.

16. Ibid., 13:366–67.

17. Ibid., 13:368.

18. Schapiro, "The Apples of Cézanne," 9. The Saint-Denys was published anonymously in 1867 and reprinted (Paris: Tchon, 1964).

19. For a more extended account of this reading of the picture, see my essay, *"Manet's 'Le Déjeuner sur l'herbe' as a Family Romance,"* in *Manet's "Le Déjeuner sur l'herbe,"* ed. Paul Hayes Tucker (New York: Cambridge University Press, 1998), 120–22.

20. See *Ordonnances et arrêtés emanés du Préfet de Police Boittelle* (Paris: Boucquin, 1864), for example, ordinance of 31 May 1861 (no. 59: 337–40); 9 May 1862 (no. 73: 431–34); etc. In these ordinances, Article I prohibited public bathing outside the designated zones in areas such as Boulogne, Charenton, Clichy/St.-Ouen, Gennevilliers, and the like. Article II forbad nude bathing. Police prefect S.C.J. Boittelle (tenure 1858–66) was upholding a decision by the Cour de Cassation of 15 October 1824 (also 7 October 1852 and 22 April 1858), which designated separate zones for men and women ("couverts de caleçons"). See F. Brayer, *Dictionnaire général de police administrative et judiciaire*, 2d ed., 4 vols. (Paris: Brayer, n.d.), 1:373.

21. "J'ai passé hier une grande heure à regarder se *baigner les dames*. Quel tableau! Quel hideux tableau! Jadis, on se baignait ici sans distinction de sexes. Mais maintenant il y a des séparations, des poteaux, des filets pour empêcher, un inspecteur en livrée (quelle atroce chose lugubre que le grotesque!)" (Flaubert, letter from Trouville of 14 August in *Correspondance, 1850–1859* [Paris: Club de l'Honnête Homme, 1974], 383; English quoted from *The Letters of Gustave Flaubert, 1830–1857*, ed. and trans. Francis Steegmuller [Cambridge: Belknap Harvard, 1980], 195).

22. Freud's letter to Wilhelm Fliess of 21 September 1897: "And now I want to confide in you immediately the great secret that has been slowly dawning on me in the last few months. I no longer believe in my *neurotica* [theory of the neuroses]"(*The Complete Letters of Sigmund Freud to Wilhelm Fliess, 1887–1904*, trans. and ed. Jeffrey Moussaieff Masson [Cambridge: Belknap Harvard, 1985], 261). After Freud expressed his doubts about childhood seduction, his letter of 15 October suggests that each of us "was once a budding Oedipus in fantasy" (272).

23. The best compendium of material and outline of the early history of psychoanalysis remains Henri F. Ellenberger, *The Discovery of the Unconscious* (New York: Basic Books, 1970).

24. See Debora L. Silverman, *Art Nouveau in Fin-de-Siècle France: Politics, Psychology and Style* (Berkeley: University of California, 1989), 75–106.

25. *Conférences historiques faites pendant l'année 1865* (Paris: Baillière, 1866). See Jan Goldstein, *Console and Classify: The French Psychiatric Profession in the Nineteenth Century* (New York: Cambridge University Press, 1987), 355. Sartre also refers to the 1865 debates of the Société Médico-Psychologique in his 1936

work, *L'imagination* (Paris: PUF, 1989), 21.

26. Aaron Sheon, "Courbet, French Realism, and the Discovery of the Unconscious," *Arts* 55, no. 6 (February 1981): 114–28.

27. Goldstein, *Console and Classify*, 53.

28. Ibid., 245.

29. Ibid., 243.

30. Published by Didier. Edmond Duranty credits it in one of his articles on dreams, "Notes sur la vie nocturne," *Nouvelle Revue de Paris* (1 November 1864): 558.

31. See, for instance, founding member Jules Baillarger's review of the book in the *Annales Médico-Psychologiques*, 3rd ser., 8 (April 1862): 350–60.

32. Goldstein, *Console and Classify*, 341. The author discusses the foundation of the society in some detail. Jules Baillarger's original idea was simply "an association of asylum doctors" (340), but with various reforms, the society became more of an interest group, both professional and interdisciplinary (342).

33. Alfred Maury, *Le Sommeil et les rêves: études psychologiques sur ces phénomènes* (Paris: Didier, 1861), 38: "Ce n'est ni l'attention ni la volonté qui amènent devant le regard intellectuel ces images que nous prenons en rêve pour des réalités; elles se produisent d'elles-mêmes, suivant une certaine loi due au mouvement inconscient du cerveau et qu'il s'agit de découvrir; elles dominent ainsi l'attention et la volonté, et par ce motif nous apparaissent comme des créations objectives, comme des produits qui n'émanent point de nous et que nous contemplons de la même façon que des choses extérieures. Ce sont, non pas seulement des idées, mais des images, et ce caractère d'extériorité est précisément la cause qui nous fait croire à leur réalité."

34. Jules Baillarger, "Théorie de l'automatisme," 1845, reprinted in *Recherches sur les maladies mentales* (Paris: G. Masson, 1890), 1:494–500. The term gained much currency, one example being Ernest Mesnet, *De l'automatisme de la mémoire et du souvenir dans le somnambulisme pathologique* (Paris, 1874).

35. Goldstein, *Console and Classify*, 263.

36. Ibid., 263.

37. Duranty, "Notes sur la vie nocturne," 536: "C'est sur un fond noir, qui n'est autre que celui des paupières quand les yeux sont fermés, que les images des rêves viennent se peindre. Elles s'y *peignent* dans toute l'acception du mot, car jamais dans le rêve, ni le soleil, ni l'apparition d'une source lumineuse dont l'éclat est réfléchi par les autres objets, ne se manifestent. [. . .] Les objets se montrent colorés comme de pures peintures, et tantôt ils couvrent le fond noir tout entier [. . .], tantôt ils s'y détachent seulement [. . .]." Duranty's name appears in Manet's address book: see "Copie pour Moreau-Nélaton de documents sur Manet appartenant à Léon Leenhoff," Bibliothèque Nationale (hereafter BN), Cabinet des Estampes, Yb3. 240 1/8. For a thorough documentary discussion of Duranty, see Marcel Crouzet, *Un méconnu du Réalisme: Duranty (1833–1880)* (Paris: Nizet, 1964). Duranty

published at least one other article on dreams, "Le Sommeil et les rêves," *Musée Universel* 2 (1873): 218–20.

38. Duranty, "Notes sur la vie nocturne," 535: "fond noir, comme si c'eût été une peinture sur toile noire."

39. Théodore Jouffroy, "Des facultés de l'âme humaine" (1828), reprinted in *Mélanges philosophiques*, 4th ed. (Paris: Hachette, 1866), 250–52; translated by and quoted in Goldstein, *Console and Classify*, 263.

40. A.-J.-F. Brierre de Boismont, *Des hallucinations, ou histoire raisonnée des apparitions, des visions, des songes, de l'extase, du magnétisme et du somnambulisme* (Paris: Baillière, 1852).

41. Baudelaire's *Mon coeur mis à nu* contains notations on *Du suicide et de la folie-suicide considérés dans leurs rapports avec la statistique, la médicine et la philosophie*. See *Oeuvres complètes*, 626.

42. Brierre de Boismont, *Des hallucinations*, 537: "Les hallucinations peuvent se rapporter à des objets perçus à une époque éloignée, à des sujets oubliés depuis longtemps et qui sont remis en mémoire par des causes inappréciables, souvent en vertu de l'association des idées; aussi est-il vrai de dire que, dans la grande majorité des cas, les hallucinations ne sont que des réminiscences, des créations d'objets connus."

43. To be precise: we would now say, "long forgotten *because* long repressed." Brierre de Boismont here does use the word *oublier* ("sujets oubliés depuis longtemps"), and I do not wish to muddle the fact that many writers, including Maury and Duranty, do use the verb *refouler* to describe the appearance of repressed desires in dreams.

44. Maury, *Le Sommeil et les rêves*, 35–36: "Tantôt notre esprit évoque des images à lui connues, par exemple la figure d'un ami, d'un parent, sans se rappeler son nom; tantôt les sensations que nous transmettent les sens, aux trois quarts éveillés, ne sont qu'imparfaitement perçues; nous leur attribuons une intensité, un caractère qu'elles n'ont pas. Dans le premier cas, il y a atonie de la mémoire; dans le second, affaiblissement de la perceptivité."

45. Ibid., 96: "La théorie du souvenir que j'ai donnée plus haut me paraît suffire, du reste, à expliquer le phénomène, sans qu'on ait besoin d'admettre, comme l'ont fait quelques auteurs, qu'il y a deux vies distinctes, la vie réelle et la vie du rêve, poursuivant chacune séparément leurs cours et répondant chacune à deux chaînes distinctes d'actes."

46. Louis-François Lélut, "Mémoire sur le sommeil, les songes, et le somnambulisme," *Annales Médico-Psychologiques* 4 (July 1852): 331–63. Goldstein notes that Lélut was a student and colleague of Ferrus at the Bicêtre hospital: *Console and Classify*, 299n.

47. Lélut, "Mémoire sur le sommeil," 354.

48. Ibid., 347: "[L]es rêves constituent l'état de la pensée dans le sommeil. [. . .] ce serait le retour de l'esprit à sa libre allure, une allure libre et reposée; [. . .] ce serait le retour de ce même esprit à sa manière d'être originelle, à l'état où, dans le sein maternel, il a passé les temps obscurs de sa vie."

49. Baillarger, review of Maury, "Le Sommeil et les rêves," 356: "L'hallucination [hypnagogique] devient évidemment un fait complexe et formé de deux éléments, 'l'impression nerveuse *primitive*' et la réaction de l'esprit qui, comme le dit M. Maury, métamorphose cette impression. La transformation, au lieu de porter sur les idées, porte sur les impressions nerveuses primitives."

50. "Traumarbeit," according to Freud, the transformation of dream-thoughts into the manifest content of the dream. See Laplanche and Pontalis, "Fantasy and the Origins of Sexuality," 125; Freud, *The Interpretation of Dreams*, in *Standard Edition*, 5:506.

51. Brierre de Boismont, *Des hallucinations*, 533, quotes A. Dechambre, "Analyse de l'ouvrage du docteur Szafkowski, sur les hallucinations," *Gazette Médicale* (1850): 274: "Nous ne nous sommes jamais rendu un compte bien clair, malgré la grande autorité de Müller et de Burdach, de la prétendue intervention des sens dans l'hallucination. Suivant le premier, les *visions* sont *réellement des états des sens de la vue*, et suivant le second, nous avons alors *dans l'oeil*, à l'occasion de la pensée, la même sensation que si un object extérieur se trouvait placé devant cet oeil vivant et ouvert." The translation quoted here is from *A History of Dreams, Visions, Apparitions, Ecstasy, Magnetism, and Somnambulism*, 1st American edition, from the 2d French edition by Lindsay and Blakiston (Philadelphia, 1853), 411–12.

52. Brierre de Boismont quotes Dechambre in *A History of Dreams*, 412, *Des hallucinations*, 534–35: "On ne peut vouloir dire que l'une de ces deux choses: ou qu'une sensation fausse, formée dans l'oeil, se transmet au cerveau, ou que le cerveau, par le travail d'une pensée fausse, fait naître une sensation dans l'oeil. [. . .] Comment une conception cérébrale, une conception psychique, peut-elle engendrer la sensation d'une image dans l'oeil? [. . .] Dans l'hallucination, le cerveau les imagine, les crée de toutes pièces, et c'est là précisément le caractère fondamental du phénomène. Tout cela n'empêche pas qu'on ne puisse établir une distinction entre les hallucinations toutes intellectuelles et celles qui sont caractérisées par un signe sensible, un phénomène de l'ordre sensoriel."

53. Brierre de Boismont, *A History of Dreams*, 414; *Des hallucinations*, 537: "Les hallucinations paraissent quelquefois affecter des formes étranges; mais les examinant avec soin, on reconnaît que les éléments ont été pris dans les lectures, les peintures, les traditions, etc. C'est ainsi qu'au moyen-âge les figures du diable étaient empruntées à l'architecture du temps, dont les compositions bizarres formaient des ornements plus qu'extraordinaires dans les églises catholiques, témoin l'abbaye de Saint-Martin de Bocherville, près Rouen."

54. One of these series, published by Masson, the "Études médico-psychologiques sur les hommes célèbres," included Brierre de Boismont's study of Shakespeare (1869). The flurry of interest in Shakespeare in and around the 300th anniversary of his birth, 23 April 1864, as well as Victor Hugo's book on Shakespeare and

Hugo *fils*'s translation, can account for some of this attention, but one can nevertheless document a wave of psychological histories of "great men." Lélut published (with Baillarger) studies on Socrates (*Du démon de Socrate: spécimen d'une application de la science psychologique à celle de l'histoire* [Paris: Baillière, 1836 and revised 1856]) and on Pascal (*L'Amulette de Pascal: pour servir à l'histoire des hallucinations* [Paris: Baillière, 1846]). Baudelaire was notoriously scornful of these studies, as he made clear in "Assommons les Pauvres!" (*Oeuvres complètes*, 182–83) and in a letter to Sainte-Beuve from Brussels, 2 January 1866. See *Correspondance*, ed. Claude Pichois with Jean Ziegler (Paris: Gallimard, 1973), 2:563.

55. "De certains faits observés dans les rêves," *Annales Médico-Psychologiques*, 3d ser., 3 (1857): 172: "J'ai réuni deux mots fort discordants, quand j'ai dit, une conscience inconsciente d'elle-même. Le rêve en effet est le théâtre des contradictions, et les actions les plus opposées s'y produisent de manière à démentir toutes nos théories psychologiques. En songe, je poursuis des actes, des pensées, des projets dont l'exécution et la conduite dénotent presqu'autant d'intelligence que j'en puis apporter dans l'état de veille."

56. Maury: "l'attention et la volonté affaiblies laissent un libre cours aux idées spontanées et à la production des images"; quoted in Baillarger, review of Maury, "Le Sommeil et les rêves," 359.

57. Baillarger, review of Maury, "Le Sommeil et les rêves," 359.

58. The first part of this text was published on 30 September 1858 in the *Revue Contemporaine* under the title "De l'idéal artificiel, le haschisch," and the second, 15 January and 30 January 1860 in the same journal under the title "Enchantements et tortures d'un mangeur d'opium." See Baudelaire, *Oeuvres complètes*, 566–616.

59. Baudelaire, *Oeuvres complètes*, 602: "car la volonté n'a plus de force et ne gouverne plus les facultés," "l'homme n'évoque plus les images, mais que les images s'offrent à lui, spontanément, despotiquement."

60. Jacques Joseph Moreau de Tours, *Du hachish et de l'aliénation mentale: études psychologiques* (Paris: Masson, 1845; edition quoted here: Geneva: Slatkine, 1980); *Hashish and Mental Illness*, ed. Helene Peters and Gabriel G. Nahes, trans. Gordon J. Barnett (New York: Raven Press, 1973).

61. Moreau de Tours, *Hashish*, 192; *Du hachish*, 367: "'Dans les hallucinations, dit-il ailleurs, il n'y a ni sensation, ni perception, *pas plus que dans les rêves* et le somnambulisme, puisque les objets extérieurs n'agissent plus sur les sens.—Celui qui est en délire, *celui qui rêve*, ne pouvant commander à son attention, ne peut la diriger, ni la détourner de ces objets fantastiques; il reste livré à ses hallucinations, à ses rêves. . . . *Il rêve tout éveillé*. Chez celui qui rêve, les idées de la veille se continuent pendant le sommeil; tandis que celui qui est dans le délire achève, pour ainsi dire, son rêve, quoique tout éveillé. Les rêves, comme les hallucinations, reproduisent toujours des sensations, des idées anciennes. Comme dans le rêve, la série des images est quelquefois régulière; plus souvent,

les images et les idées se reproduisent dans la plus grande confusion et offrent les associations les plus étranges. Comme dans le rêve, ceux qui ont des hallucinations ont quelquefois la conscience qu'ils sont dans le délire, sans pouvoir en dégager leur esprit.'"

62. Moreau de Tours, *Hashish*, 87; *Du hachish*, 172: "Au fur et à mesure que l'action du hachisch se fait plus vivement sentir, on passe insensiblement du monde réel dans un monde fictif, imaginaire, sans perdre, toutefois, la conscience de soi-même; en sorte qu'on peut dire qu'il s'opère une sorte de fusion entre l'état de rêve et l'état de veille; *on rêve tout éveillé.*"

63. Baudelaire, *Oeuvres complètes*, 566; Moreau de Tours, trans. Barnett (1973), ix–x; Claude Pichois et Jean Ziegler, *Baudelaire* (Paris: Julliard, 1987), 214–16. The *invités* at the club meetings included Alphonse Karr, Henri Monnier, Honoré Daumier, Gérard de Nerval, Louise Pradier, James Pradier, and Fernand Boissard de Boisdenier. Balzac attended at least one meeting on 22 December 1845, later claiming he only observed. Making no such claims of abstinence was Théophile Gautier, who wrote about the experience in the *Revue des Deux Mondes* n.s. 13 (1 February 1846): 520–35.

64. Baudelaire, *Oeuvres complètes*, 611.

65. Freud, "A Note on the Mystic Writing-Pad," *Standard Edition*, 19:227–32.

66. Baudelaire, *Artificial Paradise: On Hashish and Wine as Means of Expanding Individuality*, trans. Ellen Fox (New York: Herder and Herder, 1971), 42; *Oeuvres complètes*, 570: "Les rêves de l'homme sont de deux classes. Les uns, pleins de sa vie ordinaire, de ses préoccupations, de ses désirs, de ses vices, se combinent d'une façon plus ou moins bizarre avec les objets entrevus dans la journée, qui se sont indiscrètement fixés sur l'homme lui-même. Mais l'autre espèce de rêve! le rêve absurde, imprévu, sans rapport ni connexion avec le caractère, la vie et les passions du dormeur! ce rêve, que j'appellerai hiéroglyphique, représente évidemment le côté surnaturel de la vie, et c'est justement parce qu'il est absurde que les anciens l'ont cru divin."

67. Duranty, "Notes sur la vie nocturne," 526: "Rien de plus bizarre, de plus oppressant, que mes rêves relatifs à mon père depuis qu'il est mort. D'abord il est à chaque fois différent de lui-même, et cependant il faut que ce soit lui. En même temps, tandis que le rêve se poursuit, je me dis: 'Mais suis-je bien le fils de cet homme si étrange avec qui je me trouve transporté dans des actions singulières qui me plongent dans l'étonnement, quoique j'y voie une nécessité que je subis?' [. . .] L'idée qui me frappe est que c'est un être étranger qui est mon père; et si j'assiste à son sort avec intérêt, parce qu'il est mon père, je n'interviens pas parce qu'il m'est étranger."

68. Ibid., 557–58: "De là [dans le rêve] cette sorte d'exaltation de nos sentiments de toute espèce; de là une obéissance immédiate aux choses, qui nous paraîtra une plus grande liberté, ou un affaiblissement comparable à la folie. Par là se révéleront nos penchants

secrets d'un côté, tandis que d'un autre ce passé qui jaillit, libre de la contrainte des objets présents, nous montrera des spectacles d'autrefois que, dans la vie éveillée, refoule, efface ou cache la puissance dominatrice des spectacles nouveaux ou immédiats."

69. Maury, *Le Sommeil et les rêves*, 86–87: "La meilleure preuve que dans le rêve l'automatisme est complet et que les actes que nous accomplissons s'opèrent par un effet de l'habitude imprimée par la veille, c'est que nous y commettons, en imagination, des actes répréhensibles, des crimes même dont nous ne nous rendrions jamais coupable à l'état de veille. Ce sont nos penchants qui parlent et qui nous font agir, sans que la conscience nous retienne, bien qu'elle nous avertisse parfois. J'ai mes défauts et mes penchants vicieux; à l'état de veille, je tâche de lutter contre eux, et il m'arrive assez souvent de n'y pas succomber. Mais dans mes songes j'y succombe toujours, ou pour mieux dire, j'agis par leur impulsion, sans crainte et sans remords. Je me laisse aller aux accès les plus violents de la colère, aux désirs les plus effrénés, et quand je m'éveille, j'ai presque honte de ces crimes imaginaires. Evidemment les visions qui se déroulent devant ma pensée et qui constituent le rêve me sont suggérées par les incitations que je ressens et que ma volonté absente ne cherche pas à refouler."

70. Ibid., 88–89.

71. Ibid., 87–88.

72. Ibid. "C'est ainsi que dans mes songes je me suis trouvé des scrupules religieux, des terreurs puériles que j'ignore complètement à l'état de veille, et qui remontent à ma première enfance. [. . .] quand la volonté est abolie [. . .] nous devenons de vrais automates [. . .]."

73. Ibid., 89: "imprimées à l'homme par l'éducation première."

74. De Quincey, *Collected Writings*, 13:339.

75. John Barrell, *The Infection of Thomas de Quincey: A Psychopathology of Imperialism* (New Haven: Yale University Press, 1991), 20.

76. Baudelaire, *Artificial Paradise*, 80. "Enfin, et ceci est très-important, le récit de certains accidents, vulgaires peut-être en eux-mêmes, mais graves et sérieux en raison de la sensibilité de celui qui les a supportés, devient, pour ainsi dire, la clef des sensations et des visions extraordinaires qui assiégeront plus tard de son cerveau. Maint vieillard, penché sur une table de cabaret, se revoit lui-même vivant dans un entourage disparu: son ivresse est faite de sa jeunesse évanouie" (*Oeuvres complètes*, 586).

77. Jean-Paul Sartre, *Baudelaire*, trans. Martin Turnell (New York: New Directions, 1967), 16.

78. Pierre Jean Jouve considers the Orestes complex to be foundational to Baudelaire's work. See *Le Tombeau de Baudelaire* (Paris: Seuil, 1958), 161. See also the discussion in Henri Lecaye, *Le Secret de Baudelaire* (Cahors: Jean Michel Place, 1991).

79. Baudelaire, *Artificial Paradise*, 38. "Ils se figurent l'ivresse du haschisch comme un pays prodigieux, un vaste théâtre de

prestidigitation et d'escamotage, où tout est miraculeux et imprévu" (*Oeuvres complètes*, 570).

80. Ibid., 39. "L'ivresse, dans toute sa durée, ne sera, il est vrai, qu'un immense rêve, grâce à l'intensité des couleurs et à la rapidité des conceptions; mais elle gardera toujours la tonalité particulière de l'individu" (*Oeuvres complètes*, 570).

81. Baudelaire, *Oeuvres complètes*, 571. "Each care will become a torture and each anxiety a cruel torment" (Baudelaire, *Artificial Paradises*, 41).

82. Baudelaire, "Le Voyage," *Oeuvres complètes*, 124; trans. Joanna Richardson, *Selected Poems* (New York: Penguin Books, 1978), 217.

83. This passage is also reminiscent of the dedication to *Les Paradis artificiels*.

84. The contradiction between Baudelaire's reluctance to travel and the longing for exotic travel as a motif in his poetry is brilliantly discussed by Sartre, *Baudelaire*; see for instance 15, 97.

85. According to Marcel Ruff in Baudelaire, *Oeuvres complètes*, 122.

86. Richard Howard translates from "Venez vous enivrer de la douceur étrange / De cette après-midi qui n'a jamais de fin." See his edition of *Les Fleurs du mal* (Boston: David R. Godine, 1993), 156.

87. See Clej, *A Genealogy of the Modern Self*, 60.

88. A concise summary of this reaction can be found in Sarah Faunce and Linda Nochlin, *Courbet Reconsidered*, exh. cat. (Brooklyn: Brooklyn Museum, 1988), 133–34.

89. Sheon, "Courbet, French Realism," 125.

90. Annie Gutmann, "À propos de la représentation de Narcisse chez Poussin," *Miroirs, visages, fantasmes*, ed. A. Fognini et al. (Lyons: Éditions C.L.E., 1988), 33–72.

91. Ibid., 38: "Spem sine corpore amat," "corpus putat esse quod unda est."

92. Ibid., 43, 54.

93. Ibid., 56–57.

94. Here I would like to acknowledge my debt to lectures by Professor T. J. Clark, and to conversations with Yule Heibel. Clark emphasizes Cézanne's interest in Delacroix, notably the Sardanapalus figure I discuss below. Heibel helped me to see the stagelike artificiality of the female figures' poses in these problematic canvases.

95. Mary Louise Krumrine, "Parisian Writers and the Early Work of Cézanne," in *Cézanne: The Early Years, 1859–1872*, cat. Lawrence Gowing (London: Royal Academy, 1988), 20–31. She focuses on *Le Déjeuner sur l'herbe* (V. 107, private collection) of 1870–71.

96. See Adrien Chappuis, *The Drawings of Paul Cézanne: A Catalogue Raisonné*, 2 vols. (London: Thames and Hudson, 1973), 2: cats. 248, 249, 250.

97. Wollheim, *Painting as an Art*, 102–30, 164.

98. Théophile Thoré, in *L'Indépendance belge*, 11 June 1863;

also quoted in Alan Krell, "Manet's *Déjeuner sur l'herbe* in the *Salon des Refusés*: A Re-Appraisal," *Art Bulletin* 65, no. 2 (June 1983): 318: "C'est ce contraste d'un animal si antipathique au caractère d'une scène champêtre, avec cette baigneuse sans voiles, qui est choquant."

99. Ambroise Tardieu, *Étude médico-légal sur les attentats aux moeurs*, 4th ed. (Paris: Baillière, 1862 [1857]), 10.

100. As Zola wrote, "Ce qu'il faut voir dans le tableau, ce n'est pas un déjeuner sur l'herbe, c'est le paysage entier, avec ses vigueurs et ses finesses [. . .]," in "Une nouvelle manière en peinture: Édouard Manet," published by Dentu in the *Revue du XIXe Siècle* edited by Arsène Houssaye in 1867; it also appeared as a brochure for Manet's independent exhibition at the Pont de L'Alma in 1867 under the title *Édouard Manet, étude biographique et critique*. Reprinted in *Pour Manet*, ed. J.-P. Leduc-Adine (Brussels: Éditions Complexe, 1989), 120.

101. Griselda Pollock, "Modernity and the Spaces of Femininity," in *The Expanding Discourse: Feminism and Art History*, ed. Norma Broude and Mary D. Garrard (New York: HarperCollins, 1992), 246n.

102. Freud, *Interpretation of Dreams*; *Standard Edition*, 4:245.

103. Ibid., 4:238. The German reads "in sehr unvollständiger Toilette." Fascinating commentary on Freud's dream can be found in Didier Anzieu, *Freud's Self-Analysis*, trans. P. Graham (London: Hogarth Press, 1986), 224–28, as well as in Gérard Bonnet, *Voir— être vu: études cliniques sur l'exhibitionnisme*, 2 vols. (Paris: PUF, 1981), 152–56; 161–65. Both are indebted to A. Grinstein, *On Sigmund Freud's Dreams* (Detroit: Wayne State University Press, 1963), chapter 7.

104. Beatrice Farwell, *Manet and the Nude* (New York: Garland, 1973), 240–54.

105. Werner Hofmann, *Das Irdische Paradies: Kunst im neunzehnten Jahrhundert* (Munich: Prestel-Verlag, 1960), 348.

106. I am here indebted to Michael Fried's discussion of the place of the viewer vis-à-vis Géricault's *Raft of the Medusa* in his book *Courbet's Realism* (Chicago: University of Chicago Press, 1990), 29–32.

107. Adrien Paul, in *Le Siècle*, 19 July 1863: "Il traite de la même façon les êtres et les choses." Ernest Chesneau, in *Le Constitutionnel*, 19 May 1863: "Les figures de M. Manet font involontairement songer aux marionettes des Champs-Elysées: une tête solide et un vêtement flasque." Both cited by Krell, "Manet's *Déjeuner*," 317.

108. Charles Monselet, "Les Refusés, ou les héros de la contre-exposition," *Le Figaro*, 24 May 1863, 5–6. Excerpts from Monselet's remarks appear in Krell, "Manet's *Déjeuner*," 320; see also Adolphe Tabarant, *La Vie artistique au temps de Baudelaire* (Paris: Mercure de France, 1963 [1942]), 313.

109. Monselet, "Les Refusés," 5–6: "tous les artistes voudraient en être, aujourd'hui. C'est une rage."

110. Ibid., 6: "—*Le bain.* Au milieu d'un bois ombreux, une demoiselle, privée de toute espèce de vêtements, cause avec des étudiants en béret. M. Manet est élève de Goya et de Baudelaire. Il a déjà conquis les répulsions des bourgeois. C'est un grand pas."

111. Gustave Mathieu, in *Le Figaro*, 31 May 1863 (letter dated 26 May), 6: "Vous devriez savoir qu'il y a quatre choses à propos desquelles il est de bon goût de garder le silence: La famille,—les vêtements,—les amours,—la figure." The reference was apparently to a joke Monselet had made about the author's hair.

2 FAMILY ROMANCES

1. Jean-Paul Sartre, *Mallarmé, or the Poet of Nothingness*, trans. Ernest Sturm (University Park: Pennsylvania State University Press, 1991), 111.

2. Ibid., 19.

3. Ibid., 112.

4. Clark, *Painting of Modern Life*, 12.

5. Tony Tanner, *Adultery in the Novel* (Baltimore: Johns Hopkins University Press, 1979), 3.

6. Here again I am following in the footsteps of Tanner, seeing figure painting as he sees the novel: "The bourgeois novel of adultery finally discovers its own impossibility, and as a result sexuality, narration, and society fall apart, never to be reintegrated in the same way—if, indeed, at all" (ibid., 14).

7. Anne Middleton Wagner, "Why Monet Gave Up Figure Painting," *Art Bulletin* 76, no. 4 (December 1994): 614.

8. Adolphe Tabarant (*Manet et ses oeuvres* [Paris: Gallimard, 1947], 7) mistakenly assumed the year of Auguste Manet's birth to be 1797. The error, perpetuated by other authorities, was based on the age of Manet *père*, 35, at the time of Édouard Manet's birth on 23 January 1832 (birth certificate, Tabarant Archives, J. Pierpont Morgan Library, New York). He could only have been 35 if his birthday were earlier in January. The same type of error has dogged some records of Eugénie-Desirée Fournier Manet, born 12 February 1811, not 1812.

9. Robert Quinot, *Gennevilliers: évocation historique* (Ville de Gennevilliers, 1966), 1:297–98. According to a document in the Archives municipales de Gennevilliers, in 1749 the great-grandfather of Auguste, Augustin François Manet (1695–1755), held the titles of "Écuyer président de France et garde scel en la Généralité d'Alençon, ancien avocat au Parlement, prévost de la prévosté de Gennevilliers, Asnières, Villeneuve-la-Garenne et dépendances pour messieurs les religieux, grand prieur de couvent de l'abbaye royale de Saint-Denis en France, seigneurs desdits autres lieux." Auguste's grandfather, Clément Jean-Baptiste, was "écuyer, conseiller du roi, président trésorier de France au bureau des finances d'Alençon." The title *écuyer* is, according to Pierre Goubert, a reliable identifier of members of the nobility; see *The Ancien Régime:*

French Society, 1600–1750, trans. Steve Cox (New York: Harper and Row, 1974), 154. It should be noted that *gens de robe* were members of the nobility who had acquired their titles by buying noble offices, but that by the mid-eighteenth century, tensions between *gens de robe* and *gens d'épée* were disappearing.

10. Quinot, *Gennevilliers*, 165–68. Clément Jean-Baptiste started the practice, carried on by Auguste, of living in Paris and using Gennevilliers as a retreat (297). Auguste's father Clément (1764–1814) was mayor of Gennevilliers from 1808 until his death in 1814. See *Exposition Gennevilliers à travers les âges* (Imprimerie Gutenberg, 1953), n.p. and *Gennevilliers: notice historique et renseignements administratifs* (Montévrain: Imprimerie Typographique de l'École d'Alembert, 1898), 26. Clément was also the president of the cantonnal assembly of Nanterre. See below, *dossier*, document 5.

11. Tabarant, *Manet et ses oeuvres*, 60. Quinot, *Gennevilliers* (306) reproduces a photograph of the Manet family farmhouse, rue de Saint-Denis and rue des Petits-Pères.

12. Jean-Pierre Royer, Renée Martinage, and Pierre Lecocq, *Juges et notables au XIXe siècle* (Paris: PUF, 1982), 104–9.

13. Quinot, *Gennevilliers*, 300–303.

14. Archives Nationales BB6II 276, the *dossier de remplacement* of Auguste Manet, contains most of the documents discussed here. Auguste Manet's own account of his years of apprenticeship can be found in the "Notice Individuelle" (labeled document 5) he filled out on 1 September 1856 as an application for a position as counsel to the Paris court. Information below about his salaries and job moves comes from document 5. Les Archives du Ministère de la Justice, place Vendôme, still contain the original *fiche* of Auguste Manet, employee number 3890. All other documents from the justice archives are now in the Archives Nationales (hereafter abbreviated A.N.), Séries BB.

15. A.N., BB5 contains the *demandes de place* collated by Manet.

16. His folder of nomination and matriculation as a Chevalier of the Legion of Honor can be found in the A.N., BB33.

17. Royer et al., *Juges et notables*, 109–18.

18. A.N., BB5 479, decree of 26 January 1841. The official record of his appointment and retirement from the bench can be found in the *Registres du personnel*, *BB6 552, 72 recto and 75 verso.

19. There is no evidence in the personnel records or in his *dossier*, both of which document his retirement, that he was given the Paris court counsel position, as Françoise Cachin suggests in *Manet, 1832–1883*, exh. cat. (New York: The Metropolitan Museum of Art, 1983), 48.

20. Case records at which Auguste Manet sat or presided, from the first half of 1846 (4th Chamber), are conserved at the Archives de l'Ancien Département de la Seine, D. 1U5 30. The reader can get a better overview of civil cases of the period by perusing the *Gazette des Tribunaux* or *Le Droit*.

21. Law of 11 April 1838, in *L'Annuaire de la cour impériale de*

l'ordre judiciaire de l'empire français, ed. B. Warée (Paris, 1859), 6.

22. *Dossier*, doc. 5. On an employee fact sheet which was part of a promotional review, Auguste Manet listed "20,000 francs" in reponse to the question: "Quel est son revenu, indépendent de son traitement?" This represents a correction of the statement in my article, "New Documentary Information on Manet's 'Portrait of the Artist's Parents'" (*Burlington Magazine* 133, no. 1057 [April 1991]: 249), in which the figure of 20,000 francs was listed as his actual salary as a judge. The sum of 32,000 francs would have made the Manets extremely comfortable. Consider the fact that a skilled worker could hope to get 3.5 to 5 francs for his 11-hour day's work, and a woman garment worker possibly 2.5. See Emile Chevallier, *Les Salaires au XIXe siècle* (Paris: Rousseau, 1887), 52–69.

23. Royer et al., *Juges et notables*, 142–43.

24. Information about Eugénie's birth and parents can be found in Émile Taillefer, "Contribution d'un Grenoblois à l'histoire de la Suède," *Bulletin du Musée Bernadotte* 17 (December 1972): 13–21. Taillefer draws on documents in the A.N. as well as papers and memorabilia conserved by Fournier descendants. Note that the Rouart-Wildenstein *Édouard Manet: catalogue raisonné* (Paris: Bibliothèque des Arts, 1975), 1:9 errs in claiming only 3 Fournier children.

25. This appears to have been the last position he held, for in 1856, Auguste Manet listed it on an official form as his father-in-law's occupation (see above n. 14, A.N., Manet *dossier*, "Notice Individuelle").

26. Paul Jamot, introduction to Paul Jamot and Georges Wildenstein, *Manet*, 2 vols. (Paris: Les Beaux-Arts, 1932), 1:7.

27. Taillefer, "Contribution d'un Grenoblois," 20; see also Tabarant, *Manet et ses oeuvres*, 7.

28. A document by Léon Leenhoff in the Tabarant Archives at the J. Pierpont Morgan Library, New York, contains a list of the guests at the Tuesday and Thursday receptions.

29. Étienne Moreau-Nélaton, *Manet raconté par lui-même*, 2 vols. (Paris: Laurens, 1926), 1:27.

30. Letter in Tabarant Archives, New York.

31. Moreau-Nélaton (*Manet raconté par lui-même*, 1:27) mentions the difficulty surrounding the death of Eugénie's mother. I have no documentation of her whereabouts at the time, but it stands to reason that at the very least Eugénie was preoccupied. We can also gather from Manet's correspondence with his mother during his 1848–49 voyage to Rio de Janeiro that Eugénie's mother did not live with the Manets: he asks his mother to kiss "grand'mère, si elle est encore à Paris" (*Lettres de jeunesse: voyage à Rio, 1848–49* [Paris: Louis Rouart et fils, 1928], 16).

32. The late Mina Curtiss published a claim that "a highly distinguished and reliable writer" who had married into the Manet family confided the paternity to a close friend. See "Letters of Édouard Manet to His Wife during the Siege of Paris: 1870–71," *Apollo* 113, no. 232 (June 1981): 378–89. In light of other events of the previous year, it seems quite plausible that Auguste, like so many men of his society, might have sought a clandestine mistress. As Anne Higonnet notes, it was not unusual for artists in Manet's circle to father illegitimate children and subsequently to legitimize them (as Monet, Renoir, Pissarro and Cézanne did, and as Édouard Manet did not when he married Suzanne Leenhoff). See *Berthe Morisot* (New York: Harper and Row, 1990), 45–46. What is without doubt is how scandalous it would have been for a civil judge, who was often called upon to determine the validity of paternity claims, to have fathered an illegitimate child. Further discussion of circumstantial evidence pointing to Auguste as the father will be discussed in chapter 4.

33. Code Pénal, Livre III, Tit. II, Section IV, n. 333. The age for what we would call statutory rape was only 15 for girls, although there were stricter penalties for the molestation of children under 11. The age of majority, 21, was used for cases of contributing to the delinquency of a minor.

34. Royer et al., *Juges et notables*, 127–38. Royer's research examines a range of charges, including alcoholism, gambling, frequenting prostitutes and the like. There were no hard-and-fast rules about particular vices resulting in particular disciplinary actions.

35. The *dossier* contains a 20-day vacation grant dated 31 July 1852, "pour cause de mauvaise santé."

36. Manet inscribed his name on the register of the Rijksmuseum in Amsterdam on 19 July 1892; see J. Verbeek, "Bezvekers van het Rijksmuseum in het Trippenhuis," *Bulletin van het Rijksmuseum, Gedenboek* (1958): 64; see Petra ten-Doesschate Chu, *French Realism and the Dutch Masters: The Influence of Dutch Seventeenth-Century Painting on the Development of French Painting between 1830–1870* (Utrecht: Haentjens Dekker & Gumbert, 1975).

37. A letter he wrote to the justice minister on 6 May 1856 (doc. 12) discusses a promise of this promotion having been made by a previous minister. In no uncertain terms he spells out his frustration at being overlooked by a dozen ministers.

38. Although the requested vacation was granted on 13 March for a leave from 25 March to 22 April, we do not know whether it was taken (see *dossier*).

39. According to the journal of Emile Ollivier, Eugène Manet identified himself as a law student in 1853. See *Journal, 1846–1860*, ed. Theodore Zeldin, 2 vols. (Paris: Julliard, 1961), 1:168.

40. When Édouard created controversy by declaring his interest in art, he had to contend with the example of his first cousin Jules de Jouy, son of Auguste's sister Emilie, who was appointed a lawyer to the imperial court in 1849. The career choice was one of the factors in the aforementioned dispute that erupted between the Fourniers and the Manets. Auguste's professional interests appear to have created disputes outside the family as well. In 1858, Louis-Adolphe Chaix d'Est-Ange (1800–1876), father of Gustave (who was Baudelaire's defense attorney in the *Fleurs du*

mal trial), became the imperial public prosecutor for the imperial court. Just a handful of years before, he had been arguing cases presided over by Auguste Manet. The elder Chaix was something of a legend in mid-century Paris, even beyond the world of the bar. He not only represented some of the wealthiest clients, but also the city of Paris in the spate of expropriation lawsuits brought on by Haussmann's building projects. (See, for instance, *Le Droit,* 14 July 1853, 664–65.) According to a letter in the Manet *dossier,* the Manet family refused all communication with him during the elder Manet's illness and retirement; it is not clear why.

41. *Dossier,* doc. 7. The letter by imperial prosecutor Cordoën gives the date of December 18. The general prosecutor at the imperial court, Chaix d'Est Ange, however, refers to the origin of the paralysis as 18 October 1857 (doc. 6, letter dated 20 January 1859). Chaix's letter describes how the Conseil d'État—the advisory body with the highest administrative jurisdiction—had assigned him the task of checking into the state of Auguste Manet. According to Chaix's lengthy, indignant testimony, Madame Manet had refused all communication with him, claiming she would go over his head, directly to the minister of justice (garde des sceaux), in response to official inquiries.

42. Letter in Mme Manet's hand dated 16 February 1858, *dossier,* doc. 19.

43. Letter by Mme Manet, *dossier,* doc. 4.

44. *Bulletin des lois de l'empire français,* 9th ser., 15 (Paris, 1860), partie supplémentaire, 486–87. The pension was based on his position and on his thirty-plus years of civil service.

45. See Charles Dupêchez, *Marie d'Agoult, 1805–1876,* 2d ed. (Paris: Plon, 1994), 354.

46. Charles Limet, *Un vétéran du barreau parisien: quatre-vingts ans de souvenirs, 1827–1907* (Paris: Lemerre, 1908), 249.

47. An account of Maisonneuve's career (1809–1897) can be found in the Larousse *La Grande Encyclopédie,* 27:1017. A discrepancy exists between the Larousse and contemporary library records as to his first names. I am following the library records for the names and the Larousse for the outline of his career, which would agree with documents at the A.N. and at the Bibliothèque de l'Académie de Médecine, Paris.

48. *Dossier,* doc. 20, dated 23 January 1858: "a été atteint d'une congestion cérébrale, dont il est actuellement convalescent."

49. Charles Baudelaire, who was aware of his own syphilitic condition, wrote to his mother in 1860 that he was suffering from "une congestion cérébrale": *Correspondance générale,* ed. J. Crépet, 6 vols. (Paris: Conard, 1948) 3:14–15 (letter of 15 January 1860). See Roger L. Williams, *The Horror of Life* (University of Chicago Press, 1980), 51. Philippe Burty, Édouard Manet's friend, wrote after the painter's death that the syphilitic artist died "of the same malady as his father" (*La République Française,* 3 May 1883); quoted also in Cachin, *Manet, 1832–1883,* 50.

50. J.G.T. Maisonneuve, *Traité pratique des maladies vénéri-*

ennes (Paris: Labé, 1853).

51. This treatment was also prescribed by Édouard Manet's doctor Siredey, some twenty years later. See his "Ataxie locomotrice progressive; action thérapeutique du bromure de potassium," *Annales Médico-Psychologiques,* 5th ser., 14 (1875): 445.

52. Maisonneuve, *Traité pratique,* 330–33.

53. Morton N. Swartz, "Neurosyphilis," in *Sexually Transmitted Diseases,* ed. K. K. Holmes et al., 2d ed. (St. Louis: McGraw-Hill, 1990), 231–46. Seizures, aphasia, and hemiplegia, all referred to in the Manet *dossier* letters, are among the symptoms of neurosyphilis. It should be noted that the infectious period of syphilis is the early stage, and that during late or tertiary stages it is no longer transmittable despite the more serious harm to the patient. See Theodore Rosebury, *Microbes and Morals: The Strange Story of Venereal Diseases* (New York: Viking, 1971), 73–77 and 335–36 for a layperson's discussion of the disease and of some well-known nineteenth-century sufferers.

54. *Gazette des Tribunaux,* 28 September 1862, 3. He had died six days earlier. *Le Droit* ran an almost identical obituary. It was not typical for major Parisian daily newspapers to run obituaries except for the most noteworthy individuals.

55. A brief summary of critical reaction can be found in Cachin et al., *Manet, 1832–1883.* See also George Heard Hamilton, *Manet and His Critics* (New Haven: Yale University Press, 1954), 26.

56. Tabarant, *Manet et ses oeuvres,* 41. Jacques-Émile Blanche gives a contrasting account based on the remarks of one of Mme Auguste Manet's friends, the kind of society lady who no longer exists, as he called her. She remarked that the painting made the elegant couple look like the concierge and his wife. See *Essais et portraits* (Paris: Les Bibliophiles fantaisistes, 1912), 153–64.

57. There is some disagreement about the date of the picture. I would support Sandra Orienti's date of 1863 (*The Complete Paintings of Manet,* New York: Viking Penguin, 1970, cat. 63), that also being Tabarant's (*Manet: Histoire catalographique,* Paris, 1931, cat. 68). Rouart and Wildenstein (1: cat.62) date it to 1862. Moreau-Nélaton (*Manet raconté par lui-même,* 1: fig. 89) and the Jamot-Wildenstein catalogue (cat. 134) both give the date of 1866.

58. Alain de Leiris, *The Drawings of Édouard Manet* (Berkeley: University of California, 1969), cat. 149. Leiris notes the formality of the painting and the disparities of illumination between painting and drawings (26).

59. *Dossier:* "l'expression de douleur qui s'est peinte sur sa figure."

60. Michelle Perrot and Anne-Martin Fugier, *A History of Private Life,* ser. ed. Philippe Ariès and Georges Duby, trans. Arthur Goldhammer, 5 vols. (Cambridge: Belknap Harvard, 1990), 4:334–35.

61. Higonnet (*Berthe Morisot,* 132–33) recounts a series of letters between Morisot and her mother in which Morisot describes her nervousness about establishing good relations with

Mme Manet *mère*, who chastised her for such things as not writing to her as often as Suzanne Leenhoff Manet; Mme Morisot tried to placate the Manet matriarch and to reassure her daughter of her superiority to the "plump" Suzanne.

62. Leenhoff, description of the Gardner portrait, original document in the Tabarant Archives of the J. Pierpont Morgan Library, New York, 10: "[It] was not an ordinary filial affection, but a genuine worship."

63. Ibid.

64. *Bulletin des lois de l'empire français*, 9th ser., 21 (Paris, 1863), 198.

65. Tabarant, *Manet et ses oeuvres*, 113. Note that Tabarant refers to it as the "Château de Sillé-le-Guillaume," where some Fournier cousins lived. The actual Château de Vassé is in the commune of Rouessé-Vassé and is not to be confused with the Château de Sillé-le-Guillaume.

66. The complete description of each lot, with prices, can be found in the Abbé Girault, "La Vente des biens nationaux dans les coëvrons sarthois," *Bulletin de la Société d'Agriculture, Science et Arts de la Sarthe*, 3rd ser., 9, fasc. 1 (Le Mans, 1941), 69–70. The transaction was actually carried out by a registration inspector named Parrain from Le Mans. I should add that these buildings, grounds, and windmills, impressive as they are, were only a fraction of the Vassé property.

67. Claire Richard Vial, *Découvrir la Sarthe* (Sablé-sur-Sarthe: Coconniers, 1984), 212.

68. Born 6 October 1794; died 11 August 1875. See Fortuné Legeay, *Nécrologie et bibliographie contemporaines de la Sarthe, 1844–1880* (Le Mans: Leguicheux-Gallienne, 1881), 177–78.

69. Higonnet, *Berthe Morisot*, 171.

70. See "Copie faite pour Moreau-Nélaton de documents sur Manet appartenant à Léon Leenhoff," Bibliothèque Nationale, Cabinet des Estampes, Yb3 2401, 72.

71. Higonnet, *Berthe Morisot*, 116–17. A few of the autobiographical aspects are discussed below.

72. Tabarant, *Manet et ses oeuvres*, 61; Étienne Moreau-Nélaton, *Manet raconté par lui-même*, 1:49; Proust, *Édouard Manet: souvenirs* (see chapter 1 n. 12).

73. Higonnet (*Berthe Morisot*, 42) disputes this point, claiming it was Gustave.

74. Tabarant makes this claim, apparently based on the opinions of Léon Leenhoff. There are problems construing the resemblance. Françoise Cachin, in *Manet 1832–1883* (236), proposes one of the models from *Jésus insulté par les soldats*.

75. Philip Nord, "Manet and Radical Politics," *Journal of Interdisciplinary History* 19, no. 3 (Winter 1989): 450–51.

76. Margaret Mary Armbrust Seibert ("A Biography of Victorine-Louise Meurent and Her Role in the Art of Édouard Manet" [Ph.D. diss., Ohio State University, 1986], 122) refers to the Manet-Leenhoff marriage certificate in the Gemeente Zaltbömmel, which gives the birthdates and occupations of Suzanne and her parents. She hereby corrects the mistakes in the Manet literature, as Suzanne's birthdate is usually given as 1830, and place of birth as Zalt-Bömmel, where she and her parents later resided.

77. Leenhoff, "Copie faite pour Moreau-Nélaton," 72.

78. Curtiss, "Letters," 378–79. Her claim has been acknowledged as a distinct possibility by Juliet Wilson-Bareau in *The Hidden Face of Manet: An investigation of the artist's working processes* (London: Burlington Magazine, 1986), 30. Other art historians who have given some support for the theory include Kathleen Adler, *Manet* (Oxford: Phaidon, 1986), 229, n. 6, and Robert Rosenblum and H. W. Janson, *Nineteenth-Century Art* (New York: Abrams, 1984), 295.

79. It would also be in keeping with the family's sense of duty and social decency that if one of the Manets got her into the predicament, one of them—the eldest son—would be obliged to marry her and keep the paternity under wraps.

80. Theodore Reff notes this fact in "The Symbolism of Manet's Frontispiece Etchings," *Burlington Magazine* 104, no. 710 (May 1962): 186.

81. Baudelaire, *Correspondance générale*, 4:194.

82. Leenhoff, "Copie faite pour Moreau-Nélaton," 71.

83. "Si vous voyiez votre filleul–celle qui sera Mme Camille Pissarro en est la marraine–comme il est gentil à présent"; letter from Fécamp, end of 1868, quoted in Aleth Jourdan, Dianne W. Pitman, and Didier Vatuone, *Frédéric Bazille et ses amis impressionnistes*, exh. cat. (Montpellier: Musée Fabre et Réunion des Musées Nationaux, 1992), 44.

84. Beth Archer Brombert, *Édouard Manet: Rebel in a Frock Coat* (New York: Little, Brown and Company, 1996), 137.

85. Leenhoff, "Copie faite pour Moreau-Nélaton," 71. The text reads: "Je me souviens d'avoir été rue de Douai à son atelier pour le jour de l'an. C'est de là que j'ai rapporté au petit bureau rue Rollet, aujourd'hui rue St.-Louis. Je demeurais avec la grand-mère et Ferdinand, puis Rudolph. / "Les Mezzara demeuraient rue St.-Georges. / "Après la mort de la grand-mère, nous avons demeuré tous les 3 rue de l'Hôtel-de-Ville tout en haut appartement avec balcon."

86. Ibid., 73: "Avant le mariage en 1862 et 1863, Eugène venait souvent. Je me souviens toujours qu'on parlait toujours d'un tel d'un tel, je me disais—qu'est-ce que c'est que cet un tel dont on parlait tant. Nous avions 3 pièces—une salle à manger, un Salon et 1 chambre. Je couchais dans le salon sur un lit-cage."

87. Letter in the Fonds Rouart at the Musée Marmottan, Paris. The letter is discussed by Beth Archer Brombert in *Rebel*, 83 and 462, n. 10. Since Brombert interprets the family dilemma to have been that Édouard had fathered the illegitimate Léon, she also reads this letter to point to "Suzanne's 'crime'" as "her misguided notion of propriety, which denied Léon his rightful name."

It is doubtful that Mme Manet *mère*'s stinging reference to a "crime" would entail semantics and propriety.

88. See Leenhoff documents, Tabarant Archives, J. Pierpont Morgan Library, New York.

89. The letter, among other things, congratulates Astruc on the anticipated arrival of a baby: "Dites à Mme Astruc tous les voeux que nous faisons pour la bienvenue de votre héritier. Nous voudrions bien qu'il nous en arrive autant." Letter in the Prins collection, published in Juliet Wilson-Bareau, ed., *Édouard Manet: voyage en Espagne* (Caen: L'Échoppe, 1988), 9–10.

90. Eugène Manet, *Victimes!* (Clamecy: Straub, 1889), 28.

91. Léon Leenhoff identified his mother as the model of the picture. See Julius Meier-Graefe, *Édouard Manet* (Munich, 1912), 38.

92. Two more early representations of Suzanne are reproduced in Jacques Mathey, *La Succession de Mme Veuve Édouard Manet* (Paris: Editart, 1964), cats. 3, 4. Catalogue 3 is a painting on panel (5.55 x 3.50 m), which I find difficult to attribute to Manet. Catalogue 4 is a *mine de plomb* drawing from an 1855 Rome sketchbook, which looks more typical of Manet's draughtsmanship.

93. Ambroise Vollard, *En écoutant parler Cézanne, Degas, et Renoir* (Paris: Grasset, 1938), 187.

94. Higonnet, *Berthe Morisot*, 84.

95. See the letter, Léon Leenhoff to Tabarant, dated Bizy, 6 December 1920, in the Tabarant Archives, J. Pierpont Morgan Library, New York: "Dans les familles Manet et Leenhoff je disais toujours parrain et marraine, dans le monde c'était mon beau-père et ma soeur. Secret de famille dont je n'ai jamais su le fin mot, ayant été choyé, gâté par tous les deux, qui faisaient toutes mes fantaisies."

96. Tabarant, *Manet et ses oeuvres*, 17, 483: "Nous vivions tous les trois heureux, surtout moi, sans aucun souci. Je n'avais donc aucune question à soulever sur ma naissance," he wrote to Tabarant.

97. Ibid., 482.

98. Ibid., 483.

99. See Reff, *Manet and Modern Paris*, 174–91. I disagree with Reff that Manet's occasional studio assistant, the "poor deranged boy" Alexandre who appears in *Boy with Cherries* and is the subject of Baudelaire's "La Corde," appears in the picture. The dark-haired boy on the right resembles the model for *Boy with Dog*.

100. Timothy Clark pointed out in a lecture course given at Harvard University that the *Philosophe à la main tendue* (Art Institute of Chicago) appeared in *La Musique*. The series includes Orienti cats. 95–97. For more on the series, see Anne Coffin Hanson, "Manet's Subject Matter and a Source of Popular Imagery," *Museum Studies, Art Institute of Chicago* 3 (1969): 63–80.

101. Art Institute of Chicago; Orienti cat. 95.

102. See Beatrice Farwell, "Manet's 'Espada' and Marcantonio," *Metropolitan Museum Journal* 2 (1969): 204–6.

103. Ewa Lajer-Burcharth, "Modernity and the Condition of Disguise: Manet's 'Absinthe Drinker,'" *Art Journal* 45, no. 1 (Spring 1985): 18–26. Lajer-Burcharth recast her central argument in light of Lacanian notions of self-formation and feminist theory—principally that of Joan Rivière and Mary Ann Doane on the concept of masquerade in a talk, "Masculinity and Masquerade: Manet's 'Absinthe Drinker' Revisited," given 1 April 1992 at Harvard University.

104. Moreau-Nélaton, *Manet raconté*, 1:25–26.

105. Anne Coffin Hanson noted a relation between Manet's image and that of a lithograph by Charles-Joseph Traviès, *The Ragpicker*, in *Les Français peints par eux-mêmes*, 9 vols. (Paris: Curmer, 1840–42). See Hanson's "Popular Imagery and the Work of Édouard Manet" in Ulrich Finke, ed., *French Nineteenth-Century Painting and Literature* (Manchester: Manchester University Press, 1972), 133–63.

106. Of the many iterations of this infamous reversal, the reader might see George Mauner's description in *Manet: Peintre-Philosophe* (University Park: Pennsylvania State University Press, 1975), 158–59.

107. Professor Henri Zerner noted, in the audience discussion of Lajer-Burcharth's lecture noted above, that the face of the drinker is unusually blurry compared with other works by Manet.

108. Lajer-Burcharth, "Modernity," 24.

109. I have in mind the stance described by Thomas Crow in "Modernism and Mass Culture in the Visual Arts," *Pollock and After: The Critical Debate*, ed. Francis Frascina (New York: Harper and Row, 1985), 233–66.

110. Lajer-Burcharth, in the lecture at Harvard University cited above, also introduced the notion of the father as the ultimate spectator of the sexual masquerade, as discussed by Joan Rivière in "Womanliness as a Masquerade," in *Formations of Fantasy*, ed. Victor Burgin et al., 35–44; first published in the *International Journal of Psychoanalysis* 10 (1929).

111. See the discussion in Jean Laplanche and J.-B. Pontalis, *The Language of Psycho-Analysis*, trans. D. Nicholson-Smith (New York: Norton, 1973), 261–63. They cite the early *Studies on Hysteria* (1895) for the following: "The deeper we go the more difficult it becomes for the emerging memories to be recognized, till near the nucleus we come upon memories which the patient disavows even in reproducing them" (*Standard Edition*, 2:289). Freud's formulation of the concept became more developed during work on the case of the "Rat Man." See "Notes upon a Case of Obsessional Neurosis" (1909), *Standard Edition*, 10:155 ff.

112. Sándor Ferenczi, "Social Considerations in Some Analyses," *International Journal of Psycho-Analysis* 4 (1923): 477. See also P. R. Lehrman, "The Fantasy of Not Belonging to One's Family," *Archives of Neurology and Psychiatry* 18 (1927): 1015–23.

113. For example: Marilyn R. Brown, *Gypsies and Other Bohemians: The Myth of the Artist in 19th-Century France* (Ann Arbor: UMI Research Press, 1985); Clark, *Painting of Modern Life;*

Hollis Clayson, *Painted Love: Prostitution in French Art of the Impressionist Era* (New Haven: Yale University Press, 1991); Reff, *Manet and Modern Paris*, as well as the work of historians such as Alain Corbin, Anne-Martin Fugier, and others.

114. Juliet Wilson-Bareau has suggested, after the resurfacing of Manet's painting of Ambroise Adam, the likelihood that every early Manet etching was done after a painting. See *The Hidden Face of Manet*, 87, n. 16, and "The Portrait of Ambroise Adam by Édouard Manet," *Burlington Magazine* 126 (December 1984): 757. The etching was catalogued by Guérin as Manet's first, from 1860. Moreover, Jay McKean Fisher has related its technical accomplishment and effective use of aquatint to slightly later works; he focuses on *La Pêche* and on the Ingelheim catalogue's discussion of similarities in the treatment of the foliage between the etching and *La Musique aux Tuileries*. See *The Prints of Édouard Manet* (Washington, D.C.: The International Exhibitions Foundation, 1985), 38–9, cat. 7. Fisher, however, neglects to relate the etching to the canvas *The Students of Salamanca*, which, with *La Pêche,* suggest a series of explorations of the Gennevilliers motif, which may have included a painted version of *The Travelers.*

115. Identified by Anne Coffin Hanson in *Édouard Manet: 1832–1883* (Philadelphia Museum of Art, 1966), 47. On the print, see Fisher, *The Prints of Édouard Manet*, 38–39.

116. T. J. Clark, *The Absolute Bourgeois: Artists and Politics in France, 1848–1851* (Princeton: Princeton University Press, 1982 [1973]), 118–23.

117. See Édouard Dalloz, *Receuil périodique de jurisprudence de législation et de doctrine* (Paris), 1847: 4. 31 (5 December 1846). Concerning advance billing, see Adrien Huard and Édouard Mack, *Répertoire de législation, de doctrine et de jurisprudence en matière de propriété littéraire et artistique*, new ed. (Paris: Marchal et Billard, 1895), 365 (Paris court ruling of 2 February 1866).

118. Albert Cler, *Physiologie du musicien* (Paris, c. 1841–43), 120–22.

119. Edmond Texier, *Tableau de Paris* (Paris: Paulin et le Chevalier, 1852–53), 1:19: "Il y a quelques années, nous avons vu traîner sur les bancs de la police correctionelle ce doyen des chanteurs en plein vent, ce représentant de la gaie science, ce troubadour en haillons, qui tour à tour tenor, basse ou baryton, tenor grave ou doux, a charmé les échos de tous les carrefours, dont la réputation fut universelle. On avait accusé ce joyeux ménestrel d'avoir violé les lois sur la propriété littéraire: les éditeurs patentes prétendaient qu'en vendant leur chansons aux ouvriers, aux bonnes d'enfants et aux grisettes, il nuisait essentiellement à leur vente, et leur avocat concluait à 500 francs de dommages-intérêts contre le délinquant, qui, se plaçant sous invocation d'Euterpe, en fut heureusement quitté pour une amende de 25 francs."

120. Étienne Blanc, *Traité de la contrefaçon en tous genres et de sa poursuite en justice*, 4th ed. (Paris: Plon, 1855), 664. Patents were

essentially civil matters according to Article 48. The civil chambers of the Tribunal de la Première Instance had authority over cases with damages sought of more than 200 francs; the justice of the peace for damages under 200 francs.

121. Blanc, *Traité,* 237. *Limonadiers* Morel (8 September 1847) and Varin (3 August 1848) paid damages to Bourget.

122. Huard and Mack, *Répertoire*, 298–99; 14 January 1852: "C'est à tort qu'on néglige d'ordinaire, avant d'employer des airs dans un vaudeville, de demander le consentement des auteurs de ces airs. Mais les auteurs de vaudevilles, qui trouvant cet usage établi, ont pu se croire autorisés à le suivre, peuvent exciper de leur bonne foi, et il y a seulement lieu de leur impartir un délai suffisant pour remplacer par d'autres les airs qu'ils n'avaient pas le droit de s'approprier."

123. An account can be found in *Pandectes chronologiques, ou Collection nouvelle résumant la jurisprudence* (Paris: Plon, 1890) 3: 1845–1859, part 2, 121. The *Pandectes* was a monthly review of cases before the Cour de Cassation and appeals courts all over France.

124. Duret, *Histoire d'Édouard Manet*, 238–39: "Victorine Meurend était une jeune fille que Manet avait rencontrée, par hasard, au milieu de la foule, dans une salle, au Palais de Justice." Tabarant claims that Victorine's residence at 17, rue Maître-Albert (near the Place Maubert) made it likely that he met her near the place where he had his copper plates etched (*Manet et ses oeuvres*, 47). More recently, Albert Boime has raised the possibility that Manet met Victorine when she modeled for his teacher Couture: a Louise Meuran appears in the record books of Couture's Senlis studio. Unfortunately, we have no records that Manet, who left Couture's Paris studio in 1856, visited the Senlis studio in December 1861 or April 1862, when we know Meurent modeled. See *Thomas Couture and the Eclectic Vision* (New Haven: Yale University Press, 1980), 464. At the same time, Boime's discovery gives the two a point of immediate connection upon their meeting in Paris.

125. Existing documentation, fragmentary as it is, of Meurent's life, has been collected in Seibert, "A Biography of Victorine-Louise Meurent." Seibert disputes the truth of George Moore's claim as well as the documentary value of an 1890 painting by Norbert Goeneutte that showed Meurent as a down-and-out street singer; see 269 and 279–80. Several additional discoveries pertaining to Meurent's life can be found in Eunice Lipton, *Alias Olympia: A Woman's Search for Manet's Notorious Model and Her Own Desire* (New York: Charles Scribner's Sons, 1992). Lipton discusses her finding of documents at the Société des Artistes Français showing that not only was Victorine a member, but also that she died in 1928 (57). She interprets evidence that Victorine shared a residence with various women, including the well-known courtesan Marie Pellegrin, as suggestive of Meurent's lesbianism or bisexuality (90).

126. Because of the incompleteness of the *greffes*, or court

transcriptions, from the chambers where Auguste Manet was a judge, it is hard to say how likely it is that cases came before him involving such things as street singers' copyright violations. The *Gazette des Tribunaux* and *Le Droit* covered the first chamber, which handled the heaviest load and the most illustrious cases, much more thoroughly than the other chambers; in addition, only the *Président* is noted in the newspaper accounts, not the rotating judges. Nevertheless, the point stands that Manet's father and his colleagues ruled in judgment of these matters.

127. *Conférence de législation et d'économie politique de 1839. Exposé de motifs: du projet de loi sur la surveillance de la haute police, et le sort des libérés* (Paris: Lacour et Maistrasse, 1843), 1–8.

128. "Instruction à MM. les Commissaires de Police" (21 July 1858), 1. The circular contained new regulations for the various formulas for daily reports, arrests, and the like.

129. See Lucien Münsch, *Répertoire général des circulaires et instructions du Ministère de la Justice* (Paris: Larose, 1900), 773.1868. The text reads: "Prescrivant de requérir contre tous vagabonds étrangers ou français, indépendamment de l'emprisonnement, la surveillance de la haute police et d'appeler de tous jugements qui ne feraient pas droit à ces réquisitions." For a contemporary discussion of the "haute police," see Henri Pascaud, "Étude sur la surveillance de la Haute Police: ce qu'elle a été, ce qu'elle est, ce qu'elle devra être," *Revue Critique* 27 (1865): 229–58.

130. F. Brayer, *Dictionnaire général de police administrative et judiciaire*, 2d ed., 4 vols. (Paris, n.d.), 1:464–65. Article 7 of the law of 3 December 1849 stipulated a severe repression of persons of Bohemian descent, who faced deportation. "C'est dans ce sens que le Ministre de la Justice, par une circulaire de 18 mai 1858, a adressé des instructions aux procureurs généraux. [. . .] Les préfets doivent donc se concerter avec ces magistrats, afin qu'il soit fait, dans leurs ressorts respectifs, une application énergique des lois de police concernant les vagabonds et les étrangers dangereux." The repression of the Bohemians is described at length in Brown, *Gypsies*, 31–35; she discusses Manet's images of gypsies, 78–85.

131. Roland Barthes, "The Reality Effect," in *The Rustle of Language*, trans. Richard Howard (New York: Hill and Wang, 1986), 141–48.

132. I owe this observation to Christopher Campbell. If we were to think in formalist terms along the lines of Manet's pictorial problem, it may be that Manet found the picture a bit too stark, too austere, hence his addition of the bright yellow wrapper and the dark red cherries. The still-life enhances the subtle blues and yellows in the gray dress; it excites the red exterior walls and the complementary green shutters. Manet similarly transformed his *Portrait of Théodore Duret,* adding a burst of color in the form of the red cushion on the stool, the carafe, glass and lemon, after the figure was complete. See Duret, *Histoire d'Édouard Manet*, 88–89.

133. Baudelaire, *Oeuvres complètes*, 101.

134. Ibid., 157: "Je sentis ma gorge serré par la main terrible

de l'hystérie." See also Jérôme Thélot, *Baudelaire: violence et poésie* (Paris: Gallimard, 1993), 489–90.

135. Proust, *Manet: souvenirs*, 40.

136. Reff, "Symbolism of Manet's Frontispiece Etchings," 185.

137. Beatrice Farwell, for instance, dates the picture to 1860–61, a reasonable hypothesis. See *Manet and the Nude* (New York: Garland, 1981), 63.

138. Theodore Reff, "Manet and Blanc's 'Histoire des peintres,'" *Burlington Magazine* 112 (July 1970): 456–57.

139. Tabarant, *Manet et ses oeuvres*, 60.

140. In my view, there is a lack of evidence to support Reff's proposal that the picture suggests Édouard as Léon's father.

141. Farwell, *Manet and the Nude*, 82.

142. Nils Gösta Sandblad, *Manet: Three Studies in Artistic Conception* (Stockholm: Lund, 1954), 17–68.

143. See Juliet Wilson-Bareau's review of the exhibition "Art in the Making: Impressionism," *Burlington Magazine* 133, no. 1055 (February 1991): 129. The photograph appears in the Manet family photograph album at the Bibliothèque Nationale, Département des Estampes. In my view, Manet's portrayal of Mme Loubens (the woman in the left foreground in a veil) was also closely based on the *carte-de-visite* photograph in the album, albeit in reverse. See the BN Estampes microfilm T038873. In this case, it is the expression, not the costume or pose, that follows the photograph.

144. Tabarant Archives, J. Pierpont Morgan Library, New York.

145. Julie Manet, daughter of Eugène Manet and Berthe Morisot, recognized the figure as her father. See Julie Manet, *Journal (1893–1899): sa jeunesse parmi les peintres impressionnistes et les hommes de lettres* (Paris, 1979), 153.

146. Juliet Wilson-Bareau proposed this identification of the widow in a talk at the Courtauld Institute in the spring of 1991. She added the provision, however, that the figure might also represent Suzanne Leenhoff's widowed mother, who had come to Paris to help the unmarried Suzanne care for Léon; Beth Archer Brombert (*Rebel*, 137) has pointed out that it was actually Suzanne's grandmother who went to Paris at this time.

147. See David Bomford, Jo Kirby, John Leighton and Ashok Roy, *Art in the Making: Impressionism* (New Haven: The National Gallery, London with Yale University Press, 1990), 118.

148. Juliet Wilson-Bareau supports this identification.

149. Hippolyte Taine, *Notes sur Paris: vie et opinions de M. Graindorge* (Paris, 1870 [1868]), 70: "Les Tuileries sont un salon, un salon en plein air, où les petites filles apprennent les manèges, les gentillesses et les précautions du monde, l'art de coqueter, de minauder et de ne pas se compromettre. /Je viens d'en écouter deux (sept ans, dix ans,) qui faisaient la résolution d'aller inviter une nouvelle venue. Elles l'ont bien regardée d'abord; elles ont vérifié si elle était de leur monde; puis, tout d'un coup, relevant la tête d'un air sémillant, elles ont marché jusqu'à la bonne avec le

mélange convenable d'assurance et de modestie, exactement comme une dame qui traverse un salon pour en saluer une autre."

150. T. J. Clark, in lectures given at Harvard University, light-heartedly suggested that the girls appear to have made fun of the boy, who rushes to his mother's lap.

151. Such was a crucial event in Guy de Maupassant's "Un parricide," published in *Le Gaulois* on 25 September 1882: "Je grandis avec l'impression vague que je portais un déshonneur. Les autres enfants m'appelèrent un jour 'bâtard.'" See *Le Horla et autres contes cruels et fantastiques* (Paris: Garnier, 1989), 27.

152. Letter in Tabarant Archives, J. Pierpont Morgan Library, New York.

153. Alpers uses the term to characterize Northern Renaissance and Netherlandish seventeenth-century painting, with its concern for a topographic mode of representation: a way of suggesting accuracy without stressing the interventions of the artist. See, for instance, *The Art of Describing: Dutch Art in the Seventeenth Century* (Chicago: University of Chicago, 1983), xxv, 41–49.

154. In at least two other paintings, *Le Déjeuner dans l'atelier* and *Un bar aux Folies-Bergère*, Manet features a top-hatted artist or dandyish figure that is not a literal self-portrait, but can be seen as analogous to one. A proviso should be added that Manet destroyed some of his early works in 1865.

155. Orienti gives the following dimensions: *La Musique* (cat. 32), 76 x 119 cm; *La Pêche* (cat. 34), 77 x 123 cm. We should keep in mind that then, as well as now, canvases were available in standard sizes.

156. Reproduced in full in Rouart-Wildenstein, *Édouard Manet: catalogue raisonné*, 1:12–13.

157. For instance: Tabarant, *Manet et ses oeuvres*, 60; following him: Cachin, *Manet, 1832–1883*, 167; Eric Darragon ("Recherches sur la conception du sujet dans l'oeuvre d'Édouard Manet [1832–1883]" [Ph.D. diss., Université de Paris-Sorbonne/Paris IV, 1987], 1:119, n. 63) mentions childhood vacations apropos of the "idyllic tone" of *La Pêche*.

158. Five lines in each of the six papers for 30 francs, a savings of 50 centimes per line over the regular price. "Les annonces anglaises," as they were called, "insérées avec une classification méthodique dans les six grand journaux de Paris [. . .] offrent à un propriétaire la possibilité de faire connaître, *à bon marché*, la maison de campagne qu'il veut vendre ou louer." See, for instance, *La Presse* of Sunday, 23 July 1865, 4. Houses in the country were the first objects to hit the classifieds because one could hardly find a prospect by hanging a sign in a window.

159. P. Joigneaux, *Almanach d'un paysan pour 1850* (Paris: Pillon, 1849) included an engraving in the Le Nain style, "Les Veillées chez M. Mathieu, par P. Joigneaux, représentant du peuple," which immediately brings to mind Courbet's *After Dinner at Ornans* of 1848–49. See T. J. Clark, *Image of the People:*

Gustave Courbet and the 1848 Revolution (Princeton: Princeton University Press, 1982 [1973]), 88.

160. Pierre-Charles Joubert's *Le Parfait Jardinier-Potager: guide de l'horticulture et de l'amateur de légumes de pleine-terre et de primeurs* (Paris: Arnault de Vresse, 1867).

161. Eugène Chavette, "Histoire invraisemblable, mais véridique, de Modeste Asile," *Le Figaro*, 9 June 1864, 2–4.

162. See, for instance, Frédéric Soulié, "Maison de campagne à vendre," and Léopold Stapleaux, "Le Château de la Rage," both in *Le Soleil*, 21–22 October 1865.

163. Arnould Frémy, *Les Moeurs de notre temps* (Paris: Bourdilliat, 1861), 64: "La vie de château est tout un fragment de l'ancienne société que nous cherchons à ressusciter, après avoir rasé tous les vieux châteaux, génération illogique et puérile que nous sommes! La manie de château a engendré la gloriole de la campagne [. . .] Ce goût de la campagne, [. . .] affaire de parade et de vanité de parvenu. On aime à avoir l'air de vivre sur les terres, toujours pour singer la noblesse. On ne peut plus dire: *mes paysans, mes vassaux*; on aime à pouvoir dire: *mon garde, mon fermier, mon jardinier*." Also quoted in Philippe Perrot, *Les Dessus et les dessous de la bourgeoisie* (Paris: Hachette, 1981), 68.

164. *Exposition Gennevilliers*, n.p.

165. Rosalind E. Krauss, "Manet's 'Nymph Surprised,'" *Burlington Magazine* 109, no. 776 (November 1967): 622–27; Beatrice Farwell, "Manet's 'Nymphe surprise,'" *Burlington Magazine* 117 (April 1975): 224–29; Giovanni [Juan] Corradini, "La 'Nymphe surprise' de Manet et les Rayons X," *Gazette des Beaux-Arts*, 6th ser., 54 (September 1959): 149–54, and *Édouard Manet: La Ninfa Sorprendida* (Buenos Aires, 1983). See also Charles Sterling, "Manet et Rubens," *L'Amour de l'Art* (September 1932): 290.

166. Wilson-Bareau, *The Hidden Face of Manet*.

167. Ibid., 27.

168. Ibid., 32. The X-radiographic image was published in the 1983 Metropolitan Museum catalogue (no. 33), but it was not related to the other bather pictures by Manet.

169. Wilson-Bareau, in Cachin et al., *Manet, 1832–1883* (92–93), notes some of the differences between the two known impressions of the first state, one of which I have examined, in the collection of Mr. and Mrs. R. Stanley Johnson, Chicago. The bed, for instance, is less clearly delineated in the first state than in the second, an impression of which I have examined in the Fogg Museum of Art, Cambridge. One of the extraordinary things about the etching is the elusive figure-ground effect as the viewer tries to make out the silhouette of the bather's hair against the curtain and the figure of the maid. This would become a favored illusion in Manet's oil paintings throughout his career, notoriously in the *Olympia*.

170. Discovery by Anna Barsakaya, "Édouard Manet's Painting 'Nymph and Satyr' on Exhibition in Russia in 1861," in *Omagiu lui George Opresxu, cu prilejul implinirii a 80 de ani*

(Bucharest, 1961). I am relying on the summary of the secondary accounts already cited.

171. Tabarant, *Histoire catalographique*, 66.

172. Corradini, *Édouard Manet: La Ninfa Sorprendida*, 66, 68–69.

173. Farwell, "Manet's 'Nymphe surprise,'" 224–27.

174. Krauss, "Manet's 'Nymph Surprised,'" 622–27.

175. Here, I mean "Salon audience" figuratively, as Manet did not actually submit the canvas to any of the Salon exhibitions. We know of only two exhibitions of it during Manet's lifetime: the 1861 St. Petersburg exhibit under the title *Nymphe et Satyre*, and the 1867 Pont de l'Alma independent one-person show, where it was called *La Nymphe surprise*.

176. Michael Fried had first called attention to this quality in "Manet's Sources: Aspects of His Art, 1859–1865," *Artforum* (March 1969), 72, n. 98: "One might say that Manet wanted to make the *painting itself* turn toward and face the beholder. [. . .]"

177. The paintings have been informally linked many times, for instance in Christian Hornig, *Giorgiones Spätwerk* (Munich, 1987), 153. A fuller exploration of the significance of Venetian painting for Manet's art can be found in my essay, "Manet's 'Le Déjeuner sur l'herbe' as a Family Romance," in *Manet's "Le Déjeuner sur l'herbe,"* ed. Tucker, 126–33.

178. Ernst Förster, *Handbuch für Reisende in Italien* (Munich, 1840), 770. A French edition appeared as *Manuel du voyageur en Italie*, 4th ed., rev. (Munich, 1850); this edition referred to the *Tempesta* as: "Scène [restée inexplicable] entre un vieillard, une femme et un enfant, en plein air" (brackets original; 571). See my letter, "More on Giorgione's 'Tempesta' in the Nineteenth Century," *Burlington Magazine* 138, no. 1120 (July 1996): 464. The oft-quoted remarks of Manet were, according to his friend: "'Il paraît, me dit-il, qu'il faut que je fasse un nu. Eh bien, je vais leur en faire, un nu. Quand nous étions à l'atelier, j'ai copié les femmes de Giorgione, les femmes avec les musiciens. Il est noir, ce tableau. Les fonds ont repoussé. Je veux refaire cela et le faire dans la transparence de l'atmosphère, avec des personnes comme celles que nous voyons là-bas'" (Antonin Proust, *Manet: souvenirs*, 43). On the Manet brothers' Venetian voyage, see Limet, *Un vétéran du barreau parisien*, 200–208. See also Ollivier, *Journal*, 1:168.

179. Beatrice Farwell, in *Manet and the Nude* (224), remarks on the ample figure of Victorine Meurent in the *Déjeuner* as uncharacteristic of Manet's representations of her in other paintings. As for whether the figure in the *Déjeuner* registered as ample with the viewers of the time, consider the fact that Alexandre de Pontmartin, in his review of Zola's *L'Oeuvre*, reads Claude Lantier's painting called *Plein air* in the novel as *Le Déjeuner sur l'herbe*, and complains about the overuse of the words "ventre" (he stops counting at 45 instances) and "cuisses" (48). See *Souvenirs d'un vieux critique* (Paris: Calmann Lévy, 1886), 7:385.

180. Jacob Burckhardt's reference reads: "—Das Bild im Pal.

Manfrin, als 'Familie G's' bezeichnet, ist ein eigentliches und zwar frühes Genrebild in reicher Landschaft" (*Der Cicerone: Eine Anleitung zum Genuß der Kunstwerke Italiens* [Basel: Schweighauser'sche Verlagsbuchhandlung, 1855], 963).

181. This appears to have been one of the anecdotes in circulation in the nineteenth century, and it is repeated by Antonio Morassi, *Giorgione* (Milan, 1942), 87. See Salvatore Settis, *La "Tempesta" interpretata: Giorgione, i committenti, il soggetto* (Turin: Einaudi Editore, 1978), 59 or the English edition: *Giorgione's Tempest: Interpreting the Hidden Subject*, trans. E. Bianchini (Chicago: University of Chicago Press, 1990), 59. Settis also discusses an 1894 reading by Angelo Conti, who held that the lightning represented the "tragedy of paternity" (50, 56).

182. There are conflicting opinions about whether Byron was describing *La Tempesta* or a painting now ascribed to a follower of Titian, the *Triple Portrait* (Collection of the Duke of Northumberland, Alnwick Castle, Alnwick.) This was a matter of dispute in the nineteenth century as well as today. Marcel Jérôme Rigollot (*Essai sur le Giorgion* [Amiens: Duval et Herment, 1852], 27), for instance, discusses the *Triple Portrait* as the picture Byron celebrated, but refers to Byron's letters and professed ignorance of painting, not to the *Beppo*.

183. The notion that the painting's subject was perhaps meant to be obscure is supported by the fact that fewer than thirty years after it was painted, an inventory of the private collection to which it belonged referred to the painting simply as a landscape with a soldier, a gypsy, and a child. "El Paesetto in tela con la tempesta, con la cingana et soldato fu de man de Zorzi da Castelfranco"—so reads Marcantonio Michiel's inventory of the Vendramin collection in 1530. Reprinted in *Notizia d'opere di disegno . . . scritta da un Anonimo Morelliano*, pub. Iacopo Morelli (Bassano, 1800), 80; see also *The Anonimo: Notes on Pictures and Works of Art in Italy Made by an Anonymous Writer in the Sixteenth Century*, trans. P. Mussi, ed. George C. Williamson (London: George Bell and Sons, 1903), 123. Williamson's introduction explains the circumstances of the discovery of the "anonymous" manuscript by the Abate Don Jacopo Morelli in 1800, and its attribution to Marcantonio Michiel. This is a very delicate point among scholars, however, as there have been many interpretations suggested for *La Tempesta* that have some merit. One could argue, for instance, that the painting depicts the legend of St. Theodore, an interpretation suggested by Nancy De Grummond ("Giorgione's Tempest: The Legend of St. Theodore," *L'Arte* 18–20 [1972]: 5–53), and that the iconography was significant to certain viewers of the time but not so striking that it made its way into the 1530 inventory. I am indebted to Alexander Nagel for sharing his views on Venetian painting with me.

184. Dennis Farr and John House, *Impressionist and Post-Impressionist Masterpieces: The Courtauld Collection* (New Haven: Yale University Press, 1987), 36. The authors note that by contrast,

the sketch in the Courtauld collection has few alterations and thus appears to have been done after the large painting.

185. Carol Armstrong, "To Paint, to Point, to Pose: Manet's 'Le Déjeuner sur l'herbe,'" in Manet's "Le Déjeuner sur l'herbe," ed. Tucker, 90–118.

186. Louis Étienne, Le Jury et les exposants: Salon des Refusés (Paris, 1863), 30.

187. Constance Penley, in "Feminism, Psychoanalysis, and the Study of Popular Culture" (in Visual Culture, ed. Norman Bryson, Michael Ann Holly, Keith Moxey [Hanover, N.H.: Wesleyan University Press and University Press of New England, 1994], 302–24), develops the idea of fantasy as operating around an identification with multiple roles within a given scenario.

188. Schapiro ("The Apples of Cézanne," 11) reproduces an 1867 frontispiece to a book on dreams by Hervey de Saint-Denys that illustrates the anxiety dream of nakedness; on the phenomenon of inhibition of exhibitionism, see Bonnet, Voir—être vu.

189. Notably Hofmann, Das Irdische Paradies, 348; Farwell (Manet and the Nude, 240–54) discusses the picture as a "paradise regained."

190. For a thoughtful set of reflections on the documentary impulse in photography, see Abigail Solomon-Godeau, "Who Is Speaking Thus? Some Questions about Documentary Photography," in her Photography at the Dock: Essays on Photographic History, Institutions, and Practices (Minneapolis: University of Minnesota Press, 1991), 169–83.

191. Sartre, Being and Nothingness, 360.

3 THE SPACE OF OLYMPIA

1. See Jacques Lacan, Les Complexes familiaux dans la formation de l'individu (Dijon: Navarin, 1984), 63–64.

2. Alain Corbin, "Backstage," in History of Private Life, 4:612. See also "La Prostituée," in Misérable et glorieuse: la femme du XIXe siècle, ed. J.-P. Aron (Brussels: Éditions Complexe, 1984), 44–45; Les Filles de noces: misère sexuelle et prostitution aux 19e et 20e siècles (Paris: Aubier Montaigne, 1978), and the English edition, Women for Hire: Prostitution and Sexuality in France after 1850, trans. Alan Sheridan (Cambridge: Harvard University Press, 1990).

3. Corbin (History of Private Life, 4:611) reproduces and analyzes the photograph.

4. See Jill Harsin, Policing Prostitution in Nineteenth-Century Paris (Princeton: Princeton University Press, 1985), 307–8.

5. Ibid., 308.

6. Michael Ryan, Prostitution in London, with a Comparative View of That of Paris and New York (London: Baillière, 1839), 78–79.

7. Ibid., quoting A.-J.-B. Parent-Duchâtelet, De la prostitution dans la ville de Paris, 2 vols. (Paris, 1837).

8. Félix Carlier, Les Deux Prostitutions: étude de pathologie sociale (Paris: Dentu, 1887), 21.

9. Ibid.

10. Corbin, Women for Hire, 186. Hollis Clayson also touches on the greater role played by "recherché aristocratic eroticism (the trademark of the deluxe brothel) or a simulation of bourgeois romance (the specialty of many clandestine prostitutes)" in Painted Love, 19.

11. Flaubert, Sentimental Education, trans. R. Baldick (New York: Penguin, 1984), 18. See also L'Éducation sentimentale (Paris: Flammarion, 1985), 50–51: "Ce fut comme une apparition: Elle était assise, au milieu du banc, toute seule; ou du moins il ne distingua personne, dans l'éblouissement que lui envoyèrent ses yeux. En même temps qu'il passait, elle leva la tête; il fléchit involontairement les épaules; et, quand il se fut mis plus loin, du même côté, il la regarda. Elle avait un large chapeau de paille, avec des rubans roses qui palpitaient au vent, derrière elle. Ses bandeaux noirs, contournant la pointe de ses grand sourcils, descendaient très bas et semblaient presser amoureusement l'ovale de sa figure. [. . .] Une négresse, coiffée d'un foulard, se présenta, en tenant par la main une petite fille, déjà grande. L'enfant, dont les yeux roulaient des larmes, venait de s'éveiller. Elle la prit sur ses genoux."

12. Flaubert, Sentimental Education, 415; L'Éducation sentimentale, 504: "Elle y restait, la taille en arrière, la bouche entrouverte, les yeux levés. Tout à coup, elle le repoussa avec un air de désespoir; et, comme il la suppliait de lui répondre, elle dit en bassant la tête: — 'J'aurais voulu vous rendre heureux.' Frédéric soupçonna Mme Arnoux d'être venue pour s'offrir; et il était repris par une convoitise plus forte que jamais, furieuse, enragée. Cependant, il sentait quelque chose d'inexprimable, une répulsion, et comme l'effroi d'un inceste. Une autre crainte l'arrêta, celle d'en avoir dégoût plus tard." Another translation of that last line would be: "the fear of feeling disgusted with it later."

13. Noted by editor Claudine Gothot-Mersch in L'Éducation sentimentale, 511, n. 1.

14. Flaubert, Sentimental Education, 415; L'Éducation sentimentale, 504: "—Adieu, mon ami, mon chèr ami! Je ne vous reverrai jamais! C'était ma dernière démarche de femme. Mon âme ne vous quittera pas. Que toutes les bénédictions du ciel soient sur vous!' Et elle le baisa au front, comme une mère."

15. For a discussion of this phenomenon in Maupassant's fiction, see Emily Apter, "Splitting Hairs: Female Fetishism and Postpartum Sentimentality in the Fin de Siècle," in Eroticism and the Body Politic, ed. Lynn Hunt (Baltimore: Johns Hopkins University Press, 1991), 164–90.

16. For an account of the three Lacanian orders, see Ellie Ragland-Sullivan, Jacques Lacan and the Philosophy of Psychoanalysis (Chicago: University of Illinois Press, 1987), 130–95.

17. Clark, Painting of Modern Life, 107.

18. Chantal Gleyses (*La Femme coupable: petite histoire de l'épouse adultère au XIXe siècle* [Paris: Imago, 1994], 39) quotes from Zola in *Le Figaro* (28 February 1881), later published as "L'Adultère dans la bourgeoisie" in *Une campagne* (Paris: Charpentier, 1882), 176.

19. Corbin discusses the "enclosed milieu" of the prostitute as one of the three essential conditions of nineteenth-century French prostitution: the enclosure protected the married women and children who were not supposed to be exposed to prostitution. See Corbin, *Women for Hire*, 9.

20. Antoine Granveau, *La Prostitution dans Paris* (Paris, 1867), 28.

21. C. J. Lecour, *De l'état actuel de la prostitution parisienne* (Paris: P. Asselin, 1874), 53–54: "Ce qu'il faut avant tout, c'est de pouvoir relancer et atteindre la prostitution clandestine dans le lieu où elle accomplit son acte de débauche, si dangereux pour la santé publique. Ce lieu, c'est le cabaret, c'est le garni, c'est encore le logement où, grâce à la connivence du propriétaire ou du concierge, la prostituée clandestine, logée dans ses meubles, peut faire ouvertement son répugnant métier. [. . .] la prostitution dans les cabarets c'est l'exception, si on la compare à celle qui s'opère dans l'hôtel meublée, chez le logeur? Cela tient à mille raisons qui n'ont pas besoin d'être expliquées et que tout le monde sait ou devine. C'est donc le garni qui est surtout le grand refuge et le lieu de débauche du plus grand nombre des prostituées clandestines."

22. For subtle discussions of the question of identity and readability or representability in 19th-century Paris, see Clark, *Painting of Modern Life*, 255–58; Christopher Prendergast, *Paris and the Nineteenth Century* (Cambridge, Mass.: Blackwell, 1995), 15–16; and the text that to some degree lies behind both: Walter Benjamin, "The Paris of the Second Empire in Baudelaire," in *Charles Baudelaire: A Lyric Poet in the Era of High Capitalism*, trans. Harry Zohn (New York: Verso, 1985), 35–66.

23. Tanner, *Adultery in the Novel*, 91.

24. C. J. Lecour, *La Prostitution à Paris et à Londres, 1789–1871*, 2d ed. (Paris: P. Asselin, 1872), 200.

25. Ibid., 200–201.

26. Corbin, *Women for Hire*, 200.

27. Louis Martineau, *La Prostitution clandestine* (Paris: Delahaye, 1885), 84.

28. Ibid., 85–86: "Il s'agit des femmes qui se livrent à la prostitution clandestine, parce que leur situation dans le monde ne leur fournit pas l'argent nécessaire pour satisfaire leur goût de luxe, leur amour effréné de la toilette, leur désir d'éclipser leurs compagnes, leurs amies ou leurs rivales. Dans les lionnes pauvres, on voit la femme mariée accepter d'un amant les ressources que le mari ne peut lui procurer et faire de l'adultère le prix de son luxe. Eh bien, dans les horribles mystères de la vie de Paris, il est des femmes qui, dévorées des mêmes besoins, les satisfont sans que l'entraînement du coeur ou des sens accompagne, explique leur dégradation; il en est, puisqu'il faut le dire, qui, trouvant compromettant de prendre un amant nommé, en prennent un anonyme."

29. Lecour, *La Prostitution à Paris*, 152.

30. Foucault, interview with Stephen Riggins, 22 June 1982, in *Essential Works*, 1:125–26.

31. Michael Fried (*Manet's Modernism*, 266) quotes remarks he had made in *Courbet's Realism*.

32. Baudelaire, "Les Bijoux," *Oeuvres complètes*, 54, as translated by Richard Howard in *Les Fleurs du mal* (Boston: David R. Godine, 1993), 26.

33. Shoshana Felman, *What Does a Woman Want? Reading and Sexual Difference* (Baltimore: Johns Hopkins University Press, 1993), 47.

34. Felman, *What Does a Woman Want?* 47 (italics original).

35. Farwell, *Manet and the Nude*, 232.

36. See Theodore Reff, *Manet: Olympia* (New York: Viking, 1976), 111–13, and Clark, *Painting of Modern Life*, 86–87 and 284–85, nn. 23–26.

37. See Clark, *Painting of Modern Life*, quoting Bertall in *Le Journal Amusant* (97); Bertall in *L'Illustration* (145); Challemel-Lacour in *La Revue Moderne* (87; 285, n. 30); Ravenel in *L'Époque* (88; 296, n. 144); Cantaloube in *Le Grand Journal* (94; 287, n. 59), respectively.

38. Clark, *Painting of Modern Life*, 186.

39. Ibid., 142.

40. This concern comes up repeatedly in Fried's *Manet's Modernism*; see, for instance, the analysis of *The Execution of Maximilian*, 354–60.

41. Fried, *Manet's Modernism*, 405–6.

42. The pioneering work that has been done in the feminist history of art has perhaps been too eager to identify heroes and villains in the art of the past when it comes to representations of women. I have in mind, for instance, Eunice Lipton's championing of Manet-as-feminist in "Manet and Radicalised Female Imagery," *Artforum* 13, no. 7 (March 1975): 48–53, and Griselda Pollock's reading of the gender-specific spaces and activities of modernity in "Modernity and the Spaces of Femininity," in *The Expanding Discourse: Feminism and Art History*, ed. Norma Broude and Mary D. Garrard (New York: HarperCollins, 1992), 245–67.

43. James H. Rubin, *Manet's Silence and the Poetics of Bouquets* (Cambridge: Harvard University Press, 1994).

44. Duret, *Édouard Manet*, 53; or see *Histoire d'Édouard Manet*, 68: "Le visage laissait voir ce type original, qui apparaissait sur les toiles peintes par Manet comme une marque de famille, mais qui constituait précisément une de ces particularités ayant le don d'exaspérer."

45. Paul Mantz, "Exposition du boulevard des Italiens," *Gazette des Beaux-Arts* 14 (15 April 1863): 383; trans. in Cachin et al., *Manet, 1832–1883*, 106.

46. Fried, *Manet's Modernism*, 401.

47. Degas spoke to Daniel Halévy of Manet's use of a

darkened mirror "to gauge values" while painting. Perhaps Manet's use of a mirror as a visual aid went even farther. See *My Friend Degas*, trans. and ed. Mina Curtiss (Middletown, Conn.: Wesleyan University Press, 1964), 94.

48. Alain Clairet, "Le Bracelet de l'Olympia: genèse et destinée d'un chef-d'oeuvre," *L'Oeil* 333 (1983): 36–41.

49. Freud, "A Special Type of Object-Choice Made by Men" (1910), in *Sexuality and the Psychology of Love* (New York: Collier, 1963), 55.

50. *The Complete Letters of Sigmund Freud to Wilhelm Fliess, 1887–1904*, trans. and ed. J. Moussaieff Masson (Cambridge: Belknap Harvard, 1985), 317.

51. Anne Martin-Fugier, "La Bonne," in *Misérable et glorieuse*, 34.

52. Freud to Fliess, "Draft L," enclosed with letter of 2 May 1897, *Complete Letters*, 241.

53. Sander Gilman, "Black Bodies, White Bodies: Toward an Iconography of Female Sexuality in Late Nineteenth-Century Art, Medicine and Literature," *Critical Inquiry* (Autumn 1985), 204–41.

54. See Beatrice Farwell, "Courbet's 'Baigneuses' and the Rhetorical Feminine Image," in *Woman as Sex Object: Studies in Exotic Art, 1730–1970*, ed. Thomas B. Hess and Linda Nochlin, *Art News Annual* 38 (New York: Newsweek, 1972), 67; Linda Nochlin, "The Imaginary Orient," in *The Politics of Vision: Essays on Nineteenth-Century Art and Society* (New York: HarperCollins, 1989), 49.

55. Ann Laura Stoler, *Race and the Education of Desire: Foucault's "History of Sexuality" and the Colonial Order of Things* (Durham: Duke University Press, 1995), 110–11. Stoler here is also invoking the work of Benedict Anderson.

56. Stoler, *Race and the Education of Desire*, 92.

57. See Weston Naef, *The J. Paul Getty Handbook of the Photographs Collection* (Malibu, Calif.: The J. Paul Getty Museum, 1995), 69.

58. In Freud, *Sexuality*, 68.

59. Here, I would like to acknowledge helpful questions raised by Anca Vlasopolos at a Humanities Center symposium, Wayne State University, Detroit, Michigan, 27 October 1995.

60. On sources for *Olympia*, see Reff, *Olympia*, 112–13.

61. Honoré de Balzac, *La Comédie humaine*, preface by Pierre-Georges Castex, notes by Pierre Citron (Paris: Seuil, 1966), 3:209–73.

62. For a complete account of these characters in *La Comédie humaine*, and changes in the characters and structure of the text of the novel, see Anthony R. Pugh, *Balzac's Recurring Characters* (Toronto: University of Toronto Press, 1974), 314–20.

63. Honoré de Balzac, *The Human Comedy: Scenes of Provincial Life*, trans. William Walton (Philadelphia: George Barrie's Sons, 1898), 6:210. Castex edition: "Jamais la duchesse n'avait été si jolie; elle sortit de son bain vêtue comme une déesse,

et voyant Adolphe couché voluptueusement sur des piles de coussins:—Tu es bien beau, lui dit-elle. —Et toi, Olympia? . . . —Tu m'aimes toujours? —Toujours mieux, dit-il. . . —Ah! il n'y a que les français qui sachent aimer! s'écria la duchesse. . . . M'aimeras-tu bien ce soir?" (243–44).

64. Reff, *Olympia*, 112–13.

65. For a detailed analysis of the 1847 seizure and trial of the Fourierist newspaper, *La Démocratie pacifique*, for its *roman-feuilleton*, Antony Méray's *La Part des femmes*, see Jann Matlock, *Scenes of Seduction: Prostitution, Hysteria, and Reading Difference in Nineteenth-Century France* (New York: Columbia University Press, 1994), 202, 220–47.

66. See Balzac's description of the debate in a letter to Mme Hanska, 9 April 1843: *Lettres à Madame Hanska, 1832–1844*, ed. R. Pierrot (Paris: Robert Laffont, 1990), 1:666–67; see also Graham Robb, *Balzac: A Life* (New York: Norton, 1994), 352.

67. Clark, *The Absolute Bourgeois*, 172, 208, n. 105. Clark notes that Balzac figures in Baudelaire's preface on Pierre Dupont, in "L'École païenne," and in both parts of "Du vin et du hachish," as well as in the text invoked here, all from 1851. It should be noted that Balzac had died in 1850.

68. Baudelaire, *Oeuvres complètes*, 297.

69. William Paulson, "De la force vitale au système organisateur: 'La Muse du département' et l'esthétique balzacienne," *Romantisme* 17, no. 55 (1987): 36.

70. Baudelaire, "Les Phares," quoted by Ravenel (see Clark, *Painting of Modern Life*, 140).

71. Bertall's wood engraving was published in *L'Illustration*, 3 June 1865; see Clark, *Painting of Modern Life*, 145, and his translation, 96.

72. Clark, *Painting of Modern Life*, 144.

73. Louis-Marie de Belleyme, *Ordonnances sur requêtes et sur référés, selon la jurisprudence du Tribunal de Première Instance du Département de la Seine, formules et observations*, 3d ed., 2 vols. (Paris: Cousse, 1855), 2:150.

4 MANET PÈRE ET FILS

The Maupassant was first published in *L'Écho de Paris*, 5 January 1889; reprinted in *La Main Gauche* (Paris: Garnier-Flammarion, 1978), 92: "Je te dis tout ça, parce que je te connais bien, mon fils. Ces choses-là on ne les conte pas au public, ni au notaire, ni au curé. Ça se fait, tout le monde le sait, mais ça ne se dit pas, sauf nécessité. Alors, personne d'étranger dans le secret, personne que la famille, parce que la famille c'est tous en un seul. Tu comprends? —Oui, père. —Tu promets? —Oui, père. —Tu jures? —Oui, père. —Je t'en prie, je t'en supplie, fils, n'oublie pas. J'y tiens."

1. *Le Lorgnon* 3 (23 August 1869): 61: "Un homme célèbre vient d'épouser la soeur de sa maîtresse. —Comme cela, a-t-on dit, il va légitimer ses nièces!"

2. Christopher Prendergast, *Balzac: Fiction and Melodrama* (London: Edward Arnold, 1978), ch. 9.

3. Louis Napoleon Bonaparte, or Napoleon III, born 20 April 1808, was the son of Hortense de Beauharnais and Louis Bonaparte, king of Holland and brother to Napoleon. Nine months before his birth, Louis and Hortense were apart, but Louis Napoleon was apparently one month premature, thus it was possible that Louis Bonaparte was his father. At the time, there were proponents of the theory that the Emperor Napoleon was the real father, or that a Dutch admiral named Carel-Hendrik was the father. Louis also accused Hortense of infidelity and sought a divorce in 1809. See David Duff, *Eugénie and Napoleon III* (London: Collins, 1978), 5–7.

4. Higonnet, *Berthe Morisot*, 46.

5. See unnumbered note, above.

6. For a thorough study of legitimation, see Marie-Josèphe Gebler, *Le Droit français de la filiation et la vérité* (Paris: R. Pichon and R. Durand-Auziers, 1970). Key aspects of laws concerning the illegitimate are summarized in Étienne van de Walle, "Illegitimacy in France during the Nineteenth Century," in *Bastardy and Its Comparative History*, ed. P. Laslett, K. Oosterveen, and R. M. Smith (Cambridge: Harvard University Press, 1980), 264–75.

7. Code Napoléon, Articles 331 and 336: "Le mariage seul légitime l'enfant antérieurement reconnu par l'un des conjoints et indiqué par l'acte de naissance comme issu de l'autre, si à cette indication vient se joindre la possession d'état d'enfant de ce conjoint." The concept of "possession d'état" is difficult to translate—it is something like "birthright"—but it involves the establishment of civil status (i.e., name and filiation, with accompanying rights), and it encompassed three elements: *nomen* (the person bears the name of his *état*), *tractatus* (the person's family considers that he possesses the *état*), and *fama* (the person is known by the community as one bearer of the *état*). See Raymond Guillien and Jean Vincent, *Lexique de termes juridiques* (Paris: Dalloz, 1988). For a discussion of the number of "marriages of reparation" in the latter half of the nineteenth century, see van de Walle, "Illegitimacy in France," 270–71.

8. Van de Walle, "Illegitimacy in France," 265.

9. The case was judged first by the civil tribunal, 5 May 1846, and was confirmed by the appeals court 14 December 1846. See Jean-Louis Henri Bertin, *Chambre du conseil en matières civile et disciplinaire*, 2 vols. (Paris: Journal Le Droit, 1853), 1:206–8.

10. *Naissance du code civil*, pref. F. Ewald (Paris: Flammarion, 1989), 230–40.

11. Article 340.

12. Gebler, *Le Droit français*, 437.

13. Dalloz, *Répertoire de législation, de doctrine et de jurispru-dence* (Paris, 1855), vol. 35, "Paternité et filiation," tit. 2, chap. 1, 413: "Comment pénétrer le secret impénétrable de la nature? On comprend qu'il était impossible d'établir la preuve positive du fait mystérieux de la paternité."

14. See, for instance, Rachel Fuchs, *Poor and Pregnant in Paris: Strategies for Survival in the Nineteenth Century* (New Brunswick, N.J.: Rutgers University Press, 1992), 37. She discusses welfare and charity available to single mothers in subsequent chapters.

15. Royer et al., *Juges et notables*, 127.

16. Reproduced in full by the *Journal des curieux* (10 March 1907); by Moreau-Nélaton, *Manet raconté par lui-même*, 1:102–3; and in the Rouart-Wildenstein catalogue, 1:25: "J'institue Suzanne Leenhoff, ma femme légitime, ma légataire universelle. Elle léguera par testament tout ce que je lui ai laissé à Léon Koëlla, dit Leenhoff, qui m'a donné les soins les plus dévoués, et je crois que mes frères trouveront ces dispositions toutes naturelles. Une vente de tableaux [. . .] Sur la somme résultant de la vente de mes tableaux, il sera prélevé une somme de 50,000 francs qui sera donnée à Léon Koëlla, dit Leenhoff. Le reste reviendra à Suzanne Leenhoff, ma femme. [. . .] Si je mourais avant que mes propriétés à Gennevilliers soient réalisées, je désirerais que ma femme continue à vivre avec ma mère. [. . .] Fait à Paris et complètement écrit de ma main le 30 septembre 1882. Édouard MANET. Il est bien convenu que Suzanne Leenhoff, ma femme, laissera par testament à Léon Koëlla, dit Leenhoff, la fortune que je lui ai laissée."

17. See Dalloz, *Jurisprudence générale du recueil périodique* (Paris, 1867), "Filiation naturelle," art. 2, sect. 1.2: "Un mineur a capacité pour reconnaître un enfant naturel."

18. "Les enfants nés hors mariage, autres que ceux nés d'un commerce incestueux ou adultérin, pourront être légitimés par le mariage subséquent de leurs père et mère. . . ." See also articles 335 and 342, or the discussion in Gebler, *Le Droit français,* 415–16.

19. Dalloz, *Répertoire de législation*, "Paternité et filiation," tit. 2, chap. 1, 391: "L'enfant naturel doit le jour à une violation des lois morales sur lesquelles reposent les sociétés; son existence est une protestation sans cesse renouvelée contre la sainteté du mariage; il était donc naturel que les législateurs ne le traitassent point avec la même faveur que les enfants issus d'une union légitime, qu'ils ne lui accordassent pas les mêmes avantages, les mêmes prérogatives."

20. Gebler, *Le Droit français*, 416, 435–37. This would include the right to sue for child support. Interestingly, in legal terms, the child remained "filius nullius," even though he had legal claim to a father and a mother.

21. Ibid., 389.

22. Dalloz, *Jurisprudence générale*, "Filiation adultérine et incestueuse," 10: "La reconnaissance volontaire d'une paternité adul-térine est nulle et, par suite, ne peut profiter à l'enfant reconnu [. . .]."

23. Ibid., 15.

24. Ibid., 16–20.

25. John Rewald, *Paul Cézanne* (New York: Abrams, 1986), 94.

26. Dalloz, *Jurisprudence générale*, "Filiation naturelle," art. 3, sect. 1:67. Following Napoleonic Code, Art. 99, such a substitution fell under the category of "rectifications" in the birth certificate, which did not annul it.

27. Ibid., "Acte de l'État civil," sect. 6:37.

28. Sandra Orienti (cat. 25) dates it 1860; Françoise Cachin, in *Manet, 1832–1883*, believes it may have been done in 1859 (cat. 2).

29. Joel Isaacson, *Manet and Spain: Prints and Drawings*, exh. cat. (Ann Arbor: The Museum of Art, University of Michigan, 1969), 26.

30. Theodore Reff proposed an engraving after this painting as a source for Manet's *Mlle V. . . in the Costume of an Espada*; see "'Manet's Sources': A Critical Evaluation," *Artforum* 8 (September 1969): 41–42.

31. See Boime, *Thomas Couture*.

32. The Louvre exhibition catalogue *Copier, créer* (Paris: Réunion des Musées Nationaux, 1993) affords the possibility of contemplating the nature of student copies in the Louvre, including Manet's copy of Tintoretto, and his indebtedness to Rubens in *La Pêche* (considered in the exhibition as a "fantasy" rather than a strict copy).

33. For an analysis of the studio practice, see Judith Wechsler, "An Apéritif to Manet's 'Déjeuner sur l'herbe,'" *Gazette des Beaux-Arts*, 6th ser., 91 (January 1978): 32–34.

34. Krauss, "Manet's 'Nymph Surprised,'" 627.

35. My argument here contrasts with that of Albert Boime, who groups *Boy with a Sword* with other portraits of Manet's "urchins." See Boime, *Thomas Couture*, 460.

36. Goubert, *The Ancien Régime*, 162.

37. See Dalloz, *Répertoire de législation*, vol. 35, "Paternité et filiation," tit. 2, chap. 1, 410: "Les bâtards non légitimés étaient-ils capables de posséder des dignités de des offices de robe ou d'épée? [. . .] La question était controversée."

38. Some of the proposed sources in Goya and Velázquez are summarized in Cachin et al., *Manet, 1832–1883*, 76.

39. Alain Plessis, *The Rise and Fall of the Second Empire, 1852–1871*, trans. J. Mandelbaum (Cambridge: Cambridge University Press, 1987), 2.

40. Anne M. Wagner, *Jean-Baptiste Carpeaux: Sculptor of the Second Empire* (New Haven: Yale University Press, 1986), 190–91. The imperial prince was born in 1856.

41. Clark, *Painting of Modern Life*, especially chaps. 2 and 4.

42. Although this was Manet's earlier title for the work, it was exhibited at the Salon of 1869 under its present title, *Le Balcon*.

43. Moreau-Nélaton, *Manet raconté par lui-même*, 1:12.

44. Tabarant, *Manet et ses oeuvres*, 223.

45. Registre Leenhoff, Bibliothèque Nationale, Cabinet des Estampes, Paris, Yb3 4649 8° Rés. A microfilm copy of the register exists at the Pierpont Morgan Library, New York, which comple- ments the Tabarant collection of Manet's albums of Godet and Lochard photographs of his works. See microfilm frames P189976 and P190455.

46. This is one of many cases in the Registre Leenhoff in which Léon names himself in his annotations to a photograph of the painting: "Mlle Eva Gonzalès [. . .] et Leenhoff en costume d'espagnol est assis sur le coin d'une table." Microfilm of the BN document, frame P190025. Léon dates the painting 1869–70.

47. Jacques de Caso, "Une fuente del hispanismo de Manet," *Goya* 68 (September–October, 1965): 94–97. The article appeared in French in the *Bulletin de la Société d'Études pour la Connaissance d'Édouard Manet* 2 (January 1968): 1–13.

48. Beatrice Farwell, "Manet's 'Espada' and Marcantonio," *Metropolitan Museum Journal* 2 (1969): 200–202.

49. X-radiographic study by H. F. von Sonnenberg of the Bayerische Staatsgemäldesammlungen, Munich, referred to in Cachin et al., *Manet, 1832–1883*, 290–94.

50. For instance, Steven Kovács, "Manet and His Son in 'Déjeuner dans l'atelier,'" *Connoisseur* 181 (November 1972): 196–202; also his Ph.D. qualifying paper, Harvard University, Fine Arts Library.

51. Clark proposes a possible narrative reading of the studio in a paper given at the 1983 Manet symposium at the Metropolitan Museum of Art, New York, in conjunction with the 1983 retrospective exhibition.

52. See Raquel Da Rosa, "Still Life and the Human Subject in Mid-19th-Century France," Ph.D. diss., Columbia University, 1994; see also her "Manet and the Modernist Still-life," in *Natura Naturata (An Argument for Still Life)* (New York: Josh Baer Gallery, 1989).

53. See Dalloz, *Répertoire de législation*, vol. 35, "Paternité et filiation," tit. 2, chap. 1, 411: "C'était une règle généralement admise que les bâtards, considérés comme étrangers dans leur famille, ne *succédaient* point à leurs parents."

54. Duranty, "Notes sur la vie nocturne," 537: "Où cet état de vague et d'indétermination devient encore plus frappant, plus déroutant, c'est quand il s'applique aux personnes et aux choses *connues* qui semblent nous apparaître dans le rêve. Or, quelle que soit ici l'illusion des gens qui rêvent, jamais les personnes ni les choses *connues* ne nous apparaissent exactes, identiques. Nos amis, nos parents, les lieux que nous habitons n'ont dans le songe aucune ressemblance avec les êtres et les objets réels. Cependant notre esprit les accepte pour tels."

55. Jules-Antoine Castagnary, *Le Siècle*, 11 June 1869, 3: "Que fait ce jeune homme du *Déjeuner*, qui est assis au premier plan et qui semble regarder le public [. . .] où est-il? Dans la salle à manger?"

56. Ibid.: "Mais le sentiment des fonctions, mais le sentiment de la convenance sont choses indispensables. Ni l'écrivain, ni le peintre ne les peuvent supprimer. Comme les personnages dans

une comédie. . . ."

57. Jean-Paul, *Gazette de France*, 17–18 May 1869, 2: "Et pourtant le peinture d'*Olympia* et de son chat semble avoir laboricusement fouillé dans les bas-fonds de la laideur humaine pour en extraire la figure affligeante qu'il nous montre au premier plan de son *Déjeuner*."

58. Armand Silvestre, *La Revue Moderne* 53 (1869): 156: "Et le *Déjeuner*! A vrai dire, rien n'est moins intéressant que ce grand jobard vêtu à la mode, et qui aurait bien mieux fait de rester dans le plat d'hîtres [sic] dont il semble s'échapper que de prendre une forme humaine. Mais les accessoires qui surchargent la chaise constitutent une nature morte d'une inconcevable vérité."

59. Arthur Baignières, *La Revue Contemporaine* 104 (31 May 1869): 263: "*Déjeuner*, c'est un jeune homme fort mal élevé qui garde sur sa tête un chapeau de paille et qui s'assied dans une assiette d'huîtres. Singulière façon de les manger! avouez-le. Il n'y a pas à dire que le repas soit fini, les huîtres sont là béantes, faisant office de coussin."

60. Maupassant, "Hautot père et fils," in *La main gauche*, 99.

61. André Green, "Oedipus, Freud, and Us," in *Psychoanalytic Approaches to Literature and Film*, trans. C. Coman, ed. M. Chasney and J. Reppen (London, Ontario: Associated University Press, 1987), 230.

62. Foucault, *The History of Sexuality: An Introduction*, 108–9.

63. For a full account, see "Mme la baronne Dudevant (George Sand) contre son mari, Tribunal civil de la Châtre, 1836," in Louis Michel de Bourges, *Plaidoyers et discours*, ed. Louis Martin (Paris: Dunod and Pinat, 1909), 133–49. The work refers to the account published in *Le Droit* (134).

64. As carried in *Le Temps*; see especially 26–27 February 1867.

65. Michael Paul Driskel examines the various philosophical and theological currents in circulation around Renan in "Manet, Naturalism, and the Politics of Christian Art," *Arts* 60, no. 3 (November 1985): 44–54. See also Driskel's *Representing Belief: Religion, Art, and Society in Nineteenth-Century France* (University Park: Pennsylvania State University Press, 1992).

66. See, for instance, Jennifer M. Sheppard, "The Inscription in Manet's 'The Dead Christ with Angels,'" *Metropolitan Museum Journal* 16 (1981):199–200.

67. Jane Mayo Roos ("Édouard Manet's 'Angels at the Tomb of Christ': A Matter of Interpretation," *Arts* 58, no. 8 [April 1984]: 86) discusses the precise moment depicted and the liberties taken with the Gospel text.

68. Ibid.

69. Linda Nochlin, *Realism* (New York: Penguin, 1971), 82.

70. Of course, we should keep in mind that the 1877 portraits of Faure were commissioned.

71. Didier Anzieu, *Freud's Self-Analysis*, trans. P. Graham (London: Hogarth, 1986), 245. Anzieu is, of course, analyzing Freud's interest in *Hamlet* and his famous slip, in which Hamlet murders "Laertes" rather than Polonius.

72. Alfred Maury, *Histoire des religions de la Grèce antique*, 3 vols. (Paris: Ladrange, 1857–59), 1:307. Maury also asserts that Laius, father of Oedipus, appeared to have been the first pederast in Greek literature; however, he does not discuss the details of Laius's rape of Chrysippus as the original event that brought on the famous curse of Laius's son (3:38). This aspect of the myth is discussed in Laura Mulvey, "The Oedipus Myth: Beyond the Riddles of the Sphinx," in *Visual and Other Pleasures* (Bloomington: Indiana University Press, 1989), 197–200.

73. The critic's name and address appear in Manet's address book, now in the Bibliothèque Nationale, Paris, Cabinet des Estampes, Yb3.2401, in octavo.

74. Xavier Ambryet, *Les Jugements nouveaux*. (Paris: Bourdilliat, 1860), 174. Ambryet is referring to a study of *Hamlet* which had appeared in the *Revue des Deux Mondes*. "Hamlet est le représentant le plus complet de la fatalité moderne, comme Oedipe est le plus complet représentant de la fatalité antique."

75. Ibid., 175.

76. David Solkin, "Philibert Rouvière: Édouard Manet's 'L'Acteur tragique,'" *Burlington Magazine* 117 (November 1975): 702–9. Rouvière died 19 October 1865, before Manet finished the painting.

77. As his well-known letter to Baudelaire indicates; see *Lettres à Charles Baudelaire*, ed. Claude Pichois (Neuchâtel, 1973), 233–34. It is from another letter to Baudelaire dated 27 March 1866 (238–39) that we know it was Manet's intention to paint Rouvière as Hamlet but to name the painting *L'Acteur tragique* to avert criticism for lack of verisimilitude.

78. Gautier, *Le Moniteur Universel*, 13 February 1865: "cette horreur sacrée en face de la tâche imposée par le spectre paternel."

79. See Eric Darragon, *Manet* (Paris: Citadelles, 1991), 159, and "Recherches sur la conception du sujet," 304–14.

80. Pichois and Ziegler, *Baudelaire*, 250–85.

81. Baudelaire's letter to the editor-in-chief of *Le Figaro* appears in the *Oeuvres complètes*, 647–48. Guizot's *Shakspeare et son temps. Étude littéraire* [sic] (Paris: Didier, 1876) was first published in 1852.

82. The telegram was sent 19 April 1864. See, for instance, Louis Lapeyre's front-page article in *Le Courrier du Dimanche*, 1 May 1864. The article refers to an uproar in foreign newspapers over the telegram and its timing after the 18 April victory.

83. *La Nouvelle Galérie des artistes dramatiques vivants*, 61st fasc., 1856, cited in Baudelaire, *Oeuvres complètes*, 443: "Voilà une vie agitée et tordue, comme ces arbres, le grenadier, par exemple,—noueux, perplexes dans leur croissance, qui donnent des fruits compliqués et savoureux, et dont les orgueilleuses et rouges floraisons ont l'air de raconter l'histoire d'une sève longtemps comprimée."

84. Henry Houssaye, *Revue des Deux Mondes*, 15 June 1877, 838: "Le portrait de M. Faure en costume d'Hamlet, figure plaquée, sans proportion, sans relief, sans air, sans vie, et qui n'est pas d'aplomb sur ses jambes, démontre définitivement l'inanité du prétendu tempérament de M. Manet et l'insuffisance de ses études premières. Ce portrait ridicule clôt la nombreuse série des portraits à sensation au Salon de 1877."

85. "The work of a hallucinating person," as cited in Darragon, *Manet*, 269.

86. E. Onimus, "La Psychologie médicale dans les drames de Shakspeare [sic]," *Revue des Deux Mondes*, 1 April 1876, 636: "'Mon père! Il me semble que je le vois par l'oeil de mon âme,' dit Hamlet à Horatio, donnant ainsi en quelques mots la définition le plus courte et la plus exacte de l'hallucination."

87. Phillipe Burty, *La République Française* (26 May 1877). Also quoted in Darragon, *Manet*, 269: "M. Faure, l'épée à la main, s'élance vers le fantôme qui est censément du côté même du spectateur, disposition ingénieuse et théâtrale."

88. Charles S. Moffett, in Cachin et al., *Manet, 1832–1883*, 407.

5 THE PROMISES OF A FACE

Manet's letter of 26 August, 1868; Moreau-Nélaton, *Manet raconté par lui-même*, 1:103: "Je suis de votre avis: les demoiselles Morisot sont charmantes. C'est fâcheux qu'elles ne soient pas des hommes." I am following Juliet Wilson-Bareau's translation: *Manet by Himself*, 49. The quotation attributed to Flaubert appears in *The Letters of Gustave Flaubert, 1830–1857*, ed. and trans. Francis Steegmuller, 234.

1. Yule Heibel made the suggestion at the Department of Prints, Harvard University Art Museums.

2. This idea, which I explored somewhat differently in my Ph.D. dissertation (Harvard University, 1992), might be contrasted with Carol Armstrong's contention that Victorine Meurent was the alter ego of Édouard Manet. See her "Manet/Manette: Encoloring the I/Eye," *Stanford Humanities Review* 2, nos. 2–3 (Spring 1992), 3, 35–40. She develops the idea that Meurent was a kind of "studio persona" in "To Paint, to Point, to Pose: Manet's 'Le Déjeuner sur l'herbe'" in *Manet's "Le Déjeuner sur l'herbe,"* ed. Tucker, especially 100–102.

3. The quoted passages are from Higonnet, *Berthe Morisot*, 55; Brombert, *Rebel*, 244; and Marni Reva Kessler, "Unmasking Manet's Morisot," *Art Bulletin* 81, no. 3 (September 1999): 477–78; see also her "Sheer Material Presence, or the Veil in Late-Nineteenth-Century French Avant-Garde Painting" (Ph.D. diss., Yale University, 1996), 116–18.

4. For a fuller consideration of this period in the artist's work, see Deborah Ann Gribbon, "Édouard Manet: The Development of His Art Between 1868 and 1876" (Ph.D. diss., Harvard University, 1982).

5. Although Margaret Shennan questions the idea that Manet met Morisot only in 1868, and not earlier, there is no evidence to the contrary. It makes sense that the context for Manet's letter to Fantin quoted in the epigraph would have been a recent introduction, not a reacquaintance or a comment made about a long-standing friendship. See *Berthe Morisot: First Lady of Impressionism* (Thrupp, Stroud, Gloucestershire: Sutton Publishing Limited, 1996), 289–91. This book is interesting as a fleshed-out narrative of Morisot's life; many of its claims must be aproached with care, however, as there are numerous inaccuracies and exaggerations.

6. See the letter of 13 August 1869 to her sister Edma, in *Correspondance de Berthe Morisot avec sa famille et ses amis Manet, Puvis de Chavannes, Degas, Monet, Renoir, and Mallamé,* ed. Denis Rouart (Paris: Quatre-Chemins-Editart, 1950), 33, or *The Correspondence of Berthe Morisot with Her Family and Her Friends Manet, Puvis de Chavannes, Degas, Monet, Renoir, and Mallamé,* ed. Denis Rouart, trans. Betty W. Hubbard (London: Lund Humphries, 1959), 38.

7. Tabarant, *Manet et ses oeuvres*, 153.

8. Cachin, *Manet, 1832–1883*, 304. Joel Isaacson notes the connection to the Goya painting in *Manet and Spain*, 12.

9. Moreau-Nélaton, *Manet raconté par lui-même*, 1:105.

10. See, for instance, Kessler, "Unmasking Manet's Morisot," 473. I would also like to acknowledge some thoughtful comments on this subject made by John Klein.

11. Brombert, *Rebel*, 261–69, 314–22; and Shennan, *First Lady*, 136–38.

12. As Morisot wrote to Edma: "ce que j'y vois le plus clairement, c'est que mon état est insoutenable à tous les points de vue" (*Correspondance*, 73; trans. Hubbard, 78). On her melancholy and apparent anorexia, see her mother's letter of 22 March 1870 (*Correspondance*, 38; trans. Hubbard, 42–43).

13. Morisot gave to her brother Tiburce the following account of her marriage to Eugène: "[J']ai trouvé un honnête et excellent garçon, et qui je crois, m'aime sincèrement. Je suis entrée dans le positif de la vie après avoir vécu bien longtemps de chimères qui ne me rendaient pas bien heureuse" (*Correspondance*, 80; trans. Hubbard, 84). See also discussion in Shennan, *First Lady*, 157, 159.

14. See the letter to his mother in *Lettres du Siège de Paris, précédées des lettres du voyage à Rio de Janeiro* (Vendôme: Éditions de l'Amateur, 1996), 23. "[P]our l'Européen quelque peu artiste elle offre un cachet tout particulier; on ne rencontre dans la rue que des nègres et des négresses; les Brésiliens sortent peu et les Brésiliennes encore moins; on ne les voit que lorsqu'elles vont à la messe ou le soir après le dîner; elles se mettent à leurs fenêtres; il est alors permis de les regarder tout à votre aise, car dans le jour si

par hasard elles sont à leurs fenêtres et qu'elles s'aperçoivent qu'on les regarde elles se retirent aussitôt."

15. Mona Hadler, "Manet's 'Woman with a Parrot' of 1866," *Metropolitan Museum Journal* 7 (1973): 122.

16. Armstrong, "Manet/Manette," 21, 28–29.

17. The Gavarni woodcut from the heyday of the *physiologie* dates from 1840–42. See Novelene Ross, *Manet's "Bar at the Folies-Bergère" and the Myths of Popular Illustration* (Ann Arbor, Mich.: UMI Research Press, 1982), 48–49. The play mentioned is Eugène Labiche, "Le Perroquet d'une vieille fille," *Étude de moeurs: la clef des champs*, 2d ed. (Paris: G. Roux, 1839), especially 78–98.

18. This aspect of the drawing was exaggerated by caricaturists in 1868.

19. Hadler notes the possibility that she is dressing for, or coming home from, a ball; "Manet's 'Woman with a Parrot,'" 121.

20. Michael Fried's work on Manet is of critical importance on the subject of self-consciousness and the gaze; see *Manet's Modernism*. See also Armstrong, "To Paint, to Point," 111–12, in which she writes that "Victorine is not much of an object to solicit the gaze; instead, it is as if she *is* the gaze itself, in female form."

21. See Paul Valéry, "La Triomphe de Manet," in *Exposition Manet, 1832–1883* (Paris: Éditions des Musées Nationaux, 1932), 23–25.

22. Baronne Staffe, *Les Hochets féminins: les pierres précieuses, les bijoux, la dentelle, la broderie, l'éventail, quelques autres superfluités* (Paris: Flammarion, 1902), 291.

23. Beatrice Farwell, "Manet, Morisot, and Propriety," *Perspectives on Morisot*, ed. T. J. Edelstein (New York: Hudson Hills Press, 1990), 55.

24. Higonnet, *Berthe Morisot*, 55.

25. Kessler, "Unmasking Manet's Morisot," 475.

26. Ibid., 475, 479–81, and Kessler, "Sheer Material Presence," 93–137; see especially 125.

27. Kessler, "Unmasking Manet's Morisot," 481. As Julie Manet, Morisot's daughter, recalled of one of her mother's sittings for Édouard: "Ce jour-là mon oncle Édouard dit à Maman qu'elle devrait épouser Papa et lui en parle très longuement" (*Julie Manet, Journal [1893–1899]: sa jeunesse parmi les peintres impressionnistes et les hommes de lettres* [Paris: Librairie C. Klincksieck, 1979], 74–75; *Growing Up with the Impressionists: The Diary of Julie Manet*, trans., ed., intro. Rosalind de Boland Roberts and Jane Roberts [New York: Sotheby's Publications, 1987], 79). On Manet's other acts of encouragement toward Eugène's courtship of Morisot, see also Shennan, *First Lady*, 137–38, and Brombert, *Rebel*, 285–86.

28. Higonnet, *Berthe Morisot*, 55.

29. Laura Mulvey, originally published in *Screen* 16, no. 3 (Autumn 1975): 6–18; I am using the reprint in *Art after Modernism: Rethinking Representation*, ed. Brian Wallis (New York and Boston: New Museum of Contemporary Art and David R. Godine, 1984), 361–73.

30. Jacques Lacan, *Four Fundamental Concepts of Psycho-Analysis*, ed. J.-A. Miller, trans. A. Sheridan (New York: W. W. Norton, 1981), 182.

31. Ibid., 192.

32. Ibid.

33. Ibid., 193. Joan Rivière's essay "Womanliness as a Masquerade" was first published in *The International Journal of Psychoanalysis* 10 (1929); see also the reprint in *Formations of Fantasy*, ed. Victor Burgin et al., 35–44.

34. Carol Armstrong, "Facturing Femininity: Manet's 'Before the Mirror,'" *October* 74 (Fall 1995): 75–104.

35. Ibid., 98.

36. Jean Clay, "Ointments, Makeup, Pollen," *October* 27 (Winter 1983): 3–44. For Mallarmé, see "The Impressionists and Édouard Manet," *Art Monthly Review* 1, no. 9 (30 September 1876) and "Le Jury de peinture pour 1874 et M. Manet," in *Oeuvres complètes* (Paris: Gallimard, 1945), especially 698.

37. Baudelaire, "Le peintre de la vie moderne," *Oeuvres complètes*, 561–63.

38. Armstrong, "Facturing Femininity," 90, 100.

39. For Mallarmé's pseudonymous writings (as "Marguerite de Ponty," "Ix," "Une dame créole," etc.) in the publication he founded, *La Dernière Mode: Gazette du Monde et de la Famille*, see the *Oeuvres complètes*, 707–847. My thanks to Charles Stivale for help on this matter.

40. Freud, "On Narcissism: An Introduction," *Standard Edition*, 14:85. An excellent discussion of narcissism can be found in Gutmann, "À propos de la représentation de Narcisse," 33–72. Gutmann's account is both a discussion of the theory of narcissism and a thorough psychoanalytic and art-historical treatment of Poussin's *Narcissus*.

41. Freud, *Standard Edition*, 14:94.

42. Jean Clay, "Ointments, Makeup, Pollen," 24–25.

43. Higonnet, *Berthe Morisot*, 56 and 225, ch. 5, n. 2. As Higonnet notes, early buyers included Caillebotte, Durand-Ruel, Duret, and Manet's physician, Dr. de Bellio.

44. Michel Leiris, "Le 'Caput Mortuum' ou la femme de l'alchemiste," *Documents* 2, no. 8 (1930): 26.

45. My language here is almost a paraphrase of Tony Tanner, *Adultery in the Novel*, 368: "Apparently complicit with the sanctity of the family, the centrality of marriage, and the authority of the Father, the novel has, in fact, in many cases harbored and deviously celebrated quite contrary feelings. Very often the novel writes of contracts but dreams of transgressions, and in reading it, the dream tends to emerge more powerfully."

46. Higonnet, *Berthe Morisot*, 92.

47. Farwell, "Manet, Morisot"; Higonnet, *Berthe Morisot*, 107.

48. Morisot, letter to Edma, 27 February 1871, *Correspondance*, 48, trans. Hubbard ["changing his uniform"], 52. See also the discussion in Brombert, *Rebel*, 281.

49. Trans. Wilson-Bareau, *Manet by Himself*, 51; Proust, *Manet: souvenirs*, 38.

50. "Je n'ai, grand Dieu, pas besoin de me défendre et de craindre mes succès ici; je suis étonnée de passer aussi inaperçue que je le fais; c'est la première fois que cela m'arrive aussi complètement. Le côté commode c'est que, n'étant jamais regardée, je trouve inutile de faire des frais de toilette" (Morisot, letter to Cornélie Morisot, *Correspondance*, 70, trans. Hubbard, 74).

51. Sartre, *Being and Nothingness*, 302.

52. David Halperin cogently analyzes Foucault's distinction between desire and pleasure in *Saint Foucault: Towards a Gay Hagiography* (New York: Oxford University Press, 1995), 94–96. I am also indebted to Kenji Yoshino for sharing his thoughts on the subject.

CONCLUSION

1. Anne M. Wagner, "Why Monet Gave Up Figure Painting," 628.

2. Dianne Pitman, *Bazille: Purity, Pose, and Painting in the 1860s* (University Park: Pennsylvania State University Press, 1998), 83–85.

3. Ibid., 87–88; 159.

4. Kermit Swiler Champa, "A Complicated Codependence," in *Monet and Bazille: A Collaboration*, exh. cat., ed. David A. Brenneman (Atlanta and New York: High Museum of Art and Harry N. Abrams, 1999), 76. Champa's analysis of Bazille's self-preservation in letters and in friendships with other artists is highly nuanced regarding Bazille's "self-feminizing" strategies.

5. Richard A. Kaye, "Losing His Religion: Saint Sebastian as Contemporary Gay Martyr," in *Outlooks: Lesbian and Gay Sexualities and Visual Cultures*, ed. Peter Horne and Reina Lewis (New York: Routledge, 1996), 86–105. The author provides evidence that by the later nineteenth century, representations of St. Sebastian generated an "ungovernable set of meanings" as they became "subcultural icons" (88). Kaye makes the distinction between a reading-into the image and a public discourse about homosexuality, a separate matter. Pitman is right to quote Whitney Davis that "it is an open question whether 'homosexuality' [. . .] can be identified in the homoeroticism of earlier periods" (*Bazille*, 254, n. 25); however, it is precisely the homoeroticism of Bazille's images that Pitman downplays.

6. Pitman, *Bazille*, 189.

7. Ibid., 156, 254, n. 25.

8. Foucault, "What is Enlightenment?" in *Essential Works*, 1:312.

9. Ibid., 1:309.

10. Halperin, *Saint Foucault*, 106.

11. James Miller, *The Passion of Michel Foucault* (New York: Doubleday Anchor, 1993), 357.

12. Michel Foucault, "Different Spaces," in *Essential Works*, 2:175–96, and "Afterward to 'The Temptation of Saint Anthony,'" in the same volume, 103–22. I am also invoking Michael Fried's central argument in *Manet's Modernism*.

13. Miller, *The Passion*, 358.

14. Joan Copjec, *Read My Desire: Lacan against the Historicists* (Cambridge, Mass.: MIT Press, 1995).

15. Baudelaire, *Oeuvres complètes*, 616.

16. On period artists' biographies, see Petra ten-Doesschate Chu, "The Construction of Childhood in Nineteenth-Century Artists' Biographies," in Brown, ed., *Between Rousseau and Freud*.

17. See my "Baudelaire's 'La Corde' as a Figuration of Manet's Art," in Brown, ed., *Between Rousseau and Freud*.

BIBLIOGRAPHY

Additional archival sources are cited in endnotes

Ackerman, Gerald M. "Gérome and Manet." *Gazette des Beaux-Arts*, 6th ser., 70 (September 1967): 163–76.

Adler, Kathleen. *Manet.* Oxford: Phaidon, 1986.

Adler, Laure. *Secrets d'alcôve: histoire du couple de 1830 à 1930.* Paris: Hachette, 1983.

Adorno, Theodor W. *Aesthetic Theory.* Ed. Gretel Adorno and Rolf Tiedemann. Trans. and ed. Robert Hullot-Kentor. Minneapolis: University of Minnesota Press, 1997.

Allem, Maurice. *La Vie quotidienne sous le Second Empire.* Paris: Librairie Hachette, 1948.

D'Alméras, Henri. *La Vie parisienne sous le Second Empire.* Paris: Albin Michel, 1933.

Alpers, Svetlana. "Describe or Narrate? A Problem in Realistic Representation." *New Literary History* 8, no. 1 (Autumn 1976): 15–42.

———. *The Art of Describing: Dutch Art in the Seventeenth Century.* Chicago: University of Chicago Press, 1983.

Alston, David. "What's in a Name? 'Olympia' and a Minor Parnassian." *Gazette des Beaux-Arts* 91 (April 1978): 148–54.

Althusser, Louis. *Lenin and Philosophy.* Trans. B. Brewster. New York: Monthly Review Press, 1971.

———. *The Future Lasts Forever: A Memoir.* Ed. O. Corpet and Y. Moulier Boutang. Trans. R. Veasey. New York: New Press, 1993.

Ambryet, Xavier. *Les Jugements nouveaux.* Paris: Bourdilliat, 1860.

Anderson, Wayne. "Manet and the Judgment of Paris." *Art News* 72, no. 2 (February 1973): 63–69.

L'Annuaire de la cour impériale de l'ordre judiciaire de l'empire français. Ed. B. Warée. Paris, 1859.

Anzieu, Didier. *Freud's Self-Analysis.* Trans. P. Graham. London: Hogarth Press, 1986.

Apter, Emily. "Splitting Hairs: Female Fetishism and Postpartum Sentimentality in the Fin de Siècle." In *Eroticism and the Body Politic*, ed. Lynn Hunt. Baltimore: Johns Hopkins University Press, 1991.

Aretz, Gertrude. *The Elegant Woman from the Rococo Period to Modern Times.* London: Harrap, 1932.

Ariès, Philippe. *Histoire des populations françaises et de leurs attitudes devant la vie depuis le XVIIIe siècle.* Paris: Self, 1948.

Armstrong, Carol. "Manet/Manette: Encoloring the I/Eye." *Stanford Humanities Review* 2, nos. 2–3 (Spring 1992): 1–46.

———. "Facturing Femininity: Manet's 'Before the Mirror.'" *October* 74 (Fall 1995): 75–104.

———. "To Paint, to Point, to Pose: Manet's 'Le Déjeuner sur l'herbe.'" In *Manet's "Le Déjeuner sur l'herbe,"* ed. Paul H. Tucker, 90–118. New York: Cambridge University Press, 1998.

Aron, Jean-Paul, and Roger Kempf. *Le Pénis et la démoralisation de l'Occident.* Paris: Grasset, 1978.

Art after Modernism: Rethinking Representation. Ed. Brian Wallis. New York and Boston: New Museum of Contemporary Art and David R. Godine, 1984.

Asselineau, Charles. *Le Paradis des gens de lettres.* Paris: Poulet-Malassis, 1862.

Astruc, Zacharie. "Le Salon des Refusés." *Le Salon* (20 May 1863): 5.

Audéod, Alphonse. "Exposition de 1863." *La Revue Indépendante* (1 July 1863): 763.

———. "Salon de 1864." *La Revue Indépendante* (1 July 1864): 768.

———. "Salon de 1865." *La Revue Indépendante* (1 July 1865): 720–21, 758.

Babou, Hippolyte. "Les Dissidents de l'Exposition." *Revue Libérale* 2 (1867): 284–89.

Baignières, Arthur. "Le Salon de 1879." *Gazette des Beaux-Arts*, 2d ser., 19 (1 June 1879): 549–72.

Baillarger, Jules. Review of *Le Sommeil et les rêves*, by Alfred Maury. *Annales Médico-Psychologiques*, 3d ser., 8 (April 1862): 350–60.

———. "Du principe et du caractère des hallucinations: ancienne discussion à la Société Médico-Psychologique. MM. Buchez, Peisse, A. Garnier, Sandras, Baillarger, Gerdy, H. de Castelnau, Bourdin, Parchappe, Delasiauve, etc." *Journal de Médecine Mentale* 2 (1862): 171–86; 237–49; 297–306.

———. "Théorie de l'automatisme." In *Recherches sur les maladies mentales*, vol. 1. Paris: G. Masson, 1890.

Bain, A. "Les Idées de Darwin sur l'expression." *La Revue Scientifique*, 2d ser., 4a, no. 19 (7 November 1874): 433–41.

Ball, B. *La Folie érotique*. Paris: Baillière, 1888.

Balzac, Honoré de. *The Human Comedy: Scenes of Provincial Life*. Trans. William Walton. Philadelphia: George Barrie's Sons, 1898.

———. *Oeuvres complètes*. Paris: Plon, 1965.

———. *La Comédie humaine*. Preface by Pierre-Georges Castex. Notes by Pierre Citron. Paris: Seuil, 1966.

———. *Lettres à Madame Hanska*, 1832–1844. Ed. R. Pierrot. Paris: Robert Laffont, 1990.

Bareau, Juliet Wilson. See Wilson-Bareau, Juliet.

Barrell, John. *The Infection of Thomas de Quincey: A Psychopathology of Imperialism*. New Haven: Yale University Press, 1991.

Barsakaya, Anna. "Édouard Manet's Painting 'Nymph and Satyr' on Exhibition in Russia in 1861." In *Omagiu lui George Opresxu, cu prilejul implinirii a 80 de ani*. Bucharest, 1961.

Barthes, Roland. *L'Obvie et l'obtus: essais critiques III*. Paris: Seuil, 1982.

———. "The Reality Effect." In *The Rustle of Language*, trans. Richard Howard. New York: Hill and Wang, 1986.

Bataille, Georges. *Manet*. Lausanne: Skira, 1955.

Baticle, Jeannine, and Cristina Marinas. *La Galerie espagnole de Louis-Philippe au Louvre, 1838–1848*. Paris: Réunion des Musées Nationaux, 1981.

Baudelaire, Charles. *Correspondance générale*. Ed. Jacques Crépet. 6 vols. Paris: Conard, 1948.

———. *Oeuvres complètes*. Ed. Marcel A. Ruff. Paris: Seuil, 1968.

———. *Paris Spleen*. Trans. Louise Varèse. New York: New Directions, 1970.

———. *Lettres à Charles Baudelaire*. Ed. Claude Pichois. Neuchâtel, 1973.

———. *Correspondance*. Ed. Claude Pichois with Jean Ziegler. 2 vols. Paris: Gallimard, 1973.

———. *Artificial Paradise: On Hashish and Wine as Means of Expanding Individuality*. Trans. Ellen Fox. New York: Herder and Herder, 1971.

Béguin, Albert. *L'ame romantique et le rêve: essai sur le romantisme allemand et la poésie française*. 3d ed. Paris: J. Corti, 1939 [1937].

Belleyme, Louis-Marie de. *Ordonnances sur requêtes et sur référés, selon la jurisprudence du Tribunal de la Première Instance du Département de la Seine, formules et observations*. 3d ed. Vol. 2. Paris: Cousse, 1855.

Benjamin, Walter. *Charles Baudelaire: A Lyric Poet in the Era of High Capitalism*. Trans. Harry Zohn. New York: Verso, 1985.

Berg, W. J., G. Moskos, and M. Grimaud. *Saint/Oedipus: Psychocritical Approaches to Flaubert's Art*. Ithaca: Cornell University Press, 1982.

Bernard, Claude. "Phénomènes de la vie communs aux animaux et aux végétaux." *La Revue Scientifique*, 2d ser., 4a, no. 13 (26 September 1874): 289–95.

Bertin, Jean-Louis Henri. *Chambre du conseil en matières civile et disciplinaire*. 2 vols. Paris: Journal Le Droit, 1853.

Binet, M. A. "L'image consécutive et le souvenir visuel." *La Revue Scientifique*, 3d ser., 24 (12 December 1885): 805–8.

Blampignon, E. A. Review of *Du plaisir et de la douleur*, by Francisque Bouillier. *Le Correspondant*, 25 November 1866.

Blanc, Charles. *Histoire des peintres de toutes les écoles*. 14 vols. Paris, 1861–78.

Blanc, Étienne. *Traité de la contrefaçon en tous genres et de sa poursuite en justice*. 4th ed. Paris: Plon, 1855.

Blanche, Jacques-Émile. *Essais et portraits*. Paris: Bibliophiles Fantaisistes, 1912.

———. *Manet*. Paris: Éditions Rieder, 1924.

Boas, C. van Emde. "Le Geste d'Olympia." *In Livre jubilaire offert au Dr. Jean Dalsace, par ses amis, ses collègues et ses élèves*. Paris: Masson, 1966.

Boime, Albert. *Thomas Couture and the Eclectic Vision*. New Haven: Yale University Press, 1980.

Bomford, David, Jo Kirby, John Leighton, and Ashok Roy. *Art in the Making: Impressionism*. Exh. cat. New Haven: The National Gallery, London, with Yale University Press, 1990.

Bonnet, Gérard. *Voir—être vu: études cliniques sur l'exhibitionnisme*. 2 vols. Paris: Presses Universitaires de France, 1981.

Borch-Jacobsen, Mikkel. *The Freudian Subject*. Trans. C. Porter. Stanford: Stanford University Press, 1988.

Bouillier, Francisque. *Du plaisir et de la douleur*. Paris: Baillière, 1865.

Bouillon, Jean-Paul. "Manet vu par Bracquemond." *La Revue de l'Art* 27 (1975): 37–45.

Bowie, Malcolm. *Psychoanalysis and the Future of Theory*. Cambridge, Mass.: Blackwell, 1993.

Bowness, Alan. "A Note on Manet's Compositional Difficulties." *Burlington Magazine* 103 (June 1961): 276–77.

Brayer, F. *Dictionnaire général de police administrative et judiciaire*. 2d ed. 4 vols. Paris: Brayer, n.d.

Brierre de Boismont, A.J.F. *Des hallucinations, ou histoire raisonnée des apparitions, des visions, des songes, de l'extase, du magnétisme et du somnambulisme*. Paris: Baillière, 1852.

———. *A History of Dreams, Visions, Apparitions, Ecstasy, Magnetism, and Somnambulism*. 1st American ed. Philadelphia: Lindsay and Blakiston, 1853.

———. "Études psychologiques sur les hommes célèbres: Shakespeare." *Annales Médico-Psychologiques*, 4th ser., 12 (November 1868): 329–45.

Brillat-Savarin, A. *Physiologie du goût*. Brussels, 1839.

Brombert, Beth Archer. *Édouard Manet: Rebel in a Frock Coat*. New York: Little, Brown and Company, 1996.

Brown, Marilyn R. "Manet's 'Old Musician': Portrait of a Gypsy and Naturalist Allegory." *Studies in the History of Art* 8 (1978): 77–87.

———. *Gypsies and Other Bohemians: The Myth of the Artist in 19th-Century France*. Ann Arbor: UMI Research Press, 1985.

Bryson, Norman. *Vision and Painting: The Logic of the Gaze*. New Haven: Yale University Press, 1983.

Bürger, W. (Théophile Thoré). *Salons de W. Bürger, 1861 à 1868*. 2 vols. Paris, 1870.

Bulletin des lois de l'empire français. 9th ser., no. 15. Paris, 1860.

Burckhardt, Jacob. *Der Cicerone: Eine Anleitung zum Genuß der Kunstwerke Italiens*. Basel: Schweighauser'sche Verlagsbuchhandlung, 1855.

Burty, Philippe. "Édouard Manet." *La République Française*, 3 May 1883.

Butor, Michel. *Histoire extraordinaire: essai sur un rêve de Baudelaire*. Paris: Gallimard, 1961.

Cachin, Françoise, et al. *Manet, 1832–1883*. Exh. cat. Paris and New York: Réunion des Musées Nationaux and The Metropolitan Museum of Art, 1983.

Carlier, Félix. *Les Deux Prostitutions: étude de pathologie sociale*. Paris: Dentu, 1887.

Caso, Jacques de. "Una fuente del hispanismo de Manet." *Goya* 68 (September–October 1965): 94–97.

Castagnary, Jules. *Salons (1857–1870)*. 2 vols. Paris, 1892.

Champa, Kermit Swiler. *Studies in Early Impressionism*. New Haven: Yale University Press, 1973.

———. *"Masterpiece" Studies: Manet, Zola, Van Gogh, and Monet*. University Park: Pennsylvania State University Press, 1994.

———. "A Complicated Codependence." In *Monet and Bazille: A Collaboration*, exh. cat., ed. David A. Brenneman, 67–95. Atlanta and New York: High Museum of Art and Harry N. Abrams, 1999.

Chappuis, Adrien. *The Drawings of Paul Cézanne: A Catalogue Raisonné*. London: Thames and Hudson, 1973.

Chasseguet-Smirgel, Janine. *Sexuality and Mind: The Role of the Father and Mother in the Psyche*. New York: New York University Press, 1986.

Chavette, Eugène. "Histoire invraisemblable, mais véridique, de Modeste Asile." *Le Figaro*, 9 June 1864.

Chesneau, Ernest. "Le Salon des Refusés." *Le Constitutionnel*, 19 May 1863.

———. *L'Art et les artistes modernes en France et en Angleterre*. Paris, 1864.

Chevalier, Louis. *Laboring Classes and Dangerous Classes in Paris during the First Half of the Nineteenth Century*. Trans. F. Jellinek. Princeton: Princeton University Press, 1973.

Chevallier, Émile. *Les Salaires au XIXe siècle*. Paris: Rousseau, 1887.

Chu, Petra ten-Doesschate. *French Realism and the Dutch Masters: The Influence of Dutch Seventeenth-Century Painting on the Development of French Painting between 1830 and 1870*. Utrecht: Haentjens Dekker & Gumbert, 1975.

Clairet, Alain. "Le Bracelet de l'Olympia: genèse et destinée d'un chef-d'oeuvre." *L'Oeil* 333 (1983): 36–41.

Clark, T. J. *Image of the People: Gustave Courbet and the 1848 Revolution*. Princeton: Princeton University Press, 1982 [1973].

———. *The Absolute Bourgeois: Artists and Politics in France, 1848–1851*. Princeton: Princeton University Press, 1982 [1973].

———. *The Painting of Modern Life: Paris in the Art of Manet and His Followers*. New York: Knopf, 1984.

———. *Farewell to an Idea: Episodes from a History of Modernism*. London: Yale University Press, 1999.

Clay, Jean. "Onguents, fards, pollens." In *Bonjour Monsieur Manet*, exh. cat., 6–24. Paris: Musée National d'Art Moderne, 1983.

———. "Ointments, Makeup, Pollen." *October* 27 (Winter 1983): 3–44.

Clayson, Hollis. "The Representation of Prostitution in France during the Early Third Republic." Ph.D. diss., University of California at Los Angeles, 1984.

———. *Painted Love: Prostitution in French Art of the Impressionist Era*. New Haven: Yale University Press, 1991.

Clej, Alina. *A Genealogy of the Modern Self: Thomas de Quincey and the Intoxication of Writing*. Stanford: Stanford University Press, 1995.

Cler, Albert. *Physiologie du musicien*. Paris, c. 1841–43.

Cohan, Steven, and Linda M. Shires. *Telling Stories: A Theoretical Analysis of Narrative Fiction*. New York: Routledge, 1988.

Collins, Bradford R. "Manet's 'Luncheon in the Studio': An Homage to Baudelaire." *Art Journal* 38 (Winter 1978–79): 107–13.

———, ed. *Twelve Views of Manet's "Bar."* Princeton: Princeton University Press, 1996.

Conférence de législation et d'économie politique de 1839. Paris: Lacour et Maistrasse, 1843.

Conférences historiques faites pendant l'année 1865. Paris: Baillière, 1866.

Copier, créer: de Turner à Picasso: 300 oeuvres inspirées par les maîtres du Louvre. Exh. cat. Paris: Réunion des Musées Nationaux, 1993.

Copjec, Joan. *Read My Desire: Lacan against the Historicists*. Cambridge, Mass.: MIT Press, 1995.

Corbin, Alain. *Les Filles de noce: misère sexuelle et prostitution aux 19e et 20e siècles*. Paris: Aubier Montaigne, 1978.

———. "La Prostituée." In *Misérable et glorieuse: la femme du XIXe siècle*, ed. J.-P. Aron. Brussels: Éditions Complexe, 1984.

———. *Women for Hire: Prostitution and Sexuality in France after 1850*. Trans. Alan Sheridan. Cambridge: Harvard University Press, 1990.

Corradini, Giovanni [Juan]. "La 'Nymphe surprise' de Manet et les Rayons X." *Gazette des Beaux-Arts*, 6th ser., 54 (September 1959): 149–54.

———. *Édouard Manet: La Ninfa Sorprendida*. Buenos Aires, 1983.

Courthion, Pierre, and Pierre Cailler, eds. *Manet raconté par lui-même et par ses amis*. 2 vols. Geneva, 1948.

Crary, Jonathan. "Unbinding Vision." *October* 68 (Spring 1994): 21–44.

Crouzet, Marcel. *Un méconnu du Réalisme: Duranty (1833–1880)*. Paris: Nizet, 1964.

Crow, Thomas. "Modernism and Mass Culture in the Visual Arts." In *Pollock and After: The Critical Debate*, ed. Francis Frascina. New York: Harper and Row, 1985.

———. "Codes of Silence: Historical Interpretation and the Art of Watteau." *Representations* 12 (Fall 1985): 2–14.

———. *Painters and Public Life in Eighteenth-Century Paris*. New Haven: Yale University Press, 1985.

Curtiss, Mina. "Manet Caricatures: Olympia." *Massachusetts Review* 7 (1966): 725–52.

———. "Letters of Édouard Manet to His Wife during the Siege of Paris: 1870–71." *Apollo* 113, no. 232 (June 1981): 378–89.

Dalloz, Édouard. *Receuil périodique de jurisprudence de législation et de doctrine*. Paris, 1847.

———. *Répertoire de législation, de doctrine et de jurisprudence*. Paris, 1855.

———. *Jurisprudence générale du recueil périodique*. Paris, 1867.

Damisch, Hubert. *The Judgment of Paris*. Trans. J. Goodman. Chicago: University of Chicago Press, 1996.

Dangin, Édouard. "Le Spectacle de Paris: les cheveux." *Le Camarade* (21 January 1867): 2.

Darnton, Robert. *Mesmerism and the End of the Enlightenment in France*. Cambridge: Harvard University Press, 1968.

Da Rosa, Raquel. "Manet and the Modernist Still-life." In *Natura Naturata (An Argument for Still Life)*. New York: Josh Baer Gallery, 1989.

———. "Still Life and the Human Subject in Mid-19th-Century France." Ph.D. diss., Columbia University, 1994.

Darragon, Eric. "Recherches sur la conception du sujet dans l'oeuvre d'Édouard Manet (1832–1883)." Thesis, Université de Paris IV/Sorbonne, 1987.

———. *Manet*. Paris: Fayard, 1989.

———. *Manet*. Paris: Citadelles, 1991.

Davis, Whitney. "Determined Interpretation: Sigmund Freud's Drawing of the Dream of the Wolves." Lecture, Harvard University, 10 March 1992.

Dechambre, A. "Analyse de l'ouvrage du docteur Szafkowski, sur les hallucinations." *Gazette Médicale* (1850): 274.

De Grummond, Nancy. "Giorgione's 'Tempest': The Legend of St. Theodore." *L'Arte* 18–20 (1972): 5–53.

Delestre, J.-B. *De la physiognomie*. Paris: Renouard, 1866.

De Quincey, Thomas. *The Collected Writings of Thomas De Quincey*. Ed. D. Masson. Edinburgh: Adam and Charles Black, 1890.

Derrida, Jacques. *Writing and Difference*. Trans. Alan Bass. Chicago: University of Chicago Press, 1978.

———. *The Post Card: From Socrates to Freud and Beyond*. Trans. Alan Bass. Chicago: University of Chicago Press, 1988.

Descuret, J.-B.-F. *La Médecine des passions, ou les passions considérées dans leurs rapports avec les maladies, les lois et la religion*. 3d ed. 2 vols. Paris: Labé, 1860.

Dolan, Therese. "Skirting the Issues: Manet's Portrait of 'Baudelaire's Mistress Reclining.'" *Art Bulletin* 79, no. 4 (December 1997): 611–29.

Driskel, Michael Paul. "Manet, Naturalism, and the Politics of Christian Art." *Arts* 60, no. 3 (November 1985): 44–54.

———. *Representing Belief: Religion, Art, and Society in Nineteenth-Century France*. University Park: Pennsylvania State University Press, 1992.

Du Camp, Maxime. *Paris: ses organes, ses fonctions et sa vie dans la seconde moitié du dix-neuvième siècle*. 6 vols. Paris, 1869–75.

Duff, David. *Eugénie and Napoleon III*. London: Collins, 1978.

Dupêchez, Charles. *Marie d'Agoult, 1805–1876*. 2d ed. Paris: Plon, 1994.

Duranty, Edmond. "Notes sur la vie nocturne." *Nouvelle Revue de Paris* 6 (1 November 1864): 534–58.

———. "Le Sommeil et les rêves." *Musée Universel* 2 (1873): 218–20.

———. "La Nouvelle Peinture." In *The New Painting: Impressionism 1874–1886*, ed. C. S. Moffett et al. Seattle: University of Washington Press, 1986 [essay 1876].

Duret, Théodore. *Histoire d'Édouard Manet et de son oeuvre*. 4th ed. Paris: Bernheim-Jeune, 1926.

Echard, William E. *Napoleon III and the Concert of Europe*. Baton Rouge: Louisiana State University Press, 1983.

Ellenberger, Henri F. *The Discovery of the Unconscious*. New York: Basic Books, 1970.

Étienne, Louis. *Le Jury et les exposants: Salon des Refusés*. Paris, 1863.

Farr, Dennis, and John House. *Impressionist and Post-Impressionist Masterpieces: The Courtauld Collection*. New Haven: Yale University Press, 1987.

Farwell, Beatrice. "Manet's 'Espada' and Marcantonio." *Metropolitan Museum Journal* 2 (1969): 197–202.

———. "Courbet's 'Baigneuses' and the Rhetorical Feminine Image." In *Woman as Sex Object: Studies in Erotic Art, 1730–1970*, ed. Thomas B. Hess and Linda Nochlin, 64–79. *Art News Annual* 38. New York: Newsweek, 1972.

———. "Manet's 'Nymphe surprise.'" *Burlington Magazine* 117 (April 1975): 224–29.

———. *The Cult of Images: Baudelaire and the 19th-Century Media Explosion*. Santa Barbara: UCSB Museum, 1977.

———. *Manet and the Nude*. New York: Garland, 1981.

———. "Manet, Morisot, and Propriety." In *Perspectives on Morisot*, ed. T. J. Edelstein. New York: Hudson Hills, 1990.

Felman, Shoshana. *What Does a Woman Want? Reading and Sexual Difference*. Baltimore: Johns Hopkins University Press, 1993.

Ferenczi, Sándor. "Social Considerations in Some Analyses." *International Journal of Psycho-Analysis* 4 (1923): 475–78.

Ferenczi, Sándor. *First Contributions to Psycho-Analysis*. London: Hogarth Press, 1951.

Fine, Amy M. "Portraits of Berthe Morisot: Manet's Modern Images of Melancholy." *Gazette des Beaux-Arts*, 6th ser., 110 (July–August 1987): 17–20.

Fisher, Jay McKean. *The Prints of Édouard Manet*. Washington, D.C.: The International Exhibitions Foundation, 1985.

Flammarion, Camille. *Dieu dans la nature*. Paris: Didier, 1867.

Flaubert, Gustave. *Correspondance, 1850–1859*. Paris: Club de l'Honnête Homme, 1974.

———. *The Letters of Gustave Flaubert, 1830–1857*. Ed. and trans. Francis Steegmuller. 2 vols. Cambridge: Belknap Harvard, 1980.

———. *Sentimental Education*. Trans. R. Baldick. New York: Penguin, 1984.

———. *L'Éducation sentimentale*. Paris: Flammarion, 1985.

Flescher, Sharon. *Zacharie Astruc: Critic, Artist and Japonist*. New York: Garland, 1978.

Förster, Ernst. *Handbuch für Reisende in Italien*. Munich, 1840.

———. *Manuel du voyageur en Italie*. 4th ed., rev. Munich, 1850.

Foucault, Michel. *This is not a pipe*. Trans. James Harkness. Berkeley: University of California Press, 1982.

———. *The History of Sexuality: An Introduction*. Trans. R. Hurley. New York: Vintage/Random House, 1990.

———. *The Essential Works of Michel Foucault, 1954–1984*. Ed. Paul Rabinow. New York: New Press, 1997– .

Les Français peints par eux-mêmes. 9 vols. Paris: L. Curmer, 1840–42.

Frascina, F., and C. Harrison, eds. *Modern Art and Modernism*. New York: Harper and Row, 1985.

Frémy, Arnould. *Les Moeurs de notre temps*. Paris: Bourdilliat, 1861.

Freud, Sigmund. *The Standard Edition of the Complete Psychological Works*. Trans. James Strachey. 24 vols. London: Hogarth Press, 1953–74.

———. *Sexuality and the Psychology of Love*. Ed. Philip Rieff. Reprint. New York: Collier, 1963.

———. *The Complete Letters of Sigmund Freud to Wilhelm Fliess, 1887–1904*. Ed. and trans. Jeffrey Moussaieff Masson. Cambridge: Belknap Harvard, 1985.

Fried, Michael. *Three American Painters: Kenneth Noland, Jules Olitski, Frank Stella*. Exh. cat. Cambridge, Mass.: Fogg Art Museum, 1965.

———. "Manet's Sources: Aspects of His Art, 1859–1865." *Artforum* 7 (March 1969): 28–82.

———. "Painting Memories: On the Containment of the Past in Baudelaire and Manet." *Critical Inquiry* 10 (March 1984): 510–42.

———. "Courbet's Femininity." In *Reconsidering Courbet*, exh. cat., ed. Sarah Faunce and Linda Nochlin. New York: Brooklyn Museum, 1988.

———. *Courbet's Realism*. Chicago: University of Chicago Press, 1990.

———. *Manet's Modernism, or, The Face of Painting in the 1860s*. Chicago: University of Chicago Press, 1996.

Fuchs, Rachel. *Poor and Pregnant in Paris: Strategies for Survival in the Nineteenth Century*. New Brunswick, N.J.: Rutgers University Press, 1992.

Galligan, Gregory. "The Self Pictured: Manet, the Mirror, and the Occupation of Realist Painting." *Art Bulletin* 80, no. 1 (March 1998): 139–71.

Garber, Marjorie. "Fetish Envy." *October* 54 (Fall 1990): 45–56.

Gautier, Théophile. "Salon de 1868." *Le Moniteur Universel*, 11 May 1868.

Gebler, Marie-Josèphe. *Le Droit français de la filiation et la vérité*. Paris: R. Pichon and R. Durand-Auziers, 1970.

Gennevilliers. *Exposition Gennevilliers à travers les âges*. Ville de Gennevilliers: Imprimerie Gutenberg, 1953.

Gennevilliers: notice historique et renseignements administratifs. Montévrain: Imprimerie Typographique de l'École d'Alembert, 1898.

Gilman, Sander L. "Black Bodies, White Bodies: Toward an Iconography of Female Sexuality in Late-Nineteenth-Century Art, Medicine and Literature." *Critical Inquiry* (Autumn 1985): 204–41.

Girard, René. *Deceit, Desire, and the Novel*. Trans. Yvonne Freccero. Baltimore: Johns Hopkins University Press, 1965.

———. *Things Hidden since the Foundation of the World*. Stanford: Stanford University Press, 1987.

Girault, Abbé. "La Vente des biens nationaux dans les coëvrons sarthois." *Bulletin de la Société d'Agriculture, Science et Arts de la Sarthe*, 3d ser., 9, fasc. 1. Le Mans, 1941.

Gleyses, Chantal. *La Femme coupable: petite histoire de l'épouse adultère au XIXe siècle*. Paris: Imago, 1994.

Goedorp, Jacques L. "La Fin d'une légende: l'Olympia n'était pas montmartroise." *Journal de l'Amateur d'Art* (23 February 1967): 7.

Goldstein, Jan. *Console and Classify: The French Psychiatric Profession in the Nineteenth Century*. New York: Cambridge University Press, 1987.

Goncourt, Edmond de, and Jules de Goncourt. *Journal: mémoires de la vie littéraire*. 4 vols. Paris, 1956.

Gonzague-Privat. "Le Salon de 1874." *L'Événement*, 22 May 1874.

Goubert, Pierre. *The Ancien Régime: French Society, 1600–1750*. Trans. Steve Cox. New York: Harper and Row, 1974.

Gowing, Lawrence. *Cézanne: The Early Years, 1859–1872*. London: Royal Academy of Arts, 1988.

Granveau, Antoine. *La Prostitution dans Paris*. Paris, 1867.

Green, André. "Oedipus, Freud, and Us." In *Psychoanalytic Approaches to Literature and Film*. Trans. C. Coman. London, Ont.: Associated University Press, 1987.

Greenberg, Clement. *Art and Culture: Critical Essays*. Boston: Beacon Press, 1961.

Gribbon, Deborah Ann. "Édouard Manet: The Development of His Art Between 1868 and 1876." Ph.D. diss., Harvard University, 1982.

Grinstein, A. *On Sigmund Freud's Dreams*. Detroit: Wayne State University Press, 1963.

Guillien, Raymond, and Jean Vincent. *Lexique de termes juridiques*. Paris: Dalloz, 1988.

Guizot, François. *Shakspeare et son temps. Étude littéraire* [sic]. New ed. Paris: Didier, 1876.

Gutmann, Annie. "À propos de la représentation de Narcisse chez Poussin." In *Miroirs, visages, fantasmes*, ed. A. Fognini et al. Lyons: Éditions C.L.E., 1988.

Hadler, Mona. "Manet's 'Woman with a Parrot' of 1866." *Metropolitan Museum Journal* 7 (1973): 115–22.

Halévy, Daniel. *My Friend Degas*. Trans. and ed. Mina Curtiss. Middletown, Conn.: Wesleyan University Press, 1964.

Hall, Melissa. "Manet's 'Ball at the Opera': A Matter of Response." *Rutgers Art Review* 5 (Spring 1984): 28–45.

Halperin, David M. *Saint Foucault: Towards a Gay Hagiography*. New York: Oxford University Press, 1995.

Hamilton, George Heard. *Manet and His Critics*. New Haven: Yale University Press, 1954.

Hanson, Anne Coffin. *Édouard Manet, 1832–1883*. Exh. cat. Philadelphia Museum of Art, 1966.

———. "Manet's Subject Matter and a Source of Popular Imagery." *Museum Studies, Art Institute of Chicago* 3 (1969): 63–80.

———. "Popular Imagery and the Work of Édouard Manet." In *French Nineteenth-Century Painting and Literature*, ed. U. Finke, 133–63. Manchester: Manchester University Press, 1972.

———. *Manet and the Modern Tradition*. New Haven: Yale University Press, 1977.

Harris, Jean C. *Édouard Manet: Graphic Works, a Definitive Catalogue Raisonné*. New York: Collectors Editions Limited, 1970.

Harsin, Jill. *Policing Prostitution in Nineteenth-Century Paris*. Princeton: Princeton University Press, 1985.

Heraeus, Stefanie. *Traumvorstellung und Bildidee: Surreale Strategien in der französischen Graphik des 19. Jahrhunderts*. Berlin: Reimer, 1998.

Higonnet, Anne. "The Other Side of the Mirror." In *Perspectives on Morisot*, ed. T. J. Edelstein. New York: Hudson Hills, 1990.

———. *Berthe Morisot*. New York: Harper and Row, 1990.

Hoffman, Joseph. "Édouard Manet e il linguaggio corporeo." *Rivista di Psicologia dell'Arte* 6, nos. 10–11 (1984): 39–58.

Hofmann, Werner. *Das Irdische Paradies: Kunst im neunzehnten Jahrhundert*. Munich: Prestel-Verlag, 1960.

———. *The Earthly Paradise in the Nineteenth Century*. Trans. B. Battershaw. New York: George Braziller, 1961.

Holberton, Paul. "Giorgione's 'Tempest' or 'Little Landscape with the Storm with the Gypsy': More on the Gypsy, and a Reassessment." *Art History* 18, no. 3 (September 1995): 383–403.

Hopp, Gisela. *Édouard Manet: Farbe und Bildgestalt*. Berlin: De Gruyter, 1968.

Hornig, Christian. *Giorgiones Spätwerk*. Munich: W. Fink, 1987.

Houssaye, Henry. "Le Salon de 1877." *Revue des Deux Mondes* (15 June 1877).

Howard, Seymour. "Early Manet and Artful Error: Foundations of Anti-Illusionism in Modern Painting." *Art Journal* 37 (Fall 1977): 14–21.

Huard, Adrien, and Édouard Mack. *Répertoire de législation, de doctrine et de jurisprudence en matière de propriété littéraire et artistique.* New ed. Paris: Marchal et Billard, 1895.

Hutton, John. "The Clown at the Ball: Manet's Masked Ball at the Opera and the Collapse of Monarchism in the Early Third Republic." *Oxford Art Journal* 10, no. 2 (1987): 76–94.

Hyslop, Lois B., ed. *Baudelaire as a Love Poet and Other Essays.* University Park: Pennsylvania State University Press, 1969.

Isaacson, Joel. *Manet and Spain: Prints and Drawings.* Exh. cat. Ann Arbor: The Museum of Art, University of Michigan, 1969.

———. *Monet: Le Déjeuner sur l'Herbe.* New York: Viking, 1972.

Iskin, Ruth E. "Selling, Seduction, and Soliciting the Eye: Manet's 'Bar at the Folies-Bergère.'" *Art Bulletin* 77, no. 1 (March 1995): 25–44.

Izalguier. "L'Art et la réalité." *La Revue Fantaisiste* 1 (1 May 1861): 351–58.

Jamot, Paul, and Georges Wildenstein. *Manet.* 2 vols. Paris: Les Beaux-Arts, 1932.

Jeanniot, Georges. "En Souvenir de Manet." *La Grande Revue* 46 (10 August 1907): 844–60.

Jedlicka, Gotthard. *Édouard Manet.* Erlenbach-Zurich: Eugen Rentsch Verlag, 1941.

Johnson, Barbara. *Défigurations du langage poétique.* Paris: Flammarion, 1979.

Joigneaux, P. *Almanach d'un paysan pour 1850.* Paris: Pillon, 1849.

Joubert, Pierre-Charles. *Le Parfait Jardinier-Potager.* Paris: Arnault de Vresse, 1867.

Jouffroy, Théodore. "Des facultés de l'âme humaine" [1828]. In *Mélanges philosophiques.* 4th ed. Paris: Hachette, 1866.

Jourdan, Aleth, Dianne W. Pitman, and Didier Vatuone. *Frédéric Bazille et ses amis impressionnistes.* Exh. cat. Montpellier: Musée Fabre et Réunion des Musées Nationaux, 1992.

Jousset, Pierre. "De la nature de l'aliénation et de la division naturelle de la folie en formes distinctes." *Annales Médico-Psychologiques* 5 (January–June 1865): 239–44.

Jouve, Pierre Jean. *Le Tombeau de Baudelaire.* Paris: Seuil, 1958.

Kaplan, Linda Joan. "The Concept of the Family Romance." *Psychoanalytic Review* 61, no. 2 (1974): 169–202.

Kaye, Richard A. "Losing His Religion: Saint Sebastian as Contemporary Gay Martyr." In *Outlooks: Lesbian and Gay Sexualities and Visual Cultures,* ed. Peter Horne and Reina Lewis, 86–105. New York: Routledge, 1996.

Kessler, Marni Reva. "Sheer Material Presence, or the Veil in Late-Nineteenth-Century French Avant-Garde Painting." Ph.D. diss., Yale University, 1996.

———. "Unmasking Manet's Morisot." *Art Bulletin* 81, no. 3 (September 1999): 473–89.

Kinney, Leila. "Genre: A Social Contract?" *Art Journal* 46, no. 4 (Winter 1987): 267–77.

Kovács, Steven. "Manet and His Son in 'Déjeuner dans l'atelier.'" *Connoisseur* 181 (November 1972): 196–202.

Krauss, Rosalind E. "Manet's 'Nymph Surprised.'" *Burlington Magazine* 109, no. 776 (November 1967): 622–27.

Krell, Alan. "Manet, Zola, and the 'Motifs d'une exposition particulière,' 1867." *Gazette des Beaux-Arts,* 6th ser., 99 (March 1982): 109–15.

———. "*Manet's Déjeuner sur l'herbe* in the Salon des Refusés: A Re-Appraisal." *Art Bulletin* 65, no. 2 (June 1983): 316–20.

Krumrine, Mary Louise. "Parisian Writers and the Early Work of Cézanne." In *Cézanne: The Early Years, 1859–1872.* Cat. by L. Gowing. London: Royal Academy, 1988.

Labiche, Eugène. "Le Perroquet d'une vieille fille." In *Étude de moeurs: la clef des champs.* 2d ed. Paris: G. Roux, 1839.

Lacan, Jacques. *Écrits.* Trans. A. Sheridan. New York: Norton, 1977.

———. *Four Fundamental Concepts of Psycho-Analysis.* Ed. J.-A. Miller. Trans. A. Sheridan. New York: W. W. Norton, 1981.

———. *Les Complexes familiaux dans la formation de l'individu.* Dijon: Navarin, 1984.

———. *The Seminar of Jacques Lacan, Book I: Freud's Papers on Technique, 1953–1954.* Ed. J.-A. Miller. Trans. J. Forrester. New York: Norton, 1988.

———. *The Seminar of Jacques Lacan, Book II: The Ego in Freud's Theory and in the Technique of Psychoanalysis, 1954–1955.* Ed. J.-A. Miller.

Trans. S. Tomaselli, with notes by J. Forrester. New York: Norton, 1988.

Lacan, Jacques. *Le Séminaire, Livre IV: La relation d'objet, 1955–1956.* Paris: Éditions du Seuil, 1994.

Lajer-Burcharth, Ewa. "Modernity and the Condition of Disguise: Manet's 'Absinthe Drinker.'" *Art Journal* 45, no. 1 (Spring 1985): 18–26.

Laplanche, Jean, and Jean-Bertrand Pontalis. *The Language of Psycho-Analysis.* Trans. D. Nicholson-Smith. New York: Norton, 1973.

———. "Fantasy and the Origins of Sexuality." In *Formations of Fantasy,* ed. Victor Burgin, James Donald, and Cora Kaplan. New York: Routledge, 1986.

Lasègue, Charles. "Les Exhibitionistes." *L'Union Médicale* 50 (1 May 1877): 709–19.

Lecaye, Henri. *Le Secret de Baudelaire.* Cahors: Jean Michel Place, 1991.

Lecomte-Hilary, Anne. "L'Artiste de tempérament chez Zola et devant la public: essai d'analyse lexicologique et semiologique." *In Émile Zola and the Arts,* ed. J.-M. Guieu and A. Hilton. Washington, D.C.: Georgetown University Press, 1988.

Lecour, C. J. *La Prostitution à Paris et à Londres, 1789–1871.* 2d ed. Paris: P. Asselin, 1872.

———. *De l'état actuel de la prostitution parisienne.* Paris: P. Asselin, 1874.

Leenhoff, Léon. "Copie faite pour Moreau-Nélaton de documents sur Manet appartenant à Léon Leenhoff." Cabinet des Estampes, Yb3. 2401 /80, Bibliothèque Nationale, Paris.

Legeay, Fortuné. *Nécrologie et bibliographie contemporaine de la Sarthe, 1844–1880.* Le Mans: Leguicheux-Gallienne, 1881.

Legouvé, Ernest. *Histoire morale des femmes.* 3d ed. Paris: Dentu, 1856.

Legrand du Saulle. "Le Somnambulisme naturel." *Annales Médico-Psychologiques,* 4th ser., no. 1 (1863): 87–99.

Lehrman, P. R. "The Fantasy of Not Belonging to One's Family." *Archives of Neurology and Psychiatry* 18 (1927): 1015–23.

Leiris, Alain de. "Manet's 'Christ Scourged' and the Problem of His Religious Paintings." *Art Bulletin* 41, no. 2 (June 1959): 198–201.

———. "Manet, Guéroult and Chrysippos." *Art Bulletin* 46, no. 3 (September 1964): 401–4.

———. *The Drawings of Édouard Manet.* Berkeley: University of California Press, 1969.

———. "Édouard Manet's 'Mlle V. in the Costume of an Espada': Form-Ideas in Manet's Stylistic Repertory: Their Sources in Early Drawing Copies." *Arts* 53 (January 1979): 112–17.

Leiris, Michel. "Le 'Caput Mortuum' ou la femme de l'alchemiste." *Documents* 2, no. 8 (1930): 21–26.

Lélut, Louis-François. *Du démon de Socrate: spécimen d'une application de la science psychologique à celle de l'histoire.* Paris: Baillière, 1836 and revised 1856.

———. *L'Amulette de Pascal: pour servir à l'histoire des hallucinations.* Paris: Baillière, 1846.

———. "Mémoire sur le sommeil, les songes, et le somnambulisme." *Annales Médico-Psychologiques* 2d ser., no. 4 (1852): 331–63.

Lenk, Elisabeth. *Die unbewußte Gesellschaft.* Munich: Matthes and Seitz, 1983.

Lewin, Bertram. "Sleep, the Mouth, and the Dream Screen." In *Selected Writings,* ed. Jacob A. Arlow. New York: Psychoanalytic Quarterly, 1973.

Limet, Charles. *Un vétéran du barreau parisien: quatre-vingts ans de souvenirs, 1827–1907.* Paris: Lemerre, 1908.

Lipton, Eunice. "Manet and Radicalised Female Imagery." *Artforum* 13, no. 7 (March 1975): 48–53.

———. *Alias Olympia: A Woman's Search for Manet's Notorious Model and Her Own Desire.* New York: Charles Scribner's Sons, 1992.

Locke, Nancy. "New Documentary Information on Manet's 'Portrait of the Artist's Parents.'" *Burlington Magazine* 133, no. 1057 (April 1991): 249–52.

———. "More on Giorgione's 'Tempesta' in the Nineteenth Century." *Burlington Magazine* 138, no. 1120 (July 1996): 464.

———. "Manet's 'Le Déjeuner sur l'herbe' as a Family Romance." In *Manet's "Le Déjeuner sur l'herbe,"* ed. Paul H. Tucker, 119–51. New York: Cambridge University Press, 1998.

Le Lorgnon, Journal d'Aurélien Scholl. Paris, 1869.

Mainardi, Patricia. *Art and Politics of the Second Empire: The Universal Expositions of 1855 and 1867.* New Haven: Yale University Press, 1987.

Maisonneuve, J.G.T. *Traité pratique des maladies vénériennes.* Paris: Labé, 1853.

Mallarmé, Stéphane. "The Impressionists and Édouard Manet." Trans. George T. Robinson. *Art Monthly Review and Photographic Portfolio* 1, no. 9 (30 September 1876): 117–22.

———. "Le Jury de peinture pour 1874 et M. Manet." In *Oeuvres complètes*. Paris: Gallimard, 1945.

Manet, Édouard. *Lettres de jeunesse: voyage à Rio, 1848–49*. Paris: Louis Rouart et fils, 1928.

———. *Lettres du Siège de Paris, précédées des lettres du voyage à Rio de Janeiro*. Vendôme: Éditions de l'Amateur, 1996.

Manet, Eugène. *Victimes!* Clamecy: Straub, 1889.

Manet, Julie. *Journal (1893–1899): sa jeunesse parmi les peintres impressionnistes et les hommes de lettres*. Paris: Librairie C. Klincksieck, 1979.

Mantz, Paul. "Exposition du boulevard des Italiens." *Gazette des Beaux-Arts* 14, no. 4 (1 April 1863): 381–84.

Martin, Laurent. *Les Dangers de l'amour de la luxure et du libertinage*. Paris: Libigre-Duquesne, 1865.

Martineau, Louis. *La Prostitution clandestine*. Paris: Delahaye, 1885.

Martin-Fugier, Anne. "La Bonne." In *Misérable et glorieuse: la femme du XIXe siècle*, ed. J. P. Aron. Brussels: Éditions Complexe, 1984 [1980].

Masson, Jeffrey Moussaieff. *The Assault on Truth: Freud's Suppression of the Seduction Theory*. New York: Farrar Straus Giroux, 1984.

Mathey, Jacques. *La Succession de Mme Veuve Édouard Manet*. Exh. cat. Paris: Editart, 1964.

Matlock, Jann. *Scenes of Seduction: Prostitution, Hysteria, and Reading Difference in Nineteenth-Century France*. New York: Columbia University Press, 1994.

Mauner, George. *Manet: Peintre-Philosophe: A Study of the Painter's Themes*. University Park: Pennsylvania State University Press, 1975.

Maupassant, Guy de. "Hautot père et fils." *L'Écho de Paris*, 5 January 1889.

———. *La Main Gauche*. Reprint. Paris: Garnier-Flammarion, 1978.

———. *Le Horla et autres contes cruels et fantastiques*. Paris: Garnier, 1989.

Maury, Alfred. "Nouvelles observations sur les analogies des phénomènes du rêve et de l'aliénation mentale." *Annales Médico-Psychologiques*, 2d ser., 5 (1853): 404–21.

———. "De certains faits observés dans les rêves." *Annales Médico-Psychologiques*, 3d ser., 3 (1857): 157–76.

———. *Histoire des religions de la Grèce antique*. 3 vols. Paris: Ladrange, 1857–59.

———. *Le Sommeil et les rêves: études psychologiques sur ces phénomènes*. Paris: Didier, 1861.

McCauley, Elizabeth Anne. *Industrial Madness: Commercial Photography in Paris, 1848–1871*. New Haven: Yale University Press, 1994.

Meier-Graefe, Julius. *Édouard Manet*. Munich, 1912.

Melot, Michel. *L'Estampe impressioniste*. Paris: Bibliothèque Nationale, 1974.

Mesnet, Ernest. *De l'automatisme de la mémoire et du souvenir dans le somnambulisme pathologique*. Paris, 1874.

Michel de Bourges, Louis. *Plaidoyers et discours*. Ed. Louis Martin. Paris: Dunod and Pinat, 1909.

Michiel, Marcantonio. *Notizia d'opere di disegno . . . scritta da un anonimo morelliano*. Bassano: Iacopo Morelli, 1800.

———. *The Anonimo: Notes on Pictures and Works of Art in Italy Made by an Anonymous Writer in the Sixteenth Century*. Trans. P. Mussi. Ed. George C. Williamson. London: George Bell and Sons, 1903.

Miller, James. *The Passion of Michel Foucault*. New York: Doubleday Anchor, 1993.

Milner, Max. *La Fantasmagorie: essai sur l'optique fantastique*. Paris: Presses Universitaires de France, 1982.

Monselet, Charles. "Les Refusés, ou les héros de la contre-exposition," *Le Figaro*, 24 May 1863.

Morassi, Antonio. *Giorgione*. Milan, 1942.

Moreau de Tours, Jacques Joseph. *Du hachish et de l'aliénation mentale, études psychologiques*. Paris: Masson, 1845.

———. *Hashish and Mental Illness*. Trans. Gordon J. Barnett. Ed. Helene Peters and Gabriel G. Nahes. New York: Raven Press, 1973.

Moreau-Nélaton, Étienne. *Manet raconté par lui-même*. 2 vols. Paris, 1926.

Morisot, Berthe. *Correspondance de Berthe Morisot avec sa famille et ses amis Manet, Puvis de Chavannes, Degas, Monet, Renoir, and Mallarmé*. Ed. Denis Rouart. Paris: Quatre-Chemins-Editart, 1950.

Mulvey, Laura. *Visual and Other Pleasures*. Bloomington: Indiana University Press, 1989.

Münsch, Lucien. *Répertoire général des circulaires et instructions du Ministère de la Justice*. Paris: Laroir, 1900.

Naef, Weston. *The J. Paul Getty Handbook of the Photographs Collection*. Malibu, Calif.: The J. Paul Getty Museum, 1995.

Naissance du code civil. Preface by F. Ewald. Paris: Flammarion, 1989.

Naquet, Alfred. *Religion, propriété, famille*. Paris: Chez Tous Les Librairies, 1869.

Needham, Gerald. "Manet's 'Olympia' and Pornographic Photography." In *Woman as Sex Object: Studies in Erotic Art, 1730–1970*, ed.
 Thomas B. Hess and Linda Nochlin, 81–89. *Art News Annual* 38. New York: Newsweek, 1972.

Nochlin, Linda. *Realism*. New York: Penguin, 1971.

———. *The Politics of Vision: Essays on Nineteenth-Century Art and Society*. New York: HarperCollins, 1989.

———, ed. *Impressionism and Post-Impressionism, 1874–1904: Sources and Documents*. Englewood Cliffs, N.J.: Prentice-Hall, 1966.

Nodier, Charles. *Contes de la Veillée*. Paris: Charpentier, 1853.

Nord, Philip. "Manet and Radical Politics." *Journal of Interdisciplinary History* 19, no. 3 (Winter 1989): 447–80.

———. *The Republican Moment: The Struggle for Democracy in 19th-Century France*. Cambridge: Harvard University Press, 1995.

Norris, Christopher. *Deconstruction: Theory and Practice*. New York: Methuen, 1982.

O'Brian, John. *Degas to Matisse: The Maurice Wertheim Collection*. Cambridge, Mass.: Fogg Art Museum, 1988.

Olliver, Émile. *Journal, 1846–1860*. Ed. Theodore Zeldin. 2 vols. Paris: Julliard, 1961.

Onimus, E. "La Psychologie médicale dans les drames de Shakspeare [sic]." *Revue des Deux Mondes* (1 April 1876): 635–57.

Ordonnances et arrêtés emanés du Préfet de Police Boittelle. Paris: Boucquin, 1864.

Orienti, Sandra. *The Complete Paintings of Manet*. Intro. P. Pool. New York: Viking Penguin, 1970.

Pandectes chronologiques, ou collection nouvelle résumant la jurisprudence. Paris: Plon, 1890.

Pankow, Gisela. *Structure familiale et psychose*. Paris: Aubier Montaigne, 1977.

Parent-Duchâtelet, A.-J.-B. *De la prostitution dans la ville de Paris*. 2 vols. Paris, 1837.

Parsons, Christopher, and Martha Ward. *A Bibliography of Salon Criticism in Second Empire Paris*. New York: Cambridge University Press,
 1986.

Pascaud, Henri. "Étude sur la surveillance de la Haute Police: ce qu'elle a été, ce qu'elle est, ce qu'elle devra être." *Revue Critique* 27 (1865):
 229–58.

Pauli, G. "Raphaël und Manet." *Monatschrift für Kunstwissenschaft* 1 (January–February 1908): 53–55.

Paulson, William. "De la force vitale au système organisateur: 'La Muse du département' et l'esthétique balzacienne." *Romantisme* 17, no.
 55 (1987): 33–40.

Penley, Constance. "Feminism, Psychoanalysis, and the Study of Popular Culture." In *Visual Culture: Images and Interpretations*, ed.
 N. Bryson, M. A. Holly, and K. Moxey. Hanover, N.H.: Wesleyan University Press and University Press of New England, 1994.

Perrot, Michelle, and Anne-Martin Fugier. *A History of Private Life*. Series ed. Philippe Ariès and Georges Duby. Trans. Arthur
 Goldhammer. Vol. 4. Cambridge: Belknap Harvard, 1990.

Perrot, Philippe. *Les Dessus et les dessous de la bourgeoisie*. Paris: Hachette, 1981.

———. *Le Travail des apparences, ou les transformations du corps féminin XVIIIe–XIXe siècle*. Paris: Seuil, 1984.

Pichois, Claude, and Jean Ziegler. *Baudelaire*. Paris: Julliard, 1987.

Pichois, Claude, ed. *Lettres à Charles Baudelaire*. Neuchâtel: Èditions de la Baconniére, 1973.

Pinkney, David H. *Napoleon III and the Rebuilding of Paris*. Princeton: Princeton University Press, 1958.

Pitman, Dianne. *Bazille: Purity, Pose, and Painting in the 1860s*. University Park: Pennsylvania State University Press, 1998.

Plessis, Alain. *The Rise and Fall of the Second Empire, 1852–1871*. Trans. J. Mandelbaum. Cambridge: Cambridge University Press, 1987.

Pollock, Griselda. "Modernity and the Spaces of Femininity." In *The Expanding Discourse: Feminism and Art History*, ed. Norma Broude
 and Mary D. Garrard. New York: HarperCollins, 1992.

Pontmartin, Alexandre de. *Souvenirs d'un vieux critique*. Paris: Calmann Lévy, 1886.

Prendergast, Christopher. *Balzac: Fiction and Melodrama*. London: Edward Arnold, 1978.

Prendergast, Christopher. *The Order of Mimesis: Balzac, Stendhal, Nerval, Flaubert*. New York: Cambridge University Press, 1986.

———. *Paris and the Nineteenth Century*. Cambridge, Mass.: Blackwell, 1995.

Proust, Antonin. *Édouard Manet: souvenirs*. Paris: H. Laurens, 1913.

Pugh, Anthony R. *Balzac's Recurring Characters*. Toronto: University of Toronto Press, 1974.

Quinot, Robert. *Gennevilliers: évocation historique*. Vol. 1. Gennevilliers: Ville de Gennevilliers, 1966.

Ragland-Sullivan, Ellie. *Jacques Lacan and the Philosophy of Psychoanalysis*. Chicago: University of Illinois, 1987.

Reff, Theodore. "The Symbolism of Manet's Frontispiece Etchings." *Burlington Magazine* 104, no. 710 (May 1962): 182–87.

———. "Copyists in the Louvre, 1850–1870." *Art Bulletin* 46, no. 4 (December 1964): 552–59.

———. "Manet's Sources: A Critical Evaluation." *Artforum* 8 (September 1969): 40–48.

———. "Manet and Blanc's 'Histoire des peintres.'" *Burlington Magazine* 112 (July 1970): 456–58.

———. "Manet's 'Portrait of Zola.'" *Burlington Magazine* 117 (January 1975): 34–44.

———. *Manet: Olympia*. New York: Viking, 1976.

———. *Manet and Modern Paris*. Exh. cat. Washington, D.C.: National Gallery of Art, 1982.

Rewald, John. *The History of Impressionism*. 4th ed. New York: Museum of Modern Art, 1973.

———. *Paul Cézanne*. New York: Harry N. Abrams, 1986.

Ricoeur, Paul. *Freud and Philosophy: An Essay on Interpretation*. Trans. D. Savage. New Haven: Yale University Press, 1970.

———. *Oneself as Another*. Trans. K. Blamey. Chicago: University of Chicago Press, 1992.

Rigollot, Marcel Jérôme. *Essai sur le Giorgion*. Amiens: Duval et Herment, 1852.

Rishel, Joseph. *The Second Empire, 1852–1870: Art in France under Napoleon III*. Philadelphia: Philadelphia Museum of Art, 1978.

Rivière, Joan. "Womanliness as a Masquerade" [1929]. In *Formations of Fantasy*, ed. Victor Burgin, James Donald, and Cora Kaplan. New York: Routledge, 1986.

Robb, Graham. *Balzac: A Life*. New York: Norton, 1994.

Robert, Marthe. *Origine du roman, roman des origines*. Paris: Gallimard, 1987 [1972].

Roos, Jane Mayo. "Édouard Manet's Angels at the Tomb of Christ: A Matter of Interpretation." *Arts Magazine* 58, no. 8 (April 1984): 83–91.

———. *Early Impressionism and the French State, 1866–1874*. New York: Cambridge University Press, 1996.

Rose, Jacqueline, and Juliet Mitchell. *Feminine Sexuality: Jacques Lacan and the École Freudienne*. New York: Norton, 1985.

Rosebury, Theodore. *Microbes and Morals: The Strange Story of Venereal Diseases*. New York: Viking, 1971.

Rosenberg, Pierre. *Chardin, 1699–1779*. Paris: Grand Palais, 1979.

Rosenblum, Robert, and H. W. Janson. *Nineteenth-Century Art*. New York: Harry N. Abrams, 1984.

Rosenthal, Léon. *Manet aquafortiste et lithographe*. Paris: Le Goupy, 1925.

Rouart, Denis, and Daniel Wildenstein. *Édouard Manet: catalogue raisonné*. 2 vols. Paris: Bibliothèque des Arts, 1975.

Royer, Jean-Pierre, Renée Martinage, and Pierre Lecocq. *Juges et notables au XIXe siècle*. Paris: Presses Universitaires de France, 1982.

Rubin, James H. *Manet's Silence and the Poetics of Bouquets*. Cambridge: Harvard University Press, 1994.

Ryan, Michael. *Prostitution in London, with a Comparative View of That of Paris and New York*. London: Baillière, 1839.

Saint-Denys, Hervey de. *Les Rêves et les moyens de les diriger*. Paris: Tchon, 1964 [1867].

Sandblad, Nils Gösta. *Manet: Three Studies in Artistic Conception*. Stockholm: Lund, 1954.

Sartre, Jean-Paul. *Being and Nothingness*. Trans. Hazel Barnes. New York: Washington Square Press, 1956.

———. *The Psychology of Imagination*. Secaucus, N.J.: Citadel, 1969.

———. *L'imagination*. Paris: Presses Universitaires de France, 1989 [1936].

———. *Mallarmé, or the Poet of Nothingness*. Trans. Ernest Sturm. University Park: Pennsylvania State University Press, 1991.

Schapiro, Meyer. "The Apples of Cézanne: An Essay on the Meaning of Still-life." In *Modern Art: 19th and 20th Centuries, Selected Papers*. New York: George Braziller, 1982.

Schapiro, Meyer. *Theory and Philosophy of Art: Style, Artist, and Society, Selected Papers.* New York: George Braziller, 1994.

Scharf, Aaron. *Art and Photography.* London, 1968.

Schor, Naomi. *Breaking the Chain: Women, Theory, and French Realist Fiction.* New York: Columbia University Press, 1985.

———. *Reading in Detail: Aesthetics and the Feminine.* New York: Methuen, 1987.

Sedgwick, Eve Kosofsky. *Between Men: English Literature and Male Homosocial Desire.* New York: Columbia University Press, 1985.

Seibert, Margaret Mary Armbrust. "A Biography of Victorine-Louise Meurent and Her Role in the Art of Édouard Manet." Ph.D. diss., Ohio State University, 1986.

Seigel, Jerrold. *Bohemian Paris: Culture, Politics, and the Boundaries of Bourgeois Life, 1830–1930.* New York: Penguin, 1987.

Sennett, Richard. *The Fall of Public Man: On the Social Psychology of Capitalism.* New York: Vintage Books, 1978.

Settis, Salvatore. *La "Tempesta" interpretata: Giorgione, i committenti, il soggetto.* Turin: Einaudi Editore, 1978.

———. *Giorgione's Tempest: Interpreting the Hidden Subject.* Trans. E. Bianchini. Chicago: University of Chicago Press, 1990.

Shennan, Margaret. *Berthe Morisot: First Lady of Impressionism.* Thrupp, Stroud, Gloucestershire: Sutton Publishing Limited, 1996.

Sheon, Aaron. "Courbet, French Realism, and the Discovery of the Unconscious." *Arts* 55, no. 6 (February 1981): 114–28.

Sheppard, Jennifer M. "The Inscription in Manet's 'The Dead Christ with Angels.'" *Metropolitan Museum Journal* 16 (1981): 199–200.

Sidlauskas, Susan. "Contesting Femininity: Vuillard's Family Pictures." *Art Bulletin* 79, no. 1 (March 1997): 85–111.

Silverman, Debora L. *Art Nouveau in Fin-de-Siècle France: Politics, Psychology, and Style.* Berkeley: University of California Press, 1989.

Silvestre, Armand. "Le Salon de 1869." *La Revue Moderne* 52 (1869): 699–715 and 53 (1869): 141–69.

———. "Souvenirs littéraires: le Café Guèrbois." *La Revue Générale: Littéraire, Politique et Artistique* 4, no. 66 (1 August 1886): 293–95; no. 69 (15 September 1886): 357–59; no. 70 (1 October 1886): 383–85.

Sloane, Joseph C. "Manet and History." *Art Quarterly* 14 (Summer 1951): 92–106.

Solkin, David. "Philibert Rouvière: Édouard Manet's 'L'Acteur tragique.'" *Burlington Magazine* 117, no. 872 (November 1975): 702–9.

Solomon-Godeau, Abigail. "The Legs of the Countess." *October* 39 (Winter 1986): 65–108.

———. "Who Is Speaking Thus? Some Questions about Documentary Photography." In *Photography at the Dock: Essays on Photographic History, Institutions, and Practices.* Minneapolis: University of Minnesota Press, 1991.

Soulié, Frédéric. "Maison de campagne à vendre." *Le Soleil*, 21–22 October 1865.

Spencer, Robin. "Manet, Rossetti, London and Derby Day." *Burlington Magazine* 133, no. 1057 (April 1991): 228–36.

Staffe, Baronne. *Les Hochets féminins: les pierres précieuses, les bijoux, la dentelle, la broderie, l'éventail, quelques autres superfluités.* Paris: Flammarion, 1902.

Stapleaux, Léopold. "Le Château de la Rage." *Le Soleil*, 21–22 October 1865.

Sterling, Charles. "Manet et Rubens." *L'Amour de l'Art* 7 (September 1932): 290.

Stokes, Adrian. *The Image in Form.* New York: Harper and Row, 1972.

Stoler, Ann Laura. *Race and the Education of Desire: Foucault's 'History of Sexuality' and the Colonial Order of Things.* Durham, N.C.: Duke University Press, 1995.

Stuckey, Charles F. "What's Wrong with This Picture?" *Art in America* 69 (September 1981): 96–107.

Sutcliffe, A. *The Autumn of Central Paris: The Defeat of Town Planning, 1850–70.* London, 1970.

Swartz, Morton N. "Neurosyphilis." In *Sexually Transmitted Diseases*, ed. K. K. Holmes et al. 2d ed. St. Louis: McGraw-Hill, 1990.

Tabarant, Adolphe. *Manet: Histoire catalographique.* Paris, 1931.

———. *Manet et ses oeuvres.* Paris: Gallimard, 1947.

———. *La Vie artistique au temps de Baudelaire.* Paris: Mercure de France, 1963 [1942].

Taillefer, Émile. "Contribution d'un Grenoblois à l'histoire de la Suède." *Bulletin du Musée Bernadotte* 17 (December 1972): 13–21.

Taine, Hippolyte. *Notes sur Paris: vie et opinions de M. Graindorge.* Paris, 1870.

Tanner, Tony. *Adultery in the Novel.* Baltimore: Johns Hopkins University Press, 1979.

Tardieu, Ambroise. *Étude médico-légal sur les attentats aux moeurs.* 4th ed. Paris: Baillière, 1862 [1857].

Tardieu, Ambroise. *Étude médico-légale sur les maladies produites accidentellement ou involontairement.* Paris: Baillière, 1879.

Texier, Edmond. *Tableau de Paris.* 2 vols. Paris: Paulin et le Chevalier, 1852–53.

Thélot, Jérôme. *Baudelaire: violence et poésie.* Paris: Gallimard, 1993.

Thuillier, Guy. *L'Imaginaire quotidien au XIXe siècle.* Paris: Economica, 1985.

Tucker, Paul Hayes, ed. *Manet's "Le Déjeuner sur l'herbe."* New York: Cambridge University Press, 1998.

Vacherot, Étienne. *La Métaphysique et la science.* Paris: Chamenot, 1858.

Valéry, Paul. "La Triomphe de Manet." In *Exposition Manet: 1832–83.* Paris: Édition des Musées Nationaux, 1932.

Van de Walle, Étienne. "Illegitimacy in France during the Nineteenth Century." In *Bastardy and Its Comparative History,* ed. P. Laslett, K. Oosterveen, and R. M. Smith. Cambridge: Harvard University Press, 1980.

Venant, A. *Code de la veuve.* Paris: Plon, 1854.

Verbeek, J. "Bezoekers van het Rijksmuseum in het Trippenhuis." *Bulletin van het Rijksmuseum, Gedenboek* (1958): 59–72.

Vernier, A. "Causerie scientifique." *Le Temps,* 29 April 1869, 1.

Vial, Claire Richard. *Découvrir la Sarthe.* Sablé-sur-Sarthe: Coconniers, 1984.

Viola, Bill. *Reasons for Knocking at an Empty House.* Cambridge, Mass.: MIT Press, 1995.

Vollard, Ambroise. *En écoutant parler Cézanne, Degas, et Renoir.* Paris: Grasset, 1938.

Wagner, Anne Middleton. *Jean-Baptiste Carpeaux: Sculptor of the Second Empire.* New Haven: Yale University Press, 1986.

———. "Why Monet Gave Up Figure Painting." *Art Bulletin* 76, no. 4 (December 1994): 612–29.

Wechsler, Judith. "An Apéritif to Manet's 'Déjeuner sur l'herbe.'" *Gazette des Beaux-Arts,* 6th ser., 91 (January 1978): 32–34.

Weisberg, Gabriel P. *The Realist Tradition: French Painting and Drawing, 1830–1900.* Exh. cat. Cleveland: Cleveland Museum of Art, 1980.

Williams, Roger L. *The Horror of Life.* Chicago: University of Chicago Press, 1980.

Wilson, Mary G. "Édouard Manet's 'Déjeuner sur l'herbe.' An Allegory of Choice: Some Further Conclusions." *Arts* 54, no. 5 (January 1980): 162–67.

Wilson-Bareau, Juliet. *Édouard Manet: Das Graphische Werk: Meisterwerke aus der Bibliothèque Nationale und weiterer Sammlungen.* Ingelheim am Rhein: Stadtverwaltung Ingelheim, 1977.

———. *Manet: dessins, aquarelles, eaux-fortes, lithographies, correspondance.* Paris: Galerie Huguette Berès, 1978.

———. "The Portrait of Ambroise Adam by Édouard Manet." *Burlington Magazine* 126, no. 981 (December 1984): 750–58.

———. *The Hidden Face of Manet.* London: Burlington Magazine, 1986.

———. Review of *Art in the Making: Impressionism,* by David Bomford et. al. *Burlington Magazine* 133, no. 1055 (February 1991): 127–29.

———, ed. *Édouard Manet: Voyage en Espagne.* Caen: L'Échoppe, 1988.

———, ed. *Manet by Himself.* Boston: Little, Brown and Company, 1991.

Wollheim, Richard. *Art and Its Objects.* 2d ed. New York: Cambridge University Press, 1985.

———. *Painting as an Art.* Princeton: Princeton University Press, Bollingen Series, 1987.

Wood, Christopher S. *Albrecht Altdorfer and the Origins of Landscape.* Chicago: University of Chicago Press and Reaktion Books, 1993.

Wright, Elizabeth. *Psychoanalytic Criticism: Theory in Practice.* New York: Methuen, 1984.

Yriarte, Charles. "Charles Baudelaire." *La Revue Nationale et Étrangère* 7 (14 September 1867): 162–66.

———. *Goya.* Paris: 1867.

Zeldin, Theodore. *France, 1848–1945.* 2 vols. Oxford: Clarendon Press, 1977.

Zizek, Slavoj. *The Sublime Object of Ideology.* New York: Verso, 1992.

Zola, Émile. *Une Campagne.* Paris: Charpentier, 1882.

———. *Correspondance.* Ed. B. H. Bakker. 8 vols. Paris and Montréal: C.N.R.S. and Presse Université de Montréal, 1978.

———. *Pour Manet.* Ed. J.-P. Leduc-Adine. Brussels: Éditions Complexe, 1989.

INDEX

PHOTOGRAPHY CREDITS